POMPEO BATONI

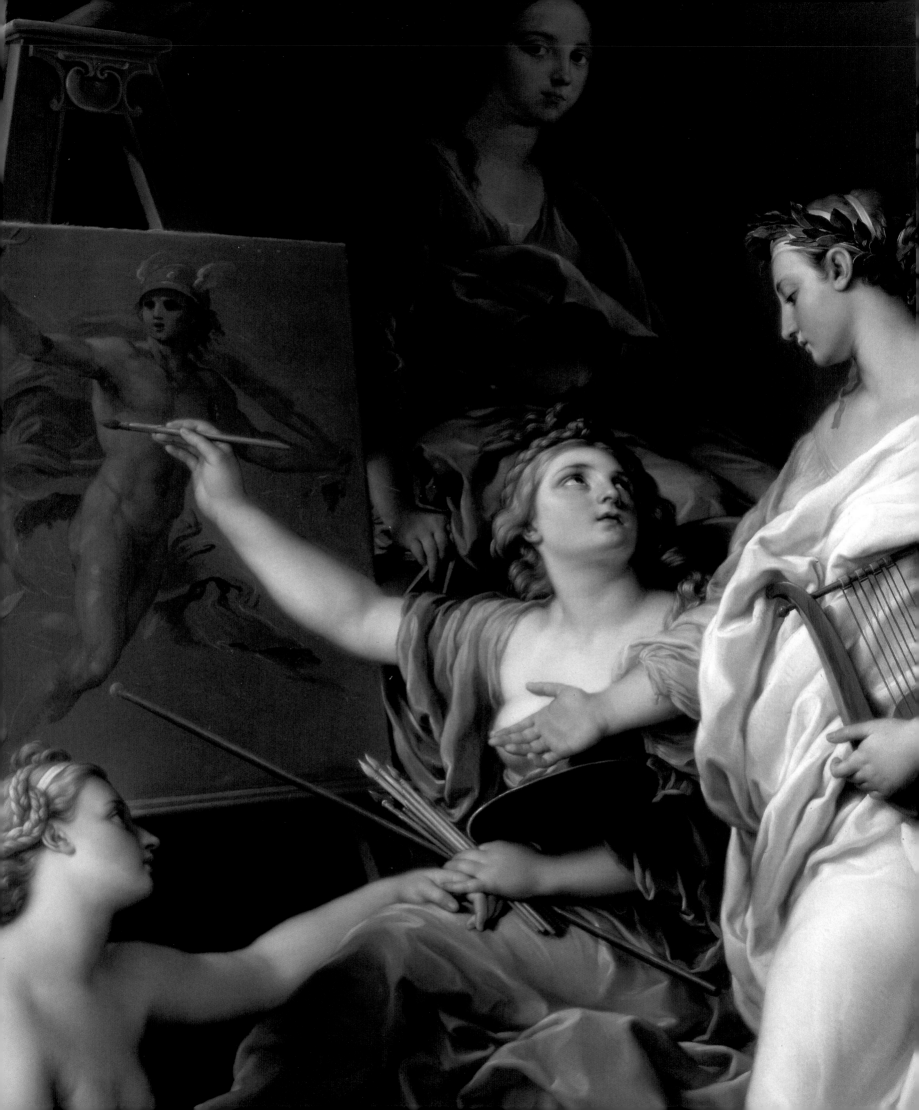

POMPEO BATONI

Prince of Painters
in Eighteenth-Century Rome

Edgar Peters Bowron and Peter Björn Kerber

Yale University Press, New Haven and London
in association with
The Museum of Fine Arts, Houston

Published in conjunction with the exhibition
Pompeo Batoni: Prince of Painters in Eighteenth-Century Rome,
organised by Edgar Peters Bowron and Peter Björn Kerber
for the Museum of Fine Arts, Houston, and the National Gallery, London.

The Museum of Fine Arts, Houston
21 October 2007–27 January 2008

The National Gallery, London
20 February–18 May 2008

An indemnity is granted by the Federal Council on the Arts and the Humanities.
Generous funding in Houston is provided by:
The Albert and Margaret Alkek Foundation Exhibition Fund
The Samuel H. Kress Foundation

Designed and composed by Laura Lindgren.
Set in Centaur and Venetian 301 types.
Printed in Singapore by CS Graphics.

Library of Congress Cataloging-in-Publication Data
Bowron, Edgar Peters.
 Pompeo Batoni : prince of painters in eighteenth-century Rome / Edgar Peters
Bowron and Peter Björn Kerber.
 p. cm.
 Catalog of an exhibition at the Museum of Fine Arts, Houston, Oct. 21, 2007–Jan.
27, 2008 and at the National Gallery, London, Feb. 20–May 18, 2008.
 Includes bibliographical references and index.
 ISBN 978-0-300-12680-8 (cloth : alk. paper) — ISBN 978-0-89090-158-8 (pbk. :
alk. paper) 1. Batoni, Pompeo, 1708–1787—Exhibitions. 2. Batoni, Pompeo,
1708–1787—Criticism and interpretation. I. Kerber, Peter Björn.
II. Batoni, Pompeo, 1708–1787. III. Museum of Fine Arts, Houston. IV. National
Gallery (Great Britain) V. Title.
 ND623.B327A4 2007
 759.5—dc22 2007025174
 10 9 8 7 6 5 4 3 2 1

Jacket illustrations: *(front) Richard Milles* (detail), c. 1758 (fig. 76); *(back) Purity of Heart,* 1752 (fig. 47)
Frontispiece: *Allegory of the Arts* (detail), 1740 (fig. 21)

CONTENTS

LENDERS TO THE EXHIBITION

Allen Memorial Art Museum, Oberlin College, Ohio

Amgueddfa Cymru—National Museum Wales, Cardiff

The Art Institute of Chicago

The Ashmolean Museum, Oxford

The Duke of Buccleuch & Queensberry KT, Boughton
House, Northamptonshire

The Chevening Estate, Kent

English Heritage

The Fitzwilliam Museum, Cambridge

Collection of the late Sir Brinsley Ford

Galleria Nazionale, Parma

Galleria Nazionale d'Arte Antica, Palazzo Barberini, Rome

Galleria degli Uffizi, Florence

Sir James and Lady Graham, Norton Conyers,
North Yorkshire

Hood Museum of Art, Dartmouth College, Hanover,
New Hampshire

Laing Art Gallery, Newcastle upon Tyne (Tyne & Wear
Museums)

Los Angeles County Museum of Art

Manchester Art Gallery

The Metropolitan Museum of Art, New York

Minneapolis Institute of Arts

The Montreal Museum of Fine Arts

Musée Municipal, Brest

Musei Vaticani, Vatican City

Museo de Arte de Ponce, Fundación Luis A. Ferré, Ponce,
Puerto Rico

Museo Nacional del Prado, Madrid

Museo Nazionale di Villa Guinigi, Lucca

Museo de la Real Academia de Bellas Artes de
San Fernando, Madrid

The Museum of Fine Arts, Houston

The National Gallery, London

National Gallery of Scotland, Edinburgh

National Portrait Gallery, London

The National Trust

The National Trust for Scotland

North Carolina Museum of Art, Raleigh

Palazzo Reale, Caserta

Pinacoteca Capitolina, Rome

The Presidency of the Republic of Italy

Private collection, on loan to the Museo Biblioteca Archivio
di Bassano del Grappa

Saint Louis Art Museum

San Vittore al Corpo, Milan

Santi Faustino e Giovita, Chiari

Staatliche Museen zu Berlin

Städel Museum, Frankfurt

The State Hermitage Museum, Saint Petersburg

Toledo Museum of Art

The Trustees of the Will of the 6th Earl of Arran

Württembergische Landesbibliothek, Stuttgart

Yale Center for British Art

The Marquess of Zetland, Aske Hall, North Yorkshire

Anonymous private collectors

DIRECTORS' FOREWORD

Among Italy's painters of the eighteenth century, Pompeo Batoni was held in exceptionally high esteem during his lifetime. His celebrity was considerable among the international travellers, especially the British, who visited Rome on the Grand Tour, and for nearly half a century he recorded their visits to the Eternal City in portraits that remain among the most memorable artistic accomplishments of the age. But Batoni was much more than a "face-painter," and the roster of patrons who clamoured for his history paintings is studded with emperors and kings, popes and princes.

Following his death and throughout the nineteenth century, Batoni's reputation suffered the neglect of most artists of the Italian Settecento, but he was more fortunate than the majority of his contemporaries in receiving the attention of a dedicated group of twentieth-century scholars and connoisseurs intent upon reviving critical regard for his work and bringing his considerable achievements to the attention of a wider public. The doctoral dissertation of the German scholar Ernst Emmerling marked the first attempt to study Batoni's œuvre in its entirety. During his tenure at the National Portrait Gallery the Englishman John Steegman launched interest in the study of Batoni as the portraitist of the English in Rome with a 1946 article in the *Burlington Magazine* after Benedict Nicolson had been encouraged to undertake work on Batoni while an attaché at the National Gallery in the 1930s. An Italian scholar, Isa Belli Barsali, greatly advanced appreciation of Batoni's paintings when she organised the first exhibition devoted to the artist, held in Lucca in 1967. One of the main contributors to that exhibition's catalogue was the American scholar and museum director Anthony M. Clark, who had already emerged as the doyen of Roman Settecento studies. For more than twenty years Clark collected information on Pompeo Batoni for the purpose of producing a monograph and catalogue of the painter's works. Clark's enthusiasm for the artist he believed to be eighteenth-century Rome's "most famous and agreeable painter, and its best draughtsman," enlisted a variety of friends and professional colleagues in his cause, none more devoted than Sir Ellis Waterhouse,

a former assistant keeper at the National Gallery, and Sir Brinsley Ford, a former trustee, whose archive of British and Irish travellers to Italy has proved to be of inestimable value to anyone interested in the period of the Grand Tour.

Owing to Clark's untimely death at the age of fifty-three, his research on Batoni remained unpublished until 1985, when Edgar Peters Bowron produced a catalogue raisonné of Batoni's paintings and drawings. In the intervening years, Bowron had played a major role in the organisation of the acclaimed exhibition *Pompeo Batoni and His British Patrons* at Kenwood in London in 1982 and reminded a New York audience of the painter's merits in an exhibition at Colnaghi in the same year. In 2000 the landmark exhibition in Philadelphia and Houston devoted to the art of eighteenth-century Rome brought the painter's brilliance to an even wider audience in North America with a generous selection of his finest portraits and history paintings.

We are truly delighted that the Museum of Fine Arts, Houston, and the National Gallery, London, are able to widen further the appreciation of Batoni's paintings and to celebrate the tercentenary of his birth with this splendid exhibition. We wish to thank, above all, the institutions and private lenders to the exhibition for their generosity in making these works available. Thanks go to the Albert and Margaret Alkek Foundation Exhibition Fund and the Samuel H. Kress Foundation for generously funding the exhibition in Houston. We are most grateful for an indemnity granted by the Federal Council on the Arts and the Humanities.

The present study builds upon and pays homage to the efforts of the many individuals who have advanced our knowledge of the artist, but it also contributes much new information, and thus we wish to thank in particular the authors and organisers of the exhibition, Edgar Peters Bowron and Peter Björn Kerber.

Peter C. Marzio, Director
The Museum of Fine Arts, Houston

Charles Saumarez Smith, Director
The National Gallery, London

PREFACE AND ACKNOWLEDGEMENTS

On a May morning in 1727, the nineteen-year-old Pompeo Batoni set off from his hometown of Lucca on a journey to Rome—a city that, with the exception of a few brief excursions, he was never to leave again for the rest of his life. Born to the goldsmith Paolino Batoni and his wife, Chiara Sesti, on 25 January 1708, Pompeo had entered his father's workshop at an early age. In 1726, Pope Benedict XIII elevated Lucca to an archbishopric. To express their gratitude, the city's governors commissioned a gold chalice from the Batoni workshop as a gift to the pontiff. The piece was designed and decorated by the precociously talented Pompeo, who was asked to go to Rome himself and present it to the pope. Like any major piece from Paolino's workshop, the chalice would have been stamped with the father's "P·B" maker's mark. Pompeo used precisely the same style of initialling many of his paintings, thereby retaining a memento of his Lucchese roots while quickly becoming the most sought-after painter in Rome and the embodiment of the Roman artistic tradition.

Thus it seems only fitting that the initial plan for this book was conceived during a stay in Rome. Aiming to produce a volume that serves as a companion to the exhibition in Houston and London and at the same time significantly expands the horizons of knowledge about the artist, we have opted for the format of a monographic study that treats key themes of Batoni's œuvre, development, and patronage. This has enabled us to consider the paintings in the exhibition not in isolation but in the larger context of other major works Batoni created over the fifty-year arc of his artistic career. In particular, we have endeavoured to shed new light on the textual and visual sources for Batoni's history paintings, often undeservedly neglected in favour of his portraits; on the origins and prototypes of his portrait style, ranging from Titian and Van Dyck to Thomas Hudson and Allan Ramsay; and on the extraordinary patronage Batoni enjoyed as perhaps the only eighteenth-century painter to work for virtually all of the major European courts. This entire undertaking would not

have been possible without the wisdom and wide-ranging knowledge of Liliana Barroero, Christopher Johns, Alastair Laing, and Francis Russell. They acted as midwifes, nurses, and godparents to the project, and we would like to record our deepest gratitude for their guidance, expertise, and practical support.

Among the many others to whom we have incurred debts of one kind or another, we would like particularly to acknowledge Victor Nieto Alcaide, Brian Allen, Sandy Beaunay, David Bomford, Colonel Richard Brook, Bill Brown, Simona Brusa, Francesco Buranelli, Tatiana Bushmina, Tom Caley, Keith Christiansen, Paolo Coen, Francesco Colalucci, Jeffrey Collins, Roberto Contini, Andrew Cormack, Françoise Daniel, Andria Derstine, Giuliana Ericani, Oliver Fairclough, Larry J. Feinberg, Maria Teresa Filieri, Gabriele Finaldi, Lucia Fornari Schianchi, Elisabetta Giffi, Louis Godart, Hilliard T. Goldfarb, Marco Goldin, George R. Goldner, Ian Gow, Sergio Guarino, Enrico Guglielmo, Cheryl Hartup, Annette Hojer, James Holloway, Simon Howell, Barbara Jatta, Elisabeth Kieven, Cesare Lampronti, Riccardo Lattuada, Fabrizio Lemme, Bernd Wolfgang Lindemann, Anna Lo Bianco, Don Rino Magnani, Judith W. Mann, J. Patrice Marandel, Laura Miani, Olivier Michel, Don Giambattista Milani, Luisa Morozzi, Kim Muir, Norman Muller, Lawrence W. Nichols, John Nolan, Patrick J. Noon, Maureen O'Brien, Carlo Orsi, Ann Percy, Ferdinando Peretti, Ugo Pierucci, John A. Pinto, Orietta Prisco, Wolfgang Prohaska, Don Pier Virgilio Begni Redona, Steffi Roettgen, Betsy J. Rosasco, Paola Sannucci, Scott Schaefer, David Scrase, Jon Seydl, Jacob Simon, John T. Spike, David H. Steel, Claudio Strinati, Peter C. Sutton, T. Barton Thurber, Maria Elisa Tittoni, the Hon. Michael Tollemache, Vera Trost, Angus Trumbull, Rosella Vodret, Marco Voena, Christoph Martin Vogtherr, Kurt Vuillemont, Jolanda van Nijen Vurpillot, Robert Wald, Colonel Peter Walton, Aidan Weston-Lewis, Catherine Whistler, Martha Wolff, and Frank Zuccari.

At the Museum of Fine Arts, Houston, a special debt of gratitude is owed to Helga K. Aurisch, associate curator of European art, and to Teresa Harson, coordinator, European art, for their indispensable and indefatigable efforts in securing loans as well as reproductions for the publication. Andrea Guidi di Bagno, chief paintings conservator, shared invaluable knowledge on questions of condition and restoration, while her irresistible charm opened doors to hitherto unseen works. Diane P. Lovejoy, publications director, and Christine Waller Manca, assistant publications director, warrant heartfelt thanks for their excellent editing of the book and for coordinating its production. Numerous other colleagues at the museum contributed significantly to the organisation and presentation of the exhibition, notably Julie Bakke, Kathleen B. Crain, and John M. Obsta, registrar's department; Jack Eby and William T. Cochrane, exhibition design; Michael Kennaugh, Richard Hinson, and the preparations and installations staff; Margaret A. Mims, education; Marcia K. Stein and the staff of the Freed Image Library; and the staff of the Hirsch Library, in particular Jonathan W. Evans and Margaret Crocker Ford. Other museum colleagues who contributed their time and advice to this project include Gwendolyn H. Goffe, Kathleen V. Jameson, Paul A. Johnson, Frances Carter Stephens, and Karen Bremer Vetter. At the National Gallery, we are deeply grateful to Dawson Carr, curator of Spanish and later Italian paintings, and his colleagues for the time and energy they have given in support of the exhibition.

We are grateful to Yale University Press for producing such a handsome publication and seeing it through the press with speed and efficiency. Our special thanks are extended to Patricia Fidler, publisher, art and architecture; Susan Laity, senior manuscript editor, for her sage and discerning editorial advice, which greatly improved the text in a multitude of ways; Laura Lindgren, freelance book designer; John Long, photo editor; Mary Mayer, production manager, art books; and Kristin Swan, editorial and production assistant.

Edgar Peters Bowron
Peter Björn Kerber

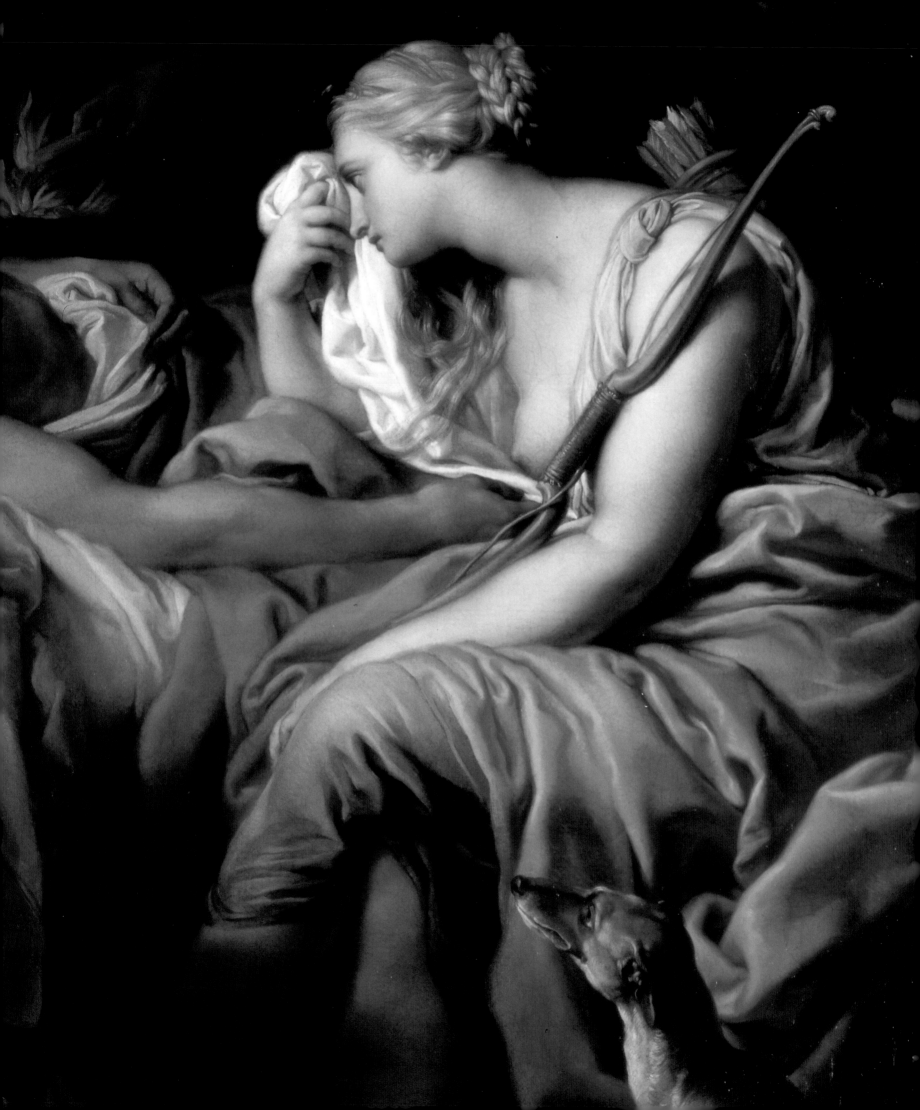

INVENTIVE STORYTELLING
The Early Subject Pictures

My honour requires me to despatch no work that isn't finished with the greatest attention and diligence, for the reason that one single slipshod work could make me lose all the credit acquired up to now.

—Pompeo Batoni to Bartolomeo Talenti, 19 December 1744

Pompeo Batoni (1708–1787) owed his first public commission to the April showers of 1732. Walking across the piazza di Campidoglio and seeking shelter from a sudden downpour, Count Forte Gabrielli Valletta of Gubbio ducked into the portico of the Palazzo dei Conservatori, where he came upon a young man making a drawing of an ancient bas-relief, oblivious to all else. Admiring his exactitude and skill, Gabrielli struck up a conversation with the artist—the twenty-four-year-old Batoni—and asked whether he might see some of his paintings. The two of them walked down the hill to Batoni's apartment in piazza di Macel de' Corvi, where the nobleman was so impressed with Batoni's talent that he offered him a commission on the spot: an altarpiece for the Gabrielli family chapel in San Gregorio al Celio, a Camaldolese monastery church.[1] For the *Virgin and Child with the Blessed Pietro, Castora, Forte, and Lodolfo*, 1732–33 (fig. 1), Batoni prepared a cartoon of the composition to scale, installed it in the chapel, and discussed it with Francesco Fernandi, called Imperiali (1679–1740), his mentor and, in a limited sense, his teacher.[2] At the time, the older artist was working

on his own altarpiece for the same church, the *Death of Saint Romuald* (1733–34; in situ). In Batoni's composition, the Virgin and Child are adapted from one of Imperiali's earlier works, the *Virgin of the Rosary with Saints Jerome, Dominic, and Francis* (1723–24; Sant'Andrea, Vetralla), while the pose of the Blessed Forte echoes the Saint Dominic in reverse.[3]

The actual altarpiece was begun in the palace of Prince Camillo Pamphili, who had offered Batoni the use of a room but once the work was under way had asked the painter to take his large canvas elsewhere. At the suggestion of the artist and antiquary Girolamo Odam (1661–1741), the Venetian cardinal Angelo Maria Querini (1680–1755), a major benefactor of San Gregorio al Celio, invited Batoni to set up a temporary studio in a spacious room in the Palazzo Venezia, then known as the Palazzo di San Marco. The finished painting was exhibited there on 30 August 1733, and Batoni was paid 200 scudi, the same amount Imperiali earned for his altarpiece of identical size. As a token of gratitude to Querini for having come to his rescue at a crucial moment, Batoni presented the cartoon to the cardinal, who placed it on display in his apartments at the Palazzo Venezia.[4] Querini himself was soon to become one of Batoni's patrons. In his role as bishop of Brescia, he

Detail, fig. 24

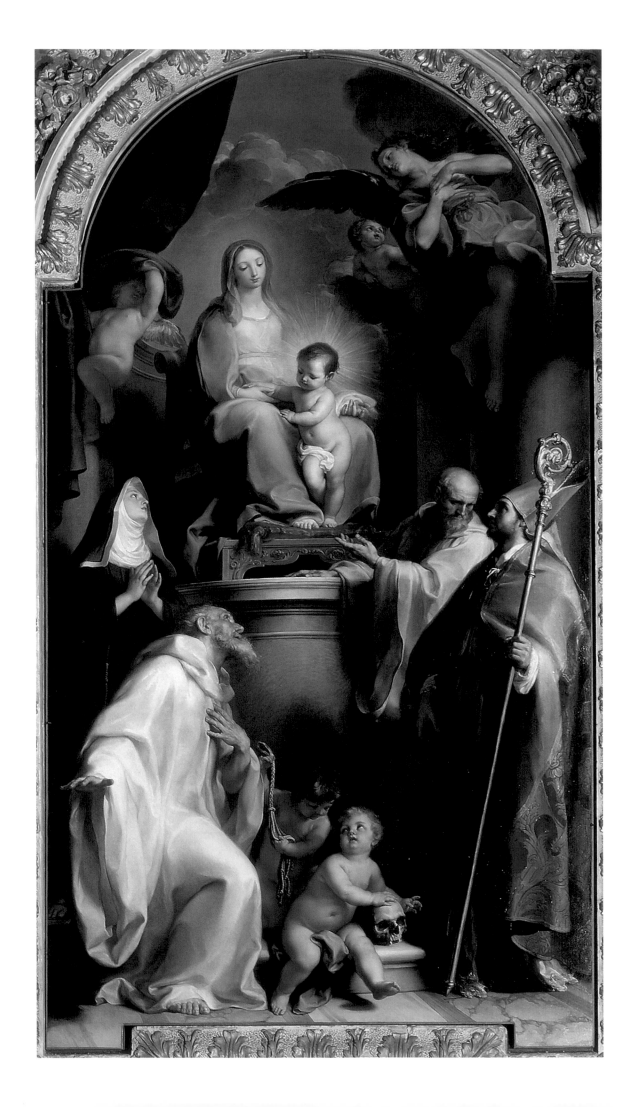

donated the costs of the high altar to the city's newly built Oratorian church of Santa Maria della Pace and awarded the commission for the enormous altarpiece, the *Presentation in the Temple*, 1735–36 (fig. 2), to Batoni.[5] The Oratorians were delighted with the painting, and they subsequently commissioned an additional altarpiece from the artist, the *Virgin and Child with Saint John Nepomuk*, c. 1743–46 (see fig. 25).[6]

Apart from accommodating Cardinal Querini, the Palazzo Venezia was also the seat of the ambassador of the Republic of Venice to the Holy See. Marco Foscarini (1696–1763), a friend of Querini's and a seasoned diplomat who had already held posts in Vienna and Milan, was appointed to this position on 1 March 1737.[7] By early April, he had taken up residence in Rome.[8] In addition to seeing Batoni's cartoon in the building where he lived, he would almost certainly have visited San Gregorio al Celio to view the painting Querini had recently commissioned from their Venetian compatriot Antonio Balestra (1666–1740) for the church's high altar, unveiled in 1735, as well as Batoni's altarpiece.[9] It did not take Foscarini long to decide that the talented young painter from Lucca was the right choice to execute a major allegorical canvas he was planning.[10]

The *Triumph of Venice*, 1737 (fig. 3), was Batoni's first important nonreligious work.[11] Like the *Presentation in the Temple*, it was painted in a makeshift studio in the Palazzo Venezia, to which Foscarini paid daily visits. The ambassador, a highly erudite collector and bibliophile who had been serving as the Serenissima's official historiographer since 1735, personally devised the picture's complex *concetto* and probably considered himself at least a co-author of the final product, in the same way that in the eighteenth century the librettist rather than the composer was regarded as the principal author of an opera.[12] Francesco Benaglio (1708–1759), Foscarini's secretary at the time, later described the programme of the *Triumph of Venice* in his biography of the artist as representing "the flourishing state of the Republic when, once the wars incited by the famous league of Cambrai were extinguished, in peacetime the fine arts began to flourish again in Venice, summoned back and nurtured by Doge Leonardo Loredan," adding that Batoni

Fig. 1. *The Virgin and Child with the Blessed Pietro, Castora, Forte, and Lodolfo*, 1732–33. Oil on canvas, 148⅞ × 84¼ in. (378 × 214 cm). San Gregorio al Celio, Rome.

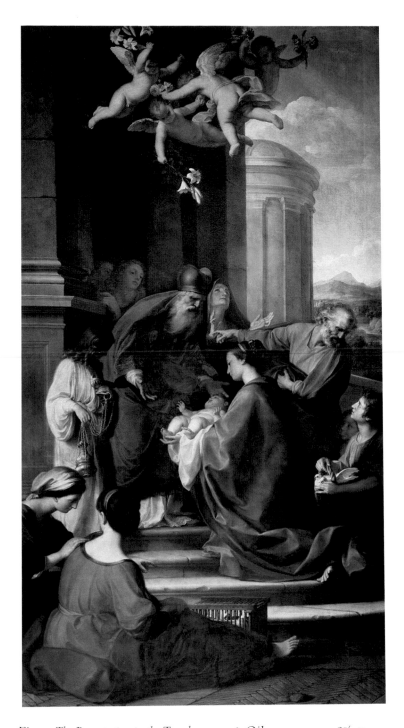

Fig. 2. *The Presentation in the Temple*, 1735–36. Oil on canvas, 198⅞ × 101⅛ in. (505 × 257 cm). Santa Maria della Pace, Brescia.

was asked to depict "sea, continent, views of the city, architecture, personages distinguished by their dignity, figures of all ages and sexes, genii, symbols of the humanities and the fine arts."[13]

On a triumphal chariot drawn by a pair of winged lions, the personification of the Venetian Republic is seated on

a shell-backed throne. As the symbol of the Evangelist Mark, the city's patron saint, the lions are the Republic's heraldic animals. Minerva, in her role as patroness of the arts, holds the olive branch of peace and recommends to Venice four putti playing with the symbols of the arts of painting, sculpture, architecture, music, drama, and poetry. Standing on the chariot next to Venice is Doge Leonardo Loredan (1438–1521), who seems to be trying to bring to her attention another group of putti offering the fruits of the Terraferma dominions.[14] At the apex of the composition, a personification of History is flanked by Fame and Mercury, with the latter handing Gasparo Contarini's *De republica* (*De magistratibus et republica Venetorum*) to a group of six sages. As the model for the view of the Molo with the Palazzo Ducale, Biblioteca, and Zecca, Batoni probably used the right-hand side of Gaspar van Wittel's view of the Bacino

di San Marco (c. 1721; Palazzo Colonna, Rome), which he could have seen in the Roman collection of Cardinal Pietro Ottoboni (1667–1740).[15]

Although most of the picture is allegorical and timeless, the striking presence of Loredan, who reigned from 1501 to 1521, firmly anchors the message at a particular point in time. The period of peace extolled in the picture, following the War of the League of Cambrai, lasted only a few years before hostilities again erupted, but significantly this particular episode in the Italian wars of the sixteenth century ended with a victory for the alliance of France and Venice over a coalition that included the Papal States. In his double role as the Republic's historian and ambassador, Foscarini seems to be arguing that even in Venice's current state of economic decline and political insignificance, he would be negotiating with the Papacy from a position of at least equal strength. Unable to claim military or economic superiority for present-day Venice, Foscarini shifted the contest to the cultural arena, duplicating the strategy deployed by Loredan after 1515 to "restore the damaged

Fig. 3. *The Triumph of Venice*, 1737. Oil on canvas, 68⅝ × 112⅝ in. (174.3 × 286.1 cm). North Carolina Museum of Art, Raleigh; Gift of the Samuel H. Kress Foundation.

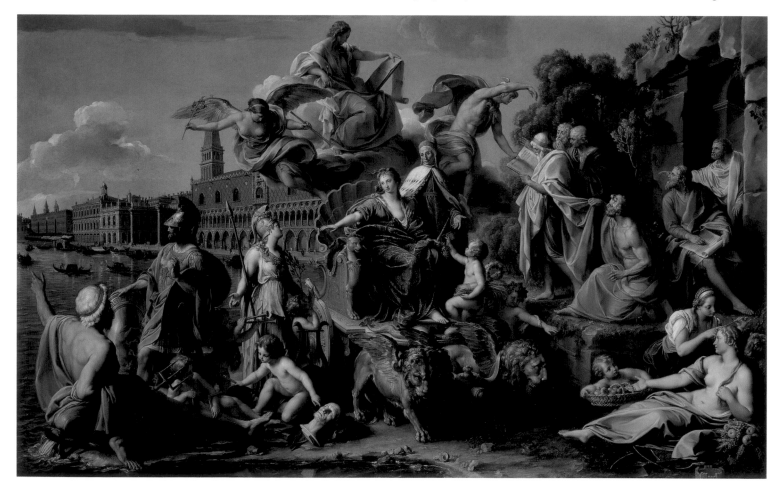

prestige of the state by presenting the republic as an ideal political society."[16] The superiority of patrician republican government as a political system—whose beneficial effects included a propitious climate for artistic excellence, as shown in the picture—was the key theme of Venetian political thought of the first half of the sixteenth century. This ideology found its most eloquent expression in the celebrated treatise shown in the picture, *De magistratibus et republica Venetorum* by Cardinal Gasparo Contarini (1483–1542).[17] It contains the nucleus of Foscarini's concetto: Venice's resurgence after the War of the League of Cambrai as a prototype for the Republic's ability to overcome its present doldrums.[18] Contarini had been Venetian ambassador to the Holy See (1528–30) as well as being a renowned author, and the implication that the current holder of the post saw himself as an heir to his illustrious predecessor would not have been lost on Foscarini's guests in the Palazzo Venezia.

In his *Della perfezione della Repubblica veneziana*, published in 1721, Foscarini quoted—with attribution to Contarini—a key passage from *De magistratibus et republica Venetorum* and named the six sages he later asked Batoni to depict: "The designs of all those ancient philosophers, who conceived various forms of government, as Theophrastus, Demetrius Phalereus, Plato, Cicero, Xenophon, Socrates, and many others, ancient and modern, did in their books, have been greatly surpassed by the real and viable constitution of our Republic."[19] The central element of the programme for the *Triumph of Venice* was also described in Foscarini's text: "[In] this state of peace, befitting the Republic . . . , it is no surprise that our native state flourishes with all those comforts and ornaments which accompany tranquillity and security of life."[20]

Foscarini and Batoni's collaborative effort expresses these ideas visually. Doge Leonardo Loredan is guiding a thriving peacetime Venice while Mercury presents Contarini's treatise to the ancient philosophers at right, who are plainly astounded that it surpasses their own designs. The volume is opened, as the inscription specifies, at book 2, which examines the office of the doge. Plato has been the first to receive the tome, and he is already engrossed in it.[21] On the left, Mars, the god of war, turns his back on the city and looks out to sea, his gaze directed by Neptune. This expresses a point made both by Contarini and by his close associate Andrea Navagero (1483–1529), in a funeral

oration for Leonardo Loredan, in 1521: Venice is immune to landward attack yet able to expand by sea.[22]

Given the demands of the complex literary programme and the artist's relative inexperience, it is perhaps not surprising that the resulting picture displays a certain awkwardness, an impression of attempting too much.[23] These problems were absent from Batoni's iconographically straightforward altarpieces immediately preceding and succeeding it, such as the *Holy Family with Saints Elizabeth, Zacharias, and the Infant Saint John the Baptist*, c. 1738–40 (fig. 4), for the Hieronymite church of Santi Cosma e Damiano in Milan.[24] Even though he did not officially assume the protectorate of the order's Lombard congregation until 1741, Cardinal Querini may have played a role in obtaining this choice commission for Batoni.

These early altarpieces first thrust Batoni's work into the public eye and can be considered the cornerstone of his subsequent career. Their number is rounded out by the *Christ in Glory with Saints Celsus, Julian, Marcionilla, and Basilissa* (1736–38; Santi Celso e Giuliano, Rome), commissioned by Giuseppe Alessandro Furietti (1685–1764), a passionate antiquarian who was at that time employing Batoni to draw objects unearthed in his excavation campaigns.[25] The painting, for the high altar of Santi Celso e Giuliano, a newly built church at the southern end of the Ponte Sant'Angelo, clearly acknowledges the Christ in Raphael's *Disputà* (1510–11; Palazzi Vaticani, Stanza della Segnatura, Vatican City), a work to which Batoni had devoted intensive study during his early years in Rome.[26] It was no accident that Anton Raphael Mengs (1728–1779) considered this painting, perhaps Batoni's most Raphaelesque, to be his rival's "most profound" work.[27] Two altarpieces—themselves echoing Raphael (1483–1520)—by Annibale Carracci (1560–1609) and his studio also appear to have influenced the design: *Saint Diego Recommending Juan de Herrera's Son to Christ* (c. 1606–7; Santa Maria di Monserrato, Rome) for the pose of Christ (in reverse) and a *Christ in Glory with Saints* (c. 1597–98, Palazzo Pitti, Florence) for the lower half of the composition.[28]

In addition to these major public and semi-public commissions, Batoni was quickly patronised by some of Rome's foremost noble families. Prince Nicolò Pallavicini (1677–1759) asked him to paint an altarpiece for the chapel in the Villa Belpoggio at Frascati, the *Vision of Saint Philip Neri*, c. 1733–34 (fig. 5), recorded there in an inventory of 1760.[29]

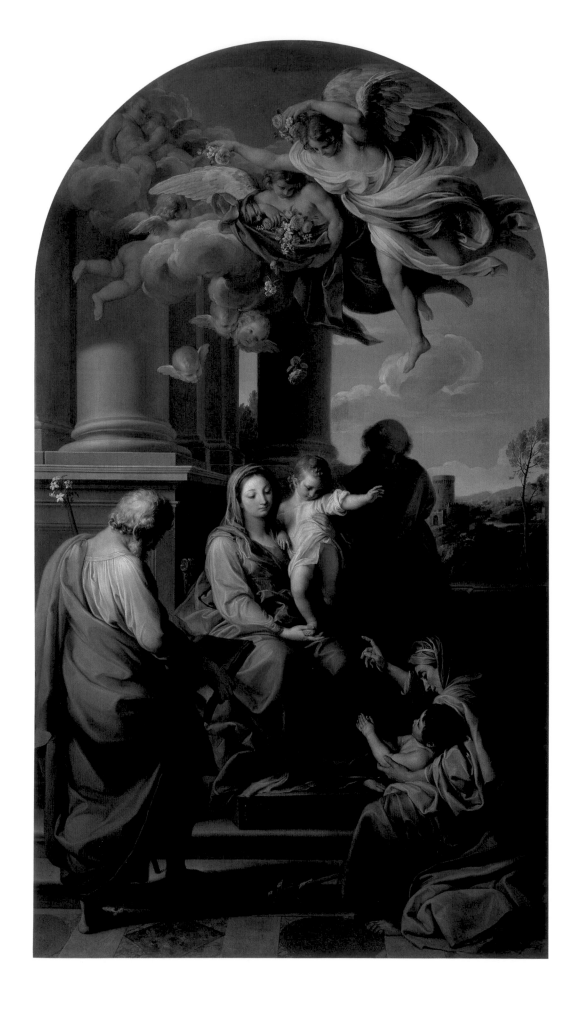

Fig. 5. *The Vision of Saint Philip Neri*, c. 1733–34. Oil on canvas, 78¼ × 55⅛ in. (200 × 140 cm). Galleria Nazionale d'Arte Antica, Palazzo Barberini, Rome.

The composition derives from Andrea Sacchi's *Virgin and Child with Saint Basil of Cappadocia* (c. 1636–40; Santa Maria del Priorato, Casa del Vescovo, Rome).[30] Batoni's vivid depiction of the saint's features was based on painstaking study of Philip Neri's death mask in the Roman Oratory at Santa Maria in Vallicella. Pallavicini also acquired from the artist a small *Visitation*, c. 1736–37 (fig. 6), in which a stooping executioner from Domenichino's *Flagellation of*

OPPOSITE: Fig. 4. *The Holy Family with Saints Elizabeth, Zacharias, and the Infant Saint John the Baptist*, c. 1738–40. Oil on canvas, 158⅛ × 89⅛ in. (403 × 228 cm). Pinacoteca di Brera, Milan.

RIGHT: Fig. 6. *The Visitation*, c. 1736–37. Oil on canvas, 19⅛ × 25⅛ in. (49.3 × 64.5 cm). Galleria Pallavicini, Rome.

Saint Andrew (1609) in the Oratorio di Sant'Andrea, part of the San Gregorio al Celio complex, reappears as a fowl vendor.[31] The kneeling acolyte in the same painter's *Last Communion of Saint Jerome* (1614) in the Vatican retained his role, now in reverse and on his feet, in Batoni's *Presentation in the Temple.*

The Development of a Pictorial Language

The single most important and lasting influence on Batoni, however, is to be found neither in the work of Raphael nor in that of Carracci, Domenichino (1581–1641), or Sacchi (c. 1599–1661), but in the paintings of Guido Reni (1575–1642). With his set of five allegorical canvases in the Palazzo Colonna, painted around 1737–39 and anchored by *Time Revealing Truth* (fig. 7), Batoni became the first eighteenth-century Roman painter to espouse an ideal of female beauty that viewed Raphael through the prism of Reni.[32] The series was ordered by Don Fabrizio Colonna (1700–1755) for the ceiling of the Sala dell'Apoteosi di Martino V, located on the *piano nobile* of a recently completed wing of the family palace flanking the piazza Santi Apostoli. The stimulus of Reni's *Aurora* fresco (1614; Palazzo Rospigliosi-Pallavicini, Casino dell'Aurora, Rome), particularly the "ornamental autonomy" of the draperies, is evident.[33] In addition, the figure of *Vigilance* paraphrases Reni's *Allegory of Fortune* (1637; Pinacoteca Vaticana, Vatican City).[34] The German critic Friedrich Wilhelm Basilius von Ramdohr (1757–1822) noted

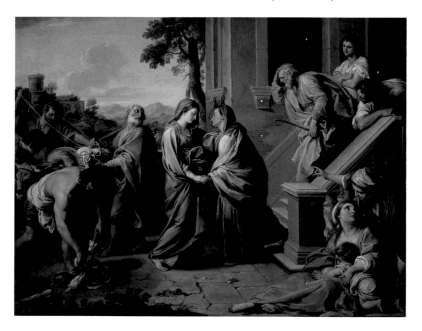

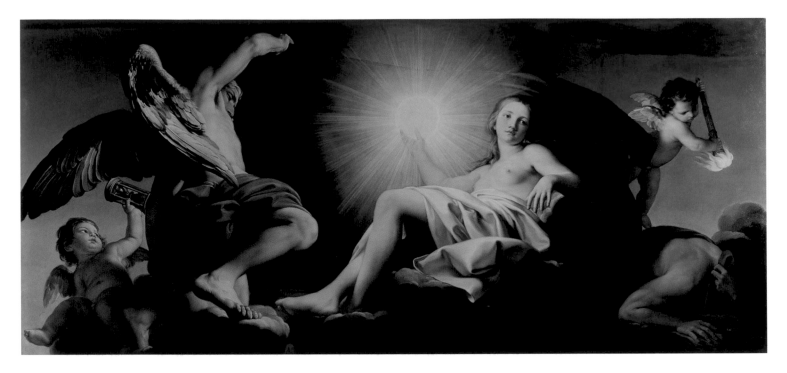

Fig. 7. *Time Revealing Truth*, c. 1737–39. Oil on canvas, 63 × 90½ in. (160 × 230 cm). Palazzo Colonna, Rome.

Vigilance's closeness to the manner of Reni, and Batoni's biographer Onofrio Boni (1739–1818) also emphasised the Reniesque qualities of one of his female figures.[35] It seems hardly surprising that British patrons commissioned several copies of Reni's major works from the artist.[36]

A distinctive aspect of Reni's manner, singled out for praise by his biographer Carlo Cesare Malvasia (1616–1693),[37] left an indelible mark in Batoni's œuvre: the type of the bearded old man, his hair in unruly wisps of grey and white, light reflecting off his balding head. It occurs in many of Reni's paintings and is exemplified by pictures such as *Saint Joseph and the Christ Child* (1638–40; The Museum of Fine Arts, Houston), then in the collection of the Gerini family, Batoni's early patrons.[38] "Siblings" of Reni's elderly male figures were given employment by Batoni throughout his career. Having successfully evaded their hairdressers' attentions, they are cast as the Blessed Pietro in the San Gregorio al Celio altarpiece and as the protagonist of the *Blessed Bernardo Tolomei Attending a Victim of the Black Death* (fig. 8). After ascending to divine heights in the *Immaculate Conception* (see fig. 16), they sink to ignominious depths in *Susannah and the Elders* (see fig. 90). Reni's prototypes spawned a flock of Saint Josephs—for

instance, in the *Presentation in the Temple*, the *Rest on the Flight into Egypt* (see fig. 17), the *Holy Family* (see fig. 22),[39] and the *Holy Family with Saint Elizabeth and the Infant Saint John the Baptist* (see fig. 100). In the realms of mythology, allegory, and history, their roles range from Prometheus (see fig. 23) and Time (see fig. 29) to the father of the bride in the *Continence of Scipio* (see fig. 99).

Several of the apostles painted by Batoni in the early 1740s for Count Cesare Merenda (1700–1754) of Forlì also recall Reni's old men, particularly *Saint Philip* and *Saint Peter*.[40] This series was commissioned for a new gallery in the Merenda family palace in Forlì. It appears to have consisted of ten apostles plus *God the Father* and reveals Roman Seicento sources in a number of ways.[41] Among the models that both patron and artist may have had in mind is a series of full-length canvases for the Barberini family, begun by Andrea Sacchi with a *Saint Peter* and continued by Carlo Maratti (1625–1713) with eight additional apostles.[42] The half-length format chosen by Batoni, combined with a whittling down of iconographic attributes to the bare essentials, evokes Reni's intimate and sensitive depictions of saints. The result, however, was very much Batoni's own

Fig. 8. *The Blessed Bernardo Tolomei Attending a Victim of the Black Death*, 1745. Oil on canvas, 102¼ × 68⅛ in. (261 × 173 cm). San Vittore al Corpo, Milan.

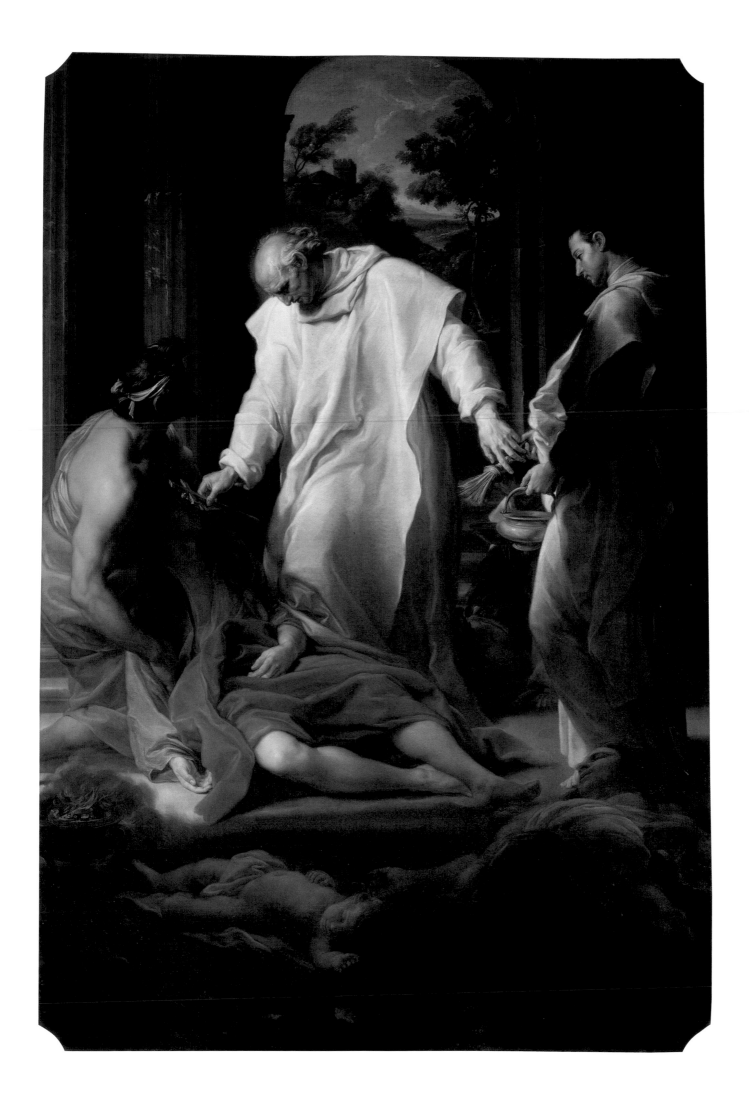

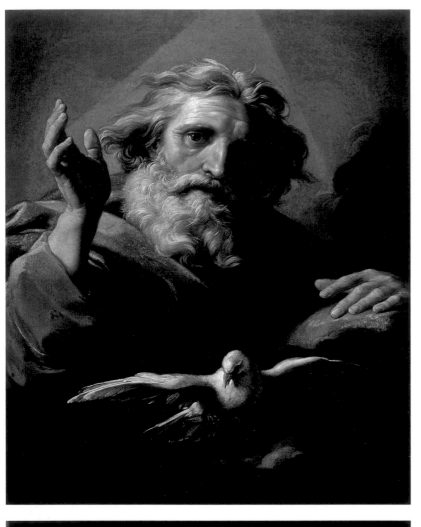
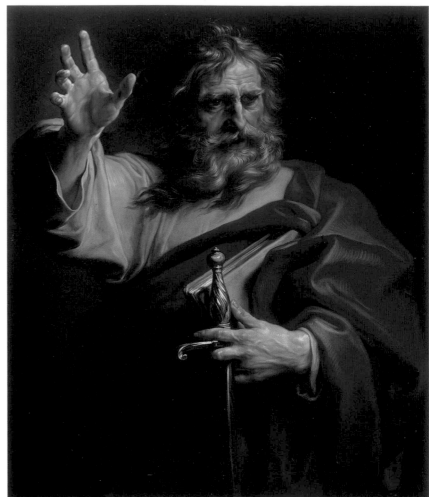
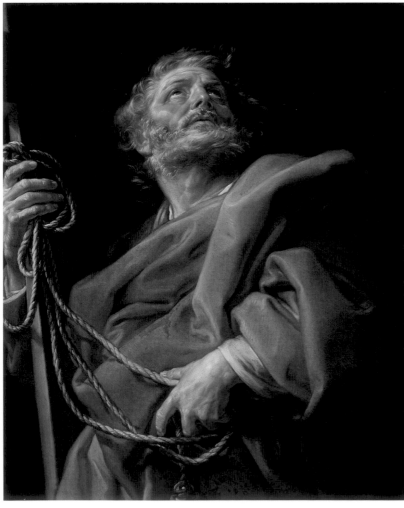
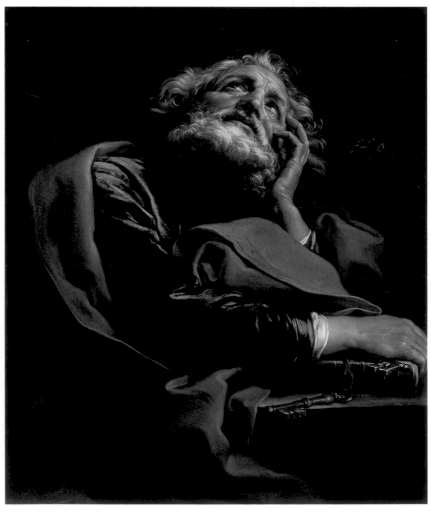

creation. His apostles are persuasive and natural, and their characterisations run the gamut from energetic forcefulness to introspective contemplation, from Saint Paul's evangelical zeal to Saint Peter's deep remorse at having denied Christ (figs. 9–12).

Whereas Batoni eliminated at an early stage the overt borrowings from other artists of the seventeenth-century Bolognese school from his repertoire of compositions and poses, he continued to pay close attention to Reni over the years. The most striking example is the *Christ on the Cross with the Virgin and Saint John the Evangelist*, 1762 (fig. 13).[43] In what may have been a deliberate homage, he fused two of Reni's well-known representations of the subject, both on view in Roman churches. A small devotional painting (1624–25; Duke of Northumberland, Alnwick Castle), then in the Cappella Gessi in Santa Maria della Vittoria and virtually the same size as Batoni's canvas, provided much of the composition as well as the figure of the Virgin. For Christ's head, torso, and legs, the painter turned to the crucified Christ in the *Trinity* on the high altar of Santissima Trinità dei Pellegrini (1625; in situ).[44]

But the echoes of Roman and Bolognese classicism, while forming an important ingredient of Batoni's style, were merely the foundations on which he built his personal pictorial language. Its signature elements were figures of arresting beauty and gracefulness, meticulously drawn and elegantly posed; a vibrantly luminous palette, distinguished by a subtle interplay of colours; dazzling light effects, creating an atmosphere of emotional intensity without being overly theatrical; and a painstakingly detailed finish almost bordering on obsession.[45] These were the

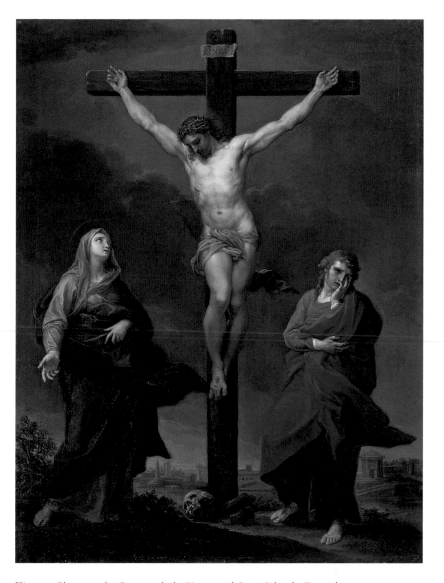

Fig. 13. *Christ on the Cross with the Virgin and Saint John the Evangelist*, 1762. Oil on canvas, 39 × 29½ in. (99 × 75 cm). Museum of Fine Arts, Boston; Henry H. and Zoe Oliver Sherman Fund, 1987.

TOP LEFT: Fig. 9. *God the Father*, c. 1740–43. Oil on canvas, 28¼ × 23¾ in. (73 × 60.3 cm). The Iliffe Collection, Basildon Park (The National Trust).

TOP RIGHT: Fig. 10. *Saint Paul*, c. 1740–43. Oil on canvas, 28¼ × 23¾ in. (73 × 60.3 cm). The Iliffe Collection, Basildon Park (The National Trust).

BOTTOM LEFT: Fig. 11. *Saint Philip*, c. 1740–43. Oil on canvas, 28¼ × 23¾ in. (73 × 60.3 cm). The Iliffe Collection, Basildon Park (The National Trust).

BOTTOM RIGHT: Fig. 12. *Saint Peter*, c. 1740–43. Oil on canvas, 28¼ × 23¾ in. (73 × 60.3 cm). The Iliffe Collection, Basildon Park (The National Trust).

distinctive qualities that gave Batoni's creations a compelling persuasiveness unequalled in the work of his Roman contemporaries.

The *Sacrifice of Iphigenia* of 1740–42 is one of the first pictures in which this pictorial language fully came to fruition, and it stands among Batoni's most powerful and arresting works (fig. 14).[46] Iphigenia, resigned to her fate and supported by two attendants, has almost reached the altar. She kisses the hand of her grief-stricken father, Agamemnon, who silently beseeches the statue of Diana for a last-minute reprieve. To striking effect, Batoni contrasts the brightness of the victim's pink-red cloak with the

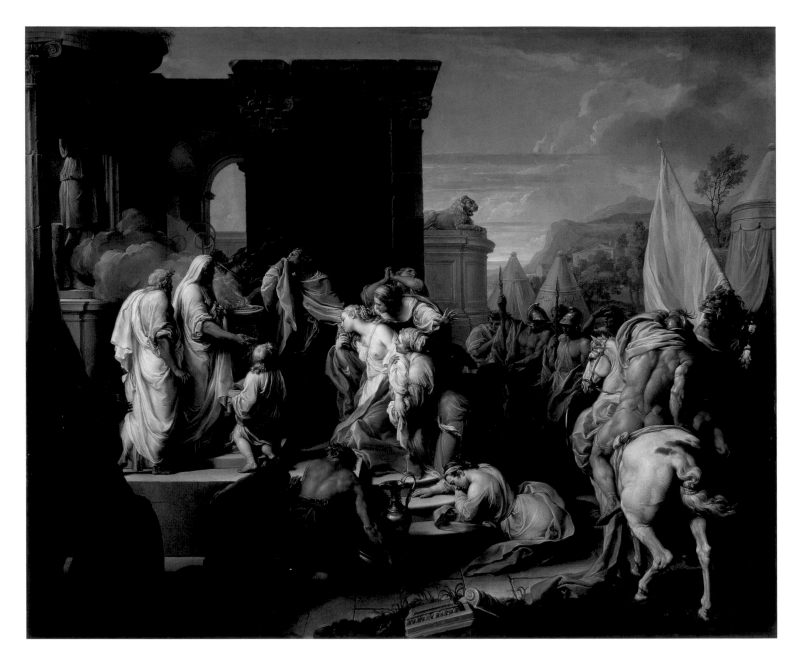

Fig. 14. *The Sacrifice of Iphigenia*, 1740–42. Oil on canvas, 60¼ × 75 in. (153 × 190.6 cm). Private collection; on loan to the National Gallery of Scotland, Edinburgh.

greyed-out lilac of her father's garment, half in shadow. The pastel hues prevalent in the other foreground figures show the influence of the blond tonality of Reni's later work, while the mounted soldier at the right and the white horse are derived from Giulio Romano's *Battle of the Milvian Bridge* (1520–24) in the Sala di Costantino.[47] With his customary attention to narrative detail, Batoni hints at the heroine's imminent rescue—a praying female figure behind Iphigen-

ia's attendant looks up at the clouds, where the stag sent by the goddess to replace the human victim is about to appear.

A similar engaging play of saturated and lighter tints characterises the *Ecstasy of Saint Catherine of Siena* (fig. 15), painted in 1743 for the high altar of the Lucchese church of Santa Caterina da Siena.[48] Strong chiaroscuro effects, unusually pronounced by the painter's standards, imbue the altarpiece with a drama and an energy rarely seen in

Fig. 15. *The Ecstasy of Saint Catherine of Siena*, 1743. Oil on canvas, 110¼ × 86⅝ in. (280 × 220 cm). Museo Nazionale di Villa Guinigi, Lucca.

Fig. 17. *The Rest on the Flight into Egypt*, c. 1758. Oil on canvas, 29⅛ × 39⅛ in. (74.5 × 100 cm). Private collection; on loan to the Museum of Fine Arts, Houston.

Batoni's œuvre. A pair of angels, tresses flying and drapery billowing, rushes in from above to prevent the swooning saint from collapsing. The intense red of the right-hand angel's cloak is visible in the bunched-up fabric above the knee, where it receives little illumination. By contrast, the strongly lit passage of drapery behind the angel's head shows a pinkish pastel tone. A similar effect may be

Fig. 16. *The Immaculate Conception*, 1750. Oil on canvas, 141¼ × 76¼ in. (360 × 195 cm). Santi Faustino e Giovita, Chiari.

observed in the careful modulation of the deep royal blue of the cloak worn by the angel standing at the left.

Batoni's pleasure in depicting angels, rendered with supreme delicacy and tenderness, is especially evident here in the play of light in their golden hair, in their rosy lips, and in their pink cheeks flushed from the effort of their headlong plunge, arriving on the scene just in time to catch Saint Catherine before she falls. Yet Batoni's angels are never too otherworldly or ethereal—in addition to being beautiful and consoling, they are youthful, energetic, and deeply committed, whether their mission is supporting God the Father on a throne of clouds in an *Immaculate Conception* (fig. 16) or worshipping the sleeping Christ Child in a *Rest on the Flight into Egypt* (fig. 17).

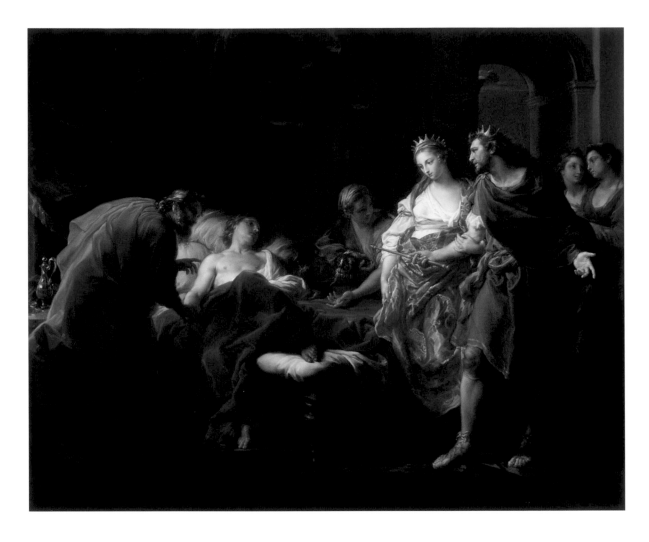

Batoni's mastery of chiaroscuro and his innate sense of colour reached a pinnacle in *Antiochus and Stratonice*, 1746 (fig. 18), the painting's vibrant hues ranging from scarlet to vermilion to ultramarine.[49] Once again, the artist fully exploited the possibilities of light and shade. The only entirely lit figure is that of the ravishing young Queen Stratonice, the linchpin of this moral tale from Plutarch's *Lives* (43:38). Her husband, King Seleucus, is about to give up his wife and kingdom to his son Antiochus, who has fallen in love with his stepmother. The court physician Erasistratus, feeling Antiochus's pulse quicken as Stratonice enters the bedchamber, has recognised the patient's passion for the queen as the real cause of his affliction. The picture's key narrative motif is all the more poignant for not being

immediately obvious: the physician's left hand, in shadow but sharply silhouetted against a bright background, literally points out the truth.

There is no hint that Stratonice might prefer the younger man. She seems distinctly hesitant, her faithfulness to the king underscored by the way she holds on to Seleucus's forearm, while a maid clutching a lively lapdog is already entreating the queen to accept her husband-to-be. An engraving of *The Death of Germanicus*, reversing Nicolas Poussin's painting (1627; Minneapolis Institute of Arts), appears to have inspired the composition, although Germanicus, here transformed into the bedridden Antiochus, is the only figure cited directly.[50]

Throughout the 1740s, Batoni produced a string of highly successful allegorical and mythological cabinet pictures. For the attributes of personifications, such as Painting or Sculpture, he generally relied on Cesare Ripa's *Iconologia* (1593). An example is *Painting, Sculpture, and Architec-*

Fig. 18. *Antiochus and Stratonice*, 1746. Oil on canvas, 74¼ × 91¼ in. (190 × 233 cm). Museo de Arte de Ponce, Fundación Luis A. Ferré, Ponce, Puerto Rico.

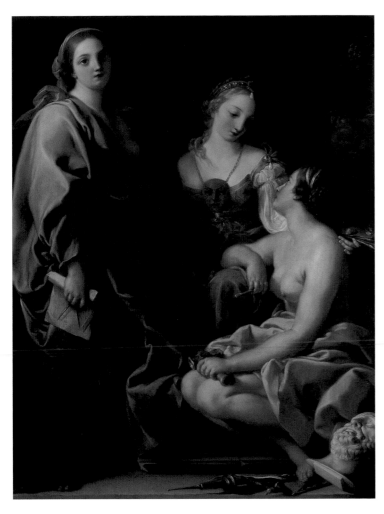

Fig. 19. *Painting, Sculpture, and Architecture*, 1740. Oil on canvas, 47¼ × 35⅛ in. (120 × 90.5 cm). Private collection.

Fig. 20. *Apollo, Music, and Metre*, 1740–41. Oil on canvas, 48¼ × 36 in. (122.5 × 91.5 cm). Private collection.

ture (fig. 19), executed in 1740 for Francesco Conti (together with a pendant; fig. 20), one of the Lucchese noblemen who had contributed to the pension enabling the young artist to pursue his studies in Rome.[51] Only a few months later, Batoni created similar personifications in his *Allegory of the Arts* (fig. 21), but here he chose to depart from both Ripa's descriptions and his own precedent in a few significant instances, which suggests that he may have been working from a concetto provided by the patron, the Florentine Marchese Vincenzo Maria Riccardi (1704–1752).[52]

The personification of Poetry, who dominates the picture in terms of mass, brightness, and elegance, holds a lyre, the attribute of Apollo in his role as the patron of poetry. At her feet are two handsomely bound volumes inscribed "ΟΜΗΡΟΣ" (Homer) and "VIRGI/LIVS" (Virgil). Painting, seated in front of her easel, holds a palette, brushes, and

a mahlstick, and she is working on a painting of Mercury in flight, which has replaced the academic nude shown in *Painting, Sculpture, and Architecture*.[53] In his right hand Mercury holds the caduceus given to him by Apollo in exchange for the lyre, which Mercury, the god of eloquence, had invented. Painting glances beseechingly at Poetry, who provides direction with an air of natural authority, as expressed by her gesture in the very centre of the composition. Sculpture, a beguiling innocent liberally displaying her ample charms, is seated on the dais, with a bust of Hadrian, a chisel, and a drill beside her. She holds a mallet and joins Painting in looking up at Poetry, seeking instruction. Standing at the right, overshadowed by Poetry, is Music; possessing none of the attributes mentioned by Ripa, she holds a double flute—the instrument played by Marsyas in his contest with Apollo, with excruciating results. Poetry

is crowned with the Apollonian laurel wreath, a symbol of victory. In sum, Batoni establishes a clear hierarchy of the arts, with composition, lighting, gesture, and mythological allusions skilfully deployed to underscore Poetry's pre-eminence.

The woman seated at the back has traditionally been identified as Architecture because she holds compasses and a set square. Unlike her sibling in the painting for Francesco Conti or the putto representing architecture in the *Triumph of Venice*, however, she lacks the floor plan that distinguishes Architecture from the related personification of Geometry, one of the seven liberal arts (the picture is described in a 1752 inventory as "le Arti liberali").[54] Demurely dressed, enthroned at the highest point of the composition, detached from the workaday bustle of the foreground, she occupies a position of serene superiority, her rank emphasised by a swag of drapery. In these features, Batoni again deviates from his previous depiction, suggesting that Geometry may be a reference to the personal interests of his aristocratic patron, who employed the distinguished Jesuit mathematician Leonardo Ximenes (1716–1786) as a tutor.[55]

The idea of a thorough grounding in geometry as an indispensable skill for a painter had achieved its foremost visual expression in Carlo Maratti's *School of Drawing*. A print of Nicolas Dorigny's engraving after Maratti was published in 1728 by Jacob Frey (1681–1752), and not long after the *Allegory of the Arts*, Batoni produced a drawing—engraved by Frey—of an *Allegory of Physics, Mathematics, Theology, and Canon Law Contemplating a Portrait of Pope Benedict XIV* (1745; The Metropolitan Museum of Art, New York), in which the tablet and compasses in the foreground appear to refer to the same depiction in the Maratti image.[56]

Vincenzo Riccardi was the scion of a noble family with a tradition of generously supporting the arts, and he was related by marriage to the Gerini, Batoni's other early Florentine patrons.[57] His collection also included a highly finished *modello* (see fig. 148) for Batoni's second Brescia altarpiece, the *Virgin and Child with Saint John Nepomuk* (see fig. 25).[58] It seems unlikely that Riccardi himself, who valued art mostly for its representative function, would have personally devised a concetto for Batoni's *Allegory of the Arts*. But as his intellectual-in-residence and librarian,

Riccardi employed the erudite journalist Giovanni Lami (1697–1770), who was about to launch the *Novelle letterarie*, a weekly literary journal, when the picture was commissioned in 1740.[59] In the well-rehearsed *paragone* between poetry and painting, this man of letters par excellence could be expected to come down firmly in favour of the former. Lami articulated his thinking about the visual arts in an academic lecture in 1757: "I shall also consider the progress of sculpture, which has such affinity with painting that Michelangelo Buonarroti considered them as one art"—a notion eloquently expressed in the intertwined hands of Painting and Sculpture in Riccardi's picture.[60] Tellingly, the mask that was hanging on a golden chain around Painting's neck in the earlier *Painting, Sculpture, and Architecture*, an attribute repeatedly described by Ripa as signifying the imitation of reality, has gone missing; in Lami's view, a painter was to derive his subject matter from literature rather than from nature. The *Allegory of the Arts* is first mentioned in July 1740, in a letter from Batoni to Lodovico Sardini, one of his Lucchese patrons. In October, the artist reported that the painting was finished and had turned out well; the finishing touches were in place by December.[61]

The picture is a notable example of Batoni's fondness for giving his female figures elaborately braided hairstyles. They probably derive from two altarpieces by Federico Barocci (c. 1535–1612) in Santa Maria in Vallicella, around the corner from Batoni's first Roman lodging: the *Visitation* (1583–86) and the *Presentation of the Virgin* (1593–1603).[62] With the addition of a laurel wreath, the head of Poetry in the *Allegory of the Arts* repeats the head of the Virgin in the *Presentation in the Temple*, which in turn was cited from Barocci's *Visitation*; all three figures wear the distinctive coil of braided hair above the nape of the neck. Sculpture's intricate blond coiffure adapts Saint Anne's from Barocci's *Presentation of the Virgin*. Other examples of ornate hairstyles include Iphigenia in the *Sacrifice of Iphigenia*, Atalanta in the *Death of Meleager* (see fig. 24), Peace in *Peace and Justice* (see fig. 34), Deidamia in *Achilles and the Daughters of Lycomedes* (see fig. 28), and the Virgin in the *Holy Family* (fig. 22).

Fig. 21. *Allegory of the Arts*, 1740. Oil on canvas, 68⅛ × 54⅛ in. (174.8 × 138 cm). Städel Museum, Frankfurt.

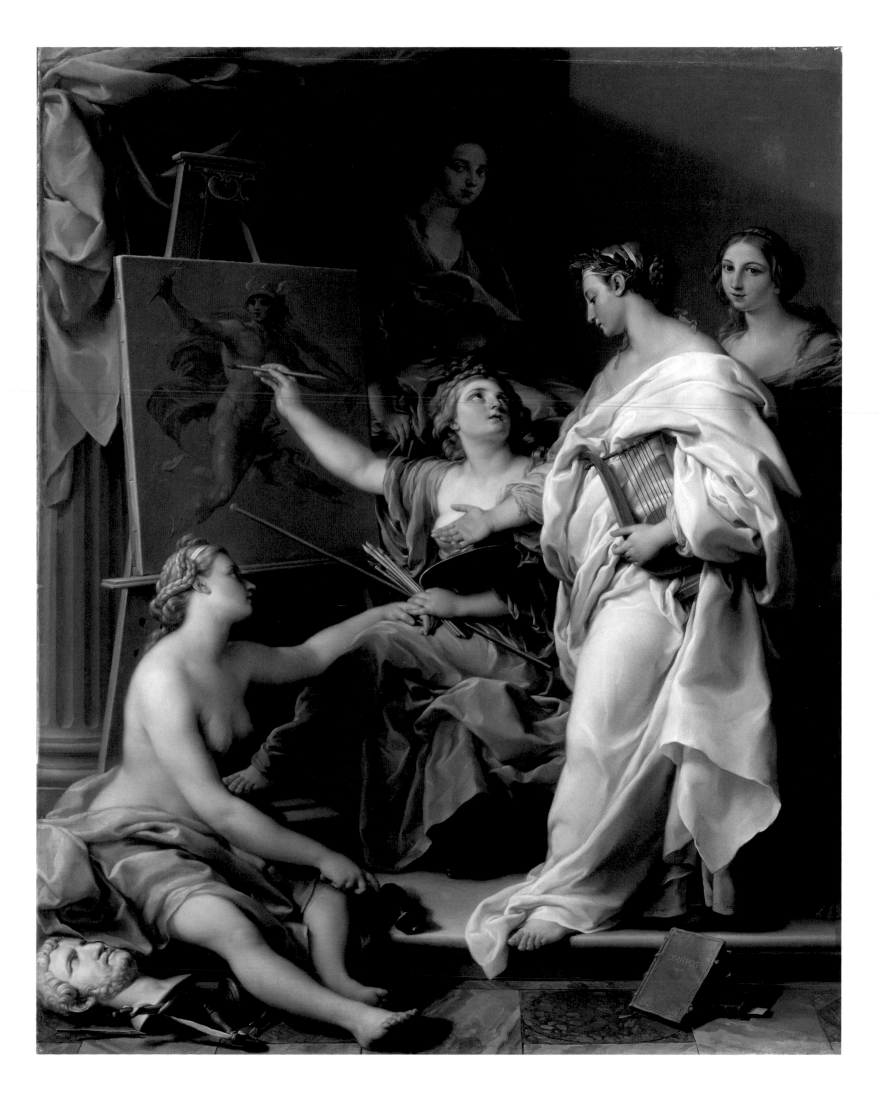

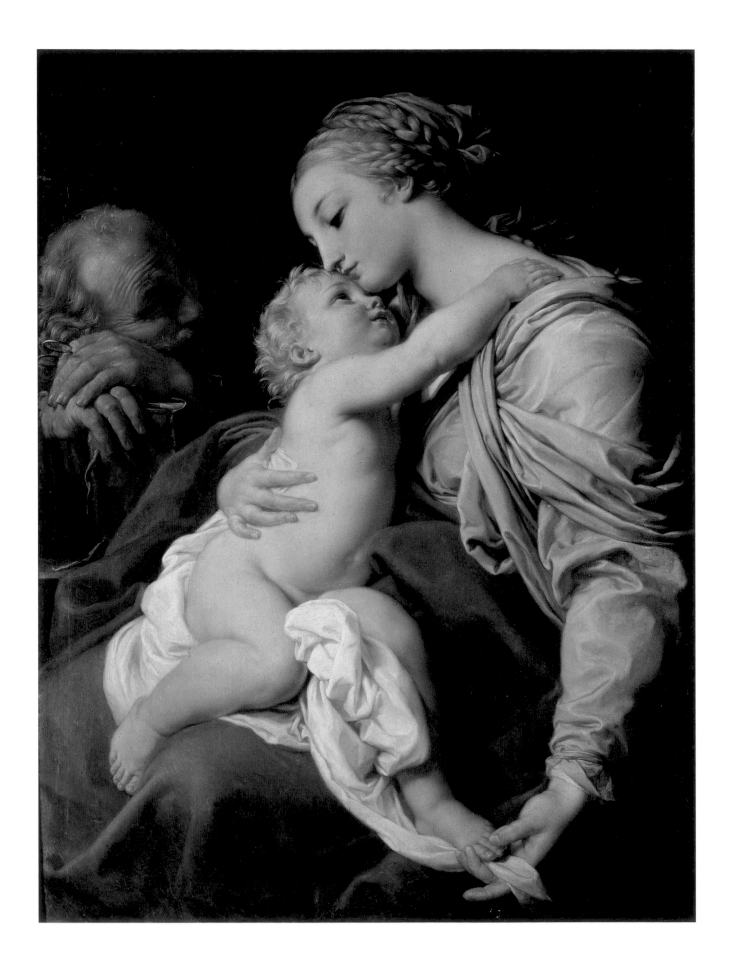

Statues and Sarcophagi: Recognisable Quotations Versus Compositional Sources

Batoni's graceful and seductive *Painting, Sculpture, and Architecture,* which had arrived in Lucca by May 1740, won the fast-rising painter great admiration, and Sardini, who had been another contributor to the pension, not only praised the work but immediately commissioned a pair of pictures for himself: *Prometheus Fashioning Man from Clay* and the *Death of Meleager,* both 1740–43 (figs. 23, 24).[63] The subjects, from Ovid's *Metamorphoses* (1:76–88; 8:260–546), appear to have been chosen by the painter rather than the patron, and Batoni provided a detailed explanation of his ideas in a long letter to Sardini in September 1740. Having described the first picture, on which he was already at work, he proudly proclaimed that this particular treatment of the Prometheus myth "has never been seen before," and proceeded to propose a subject for the pendant: "As the first [painting] alludes to the origin of life, so I would like this other one to allude to death, but not with a horrible and dreadful conception, and therefore I would like to depict the story of Meleager, after Ovid's ancient tales." He then launched into an elaborate recitation of the whole episode.[64] One senses a keen desire to display his knowledge, minor inaccuracies notwithstanding.[65]

In composing *Prometheus Fashioning Man from Clay,* Batoni directly benefited from his years of drawing antique sculptures in Roman collections. As part of a larger commission for the British collector Richard Topham (1671–1730), he had produced a drawing of a marble relief that shows Prometheus, seated in front of a finished clay statue, turning back over his right shoulder towards Minerva (c. 1730; Eton College, Windsor).[66] The goddess holds a butterfly, a symbol of the soul with which she is about to bring the statue to life. The relief, an ancient sarcophagus fragment (Musée du Louvre, Paris), was displayed in Palazzo Vitelleschi in the Corso at the time Batoni drew it before being acquired by Cardinal Alessandro Albani (1692–1779).[67] Many of the differences between the relief and the painting are owed to the rendering of the marble in the drawing, in which Batoni greatly refined the figures, particularly the faces and drapery.

Apart from size, the most important factor in determining the price of a painting by Batoni or his contemporaries was the number of figures, an issue repeatedly discussed in the artist's letters to Sardini.[68] In both pictures made for his Lucchese patron, Batoni pared down the compositions of his antique models, eliminating all the extras and distilling the action into the three figures that his agreement with Sardini evidently specified. The clay statue crafted by Prometheus not only counted as a figure, it also needed to be, in Batoni's words, "most beautiful and of handsome build." This requirement was, as eighteenth-century Europe's aesthetes concurred, best fulfilled by the *Belvedere Antinous* (Musei Vaticani, Vatican City), who was duly drafted to put in an appearance opposite Minerva.[69] In one of Batoni's typical bravura flourishes, the goddess's index finger is visible through the semitransparent wing of the butterfly she holds.

Despite Batoni's emphasis on his Ovidian source, the *Death of Meleager* actually diverges from the account in the *Metamorphoses,* in which the presence of Atalanta is not mentioned. Once again, the painter's actual source was visual, not textual. Outlining his plans for the picture to Sardini, he had described the "dying Meleager in a bed in the antique style, next to which there would be his sword, shield, and spear," yet neither bedstead nor shield nor spear is included in the finished painting. Batoni's inspiration for the composition and possibly the subject itself was a Roman marble sarcophagus depicting the death of Meleager (Musée du Louvre, Paris).[70] In the eighteenth century it stood in the Sala del Sole of the Villa Borghese on the Pincio, where it could well have been seen and drawn by the young artist on one of his many sketching expeditions. This relief features not only the bed, shield, and spear mentioned in the letter but also a grieving Atalanta, sporting a dress and hairstyle that reappear in the picture, as well as Althaea casting a log on the fire with her extended right hand while shielding herself from the glare of the flames with her left. Batoni quoted this figure almost literally. The footstool seen at an oblique angle also recalls the ancient relief.

Fig. 22. *Holy Family,* c. 1760. Oil on canvas, 38¼ × 29 in. (98.5 × 73.5 cm). Pinacoteca Capitolina, Rome.

OVERLEAF, LEFT: Fig. 23. *Prometheus Fashioning Man from Clay,* 1740–43. Oil on canvas, 53⅛ × 37⅛ in. (135 × 95 cm). Private collection.

OVERLEAF, RIGHT: Fig. 24. *The Death of Meleager,* 1740–43. Oil on canvas, 53⅛ × 37⅛ in. (135 × 95 cm). Private collection.

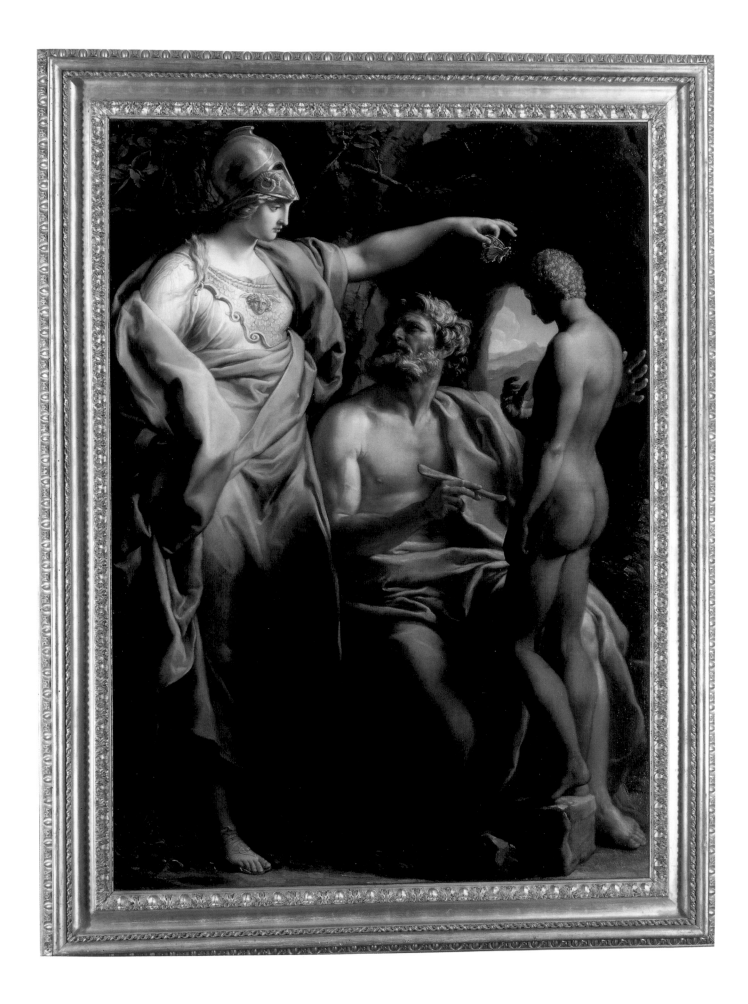

As before, Batoni concentrated on three protagonists, moving Althaea to the back of the room in order to accommodate her in the upright format. Reversing the central part of the relief so that the picture would be oriented to the left, thus balancing its pendant, Batoni raised the emotional temperature by introducing eye contact between Atalanta and Meleager, whose right hand seems astonishingly active for a moribund man. While the idea of a faithful dog looking up at its dying master evidently appealed to Batoni, the meek canine in the Villa Borghese relief lacked the necessary bite. In a clever twist, he inserted a much more recognisable dog—gazing at Meleager, it forms part of another of Rome's most celebrated antiquities. The marble is listed among the "seven principal antique statues" in the Richardsons' guidebook of 1722, a distinction it shared with the *Belvedere Antinous*.[71] The boar's head at Atalanta's feet may also have been derived from this *Meleager* group (Musei Vaticani, Vatican City).

In both paintings for Sardini, the artist employed the same recipe: a relatively obscure sarcophagus relief as the compositional source, seasoned with an obvious quotation from an antique statue widely known through plaster casts, bronze statuettes, and engravings. This provided Batoni's patron with the additional frisson of trumpeting his classical erudition. Sardini's patience was to be sorely tested, however, before he could place the pendant paintings on display in his palace in Lucca. In October 1742, more than two years after work had begun, a friend of Sardini's was despatched to the painter's studio to investigate the delay, and reported back that at least one of the pictures appeared to be finished—not to his eyes, Batoni retorted, apologising for the wait but insisting that it would result in the "greater perfection" of the paintings, which he wanted to be "superior to any of my works that you have already seen."[72] It would take him another year to complete the pictures. With more than a touch of embarrassment, he informed Sardini in September 1743 that "just as everything in this world has its end, so the two pictures have finally reached their conclusion and completion."[73]

Batoni took considerable pride in the finished paintings, asking for permission—which Sardini granted—to retain them in his studio for a fortnight in order to show them to "the patrons who have already begun to favour me" and to other visitors from the highest echelons of society, including the envoy of "His Royal Highness of Tuscany."[74] Since the Grand Duke of Tuscany was Maria Theresa's husband, Francis Stephen, later Emperor Francis I (see fig. 92), the envoy's interest in Sardini's pictures may have had far-reaching consequences: this represents Batoni's first contact with the Habsburgs, who were to number among his greatest patrons in later years.[75] Once the paintings had been despatched to Lucca, the artist pressed Sardini to exhibit them to the "virtuosi and dilettanti who will be visiting you," and to place them "on two easels in two different rooms, so that one does not diminish the lustre of the other . . . , and not too high off the ground."[76] Batoni had every reason to believe that *Prometheus Fashioning Man from Clay* and the *Death of Meleager* were going to cause a sensation. Writing to Sardini, he quoted a letter he had received from his Florentine patron, Marchese Andrea Gerini (1691–1766), who had announced his intention to issue "a special invitation (these are his precise words) to noblemen and experts in order to admire once again [some of] my very beautiful works."[77] In addition to winning Batoni great praise in Italy, the two pictures were coveted by the Elector of Saxony, King Stanislas II of Poland (1732–1798), and by several British Grand Tourists, all of whom attempted to purchase them from the Sardini family.[78]

The Sardini commission represents a turning point in Batoni's early career. The paintings were begun by a young, emerging artist still relying to a considerable extent on patronage from his hometown and from other provincial clients. Three years later, they were finished by one of Rome's foremost painters, a member of the Accademia di San Luca.[79] The artist's studio was now frequented by "all the first nobility" of the city,[80] and his clients included the pope. Batoni's success was also reflected in his sharply increased prices: "In future, no one could hope to have pictures of this size from me for a price below 200 scudi each," he declared to Sardini, who was paying him 290 scudi for the pair.[81]

This period of rapid achievement was tempered by misfortune. The death of his first wife, Caterina, in 1742 left Batoni a widower with five motherless children.[82] He had to support single-handedly a large household, which would now have included additional servants to look after the young children. The taxing situation appears to have imposed a new modus operandi upon him—the juggling

of multiple commissions at the same time, the necessity of working on pictures in turns, in stops and starts. The customary pattern was this: Batoni would accept a commission, ask for and receive a down payment (typically 30 to 40 percent of the total price), and begin the picture.[83] Long before the commission was finished, however, financial problems would arise. On one hand, there was no further payment in sight until the painting was ready to be sent to the patron; on the other, perfectionism and time-consuming working methods would not permit Batoni to finish it quickly: "My honour requires me to despatch no work that is not finished with the greatest attention and diligence, for the reason that one single slipshod work could make me lose all the credit acquired up to now."[84] Therefore, his only option would be to abandon temporarily the unfinished work and turn his attention to new commissions, for which he would again receive down payments. With patrons clamouring for his pictures, he did not find it difficult to attract additional business. In April 1743, for instance, Batoni was simultaneously working on "six paintings on my easels, all of the highest urgency and commitment." These were the pair for Sardini, a picture for Marchese Gerini, the *Ecstasy of Saint Catherine of Siena* altarpiece for Lucca, the *Virgin and Child with Saint John Nepomuk* altarpiece for Brescia (fig. 25), and an untraced self-portrait.[85] The result was a growing backlog of unfinished canvases and a stream of complaints from patrons about his dilatoriness, which became a recurring chorus over the next forty years.

When the two canvases for Lodovico Sardini were still far from finished, Batoni received a request he could hardly refuse. For a painter in papal Rome, a commission from the pontiff himself was the ultimate prize, and in 1742, at the age of only thirty-four, Batoni was asked to paint a large canvas to be set into the vault of one of the two lateral rooms in the Caffeaus in the gardens of the Palazzo del Quirinale. Pope Benedict XIV (1675–1758) had this three-room pavilion constructed in 1741–42 to the designs of Ferdinando Fuga (1699–1782), using it as an intimate retreat removed from the strictures of court protocol, and

Fig. 25. *The Virgin and Child with Saint John Nepomuk*, c. 1743–46. Oil on canvas, 176 × 87½ in. (447 × 222 cm). Santa Maria della Pace, Brescia.

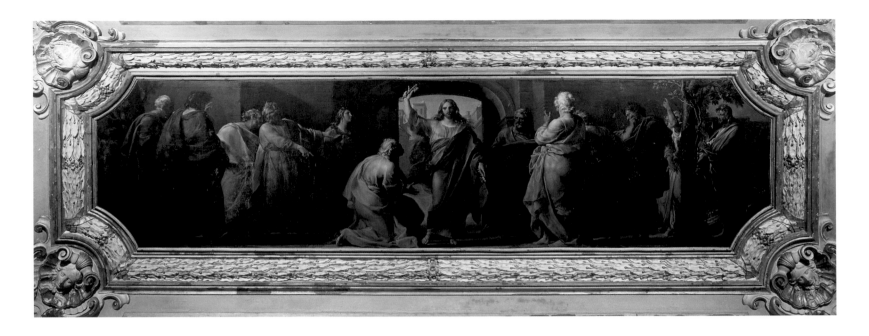

Fig. 26. *Christ Delivering the Keys to Saint Peter*, 1742. Oil on canvas, approx. 60 × 175 in. (152 × 444 cm). Palazzo del Quirinale, Casino del Giardino (Caffeaus), Rome.

for private audiences, such as the meeting with Charles of Bourbon (1716–1788), King of Naples and the Two Sicilies, on 3 November 1744.[86] The pope received Charles in the east room, beneath Batoni's *Christ Delivering the Keys to Saint Peter*, 1742 (fig. 26).[87] The painting, a *quadro riportato* making no concessions to the viewer's perspective, deploys the twelve apostles in a shallow frieze. Their disposition in two symmetrical groups on either side of Christ recalls Pietro Perugino's Sistine Chapel fresco of the same subject. But the main source was Poussin's *Sacrament of Ordination* (1647; Duke of Sutherland, on loan to the National Gallery of Scotland, Edinburgh), from which Batoni quoted the figures of Christ, Peter, and several apostles, reversed according to the print by which the Poussin was known in Rome.[88] In addition to the central ceiling canvas, Batoni painted four ovals depicting the four evangelists.[89]

The great esteem in which the young artist was already held at the papal court is demonstrated by the fact that he was paid the same amount, 400 scudi, as his older and more established colleague Agostino Masucci (1690–1768), who supplied the five equivalent canvases, *Pasce oves meas* and the *Four Prophets* (all 1742–43), for the west room.[90] The juxtaposition of *Christ Delivering the Keys to Saint Peter* and

Pasce oves meas as the two defining premises of the Petrine office was an established theme in papal iconography. In the Vatican Basilica, these same scenes of Christ's charges to Saint Peter were to have framed the view of the tribune with the pontifical throne, as overdoors in the niches now containing the monuments of Alexander VIII and Clement X, respectively. Andrea Sacchi's modello for the unexecuted *Pasce oves meas* fresco planned for the right niche was apparently known to Masucci, who adapted the kneeling figure of Saint Peter from it.[91] The modello, documented in the Palazzo Barberini at the time, is untraced today but recorded in a series of drawings.[92] The background scene of a seascape with fishermen in a sailboat, rare in depictions of this biblical episode and probably referring to the miraculous draught of fishes, is another element Masucci borrowed from Sacchi.[93]

Benedict XIV did not like to be kept waiting any more than Sardini did, and Batoni had to explain to his Lucchese patron that he had received "from His Holiness the order for a picture for the Palazzo del Quirinale, and the pope's Maggiordomo having visited me in this matter this week, and seeing that I have not yet begun in spite of having already made some studies, told me that His Beatitude desires [the picture] for the return from the coming *villegiatura.*"[94] The maggiordomo, Cardinal Girolamo Colonna (1708–1763), continued to push Batoni, informing him that the painting was "urgently desired by His Holiness, who

has all the authority to command in this country, so that I have had to abandon everything else in order to serve the reigning Prince."[95] Yet even the pope could not force Batoni to lower his standards and compromise his laborious working methods. In December 1742, the painter informed Sardini that he was planning to finish *Christ Delivering the Keys to Saint Peter* by Christmas, emphasising the large size of the canvas and the fact that it comprised thirteen life-size figures.[96] The four ovals depicting John the Evangelist, Matthew, Mark, and Luke were even longer in the making. At the end of the year, the Caffeaus interior was all but finished, and such touches as curtains were in place by the following February.[97] Work on the *Four Evangelists,* however, proceeded sluggishly. When they were still unfinished in August 1743, in spite of their having already been paid for in full, the pontifical patience was exhausted, and Benedict commanded Batoni to complete the paintings immediately.[98] The long delay notwithstanding, the pope must have been pleased with the result because Batoni soon received another papal commission, the *Annunciation* altarpiece for Santa Maria Maggiore.[99]

Erudite Concetti: Ancient Literature, Contemporary Opera, and the "Offspring of My Imagination"

Francesco Buonvisi was another member of the group of Lucchese noblemen who had underwritten Batoni's pension; the artist's relationship with the family began at the baptismal font: his godmother was Lavinia Buonvisi.[100] As early as 1740, Francesco Buonvisi had inquired about the price Sardini was paying for the *Prometheus* and *Meleager* paintings, and in 1744 he acquired a small *Saint Louis Gonzaga* (untraced).[101] There may have been an element of local one-upmanship in Buonvisi's commission for a pair of mythological pendants—the *Education of Achilles* and *Achilles and the Daughters of Lycomedes* (figs. 27, 28), each dated 1746.[102] These works were considerably larger and more complex than anything Batoni had painted for Sardini or anyone else in Lucca. A number of ancient literary sources, including Hyginus's *Fabulae* (96), Philostratus the Younger's *Imagines* (1), and Ovid's *Fasti* (5:385–86) and *Metamorphoses* (13:162–70), mention these episodes. They are treated in the greatest detail, however, by Statius in the *Achilleid.* In the *Education of Achilles,* Batoni included virtually all the elements

noted in the *Achilleid* (1:113–18), such as the arrows and quiver, the medicinal herbs on the ground, and the teaching of the lyre, strongly suggesting that the painter had access to this text.

The learned centaur Chiron, to whom Achilles has been entrusted by his mother, Thetis, instructs the adolescent demigod in music and astronomy. The latter is represented by the armillary sphere, a teaching tool developed in ancient Greece and more generally a symbol of the wisdom and knowledge Chiron is passing on to Achilles. This device is Batoni's addition; it is not mentioned by Statius. The bow and quiver hung over the herm at the right indicate that the training also encompasses archery, de rigueur for a young hero destined to fight in the Trojan War. The lyre, bow, and quiver, the instruments of Achilles' education, were again included by Batoni in two later paintings depicting the preceding and succeeding episodes: *Thetis Entrusting Chiron with the Education of Achilles,* 1760–61 (see fig. 89), and *Chiron Returns Achilles to Thetis,* 1768–70 (see fig. 98).[103] The scene in the background at the left evokes the circumstances leading to Achilles' birth as a demigod: Thetis is carried to the bridal chamber of the mortal Peleus, as described in Valerius Flaccus's *Argonautica* (1:130–36).[104] The idea of combining this incident with the main scene of Chiron teaching Achilles to play the lyre may have been prompted by Statius's text, in which the two events are mentioned together (*Achilleid* 1:186–89, 1:193). The figures of Thetis and Peleus are closely modelled on Annibale and Agostino Carracci's *Thetis Carried to the Bridal Chamber of Peleus* (1598–1601) in the Galleria Farnese.[105] As part of his education in the late 1720s, Batoni had copied the Galleria Farnese frescoes, and Ceres in his *Triumph of Venice* recalls a recumbent Venus in the *Triumph of Bacchus and Ariadne* (1598–1601).

In spite of Batoni's best efforts to study every figure in his paintings from life, a live centaur was not easy to come by, so for the equine part of Chiron's body he fell back on the centaur he knew best, the so-called *Younger Furietti Centaur* (Musei Capitolini, Rome), named for Giuseppe Alessandro Furietti, who had excavated this instantly famous antique sculpture at Hadrian's Villa in 1736.[106] Batoni made a drawing of the newly restored statue, engraved by Girolamo Frezza in 1739 (see fig. 128). By the time the *Education of Achilles* was painted, a knowledgeable patron such as

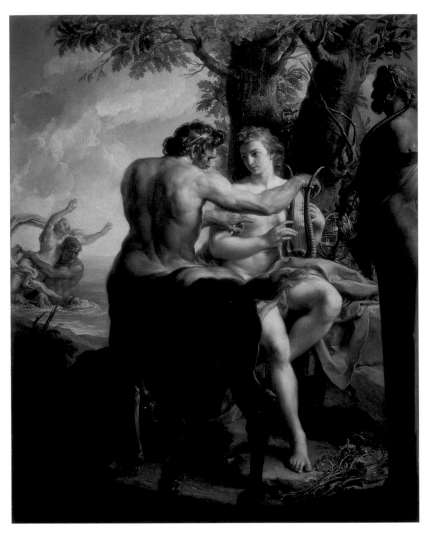

Fig. 27. *The Education of Achilles*, 1746. Oil on canvas, 62⅛ × 49¼ in. (158.5 × 126.5 cm). Galleria degli Uffizi, Florence.

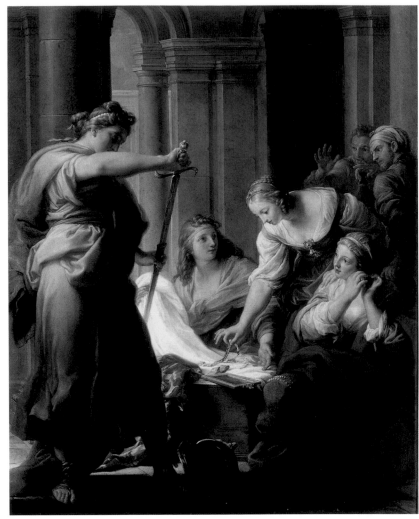

Fig. 28. *Achilles and the Daughters of Lycomedes*, 1746. Oil on canvas, 62⅛ × 49¼ in. (158.5 × 126.5 cm). Galleria degli Uffizi, Florence.

Buonvisi would have immediately recognised the *Younger Furietti Centaur*, its celebrity advanced in no small part by the engraving bearing the caption "Pompeus Battoni delin[eavit]." And just like his peer Sardini, Buonvisi would have greatly appreciated the compliment to his learning implicit in Batoni's use of such a quotation.

The pendant, *Achilles and the Daughters of Lycomedes*, was probably meant to reflect another facet of the cultural canon of eighteenth-century Europe—the dramas of Pietro Metastasio (1698–1782), the premier Italian poet of his time and imperial court poet in Vienna from 1729 until his death. Apart from being set to music dozens of times by different composers, his opera libretti were written and avidly read as literary dramas in their own right.[107] There are striking parallels between the painting and Metastasio's *dramma per musica Achille in Sciro*, in which the scene depicted by Batoni forms the centrepiece of act 2. In a recitative

accompanied by the stage instruction "He seizes the sword," Achilles exclaims: "In this hand the sword flashes. Ah! I begin now to recognise myself." Batoni seems to be conveying precisely this moment of self-recognition, while the two men at the right-hand edge enact Ulisse's aside to his confidant Arcade: "Look at him."[108] The *Achilleid* (1:852–54), the *Metamorphoses* (13:167), and Hyginus's *Fabulae* (96:3), by contrast, all mention a shield and spear in this scene, but no sword. Batoni, an ardent opera lover, may well have attended a production of *Achille in Sciro*, in a setting by Giuseppe Arena (1713–1784), at Rome's Teatro delle Dame in January 1738.[109] The text was available in that production's printed libretto (1738) and as part of a four-volume edition of Metastasio's *Opere drammatiche* published in Rome in 1741. As in other works, Batoni did not hesitate to put his formidable command of painterly detail at the service of narrative exigencies. The sword does indeed flash in Achil-

les' hand, with the hilt's gilded surface reflecting onto the young hero's fingers.

In January 1747, Batoni reported to Bartolomeo Talenti of Lucca that he had finished Buonvisi's paintings together with two for Talenti, who completes the group of Lucchese noble families resuming their early support for Batoni by giving him important commissions in the early 1740s.[110] He was certainly aware that the keen competitiveness of his aristocratic Lucchese patrons was conducive to good business, and in July 1744 he assured Talenti that his pictures would be "not only not inferior but by a long way superior to so many of the others you have seen until now, inasmuch as I am flattering myself that the subject stems from my imagination."[111] This statement represents a declaration of artistic independence, Batoni's final step on the path to

becoming a fully fledged history painter whose learning and experience enabled him to devise the concetti for his own pictures. He warmed to his theme in the next letter, accentuating the fact that the pictures would be "of my invention" and the "offspring of my imagination."[112]

The pendants painted for Talenti are *Time Orders Old Age to Destroy Beauty*, dated 1746, and the *Allegory of Lasciviousness*, dated the following year (figs. 29, 30).[113] Since Batoni announced in January 1747 that both were about to be despatched together, he probably finished them, respectively, just before and just after the turn of the year. "You can take my word for it that you will have no reason to envy the aforementioned Signor Buonvisi," the astute artist assured Talenti, whose competitive streak had not abated.[114] In *Time Orders Old Age to Destroy Beauty*, Batoni took the technique of

Fig. 29. *Time Orders Old Age to Destroy Beauty*, 1745–46. Oil on canvas, 53¼ × 38 in. (135.3 × 96.5 cm). The National Gallery, London.

Fig. 30. *Allegory of Lasciviousness*, 1745–47. Oil on canvas, 54⅛ × 39⅜ in. (138 × 100 cm). The State Hermitage Museum, Saint Petersburg.

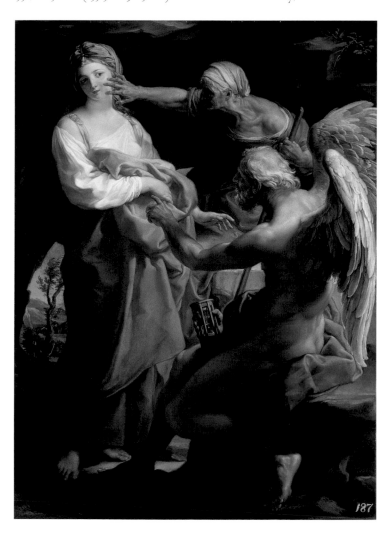

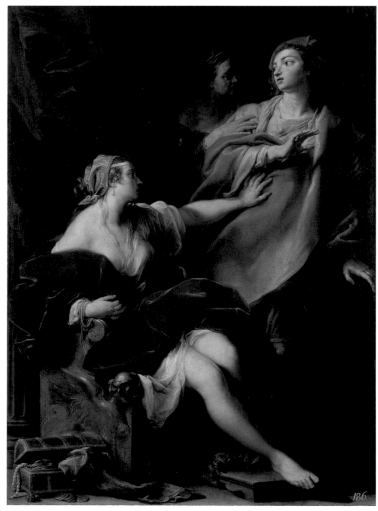

erudite allusion one step further, and he moved his hunting ground forward in time to the small repertoire of Renaissance and baroque works his contemporaries considered equal to the masterpieces of antiquity. The figure of Beauty adapts the pose of François Duquesnoy's *Saint Susanna*, which had earned the sculptor Giovan Pietro Bellori's praise as having "bequeathed to modern sculptors the example of clothed statues, advancing to equal the best of the ancients in a style that is altogether refined and delicate."[115] Marcantonio Raimondi's print of the *Judgement of Paris* (c. 1517–20) was the source for the figure of Time, whose pose reverses that of Paris.

The *Allegory of Lasciviousness*, conversely, appears to have been Batoni's own invention, both in composition and iconography, which he described as "Lasciviousness, who pushes away from herself the lover left without wealth, who at the same time will be embraced by Poverty, daughter of Lasciviousness. The latter will be a woman who displays the vanity and pomp of the world in her clothes, jewels, and headdress. . . . The lover will be of the right age, properly clothed in the Greek style with a philosopher's cloak over the shoulder; and Poverty will be another woman in whose face and clothes it will show that she is poor and miserable."[116]

When both pendants were already well under way, Talenti appears to have had second thoughts about the subjects chosen by Batoni. He even considered asking the painter to abandon the half-finished canvases and begin anew with different subjects, but in the end he allowed Batoni to complete *Time Orders Old Age to Destroy Beauty* and the *Allegory of Lasciviousness* as originally agreed.[117] Perhaps because it was his own invention, Batoni was particularly proud of the latter painting, and he singled it out in the letter reporting the completion: "Both of these pictures are graceful and clever, but especially the one which represents Lasciviousness."[118] In an earlier letter to Talenti, he had outlined his philosophy concerning the invention of concetti as well as the goals he had in mind: "The truth I have intended to express in this is not for me to explain because it will speak for itself, and will speak better in painting. The idea that perhaps both the one and the other [picture] will make clear is that without employing fable or history things can be invented that have not yet been thought up by others, or at least have not been seen painted or sculpted with equal propriety

and truth, and which need not fear comparison with the pictures of Greece, and would not have their equal in giving pleasure and as role models for the civic life."[119]

The notion of painting as a medium of moral instruction was not new. Batoni had already employed the traditional concept of *exemplum virtutis* in the two scenes featuring the young Achilles. But in the *Allegory of Lasciviousness*, he developed a method of much greater immediacy: instead of inviting beholders to imitate the protagonist of a mythological or historical episode epitomising virtuous behaviour, Batoni makes the character traits themselves come alive as personifications, enabling viewers to recognise their own situation and aspirations for moral improvement.

A second pair of paintings, smaller in size, was traditionally believed to have been commissioned by Talenti as well: *Time Revealing Truth*, c. 1745–46, and *Philosophy Reigning over the Arts*, 1745–47 (figs. 31, 32).[120] The argument for this rested on provenance: in 1798 all four paintings were acquired together by the Russian prince Alexander Andréevitch Bezborodko (1747–1799).[121] When considering whether the second pair was indeed painted for Talenti or perhaps entered the family's collection at a later date, two aspects must be taken into account. *Philosophy Reigning over the Arts* is dated 1747, and because the initial commission generated a string of letters, it is difficult to accept the idea that the second pair would have left no trace whatsoever in the correspondence, which continued until 1748 and beyond. Moreover, when describing the *Allegory of Lasciviousness*, apparently in response to concerns voiced by Talenti, Batoni had emphasised that the figure would be covered up and would not look scandalous.[122] By contrast, in *Time Revealing Truth*, Time is permitted to reveal a great deal more of Truth, making Lasciviousness look positively chaste in comparison.

Batoni had no qualms about revelling in female beauty, as is evident not only in the *Allegory of the Arts* and the *Death of Meleager* but also in religious subjects, such as a pair of allegories based on Psalm 84:11: "Mercy and truth have met each other: justice and peace have kissed." In *Truth and Mercy*, c. 1745 (fig. 33), Truth again goes above and beyond the call of duty in making revelations, while *Peace and Justice* exhibit more restraint (fig. 34).[123] The figure of Truth adapts that of Ariadne in Reni's destroyed *Wedding of Bacchus and Ariadne*—a painting sharply criticised in the seventeenth

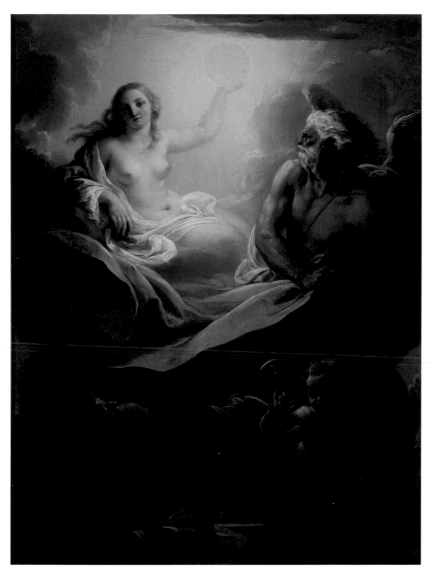

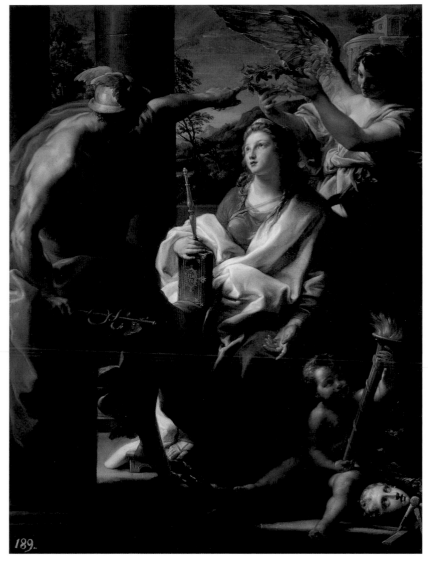

Fig. 31. *Time Revealing Truth*, c. 1745–46. Oil on canvas, 45¼ × 33½ in. (115 × 85.1 cm). Museum of Art, Rhode Island School of Design, Providence; Helen M. Danforth Fund.

Fig. 32. *Philosophy Reigning over the Arts*, 1745–47. Oil on canvas, 46½ × 34½ in. (118 × 87.5 cm). The State Hermitage Museum, Saint Petersburg.

century for being "lascivious"—which Batoni would have known through Frey's engraving of 1727.[124] Batoni appears to have worked simultaneously on the *Allegory of Lasciviousness* and *Truth and Mercy*, an assumption supported by a sheet of drawings with studies of the feet of Lasciviousness and the swans in *Truth and Mercy*.[125]

Time Revealing Truth, the only one of the four canvases not initialled and dated, reworks the composition and modifies the subject of the main Palazzo Colonna ceiling allegory (see fig. 7). At the bottom edge, a petrified male figure, holding a book inscribed "H" that was not present in the earlier version, has been knocked to the ground. The "H" is for Hesiod, whose *Theogeny* (154–81) had perpetrated, in the view of Plato (*Republic* 2:377d–e), a calumny of Cronos.

The god, whose identity had merged with the personification of Time already in antiquity, is now exposing the truth, causing the hapless Hesiod to recoil in terror. Plato compares Hesiod's "lie" to "a painter whose portraits bear no resemblance to his models" (*Republic* 2:377e), thus equating truth with correctness of imitation.[126] He returns to this concept in *Laws*, where truth is again posited as a virtue of mimetic art.[127]

In Plato's thought, it is the duty of the visual arts to produce images of virtue (*Republic* 3:400e–401b, 402c), and the *Laws* specify that virtue and the knowledge of truth are the qualifications required for judging an artistic contest. Before coming to a decision, the judges of such contests were required to take an oath invoking Heaven (*Laws*

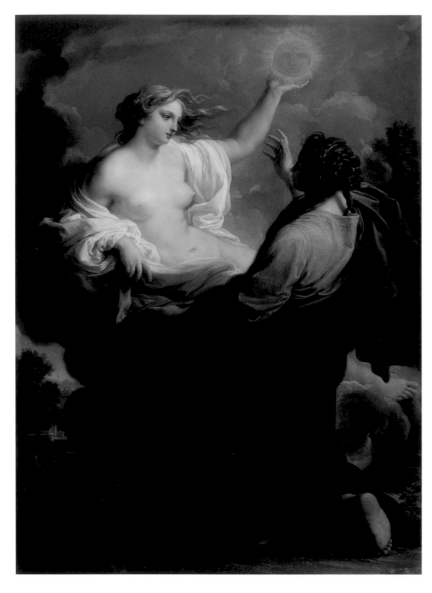

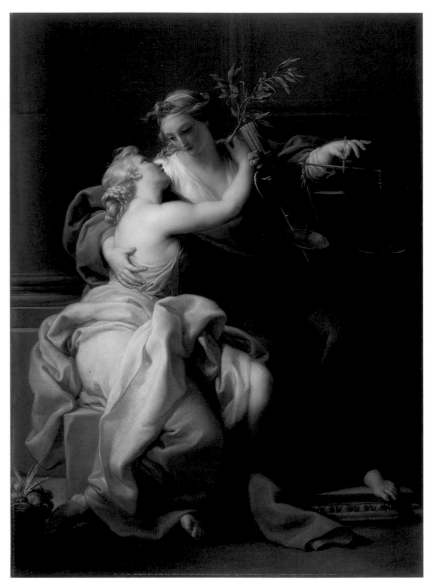

Fig. 33. *Truth and Mercy*, c. 1745. Oil on canvas, 47¼ × 35½ in. (120 × 90 cm). The Montreal Museum of Fine Arts; Purchase, Horsley and Anne Townsend Bequest, special replacement fund and gift of Mr. and Mrs. Neil B. Ivory.

Fig. 34. *Peace and Justice*, c. 1745. Oil on canvas, 47¼ × 35½ in. (120 × 90 cm). The Montreal Museum of Fine Arts; Purchase, Horsley and Anne Townsend Bequest, special replacement fund and gift of Mr. and Mrs. Neil B. Ivory.

2:659a). In Batoni's *Philosophy Reigning over the Arts*, the gods have considerately acknowledged their ultimate responsibility and despatched Mercury to make their verdict known. He points to the Temple of Glory, the reward of the virtuous, while a Genius awards the laurel wreath to Philosophy, confirming her reign over the various arts, whose attributes are scattered on the ground. In addition to the visual arts and poetry, they also include metalworking, here represented by a helmet and sword and specifically mentioned in the *Laws* (3:678d–678e). Philosophy's book is predictably inscribed "PLA/TO." In her personification, Batoni fused the upturned eyes, sceptre, and book from Ripa's description of

"Philosophy as depicted by Boethius in *Consolation of Philosophy*" with overtones of Raphael's *Philosophy* ceiling tondo in the Stanza della Segnatura, where the award of the laurel wreath is also to be found, in the *Apollo and Marsyas* panel (1510–11).

The overall theme of book 2 of Plato's *Laws* is the education of the mind, symbolised in the picture by a torch, illuminating the darkness of ignorance. Just like the arts, learning is contingent upon truth (*Laws* 2:667c), another cross-reference between the two pictures. Taken together, the interlocking concetti of the pendants visualise some of the key tenets of Plato's thought: only by accepting the

guidance of Philosophy can the arts flourish and attain virtue and social utility, primarily as an educational instrument. This requires correctness of representation, or truth. Should the arts fail to achieve veracity, their deception will be revealed and punished by Time.[128]

Philosophy Reigning over the Arts is closely related to the *Choice of Hercules*, 1748 (see fig. 88), which Batoni must have worked on almost simultaneously.[129] The theme of Hercules at the crossroads, a moral fable invented by Plato's friend Prodicus, illustrates the same values of virtue and education articulated in the slightly earlier picture. The task of indicating the Temple of Glory in the distance is now performed by Minerva, the goddess of learning, who repeats Mercury's gesture with the other arm and points to the same temple. The picture was commissioned by Prince Joseph Wenzel von Liechtenstein (1696–1772) together with a pendant, *Venus Delivering the Arms of Vulcan to Aeneas*, 1748 (see fig. 87), which features splendid products of the art of metalworking, a recollection of Batoni's boyhood training as a goldsmith.[130] He lavished enormous care on the articulation of the shield of iron, gold, silver, and blue enamel, and prepared a meticulous drawing for it (see fig. 144). In the scenes depicted, which form a syllabus of Roman history from Aeneas to Augustus, he largely adhered to Virgil's detailed description (*Aeneid* 8:608–731).[131]

What emerges from a close investigation of the textual and visual sources for a number of Batoni's key works of this period is the image of an artist whose credentials are wholly at variance with such myopic verdicts as the facile label of the "bird-brained Batoni."[132] His contemporaries understood the quotations and paraphrases in his pictures not as the results of economical working methods but as deliberate, learned allusions, considered a hallmark of pictorial erudition. Batoni's patrons appreciated and enjoyed his seamless integration of leitmotifs from a recognised, and recognisable, canon of masterworks from the antique as well as from the sixteenth and seventeenth centuries. This skill was, in fact, not only expected but greatly prized in a history painter, and Batoni took it to new heights by conceiving compositions that made the quotations look completely natural. He succeeded in having his borrowed figures interact with their co-protagonists and surroundings as if everything had been created from scratch for this precise situation. Indeed, even the quotations may have

often been restudied from life, by posing a studio model according to the original—centaurs excepted.

An Altarpiece for Saint Peter's

In early 1746, the congregation of the Reverenda Fabbrica di San Pietro, the commission responsible for building and refurbishing work in the Vatican Basilica, awarded Batoni the most important commission of his career—an altarpiece for Saint Peter's. The *Fall of Simon Magus* (fig. 35) was to replace Francesco Vanni's battered picture, dating from 1603, of the same subject.[133] On account of the Basilica's high humidity and like most of the other altarpieces there, Batoni's canvas was to be translated into mosaic. Over a period of nine years, he worked on the monumental painting, making hundreds of preparatory drawings and at least one oil sketch for the highly complex composition. His extremely ambitious design featured a multitude of facial expressions and gestures, encompassing a range of emotions from fervent faith to petrified alarm. For the figure of the fleeing man on the right, the artist paraphrased Salvator Rosa's *Martyrdom of Saints Cosmas and Damian* (1669; San Giovanni dei Fiorentini, Rome).[134] In several instalments, Batoni received a total of 1,200 scudi plus 300 scudi for expenses.[135] The finished canvas was finally exhibited in Saint Peter's on Easter Sunday, 1755, and the Fabbrica's workshop soon began the difficult process of creating a scale mosaic copy.[136]

But in March 1756, the congregation abruptly abandoned the project. The resolution to leave the Vanni painting (suddenly deemed to be in "very good state") in place because Batoni's work was "considered by some experts to be much inferior to Vanni's applauded work" certainly raises the question of why the Fabbrica had gone to the expense and trouble of commissioning a new altarpiece, rather than having the existing copy of Vanni's painting, made by Pierre-Charles Trémolières (1703–1739) in 1736 for this express purpose, translated into mosaic.[137] In October 1757, Batoni's canvas was transferred to Santa Maria degli Angeli, where it joined the Trémolières and a number of other canvas altarpieces from Saint Peter's.

Subsequent scholarship has frequently amalgamated the Fabbrica's rejection of the *Fall of Simon Magus* with negative appraisals voiced from the 1760s onwards by visitors to

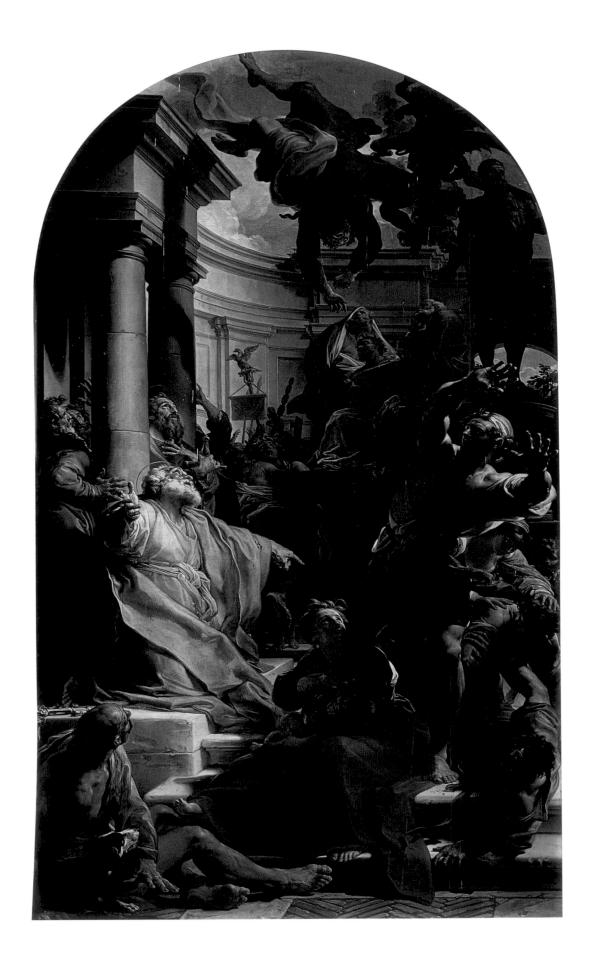

Rome of the next generation, who measured the painting against their newly developed artistic theories and found it wanting. Unsurprisingly, the tranquil and reflective *Mass of Saint Basil* (1747; Santa Maria degli Angeli, Rome) by Pierre Subleyras (1699–1749) appealed to the critics of the last third of the Settecento, whereas the vehement movement and vigorous rhetoric of Batoni's altarpiece appalled them. But it seems questionable whether the committee of elderly ecclesiastics who determined the painting's fate in 1756 would have subscribed to these criteria. The fact that the criticisms of the *Fall of Simon Magus* were put forward only when the execution of the mosaic had already been under way for nine months, at a cost of some 900 scudi, rather than during the painting's public exhibition in April of the previous year, makes Batoni's conviction that he had become the victim of intrigue at least plausible.[138] In any case, the rejection of the *Fall of Simon Magus* marked a watershed in the artist's life. His deep disappointment over the reception of this colossal, costly, and time-consuming history painting coincided with a surge in demand for his portraits, and Batoni was to find the wealthy young tourist clientele much more congenial than the Vatican's politicised bureaucracy.

Fig. 35. *The Fall of Simon Magus*, 1746–55. Oil on canvas, 216½ × 157½ in. (550 × 400 cm). Santa Maria degli Angeli, Rome.

CHAPTER 2

BRITISH PATRONS AND THE GRAND TOUR

If Lord Cholmondeley goes to Rome, pray tell him I wish he would bring me a head of himself by Pompeio Battoni.

—Horace Walpole to Sir Horace Mann, 18 November 1771

Beginning around 1750, Batoni produced a series of portraits of exceptional pictorial quality that reveals the intensity of his efforts to establish himself as the portraitist of choice for young English, Irish, and Scottish visitors to Rome on the Grand Tour. Within a relatively short period he emerged as the leading portrait painter in Rome with his depictions of informally posed sitters shown in enclosed interiors in the presence of celebrated antiquities, or in open-air settings with suggestions of the Roman Campagna in the background. *Robert Clements, later 1st Earl of Leitrim* (fig. 36) is an excellent example of these early efforts, a paradigm of Batoni's rapidly developing skill in enhancing the social status and self-esteem of his sitters.[1] By endowing them with a fashionable air of nonchalance, Batoni made them appear entirely at ease in the unfamiliar surroundings of Rome. Even at this early stage of his development as a portrait painter, Batoni displayed a confident command of light, colour, and texture that few artists could match—rarely again does he delineate the features of his sitters with quite the same anatomical precision, articulate their hands and limbs with such expressive-

Detail, fig. 68

ness, or clothe them in such vividly coloured costumes as in the 1750s.

Batoni's skill in capturing an accurate physiognomic likeness was a critical element of his eminence in the field of portraiture. No contemporary portrait painter in Rome could draw more incisively than Batoni, and his skill as a draughtsman meant that few painters could equal his ability to delineate the features of a face. Batoni "values himself for making a striking likeness of everyone he paints," wrote Father John Thorpe (1726–1792), and accurate likenesses were demanded by Batoni's clients.[2] Ralph William Grey, whose son (1746–1812) of the same name sat to Batoni (1775; Poundisford Park, Somerset), wrote in reply to a letter in which the portrait was mentioned: "I did not know that the Italians were reckoned good portrait painters for the likeness; . . . for it is the likeness of the countenance in one's relations and friends one values most in a picture, and if yours is so like as you mention, that is the main thing that can be desired." In the event, the elder Grey was pleased with the portrait, informing his son, "I think it is a very good portrait and very like you."[3] The satisfaction expressed by another sitter upon seeing his finished portrait—"In the opinion of connoisseurs, it is extremely like

37

and finely painted"—is a familiar refrain in contemporary accounts of Batoni's art.[4]

James Martin (1738–1810), who visited Batoni's studio on numerous occasions, described the portraits on view on 6 May 1764 in his travel diary: "Wt. to Battoni's the Portrait Painter & saw some very strong Likenesses of Lady Spencer, Mrs. Macarthy, Mr. Garrick, Mr. Woodhouse, ac."[5] But Batoni's portraits were more than merely accurate. They were also vivid and memorable. His portrait of Stephen Beckingham (1752–53; private collection, New York) was so compelling that a stranger, upon being introduced to the sitter at a dinner party in London, immediately recognised him and recalled seeing his portrait several years earlier in an Italian customs house where it had turned up after being nearly lost at sea.[6]

Batoni's ability to accommodate the changing fashions of his sitters' dress was another important ingredient in his success. Foreign travel, especially the Grand Tour, enabled men to indulge their taste for finery, for Italian clothing was brighter in colour and more lavishly decorated than the styles worn in England.[7] Batoni's capacity for conveying his sitters' status and interests through their clothes was unrivalled, and he paid particular attention to the details of dress because he knew this was important to his sitters. The relative restraint of Clements's costume—the elegant and sober frock coat with a turned-down red collar and waistcoat from which a fine gauze shirt emerges were worn by many travellers in the 1750s—provides little hint, however, of the extraordinary range of fashionable attire in which Batoni depicted his sitters over the years, from John Woodyeare's fancy dress Hussar costume (1750; Minneapolis Institute of Arts) to the pastoral dress of Sarah, Lady Fetherstonhaugh (see fig. 42), the Duke of Manchester's "Roman habit" (untraced), Lord George Lennox's uniform of the 2nd Foot Guards (fig. 37), the Duke of Roxburghe's ceremonial peer's robes (see fig. 40), Colonel Gordon's uniform of the Queen's Own Royal Highlanders with the Huntly tartan (see fig. 61), and Lord Coke's "Vandyke" dress (see fig. 78).[8]

The realisation of Robert Clements's likeness and the characterisation of his clothes suggest why Batoni quickly became the leading portrait painter in Rome. But the portrait is of further significance as one of his earliest uses of an antique marble to situate a Grand Tourist in Rome. The bust of Homer, one of the most celebrated ancient portraits, corresponds in all essentials to a marble then in the Palazzo Farnese in Rome.[9] Clements himself noted "the famous bust of Homer, Antich & extremely fine" during his visit to the Farnese collection in spring 1753, and thus the inclusion of the sculpture in his portrait may reflect a personal response to the aesthetic qualities of the work as well as an appreciation of Homer as an eminent signifier of the classical tradition. For a number of contemporary observers, the ancient Greek author embodied the classical virtues that visitors to Italy sought to revive and imitate, and thus it is hardly surprising that the bust of Homer appears in at least two other Batoni portraits.[10]

The Grand Tour that brought Robert Clements and most of Batoni's portrait sitters to Rome developed as a conventional feature in the education of the men, and to a lesser degree the women, of the British elite in the eighteenth century.[11] Although the "Tour" almost invariably included sojourns in the north of Europe, the travellers' ultimate goal was Italy. Dr. Johnson (1709–1784) evoked the contemporary importance of Italy with his observation that "all our religion, almost all our law, almost all our arts, almost all that sets us above savages, has come from the shores of the Mediterranean," and this conviction was shared by an increasing number of tourists as the century progressed.[12] The greatest attractions of the Grand Tour, in the order in which they were generally visited, were the cities of Florence, Rome, Naples, and Venice, but Rome was always the principal destination. Frederick Hervey, Bishop of Derry and later 4th Earl of Bristol (1730–1803), who spent some eighteen years in Italy during five separate visits, spoke perhaps for the majority of Batoni's British patrons when he observed, "Rome contains everything that can amuse, interest or instruct the mind."[13]

Robert Clements followed a typical Grand Tour itinerary via Paris and Lyon, across the Alps and into Piedmont, arriving in Turin in February 1753.[14] He travelled to Milan,

Fig. 36. *Robert Clements, later 1st Earl of Leitrim (1732–1804),* c. 1753–54. Oil on canvas, 39¼ × 28¼ in. (101 × 73 cm). Hood Museum of Art, Dartmouth College, Hanover, New Hampshire; Purchased through a gift from Barbara Dau Southwell, Class of 1978, in honor of Robert Dance, Class of 1977, a gift of William R. Acquavella, and the Florence and Lansing Porter Moore 1937 Fund.

France and then proceeded to Italy. The timing of an itinerary would be influenced by the wish to observe certain festivals: Carnival, held before Lent in Rome, Naples, or Venice; Holy Week in Rome; and Ascension Day in Venice. Because most travellers also wished to visit the sunny Campania during the winter months (and to avoid the malaria prevalent in the summer), they would often begin their tours in the autumn, moving slowly through Lucca, Florence, Siena, and Rome to Naples; on their return north they would revisit Rome and continue to Venice, through Loreto, Ancona, and Ravenna. They would often then tour the Veneto, Lombardy, and Piedmont and depart for the North via Turin. The tours of Batoni's sitters ranged typically from twelve to twenty-four months; travellers with greater enthusiasm for classical architecture and archaeology stayed longer, such as Lord Brudenell (see fig. 53), who visited all the ruins in and around Naples and then embarked on a series of expeditions to such remote sites as Paestum, Taranto, and Agrigento, remaining abroad for five years. Lord Charlemont (fig. 38) was even more adventurous, travelling the length and breadth of Italy and visiting Greece, Constantinople, Egypt, and Asia Minor before returning home after a Grand Tour of seven years.

The British in Rome, who had often attended the same schools and travelled together, frequented the same circle of agents and antiquarians, visited the same palaces and monuments, and socialised and dined with one another, ensured the rapid rise of Batoni's reputation as one satisfied client led to another. The quality, variety, and inventiveness of his portraits drew to his studio the British, Irish, and Scots from their fashionable lodgings in and around the Piazza di Spagna and led to increasing demands for a work from his hand. For many British visitors to Rome, having their portrait painted by Batoni was a highlight of their travels, and for nearly half a century they offered the artist a sustained and intensely fruitful source of patronage. His virtuosity in depicting British gentlemen on the Grand Tour was highly admired, and James Bruce's acclamation

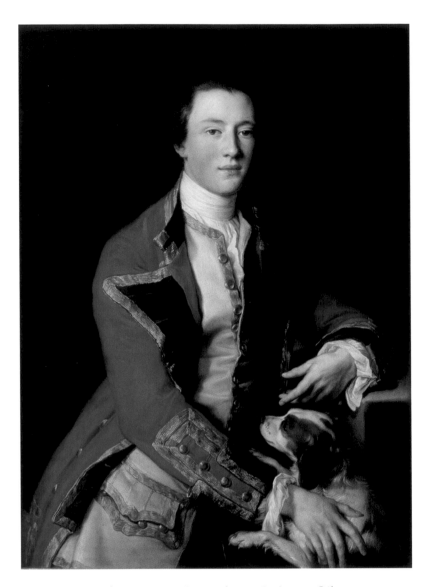

Fig. 37. *Lord George Henry Lennox (1737–1805)*, 1755. Oil on canvas, 38 × 28 in. (96 × 71.1 cm). Goodwood House, West Sussex.

Parma, Modena, and Bologna, arriving in Rome on 29 March. He remained there for three weeks, as he noted in his journal, to see "a few of it's Curiosities, and the Ceremonies Prosessions &c of the holy week," departing the city for Naples on 23 April.[15] He evidently visited Rome again on his return northward, so that his sitting to Batoni would have occurred during one of these two visits in the spring of 1753. The majority of Batoni's British sitters followed similar itineraries and visited many of the same cities as Clements. Guided by previously published accounts—Thomas Nugent's *The Grand Tour* (1749) was particularly influential—Batoni's British clients usually began their travels with a visit to the Netherlands and

Fig. 38. *James Caulfeild, 4th Viscount Charlemont, later 1st Earl of Charlemont (1728–1799)*, c. 1753–55. Oil on canvas, 38½ × 29 in. (97.8 × 73.7 cm). Yale Center for British Art, Paul Mellon Collection, New Haven, Connecticut.

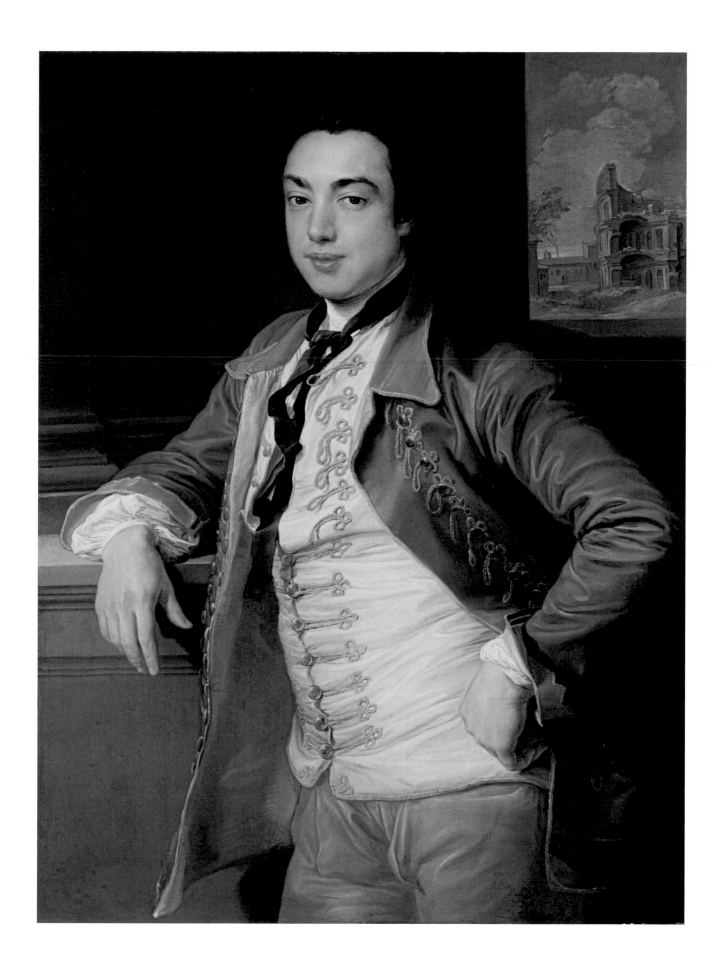

that he was "the best painter in Italy" and Lady Anna Riggs Miller's declaration that he was "esteemed the best portrait painter in the world" are typical contemporary estimations of his talent. At the height of Batoni's career it was said that "in this talent of a great painter he has not perhaps his equal."[16] Even English artists in Rome such as Nathaniel Dance (1735–1811) conceded Batoni's pre-eminence as "the best Italian Painter living."[17]

The importance of British patronage to Batoni's career as a portrait painter is indicated by the fact that of his approximately 225 known individual sitters, 175 were British. The majority, about 120, were English, followed by Irish (30), Scottish (20), and Welsh (5) sitters. Surprisingly, of the remaining sitters, only about 30 were Italians, but this may be explained by the relatively low esteem in which portraiture was said to be held throughout Italy.[18] The rest of Batoni's sitters are more or less evenly divided among several nationalities, with Poles, Russians, Germans, Austrians, Frenchmen, and Spaniards predominating; he even painted an American, Philip Livingston (1740–1810), a nephew of one of the signatories of the Declaration of Independence of the same name.[19]

A Who's Who of British Society

Most of Batoni's British Grand Tour patrons would have appeared among the great and the good in Debrett's because "the large majority of those we designate 'Grand Tourists' were exactly that—grand, wealthy, socially well connected and often politically influential."[20] Their collective cultural, political, and artistic distinction is worth emphasising because it is all too easy to cite the foibles of the Grand Tourists in eighteenth-century Rome and ridicule them as idle sprigs of the British aristocracy, "schoolboys just broke loose," as Horace Walpole described them, "or old fools that are come abroad at forty to see the world."[21] Most were the sons of the aristocracy and landed gentry, setting out on the Grand Tour after leaving university, and consequently about half of Batoni's sitters were in their early twenties when they sat to him. He painted persons of all ages, however, from infants to those of advanced years, including one unidentified Scot who wrote in a letter home, "I dare say my old friends will hardly find me out, dressed in crimson velvet, with my hair in a bag at my age of sixty-

two."[22] Batoni's portraits of British sitters overwhelmingly represent men; he painted fewer than twenty-five English, Irish, and Scottish women.

His British sitters were often of the highest social standing; nearly half were already peers or were to become so in later life. They also wielded considerable political power: more than forty sat in the House of Commons, and fifteen sat in the Irish Parliament. Among the distinguished statesmen were William Legge, 2nd Earl of Dartmouth (1731–1801), who was secretary of state for the colonies in 1772–75, and two future prime ministers, Frederick, Lord North, later 2nd Earl of Guilford (see fig. 52), and Augustus Henry Fitzroy, 3rd Duke of Grafton (1735–1811).[23] Several were diplomats, including Charles, 3rd Duke of Richmond and Lennox (1735–1806); John, Lord Mountstuart, later 4th Earl and 1st Marquess of Bute (1744–1814); David Murray, 7th Viscount Stormont (1727–1796); and George Augustus, Lord Herbert, later 11th Earl of Pembroke (1759–1827).[24] Others held important appointments at court and in the royal household.[25] And, of course, several were of royal birth themselves, notably George III's brother Edward Augustus, Duke of York (fig. 39), the first member of the British royal family to visit Italy as a tourist.[26] He was followed by his brother Prince William Henry, Duke of Gloucester (1743–1805), who commissioned from Batoni portraits of himself, his wife, his daughter, and his infant son (see figs. 101, 102).[27]

Batoni's sitters pursued varied careers, but law, the Church, and the army—all traditionally the professions of younger sons—predominate.[28] Others followed different paths, including the actor, playwright, and impresario David Garrick (see fig. 45); the traveller, archaeologist, and explorer James Bruce (1730–1794); and the travel writer Henry Swinburne (1743–1803).[29] The absence of merchants, financiers, and other "businessmen" among Batoni's British sitters is noteworthy. Perhaps only the distiller Philip Metcalfe (1733–1818), an intimate of Sir Joshua Reynolds (1723–1792) and Samuel Johnson, and the West India merchant Robert Udny (1722–1802), who distinguished himself as a collector of drawings, fall into this category.[30] Sir Matthew Fetherstonhaugh (see fig. 43), for his part, had inherited his fortune, which included large holdings in the East India Company and part ownership of several merchant ships, while Sir Sampson Gideon, later 1st Lord

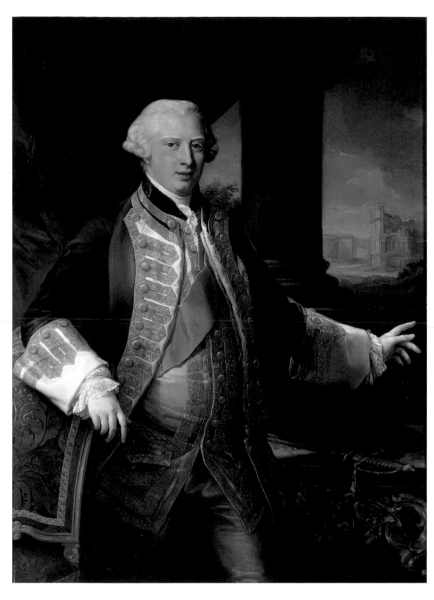

Fig. 39. *Edward Augustus, Duke of York (1739–1767)*, 1764. Oil on canvas, 54¼ × 39½ in. (137.8 × 100.3 cm). Private collection.

Eardley (see fig. 63), inherited his wealth from his father, Sampson Gideon, the well-known financier and advisor to the British government.[31] In this he typifies, with Thomas Dundas (see fig. 80), that movement in British society wherein the head of a family, having made a fortune in trade, purchased a country estate; it was left to his son to fulfil the role of landowner and, often, to be elevated to the peerage. It is no coincidence that it was the son, rather than the father, who sat to Batoni for his portrait. The greatest number of portraits by Batoni, however, depict members of the landed gentry, such as John Corbet (1751–1817), who, in the words of the *Gentleman's Magazine*, "kept up the character

of the independent country gentleman firmly attached to our glorious constitution"; the writer and sportsman Peter Beckford (1740–1811), whose book *Thoughts on Hunting* (1781) is one of the classics on fox and hare hunting; and Henry Peirse (1754–1824), who devoted himself to the management of his estates and a famous racing stud in Yorkshire.[32]

Some of the greatest British art patrons of the age are numbered among Batoni's sitters. Lord Northampton's promise as a patron ended with his early death (see fig. 56), but Lord Charlemont provided support for English artists in Rome, and the Duke of Richmond proved a significant patron of the arts when in 1758 he opened an artists' academy in Richmond House, Whitehall, and commissioned paintings from Reynolds, George Romney (1734–1802), and George Stubbs (1724–1806).[33] Lord Dartmouth, Sir Watkin Williams-Wynn (see fig. 68), and the Bishop Earl of Bristol, lauded by John Flaxman (1755–1826) for having "reanimated the fainting body of Art in Rome," all commissioned works from leading British contemporary painters and sculptors.[34] John Chute (1701–1776) was an amateur architect of considerable reputation who exemplified the eighteenth-century gentleman's passion for building.[35] The "virtuosi" among Batoni's sitters, many of whom assembled significant collections of antiquities, paintings, and sculpture during their stay in Rome, are too numerous to mention: William Weddell (1736–1792) stands foremost among such figures for the distinguished collection of ancient marbles he acquired in Italy.[36]

Other Batoni sitters are remembered for different cultural interests and accomplishments. John Ker, 3rd Duke of Roxburghe (fig. 40), was a noted collector and bibliophile whose celebrated library was dispersed in a forty-five-day sale in 1812 during which the Roxburghe Club, devoted to "the common love of rare and curious volumes," was founded.[37] The cleric, antiquary, and collector Thomas Kerrich (1748–1828) was keeper of manuscripts in the British Museum and principal Cambridge University librarian (Protobibliothecarius) as well as a gifted amateur artist; Thomas Barrett-Lennard, 17th Baron Dacre (1717–1786) was a scholar, an archaeologist, and a bibliophile.[38] Henry Bankes (1756–1834), Lord Mountstuart, the Duke of Grafton, and Philip Yorke, later 3rd Earl of Hardwicke (1757–1834), became trustees of the British

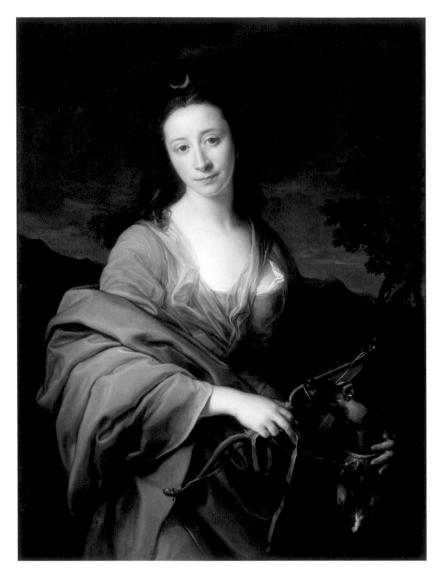

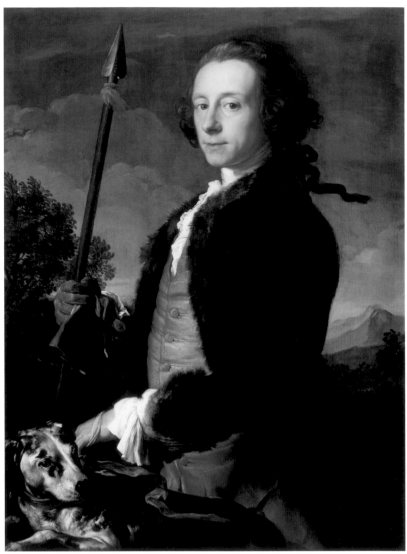

Fig. 42. *Sarah, Lady Fetherstonhaugh (1722–1788)*, 1751. Oil on canvas, 39 × 29 in. (99 × 73.7 cm). The Fetherstonhaugh Collection, Uppark (The National Trust).

Fig. 43. *Sir Matthew Fetherstonhaugh, 1st Bt. (1714–1774)*, 1751. Oil on canvas, 39 × 29 in. (99 × 73.7 cm). The Fetherstonhaugh Collection, Uppark (The National Trust).

Lucy (fig. 44), a middle-aged Warwickshire landowner, sat for his three-quarter-length portrait in a richly embroidered coat and waistcoat at the request of Mrs. Philippa Hayes, a widow to whom he posted most of his correspondence when abroad: "Agreeable to your orders, I have shown my face and person to the celebrated Pompeo Battoni, to take the likeness thereof; I have sat twice, and am to attend him again in a day or two."[48] The Rev. Richard Kaye (1736–1809) obtained one of Batoni's more intimate and perceptive Grand Tour portraits, *David Garrick* (fig. 45), through an interesting exchange of gifts with the sitter himself, as a letter written from Rome in April 1764 reveals.[49] Kaye

had, he informed his mother, acquired in Rome "some very Valuable Things for a Trifle," including "a Cameo, a Sardonyx of the Mask of a Bacchanal" bought for one zecchino from a gardener he met at the Terme di Caracalla. Covered with dust and broken, "it has since been Sett, and is become so valuable that Garrick offer'd me his Picture by the first hand in Italy for it. The Bargain was very politely struck on both sides, and I have yielded up my prize, where

Fig. 44. *George Lucy (1714–1786)*, 1758. Oil on canvas, 52 × 38 in. (132.1 × 96.5 cm). The Fairfax-Lucy Collection, Charlecote Park (The National Trust).

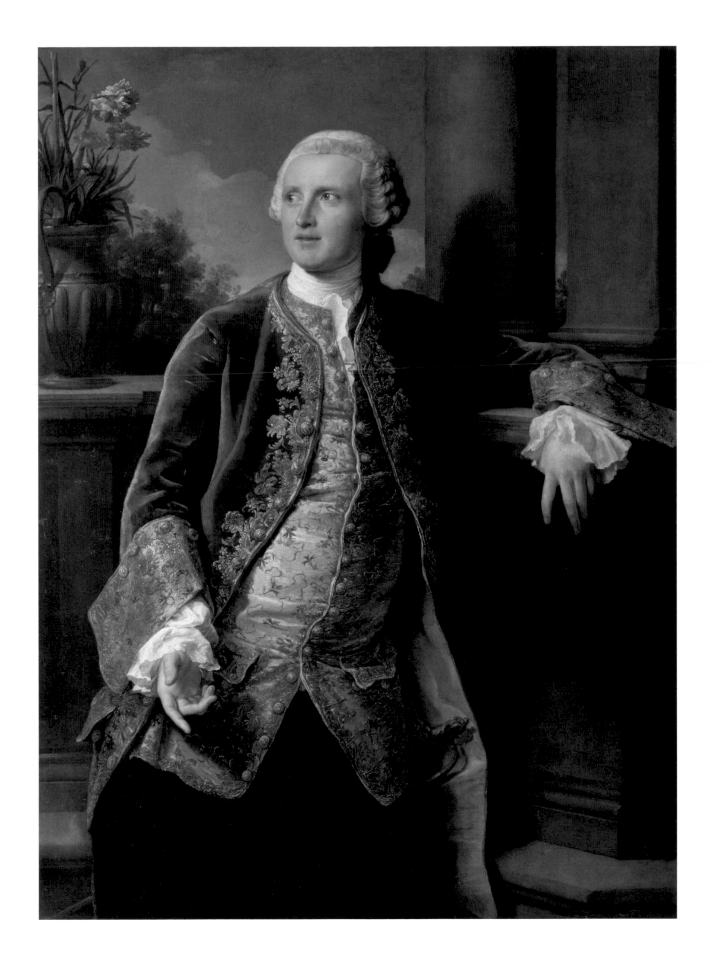

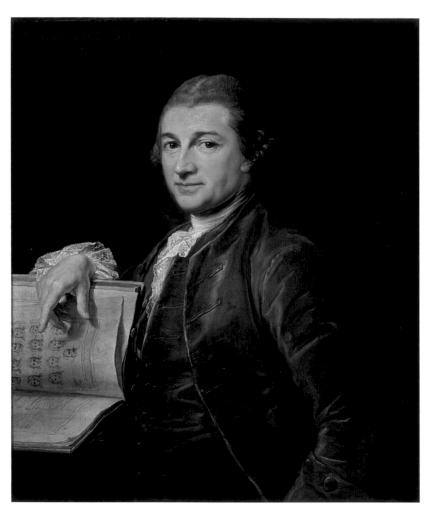

Fig. 45. *David Garrick (1717–1779)*, 1764. Oil on canvas, 30 × 24¼ in. (76 × 63 cm). The Ashmolean Museum, Oxford.

it received an additional value for the propriety of his possession. The Picture, which is a very fine one, after twelve sittings of two hours and a half each, is to have the famous Edition of Terence in the Vatican open, with its drawings of antique masks, alluding both to the character, and the circumstances of the giver and the Gift."[50]

Even the governors of the young men on the Grand Tour, or "bear-leaders," as they were then known, could play a role in a portrait commission or the sale of a painting, and it is probable that Henry Lyte (1729–1791), who served as tutor to Lord Brudenell in 1758 and a decade later directed the Italian tour of Sir William Fitzherbert (1748–1791), was responsible for the latter's sitting to Batoni.[51] Dr. John Clephane (1705–1758), who was the cultural guide for a number of young Englishmen and Scots on the Grand Tour, played a part in the commission by

Thomas, 2nd Lord Mansell (1719–1744), of Batoni's *Sacrifice of Iphigenia* (see fig. 14) and in its subsequent sale to David Wemyss, Lord Elcho (1721–1787), and it has been suggested that he may have brought Joseph Leeson to Batoni's studio.[52]

Cardinal Alessandro Albani, the most celebrated Roman collector of antiquities in the eighteenth century and an influential figure in the local art world, played a significant role in the early stages of Batoni's patronage by the British and Irish in Rome.[53] He did much to advance Batoni's career, arranging for him to receive commissions from Sir Hugh Percy, later 1st Duke of Northumberland (1714–1786), for copies after Raphael to hang in Northumberland House, London, as well as, possibly, for the altarpiece for Saint Peter's (see fig. 35) and for portraits of visiting foreigners.[54] Albani was the "Protector of the English" in the absence of an ambassador accredited to the Holy See, and through his friendship and correspondence with Sir Horace Mann (1706–1786), the British representative in Florence, proved a valuable contact both for British artists in Rome and for wealthy British patrons in search of works of art and antiquities.[55] He knew in advance of the arrival of most British visitors to the Eternal City and seems to have been particularly helpful to them with introductions to local social and cultural life, and it is clear that he directed them to Batoni's studio.

Other commissions were arranged through various ciceroni, or guides, to the Grand Tour travellers in Rome. The English painter and antiquary James Russel (c. 1720–1763), for example, served as an agent in the portrait commissions to Batoni of Ralph Howard, later 1st Viscount Wicklow (1726–1789), George Lucy, and Sir Richard Lyttelton (see fig. 60).[56] One of the most important of these agents for Batoni's career, however, was the cicerone, antiquary, and art dealer Thomas Jenkins (1722–1798), who came to dominate the art market in Rome in the second half of the eighteenth century.[57] As the principal advisor and banker for many Anglophone travellers, an intermediary in numerous dealings in antique sculptures, gems, and pictures, and unofficial "British agent" in Rome, Jenkins brought a number of patrons to Batoni. He may have been responsible for obtaining Batoni's commission to paint Lord Brudenell; it is equally likely that he played a role in the commissions from Lord North and William Weddell.[58] Throughout

their careers, Jenkins and Batoni remained on cordial terms, and as a result many English travellers who banked with the former were painted by the latter.

The artist-turned-antiquarian James Byres (1734–1817), "who for Years had the guidance of the Taste and Expenditures of our English Cavaliers, and from whose hands all bounties were to flow," provided from the 1750s a link between Batoni and the large number of potential clients among the rich young Englishmen whom he conducted on his tours of Rome.[59] That Byres's contacts with the English milordi were useful to Batoni is demonstrated by a pair of conversation pieces in which Byres is thought to be represented with a group of Englishmen on the Grand Tour. The names of the other sitters have been recorded, and five of the men represented in these two groups were painted by Batoni; all their portraits were signed and dated 1773.[60] In 1778, Byres conducted Henry Swinburne, his wife, Martha (1747–1809), and their travelling companion Sir Thomas Gascoigne (1745–1810) on a tour of the sights of Rome, and in the same year he also accompanied Philip Yorke; all four sat to Batoni for portraits the following year.[61] The artist was indebted to Byres for other commissions, such as those from Sir Watkin Williams-Wynn and William Constable (1721–1791).[62] A portrait by Batoni of Byres's sister Isabella Sandilands (see fig. 74) hung in the dining room of his house in the strada Paolina, where it was no doubt noticed by potential clients.[63] Byres also was named one of the two executors of Batoni's will of 1786.[64] His selection may be interpreted either as a proof of friendship or as the seal of confidence set on a close quasi-business association; however, it underscores the Scot's pivotal role in bringing together Batoni and the increasing number of British visitors who were arriving daily in Rome in the third quarter of the century.[65]

A number of contemporary accounts confirm the gravitation of the British towards Batoni's studio. As early as 1755, for example, Mann expressed what was to become a familiar worry on the part of those responsible for securing commissions from Batoni—namely, that the paintings in progress in Batoni's studio would be interrupted and delayed by the English travellers demanding portraits.[66] Two decades later commissions from British visitors to Rome had, if anything, increased. In January 1775, Batoni's pupil and assistant Johann Gottlieb Puhlmann (1751–1826)

reported in a letter to his parents in Potsdam that Batoni had "8 Engländer" awaiting their portraits, representing 1,600 scudi in income. In early April 1775, there were four Englishmen sitting to the painter, and in October, Puhlmann wrote, "There are also a lot of Englishmen coming."[67] Only in the last few years of his life, when Batoni's output had diminished considerably as a result of his declining health, did history paintings again surpass the number of British portraits. Another factor in the change was the reduced number of British travellers to Rome after about 1780, when the war with France effectively closed the sea routes to England, anticipating the end of the Grand Tour itself.[68]

The effect that British patronage had on Batoni's career cannot be overestimated. In the 1730s, he produced approximately thirty history paintings, ranging in size and importance from small devotional canvases to large-scale easel pictures to altarpieces. In the 1740s, Batoni's most productive period as a history painter, more than a hundred works in the genre issued from his studio. Yet it was in this decade, during which he produced only about a half-dozen portraits, that he forged his connections with the British contingent in Rome (primarily the Irish at this period), with consequences that became dramatically apparent. In the early 1750s, the number of portrait commissions Batoni received increased rapidly, and soon the portraits outnumbered the subject pictures. The return of Joseph Leeson to Rome in 1750 with his son and other members of his family initiated Batoni's sustained engagement with portraits of Grand Tourists. At the same time, Sir Matthew Fetherstonhaugh and his entourage visited Rome and further increased the demand from the British for portraits, so that Batoni was soon painting approximately a dozen a year in the early 1750s. In the decade between 1750 and 1760, Batoni produced about twenty subject paintings, yet he executed some sixty portraits of British sitters alone, and a similar ratio occurs in the following decade, with an ever greater demand for portraits.

The history pictures acquired from Batoni by the British consisted mostly of subjects from classical history and mythology—The Sacrifice of Iphigenia, Hector's Farewell to Andromache (untraced), Diana and Cupid (see fig. 59), and Bacchus and Ariadne (1769–73; private collection, Rome).[69] Sir Matthew Fetherstonhaugh bought in 1752 an exquisite

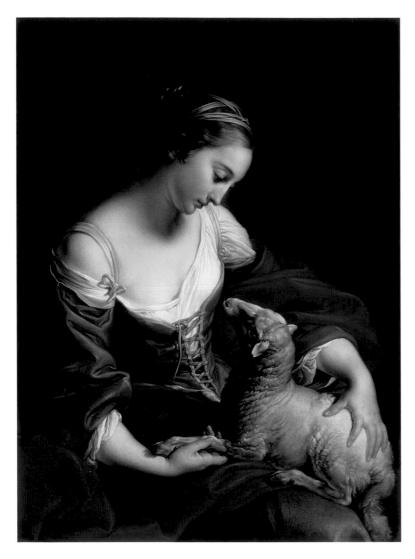

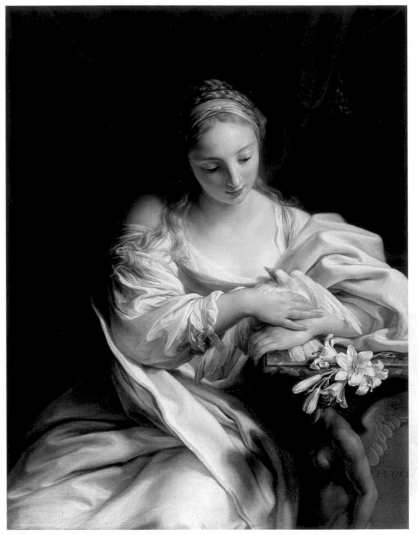

Fig. 46. *Meekness,* 1752. Oil on canvas, 39 × 29 in. (99 × 73.7 cm). The Fetherstonhaugh Collection, Uppark (The National Trust).

Fig. 47. *Purity of Heart,* 1752. Oil on canvas, 38½ × 29 in. (97.8 × 73.7 cm). The Fetherstonhaugh Collection, Uppark (The National Trust).

pair of half-length personifications of the Second and Sixth Beatitudes from the Sermon on the Mount, *Meekness* and *Purity of Heart* (figs. 46, 47).[70] Although the predominantly Protestant British Grand Tourists readily purchased religious pictures by Old Master painters, few appear to have been interested in obtaining large-scale sacred paintings from contemporary Italian artists. Thomas Dundas in 1763 purchased a *Holy Family with Saint Elizabeth and the Infant Saint John the Baptist* (untraced), although this is likely to have been a painting he admired in the artist's studio and not a specific commission. The exception to this pattern was Henry, 8th Baron Arundell (1740–1808), who commissioned a decade later the *Appearance of the Angel to Hagar in the Desert* (fig. 48).[71] Lord Arundell was described by Sir

Horace Mann as "a devout Catholic Lord," and this must account for the unique collection of religious compositions and portraits by or after Batoni that he assembled over the years.[72] Although the negotiations over the biblical painting brought Lord Arundell and his agent Father Thorpe considerable vexation owing to Batoni's delay in completing it, the elaborately finished canvas proved to be one of the most elegant and refined of Batoni's late subject paintings.

The Evolution of Batoni's Grand Tour Portrait Style

When Batoni developed his portrait practice in the 1740s, the tradition of Grand Tour portraiture had been well established in Rome for several decades. In the

1720s, a dozen British visitors sat to Francesco Trevisani (1656–1746) for their portraits; in the 1730s, Antonio David (c. 1680–c. 1738), Domenico Dupra (1689–1770), Andrea Casali (1705–1784), Ludovico Stern (1709–1777), and Louis-Gabriel Blanchet (1701–1772) received such commissions; in the 1740s, Agostino Masucci, Marco Benefial (1684–1764), and Pierre Subleyras all painted foreign visitors to Rome.[73] Batoni did not "invent" the Grand Tour portrait, and in fact nearly all of the features associated with his portraiture were foreshadowed by Roman portrait painters of the previous generation. The Grand Tour portrait showing the sitter

in the presence of antiquities or in front of a Roman background is the outcome of a combination of traditions. The fashion for depicting Englishmen in this way, for example, may be traced to the seventeenth century, both in England and in Italy: Sir Peter Lely's *Bartholomew Beale* (c. 1665–70; private collection), showing the sitter standing in a landscape with his right hand resting on a bust of Homer, and Carlo Maratti's *Robert Spencer, 2nd Earl of Sunderland* (c. 1661; Althorp, Northamptonshire), in which the sitter is depicted out-of-doors in Roman dress with his arm resting on a pedestal carved with a bas-relief and an antique fragment at his feet, anticipate by nearly a century the poses and the accessories of Batoni's portraits.[74] Several precedents confirm Batoni's inheritance from earlier Roman painting for this Grand Tour portrait format, notably *William*

Fig. 48. *The Appearance of the Angel to Hagar in the Desert*, 1774–76. Oil on canvas, 39¼ × 59¼ in. (100 × 151 cm). Galleria Nazionale d'Arte Antica, Palazzo Barberini, Rome.

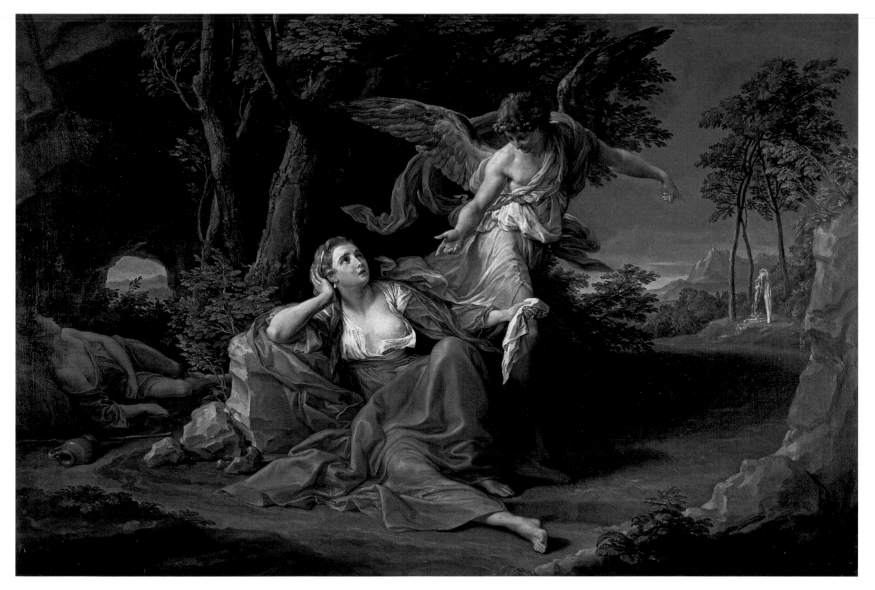

Johnstone, 1st Marquis of Annandale (1713; Hopetoun House, Edinburgh) by Andrea Procaccini (1671–1734), in which the sitter is seated at a table with coins and a cameo and a marble fragment at his feet while presenting a statuette to the beholder; Trevisani's *Thomas Coke, 1st Earl of Leicester* (1717; Holkham Hall, Norfolk), whose sitter is seated grandly with his dog in an ornate baroque setting before a curtain parted to reveal a gallery of classical sculptures; and his *Sir Edward Gascoigne* (1725; Lotherton Hall, Leeds), showing Gascoigne seated at a table with a copy of Horace, pointing to a window that commands a view of the Colosseum.[75] Andrea Casali's *Sir Charles Frederick* (1738; Ashmolean Museum, Oxford), in which the sitter is shown writing at a table before a window opening onto a distant view of the Pantheon with its seventeenth-century bell towers, or his *Mrs. Smart Letheuillier* (1738; Passmore Edwards Museum, London), in which Mrs. Letheuillier is seated with a view of the Pyramid of Cestius, provide similar precedents.[76] The full-lengths *George Lewis Coke* (Collection of the Marquess of Lothian) and *William Perry* (private collection), with the Colosseum in the background, traditionally attributed to Antonio David, further anticipate all the elements of Batoni's later Grand Tour portraits, including the antique architectural monuments, curtained backgrounds, finely carved furniture, and still lifes of globes, armillary spheres, writing implements, and books.[77] Moreover, by the 1730s, "Grand Tour portraits" were even being painted in London of sitters who had been to Italy, such as *Henry Somerset, 3rd Duke of Beaufort* (late 1730s; Duke of Beaufort), attributed to Andrea Soldi (c. 1703–1771), which shows the subject before a backdrop of the Colosseum.[78]

Although Batoni's portraits of young British visitors to Italy are generally associated with an emblematic use of antiquities and views to establish both their presence in Rome and their status as learned, cultivated, yet leisured aristocrats, antiquities are in fact notably absent from his earliest portraits. Batoni's portrait of Arthur Rowley of Summerhill (1740) does not survive, nor does that of John Chute (1701–1776) of the Vyne of a few years later, but the Irish collector and patron Joseph Leeson (fig. 49), Batoni's

earliest extant portrait of a Grand Tour sitter, is shown before a simple background of draped curtain and architectural frame of columns and pilasters that provides no indication of his presence in Rome.[79] He is shown wearing an informal *déshabillé* costume consisting of a domestic gown of green silk, fur-lined *robe de chambre,* and matching fur hat, none of which would necessarily be associated with a visit to Italy.

In the portraits of the early 1750s, Batoni often depicted British sitters in formats that underplay their identities as visitors to Italy and, frequently, celebrate instead the pleasures of country life.[80] The artistic distinction of these early portraits of Irish and English sitters is their delicate handling, liquid touch, and sensitive rendering of the textures of the sitters' dress, in particular the garments edged

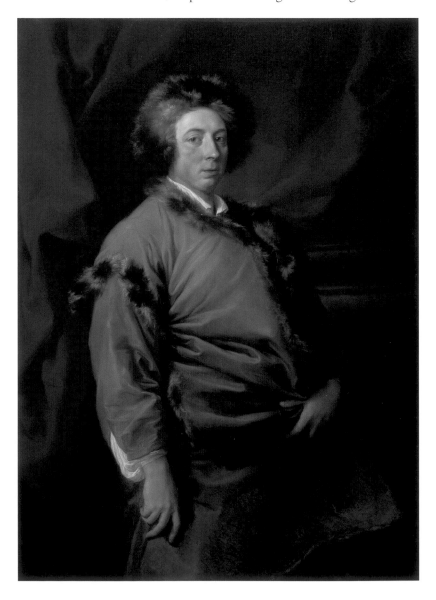

Fig. 49. *Joseph Leeson, later 1st Earl of Milltown (1711–1783)*, 1744. Oil on canvas, 53¹⁵⁄₁₆ × 40⅛ in. (137 × 101.9 cm). National Gallery of Ireland, Dublin.

with fur, which Batoni used to great effect throughout his career.[81] The series of half-lengths at Uppark commissioned in 1751 by Sir Matthew Fetherstonhaugh of himself and his relations depicts the family in various rustic or pastoral guises that provide no hint of where they were painted.[82] Sir Matthew is portrayed in hunting garb with an archaic spear to match the companion picture of his wife. She is clearly designated as Diana, a favourite motif of contemporary European portrait painters, enabling them to pay tribute to the youth and beauty of the sitter and to her virtue through the allusion to the goddess of the hunt. This genre of eighteenth-century portraiture is usually associated with France rather than Italy, but in presenting the female relatives of Joseph Leeson and Sir Matthew Fetherstonhaugh as shepherdesses and woodland deities, Batoni was merely adopting a convention begun by Trevisani of depicting ladies as personifications of Diana, Flora, or other goddesses and of establishing their identities by means of flowers, arrows, and similar attributes that had been current in Rome for several decades.[83] The backgrounds of curtains, architecture, and foliage placed immediately behind a sitter set close to the picture plane also derive from this source, and deal with the problem of effecting a satisfactory transition from foreground to middle ground, which Batoni was to solve so successfully in his later portraits.

About the time he was painting the Fetherstonhaughs in bucolic dress, however, Batoni began to develop the specific Grand Tour portrait formula upon which he would stake his claim as the city's leading portraitist. *George Damer* (fig. 50) is among the portraits that stand at the beginning of Batoni's sustained activity as the painter of *milordi inglesi* on the Grand Tour.[84] The portraits of around 1750 vary widely in conception, but none is more unusual than this one, which must have been painted at the same time as a celebrated pair of the sitter's elder brother, *Joseph Damer, later Lord Milton and 1st Earl of Dorchester,* and his wife, *Lady Caroline Damer, later Lady Milton* (both c. 1750; Drayton House, Northamptonshire).[85] The portrait of George Damer is of exceptional interest both for its presentation of the sitter with the soon-to-be-familiar devices of column and curtain, beyond which is glimpsed a wooded landscape, and for the damascened breastplate he wears over a richly embroidered waistcoat and the helmet on which he rests his hand. There is a significant precedent for the depiction

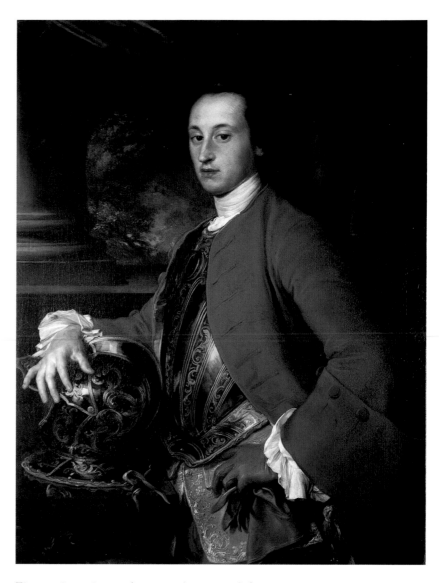

Fig. 50. *George Damer (1727–1752)*, c. 1750. Oil on canvas, 38 × 24 in. (96.5 × 61 cm). Private collection.

of a British Grand Tourist wearing armour—Francesco Trevisani's portrait of a Jacobite Scot, *Captain John Urquhart* (1732; Craigston, Banffshire);[86] in Batoni's portrait, the outfit is explained by Damer's military rank, since he became an ensign of the footguards in 1745 and was promoted to lieutenant and then captain in 1749. Although the question of how Batoni could have known, or at least been aware of, earlier eighteenth-century portraits of Grand Tourists in Rome is relevant, he almost certainly would have seen Trevisani's portrait of Urquhart because at around the time of the captain's sitting, he was commissioning from Batoni copies of well-known paintings by Guido Reni and Federico Barocci.[87]

Although Damer is shown without explicit reference to his presence in Rome, the confident and forceful pose became the norm for Batoni's sitters thereafter, many of whom are clearly identified as visitors to the Eternal City. The portrait of Robert Clements is one of the earliest examples of this type; another is the half-length portrait of the Irish statesman and patron of the arts Lord Charlemont, the earliest extant painting in which Batoni employed a view of the Colosseum.[88] The monument is glimpsed in the background through the open window, rendered as if it were a small painting, in contrast to the later, more accomplished integration of the motif with the rest of the composition. The style and handling of the portrait, particularly the treatment of the green frock coat trimmed with gold frogged fastenings inspired by Hussar uniforms, suggest that it was probably substantially completed in 1754 (the date of an inscription on the canvas, removed in a subsequent cleaning), although the finishing touches may not have been applied until a year or so later.

Batoni's search for a more profound conception of portraiture led him to consider a wide variety of compositional models and prototypes, from the Renaissance to the Settecento. It is difficult to believe that Batoni was unaware of the portraits of Titian (c. 1490–1576) and of their significance to the development of Italian and European portraiture, or of the ways that the great Venetian's imaginative patterns of half- and full-length portraits, his repertory of poses and attitudes, and the aura of ease and authority with which he imbued his aristocratic sitters could be exploited by a painter of Batoni's own day. Titian's abundant portrait accessories to suggest a sitter's interests or importance—letters, books, furniture, armour, dogs, reliefs, plinths, pedestals, columns, and curtains—all appear, appositely modified, among the paraphernalia of Batoni's portraits two centuries later. But it is Titian's extraordinary inventiveness in dealing with his sitter's hands and the prominence and liveliness of this feature of his portraits that appear to have captured Batoni's attention in particular.[89] One of the most expressive elements in Batoni's own likenesses is his treatment of hands, and in the portraits of the 1750s the elegant, finely articulated hands immediately claim the beholder's attention.

Titian's achievements in portraiture were taken up by a significant intermediary, Sir Anthony Van Dyck (1599–1641), whose portraits enjoyed a powerful resonance among Batoni's British patrons and would have been known to him from engravings, if not actual painted copies, as well as from the descriptions provided by his sitters.[90] The hands that Van Dyck painted, for example, attracted lavish praise and were extolled as models for young artists and published in a series of prints.[91] But Batoni was attentive to more than the hands in Van Dyck's portraits; he emulated his repertory of dress, pose, and decor recorded in the various editions of the so-called *Iconography*, a series of engravings after the portraits of Van Dyck that became one of the most widely used sources of portrait poses during the seventeenth and eighteenth centuries.[92] George Damer's rhythmic grace and ease of gesture as well as his armour recall numerous Van Dyck precedents, and the exact model for the pose in Batoni's *Sir Digby Legard, 5th Bt.* (1754; private collection, England), for example, in which the sitter rests his arm on a pedestal so that his hand dangles in an insouciant fashion, is Van Dyck's *Self-Portrait*, painted in Italy around 1623 (State Hermitage Museum, Saint Petersburg), which was engraved and repeated in a number of variant compositions.[93]

Batoni's development in the early 1750s of a full-length-portrait format in which the sitter is shown in the presence of an antique building or sculpture as an indication of a visit to Rome reveals a further debt to Van Dyck. He had demonstrated with his first public commission, *The Virgin and Child with the Blessed Pietro, Castora, Forte, and Lodolfo* (see fig. 1), the ability to paint on a grand scale, and it was the full-length format that provided him with the opportunity to exploit fully the possibilities of a portrait type that would differentiate his efforts from those of his immediate Italian predecessors and contemporaries and establish him as an authority in the genre. *Sackville Tufton, 8th Earl of Thanet* (fig. 51) was painted at about the same time as the portraits of Clements and Lord Charlemont and stands at the head of a long line of large, formal full-lengths of British sitters that Batoni was to produce over the next thirty years.[94] Lord Thanet, whose vast wealth led Horace Walpole to refer to him as a "young Croesus," is shown before the baroque trappings of curtain and columns with his dogs and a marble bust derived from the *Minerva Giustiniani*.[95] Batoni's debt to Van Dyck and to the British portrait tradition that reflects this influence is revealed

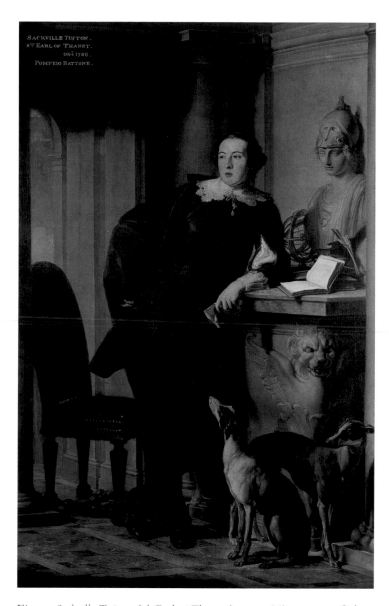

Fig. 51. *Sackville Tufton, 8th Earl of Thanet (1733–1786)*, 1753–54. Oil on canvas, 92 × 58 in. (233.7 × 147.3 cm). Private collection; courtesy of Michael Tollemache Fine Art, London.

most conspicuously, however, by Thanet's plain silk suit, with the lace collar fastened at the neck with a button and tassels, a style known as Vandyke dress.[96] The wearing of this costume by men and women was quite common among the fashionable elite as a masquerade dress in the 1740s and was popularised in English portraiture by, among others, Thomas Hudson (c. 1701–1779). Only about a half-dozen of Batoni's sitters chose to wear Vandyke dress, but there can be no doubt that Batoni was aware of its connection with the great seventeenth-century painter—in his portrait of Sir Robert Davers, 5th Baronet (1756; The National Trust,

Ickworth, Suffolk), the title of one the books employed among the accessories is a partially legible "Vandyc[. . .]."[97]

However, it is not only Lord Thanet's costume and the setting in which he is shown but also the elegance and suavity of his bearing that underscore Batoni's obligation to Van Dyck's English full-length portraits. There can be little doubt that these prototypes offered a range of idioms and conventions that Batoni adapted for his portraits of English visitors to Rome. The two-dimensional surface patterns; the subtle twists and thrusts of bodily attitudes; the backdrops of architecture, drapery, and landscape; and the psychological reserve of the sitters themselves all derive at least in part from Batoni's elegant precursor. The occasional inclusion of English furniture in Batoni's full-length portraits, a chair placed on angle to enhance a sense of immediacy and arrested movement (see fig. 57), may be an attempt to fit the portraits into their intended settings in England—"family collections which were already resplendent with Van Dycks."[98] Even "those pedestals which are so often found in painting and never anywhere else," in the words of one Batoni sitter, owe their origins to Van Dyck.[99]

Batoni's greatest tribute to Van Dyck, however, is the celebrated full-length *Thomas William Coke, later 1st Earl of Leicester* (see fig. 79), which reflects in the sitter's pose and dress an ardent emulation of such portraits as *Robert Rich, 2nd Earl of Warwick* (c. 1633; The Metropolitan Museum of Art, New York)—even the brown-and-white spaniel gazing up at his master conforms closely to a Van Dyck antecedent.[100] In this stunning portrait, the artist achieved a perfect amalgamation of baroque elegance with a real costume, faithfully recorded, which the sitter wore at a masquerade in Rome in 1773. Lord Coke's suit of white and silver silk, pink cloak lined with ermine, lace collar trimmed with a pink bow, and hat with ostrich feathers pay homage not only to Van Dyck but also to the wealth and status of the sitter, whose handsome and fashionable appearance was often noted by other British travellers.

Lord Thanet's cross-legged pose—"that foolish cross-legged style, which was to haunt British portraiture"[101]— confirms further that Batoni was keenly aware of the expectations British sitters brought to his studio and of the context in which their portraits would be appreciated back home. The pose has been traced to classical antiquity—various Roman marble statues after Greek bronze originals

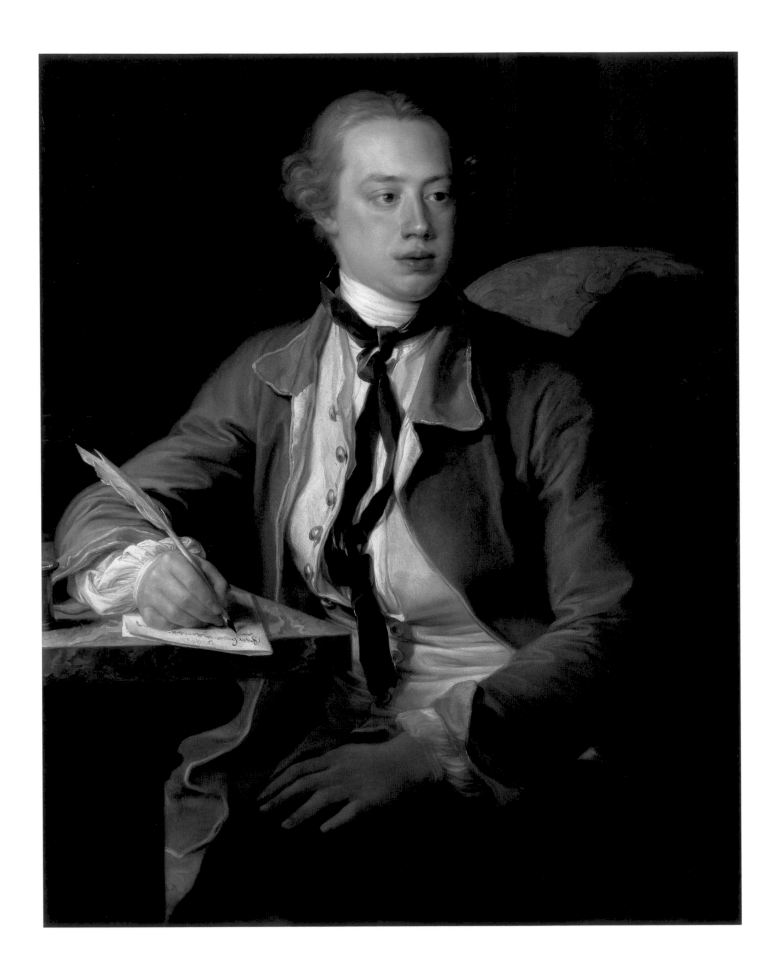

such as the famous *Mercury* in the Uffizi Gallery and the *Marble Faun* given by Pope Benedict XIV to the Museo Capitolino in 1753 employed it[102]—and no doubt Batoni intended in Thanet's relaxed posture, inclined on one side according to the typical "Praxitelean" attitude, resting his left elbow on a pedestal, his right arm counterbalanced on his hip, a deliberate reference to the classical past. But the cross-legged pose also echoes clearly the formal three-quarter- and full-lengths of the leading London portrait painters of the 1740s, Allan Ramsay (1713–1784) and Thomas Hudson, who employed it frequently in such portraits as *John Bulkeley Coventry* (c. 1742–44; Trustees of the Croome Estate) and *Theodore Jacobsen* (1746; Thomas Coram Foundation for Children, London), respectively.[103] In Hudson's full-length of Jacobsen, the features of Batoni's full-lengths are already present: the nonchalant, cross-legged pose, the device of a plinth against which the sitter leans, an engraving of emblematic significance, a column and capital in the foreground, and a glimpse of a landscape with identifiable buildings behind. The importance of all of these precedents cannot be overemphasised: they were models of emulation and inspiration both for Batoni's development of his own portrait types (which he repeated with slight variations for the rest of his career) and for their conveyance of the artistic and cultural heritage of British portraiture, of which many of Batoni's sitters would have been aware.

A key figure in Batoni's orientation towards and awareness of both the historical tradition of British portrait painting and its latest contemporary developments was Allan Ramsay. The Scottish artist had made the acquaintance of Batoni during his first visit to Italy in 1736–38, when he studied in Rome under Francesco Imperiali, and the influence of Batoni's style of painting and drawing upon the slightly younger painter has frequently been observed.[104] However, in December 1754, when Ramsay returned to Rome (where he mainly lived until May 1757), he had for years enjoyed great success as one of London's most fashionable portraitists and was in fact substantially more experienced in the practice of painting portraits than Batoni. Among the several hundred portraits Ramsay had produced since

the late 1730s are many that anticipate the formats, arrangements of figures, costumes, and even accessories of Batoni's portraits of British gentry and nobility travelling abroad.[105] Ramsay had, moreover, mastered not only the idiom of the Van Dyck tradition in English portraiture, he also had brought an acute awareness of current developments in France and of the work of such portrait painters as Jean-Marc Nattier (1685–1766), Jean-Baptiste Van Loo (1684–1745), and Maurice-Quentin de La Tour (1704–1788). The complementary qualities of the portraits of Batoni and Ramsay have not gone unremarked.[106] However, the significance of the arrival in Rome of such a major figure in British portraiture at precisely the moment that Batoni was taking up the challenge of painting English, Irish, and Scots travellers in great numbers has remained insufficiently appreciated.

In the mid-1750s, Batoni expanded considerably the narrow repertory of poses used in the portraits of his earliest sitters. He initiated a three-quarter-length seated pose, for example, that stands apart from the more characteristic Grand Tour presentations, notably in *Frederick, Lord North, later 2nd Earl of Guilford* (fig. 52), in which a sense of immediacy is achieved by cutting the canvas just below the knee, bringing the spectator into close contact with the picture plane.[107] The portrait is a brilliant example of Batoni's accurate characterisation of his sitters' features and of the great sympathy (and skill) with which he could mitigate a less than prepossessing appearance when capturing a likeness. The future prime minister was renowned for his ugliness, as Horace Walpole's description of him shortly after the portrait was painted suggests: "Nothing could be more coarse or clumsy or ungracious than his outside. Two large prominent eyes that rolled about to no purpose (for he was utterly short-sighted), a wide mouth, thick lips, and inflated visage, gave him the air of a blind trumpeter."[108] Batoni does not so much shrink from recording Lord North's extraordinary physiognomy as ease its effect through the elegant distractions of his dress. North wears a fairly casual, elegant frock coat of green Italian velvet with red facings, a buff silk waistcoat, and brown knee-breeches. But it is the sinuous movement of the black ribbon with which he ties his hair, whose ends tumble over his shirt front, that provides the right note of informal disarray and relieves his unfortunate appearance.[109] The artist's various uses of the length of black silk known as a solitaire, worn as a fashion-

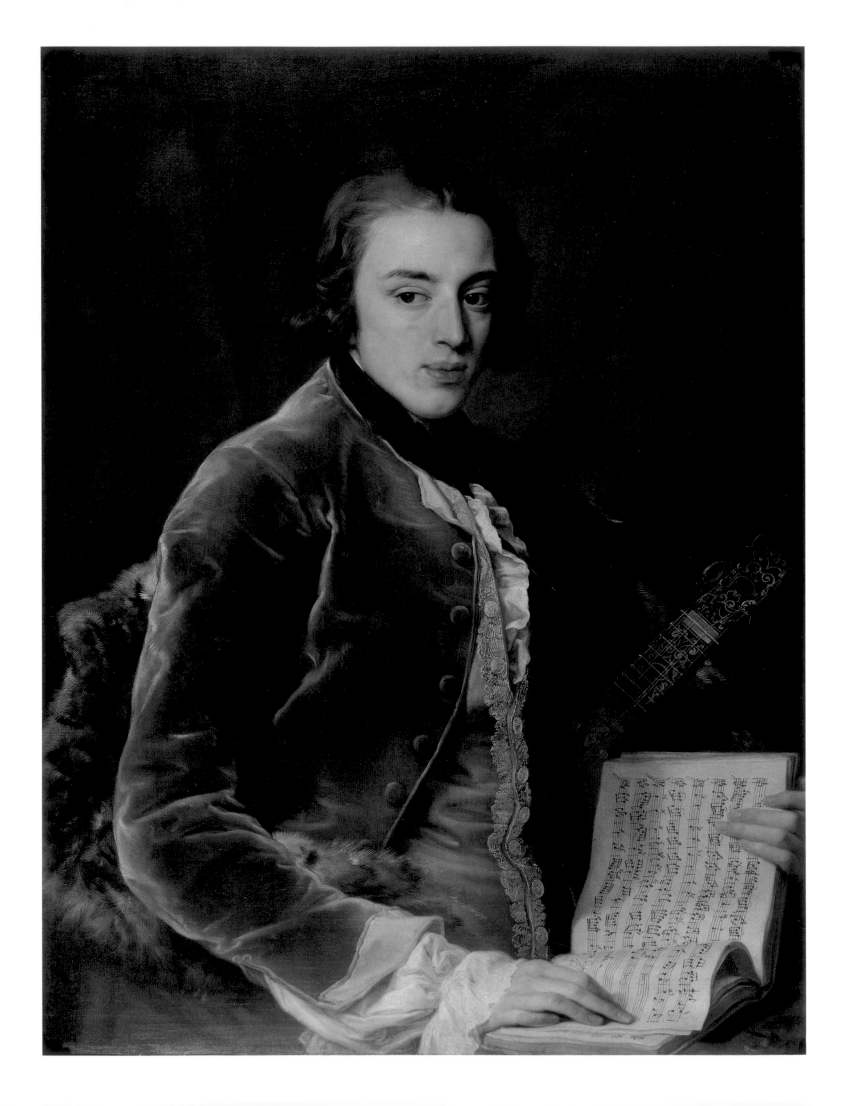

able accoutrement of well-dressed men from about 1730, reveal his dexterity in manipulating the details of sitters' dress in order to supply each with a unique, fresh image that makes every portrait individual. Sometimes used to tie the bag of a wig, on other occasions to tie back a gentleman's own hair, the ribbon would often be brought round to the front and tied in a bow.[110] About fifty of Batoni's sitters chose to be shown sporting such neckwear, and he deployed this modest item of dress to vary the presentation of his sitters from one portrait to another. For Robert Clements, Lords Charlemont and North, and Edward Dering (see figs. 36, 38, 52, 54) the ribbon is untied and allowed to tumble down the front; Lord Brudenell, William Fermor, and Richard Milles (see figs. 53, 55, 76) wear it tucked into other garments; in the portraits of Colonel Gordon (see fig. 61) and others, it is tied into a bow.[111]

Lord North's seated pose was employed with variations in several portraits of approximately the same period, including that of one of Batoni's most fascinating sitters, *John, Lord Brudenell, later Marquess of Monthermer* (fig. 53).[112] This "lively and appealing image of aristocratic preciosity" is meticulously painted,[113] its constituent elements defined with unusual precision, and it is one of Batoni's undoubted masterpieces of portraiture. Although Lord Brudenell is one of the more remarkable English Grand Tourists of the eighteenth century by virtue of the range of his interests and activities while abroad, Batoni has provided no overt clues to his visit to Rome. Nonetheless, it is evident that he sensed that the young man was more than an ordinary privileged visitor to his studio and responded accordingly with an unusually sensitive delineation of Brudenell's features and an exquisitely refined description of his sumptuous dress, musical instrument—a type of mandolin—and score. The latter is so accurately reproduced that it can be identified as a violin sonata from Arcangelo Corelli's famous opus 5, published in 1700.[114]

Edward Dering was the subject of another of Batoni's remarkable portraits in the three-quarter seated format (fig. 54).[115] Dering is shown wearing a sumptuous velvet gown lined with squirrel, red breeches, and white vest and jabot,

Fig. 53. *John, Lord Brudenell, later Marquess of Monthermer (1735–1770)*, 1758. Oil on canvas, 38 × 28 in. (96.5 × 71.1 cm). The Duke of Buccleuch & Queensberry KT, Boughton House, Northamptonshire.

Fig. 54. *Edward Dering, later 6th Bt. (1732–1798)*, c. 1758–59. Oil on canvas, 53¼ × 39½ in. (136.5 × 99.5 cm). Private collection; on loan to the Art Institute of Chicago.

seated beside a table with an open book, a quill and an ink pot, and a bust of the *Apollo Belvedere*. His presentation was anticipated nearly a century earlier by Carlo Maratti's *Sir Thomas Isham, 3rd Bt.* (1677; Lamport Hall, Northamptonshire), which depicted the sitter as a connoisseur, seated three-quarter length leaning on a gilt baroque console table before a curtain, dressed in a richly embroidered robe, and prominently displaying a miniature.[116] But Batoni's conscious striving for effect, vivid palette, exacting description of the textures and surfaces of marble, lace, velvet, and

Dyck into a sophisticated and subtle hybrid that persuasively assimilates the heritage of English painting to the sitter's presence in Rome. Sir Wyndham's debonair stance (intended to evoke one of the most famous antiquities of the time, the *Apollo Belvedere*) was later repeated and employed by the artist with subtle variations in other full-length compositions.[125]

The greyhound accompanying Sir Wyndham serves as a reminder that the inclusion of dogs in Batoni's portraits also has a British precedent, ranging from the portraits of Van Dyck to the more recent conversation pieces of Francis Hayman (c. 1708–1776),[126] which would have accustomed Grand Tour sitters to the presence of animals in their portraits. Dogs offered Batoni an additional element with which to expand his repertory of portrait adjuncts, interject a note of sentiment, and visualise his fine sense for texture, exploiting the contrast of the smooth silks and velvets of his sitters' clothes against the coats of the animals (see fig. 37).[127] Another reason dogs appear in more than thirty of Batoni's British portraits is because they often accompanied their masters on the Grand Tour. Francis Howard, 5th Earl of Carlisle (1748–1825), even informed a friend in a letter from Turin in 1768 that his dog Rover would be painted in Rome by the illustrious Pompeo Batoni. (Unfortunately, Rover, who survived a broken leg in Florence, did not sit for his portrait in Rome, and during his return journey to England later that year he was run over by a coach in Paris.)[128]

Dogs were more than a pictorial convention, however, and by including them so frequently in his portraits, Batoni may have intended to remind the beholder of specific antique precedents—for example, the highly admired Roman statue of Meleager (Musei Vaticani, Vatican City), shown with his dog seated beside him.[129] Thus, by depicting Sir Wyndham attended by his greyhound, Batoni evoked a familiar feature of British portraiture; by employing in reverse the exact pose of the dog in the celebrated *Endymion Relief* (see fig. 124) that he had copied for Richard Topham decades earlier, he invested the portrait with an additional classical reference, complementing the bust of the *Minerva Giustiniani* and the Temple of the Sibyl on either side of the sitter.

The 1760s marked a continued widening of variety in the poses and portrait formats Batoni employed for his British sitters. The portrait of Sir Humphry Morice (fig. 58), one of Batoni's more important English clients, is unique among

his works, not only for the sitter's attitude, reclining full-length across the canvas, but in such details as the fanciful suit of shot silk, landscape background, and compositional prominence given to the dogs.[130] Its striking difference from Batoni's more typical portraits of the British in Rome surely represents the artist's response to a sitter who was no longer young and was not making the standard Tour, having travelled to Italy for reasons of health. A celebrated animal lover whose will allowed the trustees £600 per year to care for the dogs and horses he left behind, Sir Humphry is shown seated in a woodland setting, surrounded by three of his hounds, with the day's game before him. The architectural complex glimpsed in the distance—the Torre Leonina and the Torre dei Venti, seen from outside the walls of the Vatican gardens—differs considerably from Batoni's usual inclusion of ancient monuments such as the Colosseum in the background of his Grand Tour portraits.

Morice, one of approximately three dozen sitters who commissioned more than one portrait from Batoni, was an avid collector of pictures, and in April 1761 he purchased Batoni's *Diana and Cupid* (fig. 59), for which his full-length portrait, with which it shares nearly identical dimensions, conformity of pose, and similarities among the dogs and landscapes, may have been intended to serve more or less as a pendant.[131] The mythological painting, with its comely alliance of figures, animals, and landscape, obviously proved irresistible to Morice when he saw it in the painter's studio. He was particularly fond of landscapes, and he may even have appreciated the subtle derivation of the figure of Diana from a famous antique marble, the *Vatican Ariadne* (Musei Vaticani, Vatican City).[132]

That Batoni's perception of his sitters' character and personalities was more acute than is generally believed is suggested by a portrait of 1762, *Sir Richard Lyttelton* (fig. 60), which provides an unforgettable image of "portly pomp."[133] Though still in his forties, Lyttelton was badly crippled by gout and could no longer pursue an active military career or assume political office. Sometime before 1761 he and his wife went to the Continent for his health. It is the Lytteltons' attractive personalities that emerge most clearly

Fig. 57. *Sir Wyndham Knatchbull-Wyndham, 6th Bt. (1737–1763)*, 1758–59. Oil on canvas, 91¼ × 63½ in. (233 × 161.3 cm). Los Angeles County Museum of Art; Gift of the Ahmanson Foundation.

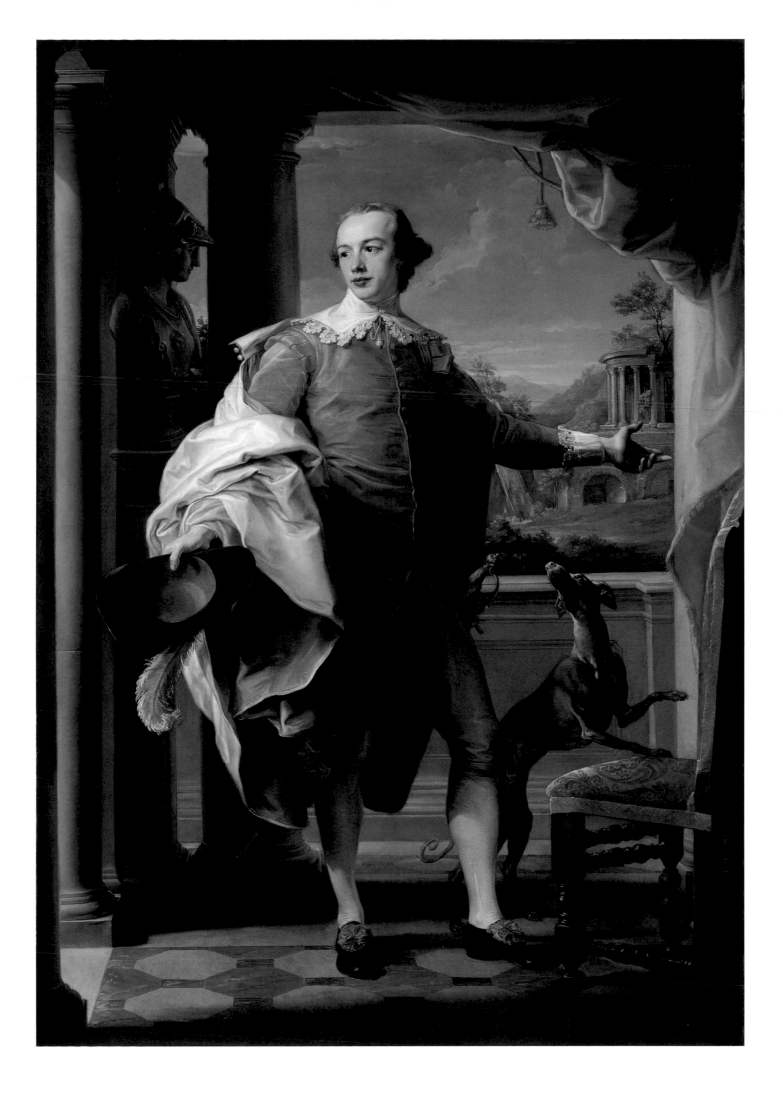

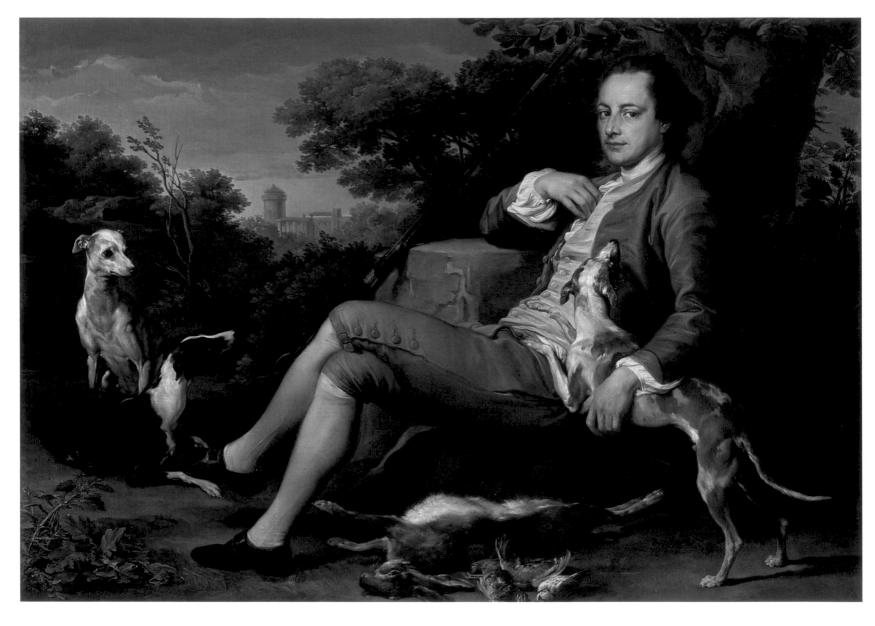

Fig. 58. *Sir Humphry Morice (1723–1785)*, 1761–62. Oil on canvas,
46¼ × 68 in. (117.5 × 172.8 cm). Sir James and Lady Graham,
Norton Conyers, North Yorkshire.

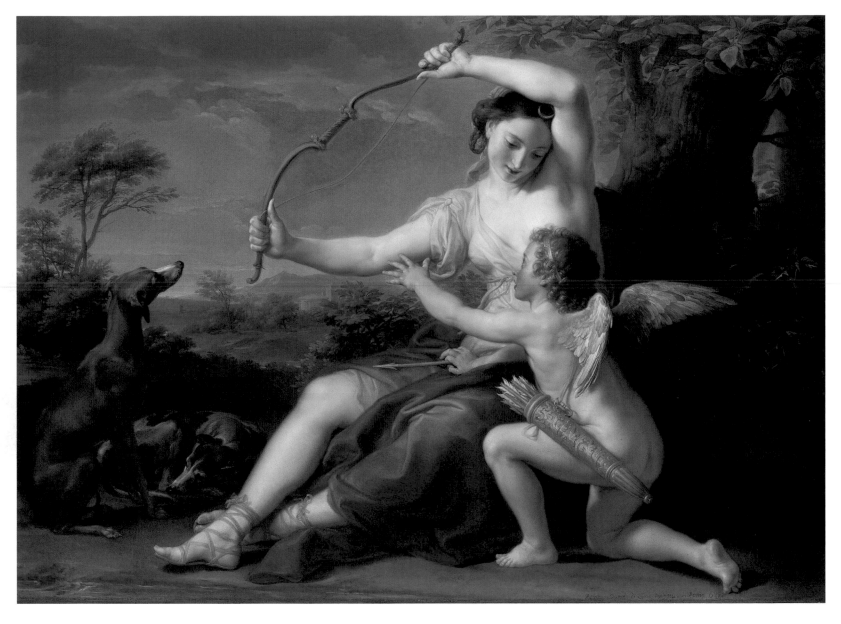

Fig. 59. *Diana and Cupid*, 1761. Oil on canvas, 49 × 68 in. (124.5 × 172.7 cm). The Metropolitan Museum of Art, New York; Purchase, The Charles Engelhard Foundation, Robert Lehman Foundation Inc., Mrs. Haebler Frantz, April R. Axton, L. H. P. Klotz, and David Mortimer Gifts; and Gifts of Mr. and Mrs. Charles Wrights-man, George Blumenthal, and J. Pierpont Morgan, Bequests of Millie Bruhl Fredrick and Mary Clark Tompson, and Rogers Fund, by exchange, 1982.

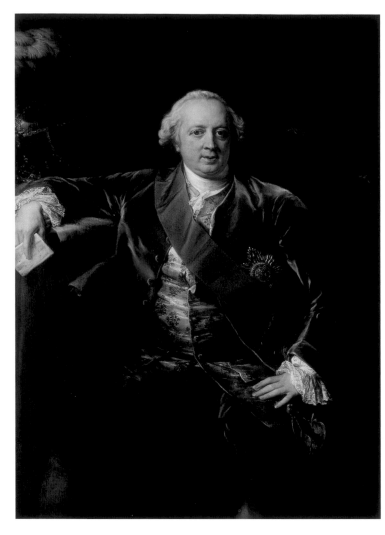

Fig. 60. *Sir Richard Lyttelton (1718–1770)*, 1762. Oil on canvas, 53½ × 39½ in. (135.9 × 100.3 cm). The Dowager Viscountess Cobham, Hagley Hall, Worcestershire.

from accounts of their travels: Walpole described them as "the best-humoured people in the world," and commented that Lyttelton was "in spight of his state the kindest and cheerfullest Person ever in company."[134] Batoni's choice of a seated pose complements the character, age, and status of his sitter, and it is a tribute to his insight and penetration into Lyttelton's character that the genial, distinguished knight who confronts the spectator here is immediately recognisable as the subject of Walpole's letter.

The pictorial complexity and grandeur of Batoni's Grand Tour portraits of the 1760s is exemplified by the full-length *Colonel the Hon. William Gordon* (fig. 61), the epitome of the Scot in Italy on the Grand Tour.[135] Taking into account such issues as the highly politicised nature of

Colonel Gordon's belted tartan costume, the proprietary swagger and martial self-possession of the pose, the iconography of the Colosseum and statue of the goddess Roma in the background, and contemporary debates about Scotland and Scottish cultural and national identity, it would seem evident that in this instance at least there was a genuine interchange between painter and patron over the choice and disposition of the antique references. That Gordon actively engaged Batoni's interest in the choice of costume, which James Boswell saw the artist painting on a visit to his studio during Holy Week in 1765, is indicated by the obvious care with which he depicted the intricately patterned plaid, which is that of the Huntly tartan.[136] The ease with which Batoni could integrate sitter and references to ancient Rome into a fictive yet completely convincing mise-en-scène is clear if one compares the detailed and complex view of the Colosseum here and the abbreviated use of the ruined amphitheatre in the portrait of Lord Charlemont painted only a decade earlier (see fig. 38).

Wills Hill, 1st Earl of Hillsborough, later 1st Marquess of Downshire (fig. 62) is unique among Batoni's Grand Tour portraits for showing the sitter mourning his recently deceased wife.[137] The couple had travelled to Italy in the hope of improving her health, but Lady Hillsborough died in Naples on 25 January 1766, and her husband left the city about six weeks later, passing through Rome on his return journey to England. He sat to Batoni in March or April 1766, and the resulting portrait shows him leaning on an antique sacrificial altar very close to that depicted in Raphael's cartoon *The Sacrifice at Lystra* (1515–16; Victoria and Albert Museum, London), despondently contemplating an oval portrait of his wife that was probably based on a portrait or miniature by a British painter. A key to the interpretation of the picture's significance as a mourning portrait is the presence of Hymen, the beautiful winged youth displaying Lady Hillsborough's portrait and extinguishing a torch. The god of marriage was known from Catullus's *Hymenaeus*, which in the late eighteenth century enjoyed a revived popularity, corresponding to a new, enlightened interest in conjugal love.[138] The Latin inscription from the

Fig. 61. *Colonel the Hon. William Gordon (1736–1816)*, 1765–66. Oil on canvas, 102 × 74 in. (259 × 187.5 cm). The National Trust for Scotland, Fyvie Castle, Aberdeenshire.

Aeneid (2:776–78) added to the sarcophagus by a contemporaneous hand reinforces the portrait's elegiac tone: "What's to be gained by giving way to grief / So madly, my sweet husband? Nothing here / Has come to pass except as heaven willed." Batoni's vivid colouring is readily appreciable in several passages, notably Lord Hillsborough's blue coat trimmed with gold braid, his velvety black waistcoat and breeches, and Hymen's striking shot-orange and yellow drapery.

Colour is a significant element in a third great full-length of this period, the double portrait *Sir Sampson Gideon, later 1st Lord Eardley, and an Unidentified Companion* (fig. 63), one of the few paintings by the artist singled out by the German connoisseur Gustav Friedrich Waagen (1794–1868) during his tour of the great private collections in England in the mid-nineteenth century.[139] The distinction between Sir Sampson, in bright blue costume with silver embroidery, and his unidentified friend or travelling companion, wearing gold-embroidered scarlet, rests in part on the vivid contrast between their respective clothing. The remaining colours, apart from the red seat of the gilt chair, are subdued in both hue and tone and restricted largely to warm grey, buff, brown, and green. But it is not the dazzling colour scheme alone that ensures the distinction of the portrait—the vaguely classicising architecture; the familiar emblems of ancient Rome, the Temple of Vesta at Tivoli and the marble bust known as the *Minerva Giustiniani*; the intimate gesture of displaying to his friend a portrait miniature of his fiancée; and the intimate harmonies of pose and attitude binding the two figures all contribute to the success of the composition.[140]

Batoni's three-quarter-length masterpiece, the resplendent *Sir Gregory Turner (later Page-Turner), 3rd Bt.* (fig. 64), also derives its immediate force from the painter's palette, notably the treatment of the gold-trimmed frock suit of the vivid red so popular with foreigners in Italy on the Grand Tour, exactly the sort of costume one would expect of a sitter who was known by his contemporaries for his extravagant and fashionable dress.[141] Shown with a bust of Minerva and a map of Rome before a distant view of the

Fig. 62. *Wills Hill, 1st Earl of Hillsborough, later 1st Marquess of Downshire (1718–1793)*, 1766. Oil on canvas, 89½ × 63½ in. (227 × 161 cm). Private collection.

Fig. 63. *Sir Sampson Gideon, later 1st Lord Eardley (1745–1824), and an Unidentified Companion*, 1766–67. Oil on canvas, 108¼ × 74⅛ in. (275.6 × 189 cm). National Gallery of Victoria, Melbourne; Everard Studley Miller Bequest, 1963.

Colosseum, Sir Gregory is depicted in an attitude adapted from the *Apollo Belvedere*, but the bold posture and magnificent clothing combine to create a very different effect from earlier portraits in the grand manner, such as *Sir Wyndham Knatchbull-Wyndham* (see fig. 57)—indeed, the young English baronet, "possessor of a complete set of Chesterfieldian skills and graces," has been interpreted as appearing in this portrait as "connoisseur, assimilator, appropriator, and even

Fig. 64. *Sir Gregory Turner (later Page-Turner), 3rd Bt. (1748–1805),* 1768–69. Oil on canvas, 53 × 39 in. (134.5 × 99.5 cm). Manchester Art Gallery.

Fig. 65. *Georgiana Poyntz, Countess Spencer (1738–1814),* 1764. Oil on canvas, 54 × 48½ in. (137.2 × 123.2 cm). The Collection at Althorp, Northamptonshire.

conqueror."[142] Batoni had first employed Sir Gregory's pose a few years earlier in *John Wodehouse, later 1st Baron Wodehouse* (see fig. 77), and he subsequently reutilised it for a number of three-quarter-length portraits.

The 1760s also marked a resumption of Batoni's portraits of British women visiting Rome on the Grand Tour. Representing only about a tenth of his portrait production, these works are as fine and memorable as those of Batoni's male sitters. Perhaps to an even greater degree than the portraits of the latter, such works as *Georgiana Poyntz, Countess Spencer* (fig. 65), are remarkably English in feeling, and English prototypes were clearly on Batoni's

mind, for Lady Spencer in both pose and demeanour evokes portraits by both Hudson and Ramsay.[143] For his portraits of British women, Batoni usually discarded the customary Grand Tour trappings. In this case he did not: described by Cardinal Albani as the most accomplished woman he had ever met, Lady Spencer is shown nearly full length before a curtain, seated beside a table with a guitar on top and holding a score, appropriate for a sitter who was exceptionally musical. A distant view of the Colosseum glimpsed through the window at the left underscores her fascination with the city: "Rome, & Rome only," she declared, "is the place to see and admire the perfection

to which painting, sculpture, and architecture have been carried."[144] Intelligent and well educated, Lady Spencer could write and converse in faultless French and Italian, and her ability to exchange thoughts and opinions directly with Batoni may mean that she played a more active role in the conception of her portrait than most of his clients. The result, in which she is shown in a splendid apricot-coloured gown, was entirely fitting for a sitter with a reputation as both a woman of culture and one of the best-dressed figures of her day.

Lady Mary Fox, later Baroness Holland, "the most amiable person that ever lived," was the subject of another of Batoni's most attractive portraits of Englishwomen (fig. 66).[145] Travelling in Italy on her wedding tour, Lady Mary arrived in Rome early in March 1767 and during a brief stay not only sat to Batoni but also made the acquaintance of Giovanni Battista Piranesi (1720–1778), who later dedicated a plate in the *Vasi, candelabri, cippi, sarcophagi . . .* (1778) to her.[146] The portrait, in which she is shown before a russet curtain holding a spaniel but without the usual Grand Tour attributes, exemplifies Batoni's simple and direct presentation of portraits of women. Lady Mary's attire, a grey travelling costume called a German habit or a Brunswick, adapted from traditional masculine riding habit by English women travellers, typifies the interest Batoni's paintings hold for the costume historian.

One of Batoni's rare portraits of a child, *Louisa Grenville, later Countess Stanhope* (fig. 67), is also characterised by the presentation of the sitter before a simple grey-green background, which has the effect of highlighting the little girl's silhouette and the subtle colours of her costume.[147] Louisa Grenville, who looks considerably older than her actual age of three years, is portrayed in a dress of apricot silk. As girls of this period left off their infant frocks at about this age, this outfit is possibly her first semi-adult dress; her scarlet-heeled flat shoes contrast with its delicacy and lightness. The portrait further underscores Batoni's subtle awareness of the authority of tradition, for it stands in a sequence of depictions of young girls in Italian painting that begins with Titian's *Clarissa Strozzi* (1542; Gemäldegalerie, Staatliche Museen zu Berlin) and includes Van

Dyck's *Maddalena Cattaneo* (1623; National Gallery of Art, Washington).[148]

Batoni brought the 1760s to a triumphant close with a truly magnificent full-length, *Sir Watkin Williams-Wynn, 4th Bt., Thomas Apperley, and Captain Edward Hamilton* (fig. 68).[149] Sir Watkin was the only British patron to order a conversation piece with three figures on a full-length scale. In the portrait he is shown at the left grasping a crayon holder and a drawing after Raphael's *Justice* in the Stanza della Segnatura. Opposite him, in scarlet uniform with white breeches with a flute in his left hand, stands Captain Hamilton, who gestures towards the learned member of the group, Thomas Apperley, seated in the centre at a marble-topped table with a volume of Dante before him. The friends appear to be drawing attention to one another's cultural interests and tastes. The gesture Apperley is making with the fingers of his right hand obviously holds some private meaning, perhaps denoting the group's common love of virtù.[150] In a niche behind the figures, Batoni introduced

Fig. 66. *Lady Mary Fox, later Baroness Holland (1746–1778)*, 1767–68. Oil on canvas, 48 × 36 in. (121.9 × 91.4 cm). Private collection.

the statue of a young woman symbolising Painting, doubt-less an allusion to Sir Watkin's interest in the arts. During his visit to Rome, the Welsh baronet proved himself an active and wide-ranging patron of contemporary artists. His principal commissions included Mengs's ambitious *Perseus and Andromeda* (1778; State Hermitage Museum, Saint Petersburg) and Batoni's lyrical *Bacchus and Ariadne* (1769–73; private collection, Rome).[151]

At the same time that he produced such extravagant compositions as the portrait of Sir Watkin and his compan-ions, Batoni painted pictures of deceptive simplicity, such as the sympathetic half-length of the Hon. John Dawson

Fig. 67. *Louisa Grenville, later Countess Stanhope (1758–1829),* 1761. Oil on canvas, 41 × 26½ in. (104.2 × 67.3 cm). The Administra-tive Trustees of the Chevening Estate, Kent; Gift of the 7th Earl Stanhope KG.

Fig. 68. *Sir Watkin Williams-Wynn, 4th Bt. (1748–1789), Thomas Apperley (1734–1819), and Captain Edward Hamilton,* 1768–72. Oil on canvas, 113¼ × 77⅛ in. (289 × 196 cm). Amgueddfa Cymru—National Museum Wales, Cardiff.

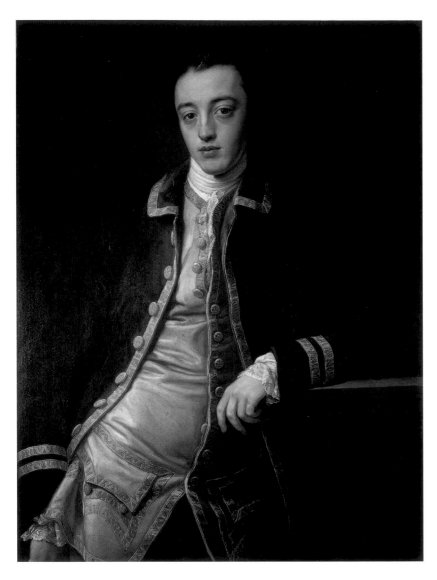

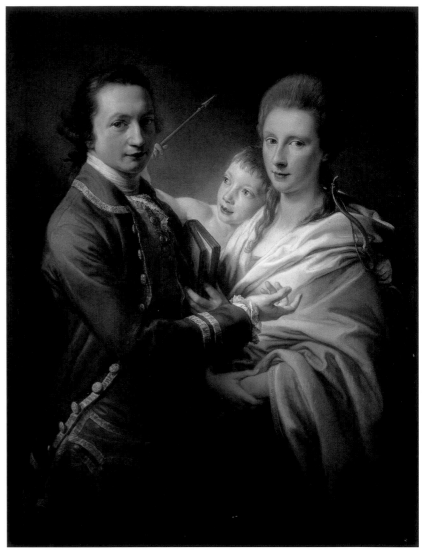

Fig. 69. *The Hon. John Dawson, later 2nd Viscount Carlow and 1st Earl of Portarlington (1744–1798)*, 1769. Oil on canvas, 38 × 28 in. (96.5 × 71.1 cm). Private collection.

Fig. 70. *The Hon. Arthur Saunders Gore, later 2nd Earl of Arran (1734–1809), with His Wife, Catherine (died 1770)*, 1769. Oil on canvas, 43½ × 32½ in. (110.5 × 82.5 cm). The Trustees of the Will of the 6th Earl of Arran.

(fig. 69).[152] Dawson leans on a plinth, his deep green coat with its gold brocade contrasting with the pale yellow of the waistcoat with its even more lavish brocade, while both are set off by the reddish brown of the background. Batoni also painted in 1769 an intriguing portrait group of the Hon. Arthur Saunders Gore with his wife (fig. 70).[153] The figure of Gore, dressed in contemporary costume, seems clearly to have been taken from life, whereas the portrayal of his wife, Catherine, shown with indeterminate features and swathed in classical drapery, suggests that she cannot have sat to Batoni. The possibility that this is a posthumous portrait is apparently ruled out by the date, but the painting could

perhaps be interpreted as an allegory of the love binding a husband and wife separated by distance—there is no evidence that Gore's wife accompanied her husband on the Grand Tour. The presence of Cupid, hovering protectively around Catherine Gore, supports an allegorical meaning; it seems unlikely that he is intended to represent the couple's son. Both portraits are notable for the absence of the more elaborate furnishings that so many of Batoni's sitters demanded and for the assured, refined handling of the paint, thus anticipating a number of portraits of the 1770s.

The lyricism that invests the portraits of the 1770s is seen to advantage in the three-quarter-length *Valentine Rich-*

ard Quin, later 1st Earl of Dunraven (fig. 71).[154] The prominence given to the sitter's fur-edged coat recalls Batoni's early style, but the active rhythms found there are replaced here by a more stately and commanding pose. On the marble-topped table stands an allegorical statue of Music with a flute, sheet music, writing implements, and several books, including Homer's *Odyssey* and a volume of Plutarch's *Lives.* The marble-topped pedestal table with its distinctive base had been employed in the portrait of Lord Thanet twenty years earlier (see fig. 51); here, in the simplified space of the portraits of this decade, the table and its contents approach the quality of an independent still life and are a tour de force of trompe l'œil painting. A comparison with Batoni's exquisitely wrought *Sir Gregory Turner* (see fig. 64) of only five years earlier demonstrates a new assertion of the surface plane and a quieter, less dramatic tone.

One of Batoni's most unusual portraits of this period was the untraced full-length of the beautiful Catherine Graeme Hampden (1749–1804), who sat to the artist together with her husband, Thomas, 2nd Viscount Hampden (1746–1824).[155] In October 1771 Father Thorpe described the portrait: "Pompeo is now painting a whole length of Mrs. Hampden in the character of a Priestess sacrificing to a Hymen: independent of the Lady's fine figure, he has given an admirable grace to the whole: in this talent of a great painter he has not perhaps his equal." Two months later he referred to the painting as a "whole length of Mrs Hampden in the character of a nymph or priestess sacrificing to the Genius of Musick; it is well advanced."[156]

A mood of reverie pervades Batoni's portraits of women in the late 1770s, in particular the delicate and tender portrait of Mrs. James Alexander (fig. 72), née Anne Crawford, the wife of a very wealthy Ulster landowner who had made a fortune in the East India Company.[157] She became pregnant on her Grand Tour in 1777 and died in childbirth in Ireland later that year. The portrait is reminiscent, in the pose and in its semi-allegorical treatment, of *Sarah, Lady Fetherstonhaugh* (see fig. 42); these superficial similarities are, however, belied by the treatment of the face,

where the idealisation of Batoni's earlier style is replaced by a much deeper and more individual characterisation. The underlying seriousness of the portrait, as compared with the Uppark painting, is underscored by the sprig of myrtle Mrs. Alexander holds, identified since the Renaissance with eternal love and, in particular, with conjugal fidelity. The portrait's elegance of form, warmer and lighter palette, and drier brushwork are all characteristic features of Batoni's mature style.

Another paradigm of the delicate colouring, sensitive modelling, and stylish elegance of Batoni's late works is the full-length *Francis Basset, later Baron de Dunstanville* (fig. 73).[158] The identity of the sitter as Francis Basset was discovered during research on the cargo of the frigate *Westmorland,* an English merchant ship that set sail from the port of Livorno at the end of 1778 with a number of antiquities, paintings, sculptures, watercolours, books,

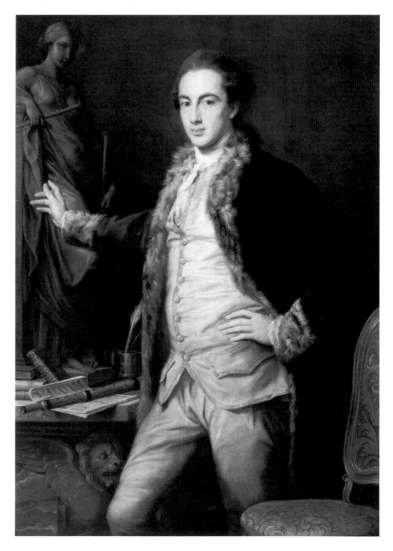

Fig. 71. *Valentine Richard Quin, later 1st Earl of Dunraven (1752–1824),* 1773. Oil on canvas, 53 × 37½ in. (134.6 × 95.2 cm). Private collection.

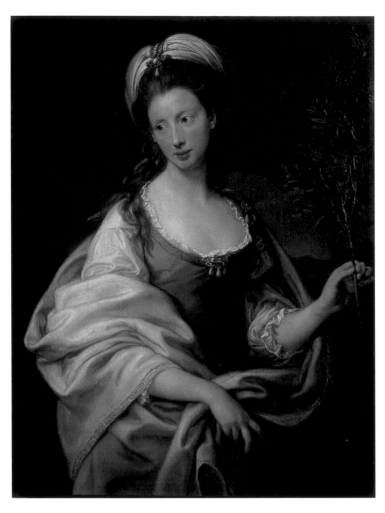

Fig. 72. *Mrs. James Alexander (died 1777)*, 1777. Oil on canvas, 39¼ × 29⅛ in. (99.5 × 74.6 cm). Private collection.

and other valuable objects acquired in Italy and France by prominent members of the British aristocracy on their Grand Tour. The ship was captured en route by the French navy and taken to the port of Málaga, where the goods, Basset's portrait among them, were confiscated and sold. King Charles III of Spain acquired the items of artistic value, which were deposited at the Real Academia de Bellas Artes de San Fernando in Madrid.[159] The portrait of Basset rounds out Batoni's production of full-lengths of British sitters over a quarter of a century; the composition closely repeats works from earlier in the decade, but the quality of the brushwork and the condition of the painting give it the distinction of being the last portrait of this size to have been painted entirely by the artist himself.[160] Basset is shown before a backdrop of the Castel Sant'Angelo and Saint Peter's, leaning against a marble plinth with

an antique *basso rilievo* of a matron and a boy derived from the celebrated *Papirius* group, then in the Ludovisi collection.[161]

Batoni's final years, in Anthony Clark's words, are "most memorable for the last portraits done in an *ultima maniera*, simple, direct, and more daring than ever before."[162] The most affecting of these are several pictures of British women, including *Mrs. Robert Sandilands* (fig. 74), *Princess Cecilia Mahony Giustiniani* (see fig. 119), and an unknown woman in a portrait in the Yale Center for British Art (fig. 75).[163] These portraits represent a wholly new style for Batoni and give the impression of an inherent sympathy and a deeper accord between painter and subject. The modelling of the women's features is extremely soft and expressive of a gentler, more reflective nature, occasioned by the fact that for the most part these sitters were older than Batoni's usual Grand Tour sitters. The details of dress are handled with a verve and fluency unmatched in Batoni's entire career, and in terms of handling these late pictures are at the other end of the spectrum from the controlled precision of the late 1750s. The portrait of Mrs. Sandilands is remarkable for its bold treatment of pose and informal mode of characterisation. She wears a white turban, an exotic headdress that had been fashionable for over a decade, and in portraits of women seems to have originated with Lady Mary Wortley Montagu as a means to signify that a female sitter was a traveller.[164] Over her dress she sports a black silk-and-lace mantle of a kind that was widely fashionable from the middle of the century in Italy and that enabled Batoni to exploit the effect of the black costume and white turban against the warm red of the background with striking results.

The handful of likenesses of British women painted in the last decade of Batoni's life are notable for their easy naturalism of pose, so different from the "swagger" portraits of the *milordi inglesi* standing before classical ruins in conventional stances.[165] The identity of the sitter of the most beguiling of these late portraits is unknown (see fig. 75). Her costume is the most informal; the dress

Fig. 73. *Francis Basset, later Baron de Dunstanville (1757–1835)*, 1778. Oil on canvas, 87 × 61¾ in. (221 × 157 cm). Museo Nacional del Prado, Madrid.

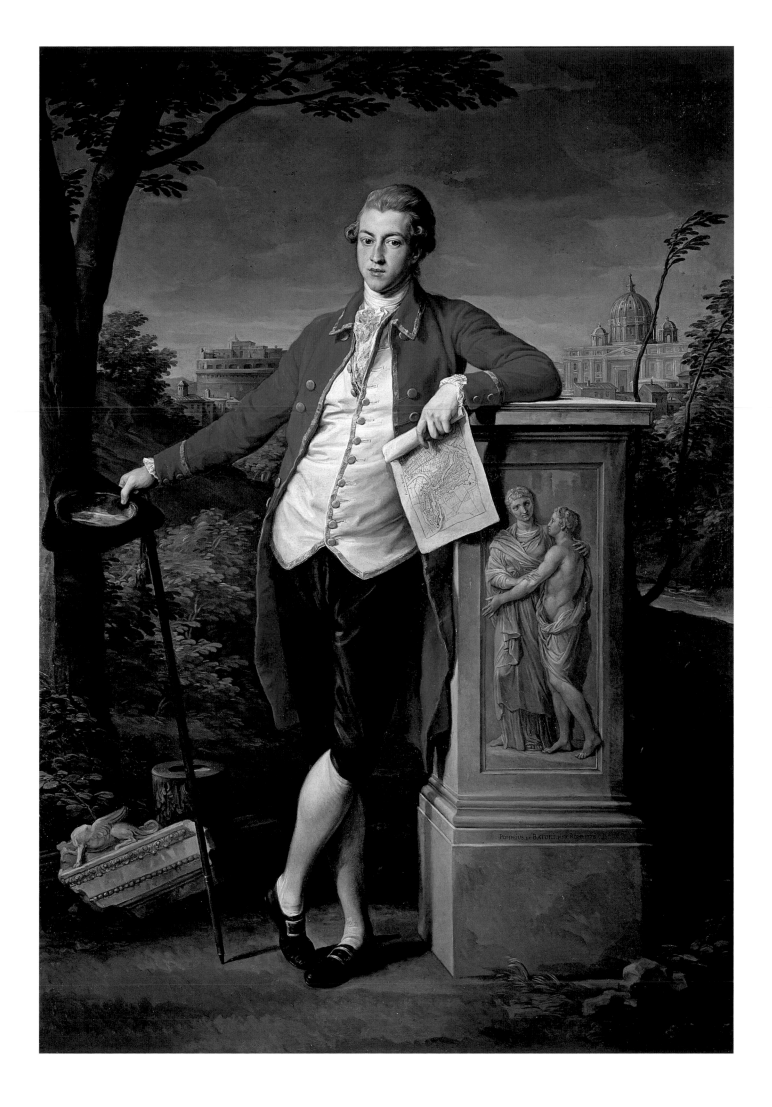

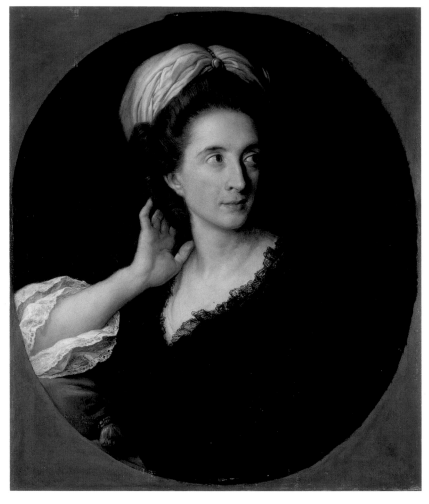 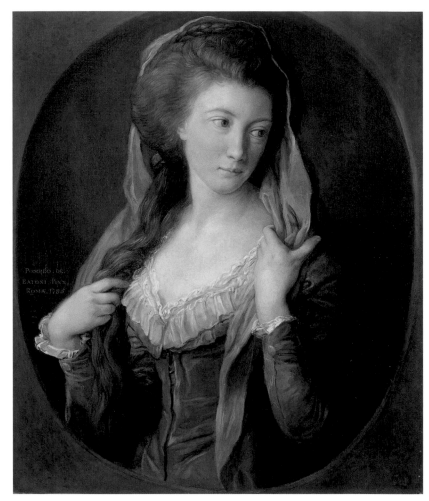

Fig. 74. *Mrs. Robert Sandilands (1737–after 1781)*, 1781. Oil on canvas, 27 × 22½ in. (68.6 × 57.2 cm). English Heritage (The Iveagh Bequest, Kenwood, London).

Fig. 75. *Portrait of a Lady*, 1785. Oil on canvas, 29½ × 25 in. (74.9 × 63.5 cm). Yale Center for British Art, Paul Mellon Collection, New Haven, Connecticut.

in the latest Anglo-French style and the long rope of hair were fashionable from the mid- to late 1780s.[166] The effect is one of a casual déshabillé unusual in Batoni's portraiture. But the lively composition, animated by the rippling effect of the scarf and the sitter's glance out of the oval in which she is enclosed, is equally unusual for the artist. This masterpiece of informal portraiture, which exemplifies the loosened handling and lack of finish in his final paintings, brings to mind the portraits of Thomas Gainsborough (1727–1788). The enormous differences between the two painters' approaches to portraiture notwithstanding, the similarities of composition, colouring, and handling in Batoni's late portraits, particularly of women, with those of his English counterpart in the late 1770s and 1780s are striking.[167]

Batoni's Grand Tour Portraits and the Antique

Batoni deserves the credit for popularising the portrait type of a casually posed sitter in an open-air setting, surrounded by classical statuary and antique fragments, and often set against the backdrop of a ruined classical monument. By the 1750s, Rome had become the site of a major reassessment of antiquity, a radical reappraisal of antique forms and structures, and significant archaeological discoveries. The increasing international interest in Rome's past inevitably led to a growing enthusiasm for portraits depicting sitters in the presence of ancient Roman sculptures and monuments. Batoni played a key role in establishing the fashion for this portrait type, several years before Anton Raphael Mengs, Nathaniel Dance, and other painters in Rome incorporated it into their own repertory.

That only about fifty of Batoni's portraits of British sitters, roughly one-quarter of the total, actually contain antique references further underscores his measured use of ancient sculptures, monuments, ruins, and maps to situate his subjects unmistakably in Rome. Unfortunately, there is no extant documentary record of a sitter instructing Batoni in how he was to be portrayed, nor any showing whether the archaeological insertions in a Grand Tour portrait held an explicitly personal meaning for the sitter. No doubt Batoni would have discussed in detail with each client the proposed presentation and resolved in advance such matters as pose, costume, and accessories. That certain demands and concessions were made by both parties in the selection of the latter is inevitable, but for the most part the antiquities Batoni depicted as portrait accessories were well established in the guidebooks his clients brought with them, along with maps, phrase books, lists of recommended inns, and money conversion tables. Early in the century guidebooks like the Richardsons' *Account of Some of the Statues, Bas-reliefs, Drawings, and Pictures in Italy* (1722) were already directing tourists to the antique sculptures in Rome that were to appear later in Batoni's portraits. These range from the celebrated—such as the seated statue restored as Roma placed above a relief of a female figure interpreted as a personification of the Roman province of Dacia (the so-called *Weeping Dacia*) in the courtyard of the Palazzo dei Conservatori ("*Roma Triumphans* sitting, not the best manner; Colossal: 'tis upon a Pedestal that has a Woman weeping: Incomparable")—to the relatively obscure, like the ancient porphyry statue of Minerva later restored as Roma (see fig. 106) on the Campidoglio ("In a Nich in the middle of this Stair-Case is a *Roma Triumphans*").[168] The continued repetition of a relatively small number of antique sculptures and monuments in the guidebooks and travel diaries in the first half of the eighteenth century meant that after 1750 the majority of Batoni's sitters responded more or less conventionally to the sights of Rome and were favourably inclined towards a canonical group of antiquities in whose company they would be shown. The travel diary of Peter Beckford, who sat to Batoni for a full-length portrait in 1766 (Statens Museum for Kunst, Copenhagen), documents his admiration for the Colosseum ("without exception, the most wonderful ruin in antiquity"), the Temple of the Sibyl at Tivoli ("one of the most elegant remains of ancient

architecture"), the Albani *Antinous* ("thought to be the very best representation of that favourite of Adrian"), and the group of "Papirius and his Mother" in the Villa Ludovisi ("an admirable piece of ancient Sculpture").[169]

If Batoni was thus more or less constrained to depict his portrait sitters in the company of a restricted group of the most famous statues and monuments of ancient Rome, he nonetheless made his selections more often than not from the sculptures previously in Cardinal Albani's collections (many of which were then in the Museo Capitolino), with which he was intimately familiar. This may in part be explained as an expression of deference towards the patron who had advanced his career and brought numerous British Grand Tourists to his studio; a more practical consideration is that when Batoni accelerated his production of portraits in the 1750s and 1760s, he could rely on the meticulous records of the Albani antiquities he had produced three decades earlier.[170]

There are a handful of ancient buildings and marble sculptures that Batoni employed again and again as portrait accessories, notably the Colosseum, the Temple of the Sibyl at Tivoli, and a bust derived from the *Minerva Giustiniani.* The vast half-ruined structure of the Colosseum possessed in the eighteenth century—as it does today—a powerful fascination for visitors to Rome, and it is understandable that the picturesque ruin appears in nearly a dozen portraits (see figs. 38, 61, 65). An equally familiar portrait accessory was a bust derived from the *Minerva Giustiniani,* a Roman adaptation of a bronze original of the fourth century B.C., today in the Musei Vaticani.[171] Batoni first employed the statue in a subject painting, the *Triumph of Venice* (see fig. 3), but it was as a tabletop bust that the Minerva appears in more than a dozen of his portraits of British visitors to Rome during the next three decades, undoubtedly reflecting the contemporary enthusiasm with which the work was regarded.[172] Johann Wolfgang von Goethe (1749–1832), for instance, was told by the custodian of the Giustiniani collection that the English worshipped the statue and kissed one of its hands so frequently that it was whiter than the rest of the marble.[173] The so-called Temple of the Sibyl was another of Batoni's favourite motifs, which he first employed in the portrait of *Sir Wyndham Knatchbull-Wyndham* (see fig. 57). The depiction of the temple is quite accurate, both by comparison with other

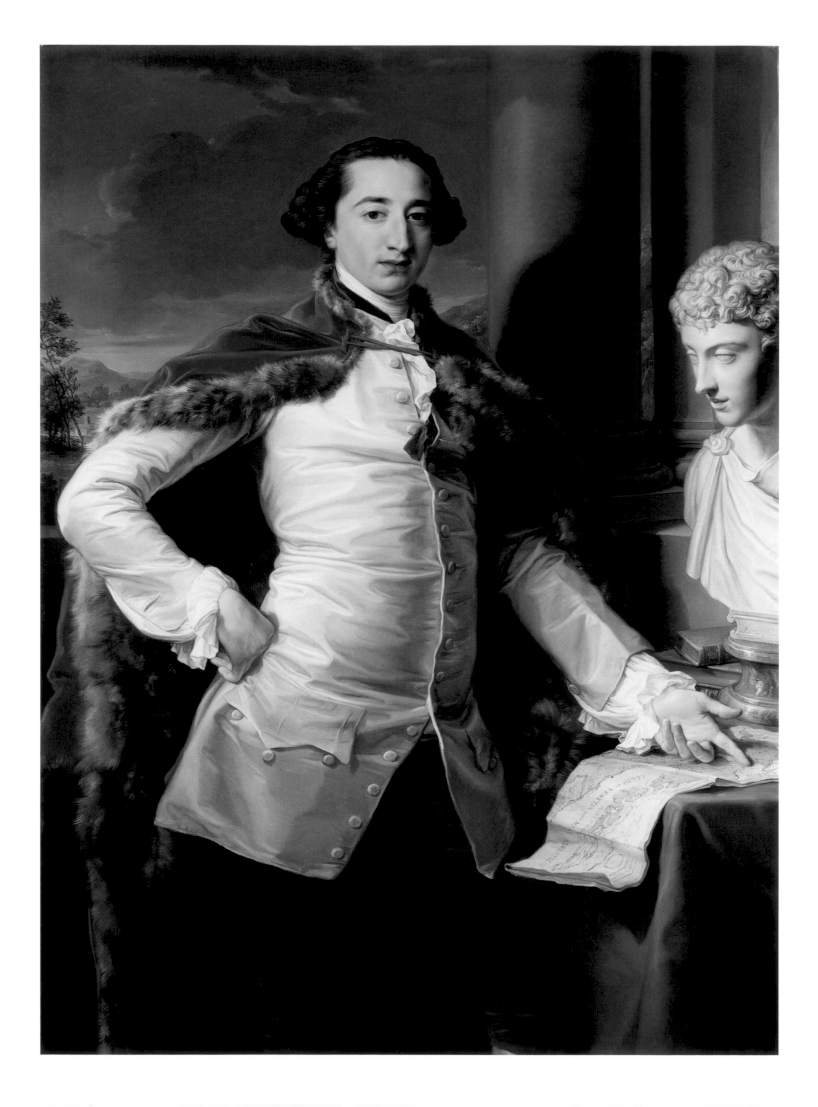

eighteenth-century representations and with the ruin as it still exists. Tivoli was to contemporary Britons a powerful image, both because of its classical associations and because it was familiar to them from the works of the wildly popular seventeenth-century landscape painters Claude Lorrain (1604/5–1682) and Gaspard Dughet (1615–1675). Batoni incorporated the ruin into nearly a dozen portrait compositions of Grand Tourists in the 1760s and 1770s.[174]

Nonetheless, in spite of the sizeable anthology of motifs alluding to ancient Rome and Roman civilisation that Batoni employed in his portraits, he did not simply keep a large supply of casts of antique statuary to be employed indiscriminately as portrait props and accessories. (The exceptions are a couple of antique architectural fragments, a broken portion of a frieze surmounted by a griffin, and a Corinthian capital, which were probably lying about the painter's studio; see figs. 61, 79.) This is confirmed by the several instances in which individual antiquities make but a single appearance in Batoni's portraits and indicates that his invocation of Rome's classical heritage was extremely thoughtful and deliberate. Only Richard Milles (fig. 76), for example, is shown with the bust of the young Marcus Aurelius in the Museo Capitolino, which had earlier attracted the attention of English visitors to the collection of Cardinal Albani.[175] A bust of the *Apollo Belvedere* embellishes a single Batoni portrait, *Edward Dering* (see fig. 54), despite the fact that such busts were ubiquitous in Roman sculpture collections by the early eighteenth century. Edward Wright, having seen several in the Giustiniani collection in the 1720s, wrote: "The countenance of these Apollo's, and many elsewhere, have more of female Delicacy than what is common even to young Men. The hair of these is rais'd like that of Women. The *Apollo* in the Belvedere is very much so."[176]

Other unique antique references in Batoni's British portraits include a bronze statuette of the *Venus de' Medici* (*Portrait of a Gentleman*, 1758–59; private collection); a terracotta statuette of the *Farnese Hercules* (*Charles John Crowle*,

1761–62; Musée du Louvre, Paris); and a marble krater recorded and illustrated in Bernard de Montfaucon's 1722 pictorial encyclopaedia of classical antiquities, *Antiquity Explained, and Represented in Sculpture* (fig. 77).[177] A Roman sacrificial altar of the first century A.D. (see fig. 62); a celebrated marble statue of *Agrippina* in the Museo Capitolino much admired by English visitors to Rome like Dr. Charles Burney (1726–1814), who noted that "it possessed such drapery and expression as I never saw in sculpture" (*John, Lord Mountstuart, later 4th Earl and 1st Marquess of Bute*, 1767; private collection); and a marble urn adorned with rilievo figures of Mercury and the infant Bacchus, the so-called Vase of Gaeta, which in the eighteenth century, after having been mutilated for the sake of "decency," was employed as a baptismal font in the local cathedral and noted by numerous

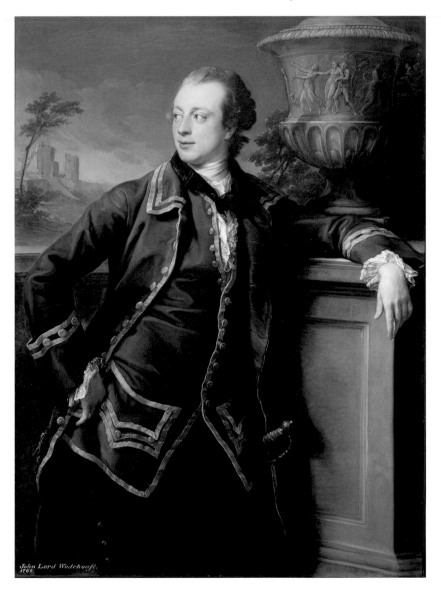

OPPOSITE: Fig. 76. *Richard Milles (c. 1735–1820)*, c. 1758. Oil on canvas, 53 × 38 in. (134.6 × 96.5 cm). The National Gallery, London.

RIGHT: Fig. 77. *John Wodehouse, later 1st Baron Wodehouse (1741–1834)*, 1763–64. Oil on canvas, 53¼ × 39 in. (136.5 × 99.1 cm). Allen Memorial Art Museum, Oberlin College, Ohio; Mrs. F. F. Prentiss Fund, 1970.

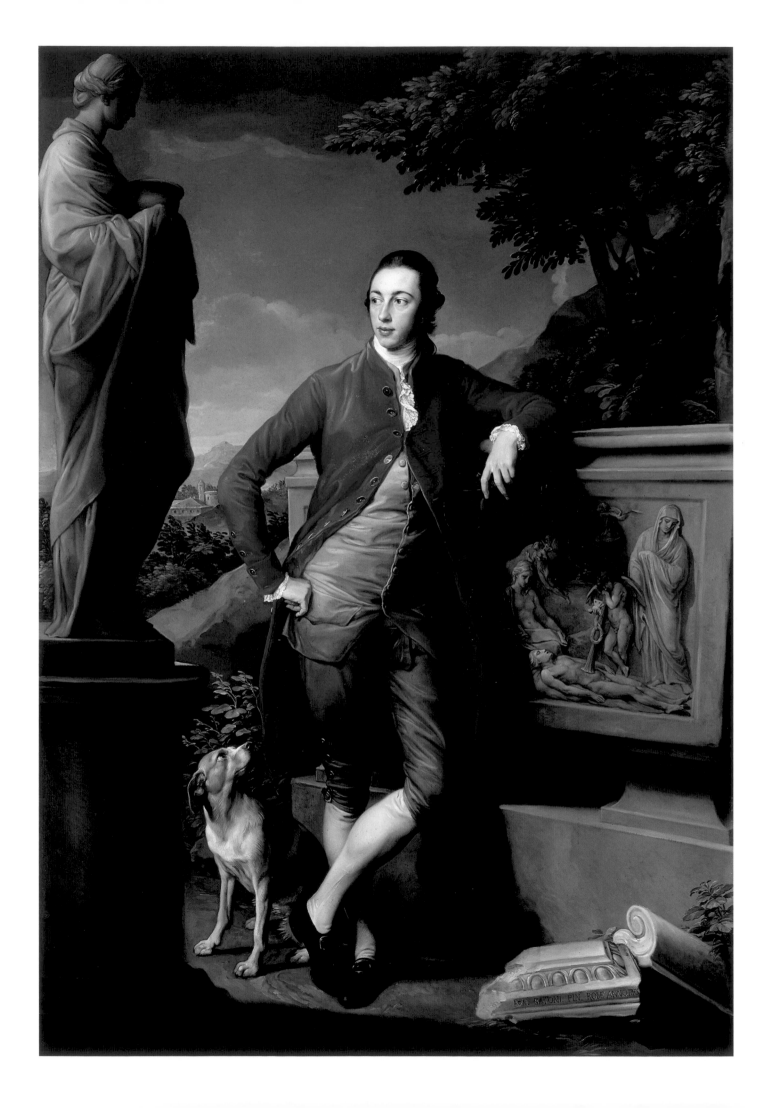

travellers in the south of Italy such as Edward Wright (*William Cavendish, 5th Duke of Devonshire,* 1768; Chatsworth), also appear but once each.[178] And a head of Menelaos from the so-called Pasquino group behind the Palazzo Braschi (*Portrait of a Gentleman,* 1774; private collection); a detail of a sarcophagus relief in the Museo Capitolino depicting the death of Prometheus (fig. 78); a bust of the Roman empress Faustina the Younger, discovered in Hadrian's Villa at Tivoli and donated in 1748 by Benedict XIV to the Museo Capitolino, where it was restored a year later by Bartolomeo Cavaceppi and widely copied by him and others for the trade (*George Legge, Viscount Lewisham,* 1778; Museo del Prado, Madrid); and a bas-relief of the *Papirius* group in the Ludovisi collection (see fig. 73) also adorn Batoni's portraits of British sitters in but a single instance.[179]

Other celebrated sculptures in Rome were employed by Batoni in only a few portraits each, indicating both the wide range of antiquities available and the care with which he selected from among them. These include the bust of Homer (see fig. 36); the bas-relief of the *Weeping Dacia* in the courtyard of the Palazzo dei Conservatori (*Peter Beckford,* 1766; Statens Museum for Kunst, Copenhagen); the so-called Medici Vase (*Henry Peirse,* 1775; Galleria Nazionale d'Arte Antica, Rome); and the priestess carrying a vessel in the Museo Capitolino (see fig. 78).[180] The *Ludovisi Mars* appeared in five full-lengths between 1768 and 1782, exactly when the popularity of the statue was at its height following Winckelmann's praise of the figure's repose.[181]

Batoni was even discreet in his use of the ancient marbles most highly esteemed in the eighteenth century, the canonical statues on display in the Cortile del Belvedere in the Vatican that so hypnotised the great princes and sovereigns of Europe and which made a visit to Italy such an important part of the education of the cultivated British gentleman: the *Apollo Belvedere, Belvedere Antinous, Laocoon,* and *Vatican Ariadne.*[182] The fame of these antique sculptures among contemporary writers, artists, and connoisseurs was

immense. The *Vatican Ariadne* is a case in point. The statue was acquired by Pope Julius II early in the sixteenth century and installed as a fountain on an antique marble sarcophagus in the Belvedere courtyard. Later the "Cleopatra" (as the sculpture was known until the late eighteenth century) was taken to a room adjoining the courtyard and again set up as a fountain in a niche, where it remained until the creation of the Museo Pio-Clementino.[183] Batoni capitalised upon the current enthusiasm for the sculpture and employed it variously in several portraits, notably in that of *Thomas William Coke, later 1st Earl of Leicester* (fig. 79), in which the statue's features were associated at the time with those of Louise von Stolberg, Countess of Albany and wife of the Young Pretender, with whom Lord Coke was said to have had an affair. Yet in spite of the reputation of the Cortile Belvedere marbles in the middle of the eighteenth century, Batoni employed them as a group only twice, once in the

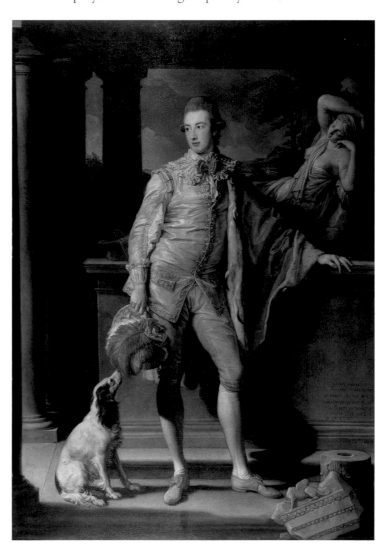

OPPOSITE: Fig. 78. *George Gordon, Lord Haddo (died 1791),* 1775. Oil on canvas, 102 × 67 in. (259.2 × 170.3 cm). The National Trust for Scotland, Haddo House, Aberdeenshire.

RIGHT: Fig. 79. *Thomas William Coke, later 1st Earl of Leicester (1754–1852),* 1773–74. Oil on canvas, 96¼ × 67 in. (245.8 × 170.3 cm). The Earl of Leicester and the Trustees of the Holkham Estate, Norfolk.

Fig. 80. *Thomas Dundas, later 1st Baron Dundas (1741–1820),* 1763–64. Oil on canvas, 117½ × 77½ in. (298 × 196.8 cm). The Marquess of Zetland, Aske Hall, North Yorkshire.

fictitious arrangement before which Thomas Dundas stands in a pose that carries the cross-legged stance of English portraiture to extremes (fig. 80).[184] The group appears two years later in an even grander full-length portrait, *Count Kirill Grigoriewitsch Razumovsky* (see fig. 96).[185] Their rarity in Batoni's work may be explained by the fact that it is certain, if not proven, that he would have charged accordingly for the extra work entailed in painting additional figures, and

few of Batoni's clients could have afforded them apart from Dundas and Razumovsky, who were among his wealthiest sitters. Even the famous *Antinous* bas-relief belonging to Cardinal Albani, excavated in 1735 at Hadrian's Villa and first recorded in an engraving after a drawing by Batoni published the following year, appears in his entire portrait œuvre but once (fig. 81).[186]

Batoni occasionally linked his sitters with Rome's ancient past through less obvious means than ruins and marble sculptures. Guidebooks, casually piled on a table beside a sitter (see fig. 81), sometimes served this purpose.[187] Ancient gems and cameos, a popular item for collectors on the Grand Tour, were also employed as references to a sitter's visit to Rome, notably that of Edward Dering (see fig. 54), a gem enthusiast whose collection was noted by Winckelmann and who is shown holding a cameo that he owned with half-length figures of Bacchus and Ariadne.[188] For *David Garrick* (see fig. 45), Batoni chose an intimate half-length format showing the actor in a stylish purplish-brown Italian velvet suit elegantly leafing through an illustrated edition of Terence's *Comedies* (1736), opened at a page showing the masks for the *Andria* copied from a well-known manuscript in the Biblioteca Vaticana. The inclusion of the volume was undoubtedly at the behest of Garrick and was intended to convey his roles as an actor and a playwright as well as an antiquarian and a connoisseur.[189] In the 1770s, Batoni portrayed several of his sitters with an engraving of an elevation of the Pantheon, with its seventeenth-century bell towers.[190]

At one remove from Batoni's use of identifiable antique sculptures—which he frequently rendered with such precision that the specific version among several prototypes can often be identified today; for example, the busts of Homer and the young Marcus Aurelius in *Robert Clements, later 1st Earl of Leitrim* (see fig. 36) and *Richard Milles* (see fig. 76), respectively—is his imaginative adaptation of classical elements in the decoration of furniture and other accessories in his portraits. The marble-topped table with its distinctive base seen in *Lord Thanet, Holy Roman Emperor Joseph II and Grand Duke Leopold of Tuscany,* and *Valentine Richard Quin*

Fig. 81. *Portrait of a Gentleman,* early 1760s. Oil on canvas, 97⅛ × 69¼ in. (246.8 × 176 cm). The Metropolitan Museum of Art, New York; Rogers Fund, 1903.

(see figs. 51, 91, 71), which appears to have been derived from a sarcophagus fragment with lion masks displayed on a staircase in the Museo Capitolino, is one example; the table with sphinx motifs beside which Elector Karl Theodor (see fig. 104) stands is another.[191]

There were of course numerous visitors to Batoni's studio who presumably had no interest in the beauties of ancient art, much less in the paraphernalia of their portraits. The French man of letters Charles de Brosses (1709–1777) arrived in Rome in 1739 to find it seething with the English, and observed, "The money the English spend in Rome and their custom of making a journey there as part of their education is of scant benefit to the majority of them," adding that there were some "who will leave the city without having seen anyone but other Englishmen and without knowing where the Colosseum is."[192] It seems he anticipated the visit in 1764 of Alexander Gordon, 4th Duke of Gordon (fig. 82), who sat expressionless in his carriage while no less a cicerone than Johann Joachim Winckelmann attempted to arouse his interest in ancient Rome.[193] But back home, admiring the striking and unusual portrait in which he is shown beside his handsome bay horse, surrounded by a profusion of dead game such as might be found in the Scottish highlands, His Grace might well have been surprised to learn that even in this rustic setting he could not escape the reach of Rome's classical past; his pose is strongly reminiscent of a life-size third-century statue of a hunter with his prey, a hare, found near Porta Latina in 1747.[194]

Fig. 82. *Alexander Gordon, 4th Duke of Gordon (1743–1827)*, 1763–64. Oil on canvas, 115 × 75½ in. (292 × 192 cm). National Gallery of Scotland, Edinburgh.

PAINTER OF PRINCES AND PRINCE OF PAINTERS

Such masters as Pompeo may be commanded by Princes . . . : they cannot be directed by common men.

—Father John Thorpe to Lord Arundell, 11 May 1776

Pompeo Batoni stands virtually alone among eighteenth-century painters in being patronised by most of Europe's major princely courts, including the imperial courts at Vienna and Saint Petersburg, the papal court at Rome, the royal courts at London, Berlin, Warsaw, and Naples, the Elector Palatine's court at Mannheim, the ducal courts at Stuttgart and Braunschweig, and the margravate of Bayreuth. The initial contacts were often triggered by visits to Rome of members of these courts, but once the links were forged, Batoni typically enjoyed a period of sustained patronage that sometimes lasted decades, as his courtly patrons returned to him for additional commissions of portraits or subject pictures.

The closely knit network of family relationships and alliances that characterised the European courts of the eighteenth century clearly worked in Batoni's favour. For example, within three years of Duke Carl Eugen of Württemberg and his wife, Elisabeth Friederike Sophie, becoming the first sovereigns to sit to Batoni, the duchess's mother and uncle, Margravine Wilhelmine of Bayreuth and King Frederick II of Prussia, each commissioned important his-

Detail, fig. 97

tory pictures from the artist. Later, Frederick's nephew Karl Wilhelm Ferdinand, heir to the Duchy of Braunschweig and Lüneburg, sat to Batoni when he visited Rome, as did Carl Eugen's niece, a Württemberg princess who married Grand Duke Paul of Russia.

A measure of Batoni's celebrity and distinction in Settecento Rome is provided by accounts of the *accademie musicali* held frequently at his residence for the Roman aristocracy, high-ranking prelates, and notable foreign guests. Visits to artists' studios were a noted feature of Roman social life, and Batoni's studio was described as "crowded every day, like a theatre, by persons of all ranks" coming to see his paintings, but these private musical evenings were an attraction in their own right.[1] The English composer and music historian Charles Burney described his attendance at one of them in 1770: "We went together to the celebrated painter, il Cavalier Battoni, who is always visited by strangers; the Emperor, Prince of Brunswick, Great Duke of Tuscany, arch-duke of Austria, Duke of York, etc have all been with him, and sat to him over and over. He has a large house, and lives in a very great style. He received me politely, and was so obliging as to converse with me on the fine arts, a considerable time."[2]

Such royal and princely commissions not only were landmarks in Batoni's career, they contributed greatly to his renown as one of Europe's pre-eminent painters by conferring enormous prestige on him. Many other patrons, whether they were members of the courtly milieu or travellers of newly minted wealth, sought to raise their social profiles by emulating Batoni's most prominent clients in commissioning pictures from him. The status of his patrons was also extremely important to the artist himself. His pupil Puhlmann reported that he had never seen Batoni so happy as on the day of a visit to the Vatican, where Pope Pius VI conversed with him for seventy-five minutes and "heaped praise and honours" on him.[3]

The Courts at Stuttgart, Bayreuth, and Berlin

At the beginning of a series of notable commissions from European rulers stands the portrait of *Carl Eugen, Duke of Württemberg* (fig. 83).[4] The duke travelled to Rome with his wife, Elisabeth Friederike Sophie (1732–1780), the daughter of Margravine Wilhelmine of Bayreuth (1709–1758) and niece of Frederick II of Prussia (1712–1786). The marriage, which had yet to produce an heir, had been foundering, owing primarily to Carl Eugen's roving eye. His advisors had suggested the trip to Italy, far from the demands and temptations of court life in Stuttgart, as a way to patch up the differences with his wife. The couple arrived in Rome in late March 1753 and stayed until early May, with a side trip to Naples. The Eternal City appears to have worked its magic, temporarily reviving the affection between Carl Eugen and Elisabeth Friederike Sophie: using a diamond, they carved their names into the buttocks of an antique marble statue of Venus at Villa d'Este, greatly amusing Pope Benedict XIV.[5]

The duke and duchess each sat to Batoni for a full-length and a half-length portrait. While the full-lengths adhered to the conventions of official state portraiture, the sitters requested an allegorical programme for the smaller portraits. As Carl Eugen's taste closely reflected the latest trends in Paris, this choice was quite possibly inspired by the *portrait historié* type popularised there by Jean-Marc Nattier, whose sitters in allegorical and mythological roles were primarily but not exclusively women.[6] The specific iconography was apparently selected by Batoni: the duke as

a personification of War (1753–55; private collection), with a drawn sword; the duchess as a personification of Peace, holding an olive twig.[7] This idea anticipated the *Peace and War* (see fig. 122) Batoni painted two decades later.[8] The portrait of Carl Eugen, wearing a breastplate and holding an unsheathed sword, seems intended to recall Titian's lost *Charles V with Drawn Sword*, which Batoni could have known by means of woodcuts and engravings, including one after a copy by Rubens (1577–1640).[9]

The commission, which included a further half-length of the duke, was paid for in full before the Württemberg party departed in May 1753, with Batoni receiving a total of 800 scudi for the five portraits.[10] The painter subsequently accepted an additional order for a pair of copies of the half-lengths, priced at 30 zecchini each, and for a miniature, costing 50 scudi, for use on a snuffbox.[11] In charge of handling all the Württemberg commissions was Alessandro Miloni (c. 1683–1770), Carl Eugen's Roman agent. The two full-length portraits were the first to be finished, winning Batoni great acclaim when he exhibited them in his studio in September 1754, and they were shipped to Stuttgart before the end of that year.[12]

The likeness of the duke recalls a full-length painted by Antoine Pesne (1683–1757) to mark Carl Eugen's succession to the Duchy of Württemberg by special dispensation at the minority age of sixteen (1744; Schloß Ludwigsburg). The duke stands in a columned foyer, dressed in a long Prussian-blue coat over a richly embroidered waistcoat, and wears the orange sash and jewel of the Prussian Order of the Black Eagle as well as, visible under the sash, the jewel of the Order of the Golden Fleece, each marked by an exacting rendition of detail and texture. Prominently displayed are the insignia of power, the ducal hat (a purple cap with an ermine brim) and sceptre, resting on a velvet cushion placed on a stool beneath a bust of the *Minerva Giustiniani*. In this instance, the presence of the bust is less a souvenir of a Grand Tour than an attribute of the ruler's wisdom and military strength. The wisdom did not extend to his marital life, and in 1756 the duchess left her philandering husband, which may explain why both of her portraits, untraced today, were considered surplus to requirements at the Stuttgart and Ludwigsburg residences, where a succession of mistresses moved into the ducal apartments.

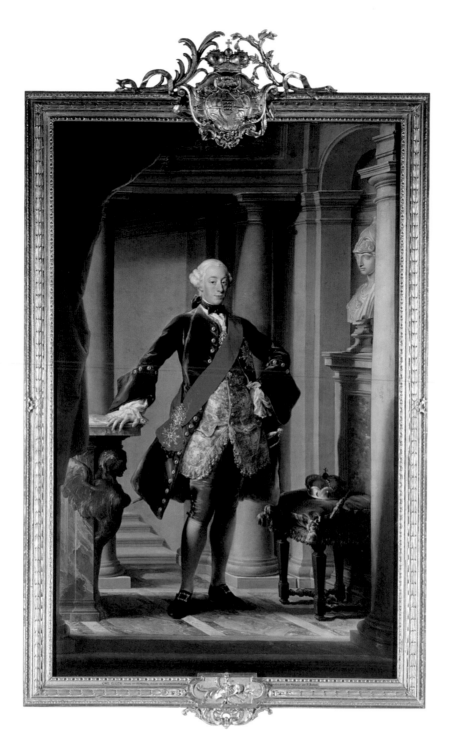

Fig. 83. *Carl Eugen, Duke of Württemberg (1728–1793)*, 1753–54. Oil on canvas, 107⅛ × 67¼ in. (273.5 × 172 cm). Württembergische Landesbibliothek, Stuttgart.

Following the official separation of the ducal couple, Elisabeth Friederike Sophie returned to her parents' court at Bayreuth. Her mother, Wilhelmine, had in the meantime undertaken her own trip to Italy, visiting Rome in May and June 1755. By that time, Batoni had finished the allegorical half-lengths of the duke and duchess as War and Peace, and when Wilhelmine desired to see the portraits of her daughter and son-in-law, Miloni put the painter and the two pictures in his coach and took them to the margravine's Roman residence.[13] She wholly approved of what she saw, writing to her brother Frederick II that, like Mengs, "Batoni, too, is a great painter and not at all expensive; he is by far superior to Pesne"—Frederick's court painter in Berlin, to whom she had repeatedly sat herself.[14] But rather than asking Batoni to paint their portraits, Wilhelmine and her husband decided to commission a history picture from

him. *Cleopatra Before Augustus* (fig. 84) and its companion, *Semiramis Called to Arms,* by Anton Raphael Mengs (1755; Neues Schloß, Bayreuth), were later installed as overdoors in the margrave's new apartment in Bayreuth, still under construction at the time of the visit to Rome.[15]

Even if Wilhelmine observed the proprieties in speaking of "the Margrave's picture,"[16] it is clear that the topics for these pendants were devised by her, not by her husband, who tended to give her carte blanche in her artistic endeavours; moreover, as a Prussian princess of royal blood, she considerably outranked him. While *Semiramis Called to Arms* is a reference to Wilhelmine's understanding of herself as a selfless ruler serving her state, it has been suggested that she intended *Cleopatra Before Augustus* as an exhortation to her husband, prompted by the political situation of 1755. In the wars over the possession of Silesia between his brother-in-law the King of Prussia and Empress Maria Theresa, the margrave had hitherto adhered to a policy of strict neutrality. When the picture was commissioned, the simmering conflict between Prussia and Austria was about to erupt again, culminating in the outbreak of the Seven Years' War in 1756. In Batoni's painting, Cleopatra (Wilhelmine) indicates to Augustus (the margrave) a bust of Caesar (Frederick II). Wilhelmine was thus shown urging her husband, who had concluded a treaty of mutual assistance with Frederick II in 1752, to abandon his neutral position and commit his political and military resources to the Prussian side.[17]

Wilhelmine's inspiration for the choice of subject may have been a sonnet she read while in Rome, which—as she reported in a letter to her brother—also drew a parallel between Frederick and Caesar.[18] Predictably, it took Batoni considerable time to complete the work, keenly awaited by the margravine. In April 1756, she wrote to her agent in Rome, Carl Heinrich von Gleichen (1733–1807), asking him to entreat Batoni to finish the picture and to have it sent immediately. She was also in touch with the Stuttgart court about the half-length portraits of Carl Eugen and her daughter, which had remained in Rome since she had seen them the previous year.[19] By August, Gleichen was able to confirm that the picture for Bayreuth had been despatched to Germany.[20] Carl Eugen, however, appeared to have forgotten about the five half-lengths, three of them already paid for but waiting unclaimed in Batoni's studio.

It was only after being reminded by Wilhelmine and his agent Miloni that he ordered them to be sent to Stuttgart and transferred the money for the last pair.[21] At the end of the year, Miloni reported that everything was ready to be shipped.[22]

Batoni had Wilhelmine of Bayreuth to thank for far more than the one painting she commissioned herself: it was she who convinced her brother Frederick II to become a Batoni patron. In the spring of 1755, Frederick was aggressively acquiring paintings for his new gallery at Sanssouci, and he placed one of the most significant artistic commissions of his entire reign, a cycle of enormous history paintings for the marble hall of the projected Neues Palais at Potsdam, with four French painters, Carle Vanloo (1705–1765), Jean-Baptiste-Marie Pierre (1714–1789), Jean Restout (1692–1768), and Pesne. But for contemporary Italian art, he had nothing but scathing contempt, and in a letter that must have reached Wilhelmine soon after her arrival in Rome, he opined that "you will find Italy like an old coquette who believes herself to be still as beautiful as she was in her youth. . . . You may find masterpieces of the arts that once flourished under Augustus and Leo X, but in the present, there are male sopranos, poor composers, miserable painters, sculptors even worse than the latter . . . ; in a word, the Italy of the present century is no longer comparable to that of Caesar or Augustus, and if one compares it to the Italy of Leo X, it is like a bad chalk drawing of a beautiful painting by Guido [Reni]."[23]

Undeterred, his elder sister, who had always known her own mind, immersed herself in Rome's artistic riches from antiquity to the present: "I have seen pictures by modern painters of the past one hundred years, amongst which there are some very beautiful ones, by Carlo Dolci, [Sebastiano] Conca, and Carlo Maratti, among others."[24] She also viewed paintings by Mengs and Batoni, met the latter artist, and commissioned works from both of them. Immediately after her return home, she summarised the results of her trip in a letter to Frederick, once again warmly recommending her new favourites: "The two painters Mengs and Batoni are held in the highest esteem; they charge 100 zecchini for one figure; the first is akin to Raphael and Guido, the second to Carlo Maratti, but his colouring is more beautiful."[25] Being one of the few people in the king's inner circle from whom he was prepared to take advice, Wilhelmine was

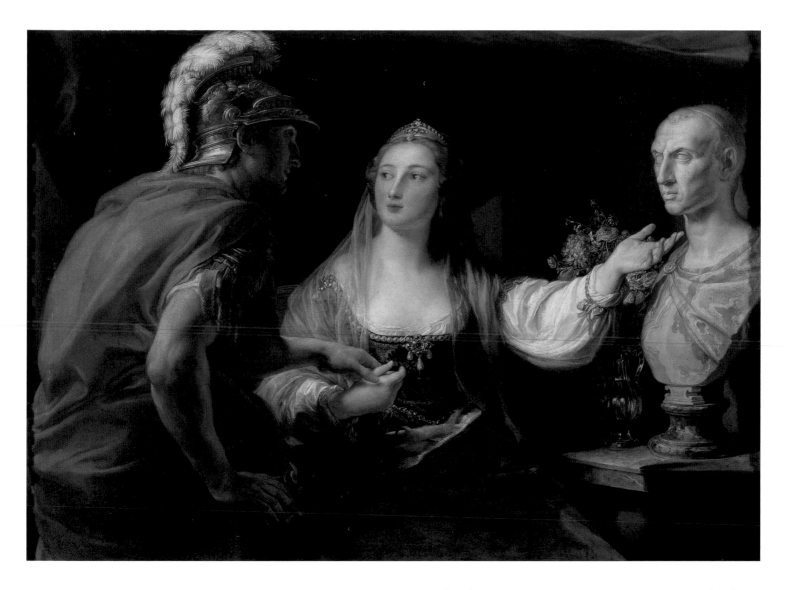

Fig. 84. *Cleopatra Before Augustus*, 1755–56. Oil on canvas, 37⅛ × 47¼ in. (95 × 120 cm). Musée des Beaux-Arts, Dijon.

proud of her influential role in shaping her brother's taste, as she affirmed to their younger brother August Wilhelm, heir to the Prussian throne: "I have indicated to [Frederick] two painters in Rome, [one is called Mengs,] the other is Batoni, who is greatly superior to Carlo Maratti but paints in his style."[26]

The King of Prussia, not otherwise known for easily changing his mind, heeded his sister's recommendation, overcame his disdain of contemporary Italian painters, and selected Batoni as the first living painter of any nationality for a commission for the picture gallery at Sanssouci. As a predominantly Protestant state, Prussia did not have an ambassador in Rome, and since Frederick evidently did not

consider the Prussian agent Giovanni Antonio Coltrolini (1685–1763) to be the right man for handling artistic commissions, he chose a different channel. One of the king's most trusted friends was Field Marshal James Keith (1696–1758), a Scotsman serving in the Prussian army, who maintained links with James Edgar (1688–1764), private secretary to James Francis Edward Stuart (1688–1766), the claimant to the British throne living in exile in Rome.[27]

In reply to a lost letter from Keith reporting that the commission had been placed with Batoni, Frederick wrote in March 1756: "I thank you a thousand times for the trouble you have gone to in ordering a picture from Pompeo for me. I would be very tempted to also have two by Mengs, and one by Costanzi . . . , that by Costanzi could make the pendant to the one Batoni is doing; one would have to agree upon the prices, but it is unheard of to make a down

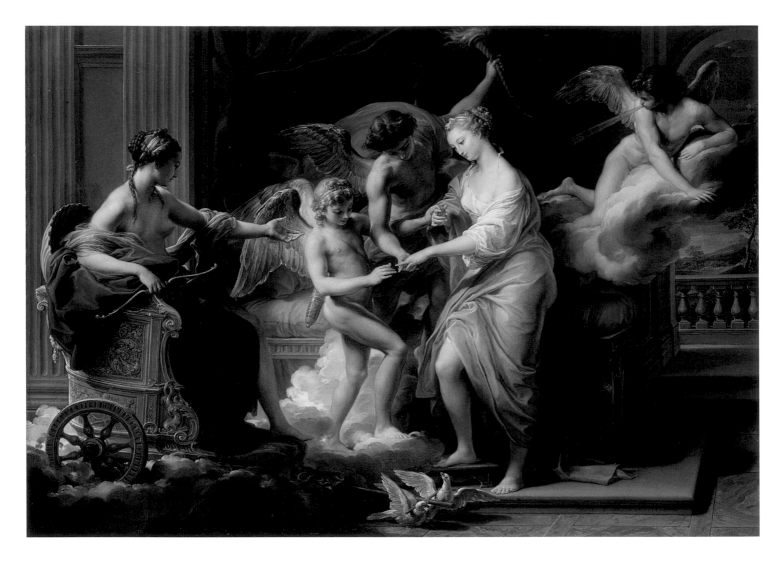

Fig. 85. *The Marriage of Cupid and Psyche,* 1756. Oil on canvas, 33½ × 46⅞ in. (85 × 119 cm). Staatliche Museen zu Berlin, Gemäldegalerie.

payment on a painting: one advances money to silversmiths when ordering a silver vessel but never to painters; I am leaving you in charge of settling the prices and the agreements as you see fit."[28] Mengs, who had grown up in Dresden, returned his commissions in patriotic protest when Prussia invaded Saxony later that year, whereas Placido Costanzi (1702–1759) completed his *Apollo and Daphne* (1757; Neues Palais, Potsdam), but it was found to be unsatisfactory and transferred to the Neues Palais.[29]

Keith corresponded with Edgar and apparently also directly with some of the artists in Rome. In June, he forwarded their replies to the king, who confirmed the commissions and was now also prepared to make down payments.[30] Batoni finished his painting, the *Marriage of*

Cupid and Psyche (fig. 85), in late 1756, and Frederick received it at his Dresden winter quarters during the Prussian occupation of Saxony, shortly before leaving the city at the end of March 1757 to resume the campaign.[31] According to Batoni's pupil Johann Gottlieb Puhlmann, the king took the picture with him on his campaigns throughout the war.[32]

After the end of the Seven Years' War, the *Marriage of Cupid and Psyche* could finally take its place in the finished picture gallery at Sanssouci. Distinguished by its charming, idealised setting, refinement of ornament and draughtsmanship, well-balanced composition, brilliant colouring, and subtle chiaroscuro modelling, the canvas affirms the importance and quality of Batoni's history paintings of the 1750s. Venus, seated in a chariot drawn by a pair of doves, motions to her son Cupid to place the ring on Psyche's finger. Hymen, the god of marriage, holds Psyche's hand with

its outstretched ring finger. Venus and the two gods float on clouds, whereas Psyche, a mortal, stands on the base of the nuptial bed. Puhlmann pointed out that the head of Psyche was a portrait of Batoni's second wife, Lucia, reputedly one of the most beautiful women in Rome.[33]

The picture was hung in the cabinet at the end of the gallery, where it was noted by Jean-Baptiste de Boyer, Marquis d'Argens (1703–1771), in 1768. By that time, Frederick had also acquired an earlier biblical painting by Batoni, the *Finding of Moses* (1746; formerly Neues Palais, Potsdam, untraced after 1945), which Argens saw in the Neues Palais.[34] In 1763, the king had invited the artist to move to Potsdam as his court painter: "I would like to engage Batoni to come here and enter my service, but need to know what he is asking and whether he is reasonable."[35] But Batoni declined the offer, and Father John Thorpe noted that "no promises, or any prospect of advantages whatever have hitherto been able to give him an inclination to leave Rome, where he has a family, that can not subsist without him. He now grows in years; it is not likely that he will ever remove. His superior excellency makes him to be sought for, where he is."[36]

Frederick's appetite for Batoni's work remained undiminished by this refusal. For the decoration of the Neues Palais, the king ordered three large paintings illustrating themes from Greek and Roman history and mythology, personally choosing their subjects: *Alexander and the Family of Darius*, 1764–75 (fig. 86); a companion, *Coriolanus Persuaded by His Family to Spare Rome* (untraced); and *Venus and Adonis* (never begun).[37] In September 1763, gallery inspector Matthias Oesterreich (1716–1778) was authorised to offer Batoni 400 zecchini per picture, presumably as a down payment.[38] Work on the first of the three canvases, the only one Batoni completed, was under way by October 1764, when the British traveller James Martin saw in the painter's studio "a picture begun by Batoni for the King of Prussia representing Alexander in the tent of Darius. The figures are about a fourth less than nature. He is to paint a companion for it the subject of which will be the Mother of Coriolanus meeting her son when he was going to attack Rome."[39]

When *Alexander and the Family of Darius* still had not been delivered by November 1770, Oesterreich, under the erroneous impression that the picture was finished, proposed to have the remainder of the agreed price of 800 zecchini paid to Batoni while at the same time obliging him to hand over the canvas, either amicably or, if necessary, by court order.[40] Two months later, the king himself wrote to the Prussian agent in Rome, Matteo Ciofani (1714–1798), issuing an ultimatum: if the painting failed to arrive within one year, he would cancel the commission.[41] In May 1772, Ciofani reported that Batoni would finish the picture in June.[42] But in fact the work was only completed in March 1775, when Father Thorpe pronounced it "a brilliant picture, and one of his best."[43] Two weeks later, it was admired by Salvadore Maria Di Blasi (1719–1814), who came away with the erroneous impression that Batoni—chronically short of money—was intending to make a gift of the picture to Frederick.[44] Chracas's *Diario ordinario* reported that it "won general acclaim from the first nobility, including foreigners, who have gone to see it, and particularly from the professionals and lovers of the fine arts."[45] The painting unites grandeur and nobility with clarity of storytelling and an emphasis on expression achieved through gesture, all within the limits of strict decorum. It appears to have arrived in Potsdam in March 1776, when an invoice for adapting its frame is recorded.[46]

Frederick is known to have read Quintus Curtius Rufus's *History of Alexander the Great*, which includes a description of the episode in which Sisygambis, Darius's mother, mistakes Alexander's friend Hephaestion for the Macedonian king.[47] Alexander courteously extends a hand to raise her to her feet, declaring: "You did not err, mother, for he, too, is Alexander."[48] Once Frederick had selected this subject, the Marquis d'Argens, his close friend and advisor, may well have suggested Charles Le Brun's canvas of the same subject (1660–61; Château de Versailles) as a compositional model.[49] Argens praised this work as "one of the most beautiful pictures in the world, both for its composition, which is sublime, and for its disposition, which is excellent."[50] The image was easily accessible in prints, one of which could have been sent from Potsdam to Rome together with the order and additional instructions, because the Le Brun shows a slightly earlier moment in the story, when Sisygambis is still prostrating herself. The depiction requested by Frederick puts a stronger accent on the monarch's magnanimity and clemency: Alexander, indicating Hephaestion, is both putting the embarrassed Sisygambis at ease and sharing his victor's laurels with his friend.

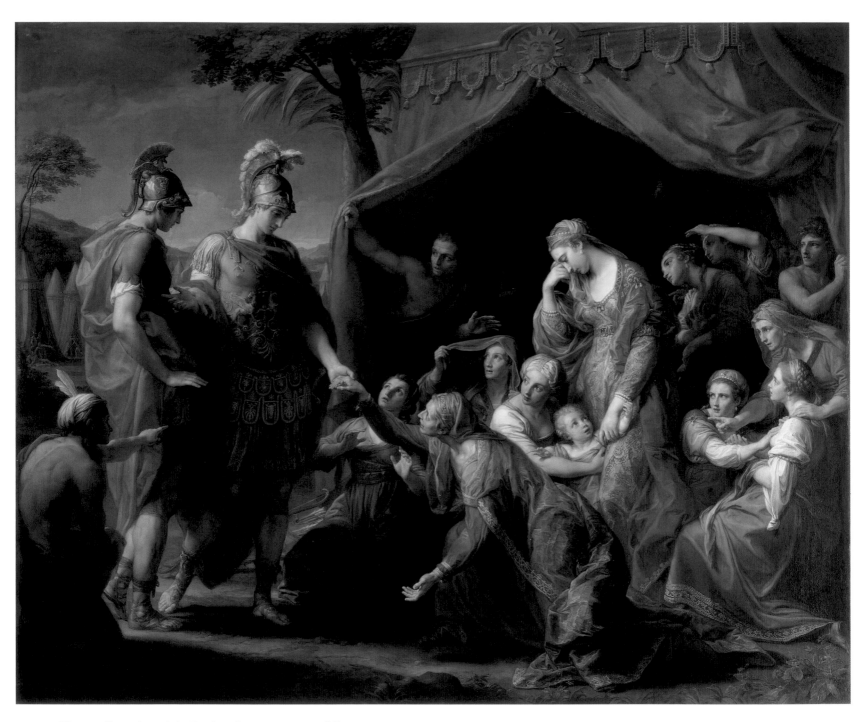

Fig. 86. *Alexander and the Family of Darius*, 1764–75. Oil on canvas,
87¼ × 106¼ in. (223 × 270 cm). Stiftung Preußische Schlösser und
Gärten Berlin-Brandenburg, Neues Palais, Potsdam.

The same Enlightenment values expressed in *Alexander and the Family of Darius* were to be illustrated by the proposed companion pictures. Delighted with the first canvas, in spite of the twelve-year wait, Frederick was keen to complete the projected group of three paintings. In these later commissions to Batoni, the king no longer acted through a Roman intermediary, and his private secretary, Henri de Catt (1725–1795), corresponded directly with the artist. Instead of *Venus and Adonis*, Batoni was now asked to paint the *Continence of Scipio*, another moral tale of a fair, compassionate, and selfless ruler, as well as the previously commissioned *Coriolanus Persuaded by His Family to Spare Rome*.[51] Puhlmann reported in January 1778 that Batoni was making good progress on the latter picture, hoping to finish both canvases by the autumn.[52] But almost two years later, the German painter Johann Heinrich Wilhelm Tischbein (1751–1829) saw the unfinished *Coriolanus* in Batoni's studio.[53] Its fate and that of the *Continence of Scipio* remain unknown. The commission does not seem to have lapsed because Frederick lost interest—in March 1781, one of the closest confidants of the ageing king, Marchese Girolamo Lucchesini (1751–1825), noted in his diary: "He does not understand the beauties of Raphael, but he loves Correggio infinitely, and among the modern painters he likes Batoni's colouring better than that of many Old Masters."[54]

The Habsburg Court at Vienna

Any attempt to claim Batoni for one or the other party in some of the major European discords of his time is rendered futile by the fact that he was deeply apolitical. He painted the *Sacred Heart of Jesus*, 1767 (see fig. 113), for the Jesuits and portrayed two Spanish diplomats who were instrumental in the suppression of the order, Marqués Manuel de Roda y Arrieta (1765; see fig. 112) and Don José Moñino y Redondo, Conde de Floridablanca (c. 1776; The Art Institute of Chicago).[55] The Hanoverian Edward Augustus, Duke of York, patronised Batoni (see fig. 39), as did the "other" Duke of York, Henry Benedict Stuart (1725–1807), known as Cardinal York and the second son of James Francis Edward Stuart.[56] Nor did the fact that Batoni was currently at work on a major commission for Frederick II deter Prussia's great antagonists, the Habsburgs, from joining the ranks of Batoni's princely patrons when the Holy

Roman Emperor Joseph II and his brother Leopold, Grand Duke of Tuscany, visited Rome in 1769.

But Batoni's first commissions from the orbit of the Viennese court reached back two decades. The collection of Prince Joseph Wenzel von Liechtenstein contained a pair of meticulously crafted history paintings, *Venus Delivering the Arms of Vulcan to Aeneas* and the *Choice of Hercules*, each dated 1748 (figs. 87, 88).[57] The pendants are known to have hung in the private rooms of the family palace on the Herrengasse in Vienna, where they are listed in an inventory of 1805. The hypothesis that the pair was commissioned by Prince Joseph Wenzel, rather than acquired by the family at a later date, can be confirmed through a letter of December 1751: Giuseppe Dionigio Crivelli (1693–1782), the Roman agent of Count Ernst Guido von Harrach (1723–1783), conveyed the news that Batoni had completed a picture for his patron and reported that "the painter desires that Your Honour has it shown to Prince Wenzel von Liechtenstein, for whom he painted two [pictures] with full-length figures."[58] The prince, equally successful as a courtier, diplomat, and commander of the imperial army in Italy in the War of Austrian Succession in 1745–46, evidently identified with and appreciated the themes depicted—military achievements and the choice of virtue over pleasure.

Prince Joseph Wenzel enjoyed the esteem and trust of Empress Maria Theresa (1717–1780) and her son Joseph II. In 1760, he was asked to go to Parma in order to escort Joseph's bride, Princess Isabella of Bourbon-Parma (1741–1763), back to Vienna for her wedding. It may not be accidental that soon after the prince's visit, Isabella's father, Duke Philip of Bourbon-Parma (1720–1765), perhaps following a recommendation from his guest, ordered a history picture from Batoni: *Thetis Entrusting Chiron with the Education of Achilles* (fig. 89).[59] In a letter of April 1761 to Carlo Innocenzo Frugoni (1692–1768), secretary of the Royal Academy in Parma, Batoni reported that he had just completed the canvas, commissioned four months earlier. Giving a detailed description of the painting, the artist emphasised the originality of the subject, which "is different from all the others, because they have all shown Chiron at the moment when he teaches [Achilles] these virtues"—as Batoni had done himself in his *Education of Achilles* (see fig. 27) of 1746.[60]

It is difficult to imagine that Count Ernst Guido von Harrach, a member of one of the most prominent families in Vienna, would not have known the Liechtenstein paintings in the original when he asked Crivelli to order *Susannah and the Elders* (fig. 90) from Batoni in 1751.[61] Even the artist in Rome was aware of the close connection between his Viennese patrons.[62] In Count Ernst Guido's collection, the *Susannah* would join works by contemporary Roman artists, including Sebastiano Conca (1680–1764), Giovanni Paolo Panini (1691–1765), Costanzi, and Mengs. In September, Crivelli saw the unfinished canvas in Batoni's studio and felt that it would surpass the paintings by Conca and Panini that he had previously obtained for the Harrach collection.[63] Batoni handed over the picture to the agent in January 1752, but it remained in Rome until May 1753, when Crivelli made preparations to have it shipped to Turin, where Harrach had been sent as imperial minister.[64]

One of Batoni's finest history paintings of this period, *Susannah and the Elders* exemplifies the several unifying pictorial qualities common to Roman painting from the beginning to the end of the eighteenth century: polished drawing, precise handling, luminous colour, idealisation of nature, and an acuity of perception and observation that approaches outright naturalism. Judged strictly by his ability to manipulate oil paint, Batoni had few rivals, in Italy or elsewhere, in creating an appealing freshness and sparkle of touch. It is precisely the polish and finish of paintings such as *Susannah and the Elders,* combined with exquisite drawing and ravishingly pretty colouring, that made Batoni's works so appealing to Europe's wealthy elite during the third quarter of the century.

The presence of important works by Batoni in the collections of Count Ernst Guido von Harrach and Prince Joseph Wenzel von Liechtenstein, both close confidants of Maria Theresa and her son, must have been a key factor in the decision to award the commission for the double portrait of Joseph and Leopold to the artist. The empress could also have heard about Batoni from Count Karl von Zinzendorf (1739–1813), a high-ranking official in the imperial administration. During a trip to Italy in 1765–66, undertaken on Maria Theresa's instructions, Zinzendorf had visited Batoni's studio.[65] In a letter to his mother three days after his arrival in Rome, the emperor mentioned in passing that

it would be difficult for him to find the time required for sitting to Batoni. This suggests that the plan to have his portrait painted and the choice of painter had already been agreed with Maria Theresa in Vienna before his departure.[66]

Joseph II's trip to Rome in March 1769 was probably triggered by the unexpected death of Pope Clement XIII, as the vacancy on the Chair of Saint Peter allowed him to escape the ceremonial strictures of protocol that an imperial visit to the papal city—the first since Charles V's—would normally have entailed.[67] His presence in Rome during the conclave also enabled the emperor to burnish his credentials in the area of foreign policy, because his political power at home in Vienna, as co-regent with his mother, was extremely limited.[68] On 16 March, Joseph scored a major coup: he was invited to tour the rooms of the conclave, normally strictly off-limits to anyone but the cardinals electing a new pontiff.[69]

Before departing for Naples at the end of the month, the emperor and his brother sat to Batoni in his studio on six consecutive mornings, beginning on 22 March. On his return to Rome on 10 April, Joseph visited Batoni once more, expressed his great satisfaction with the portrait, and presented the artist with a gold snuffbox and a medal, showing his portrait, on a gold chain.[70] The imperial favours granted to Batoni were widely noted by observers such as Father Thorpe: "The Emperor has shewn a very extraordinary regard for his merit: before he went to Naples he came divers times to his house and sat for his picture in Pompeio's own appartment; and when he returned to Rome he [a]lighted and made a long stay at his house before he went to Villa Medici. He has given Pompeo a large gold chain and medal of himself, and an elegant gold Snuffbox, besides the payment of the picture (five hundred Zequins) and the expectation of other presents from the Empress Queen when the painting arrives at Vienna. What Charles V.th did for the celebrated Titian, does not come up to what Joseph II.d has done and said to Pompeo Battoni."[71]

Alexandre-Louis Laugier (1719–1774), an imperial court physician and a close friend of Pietro Metastasio and the Mozart family, was travelling in Italy at the time.[72] After the departure of the emperor, he paid daily visits to Batoni's studio, where work on the portrait of the Holy Roman Emperor Joseph II and Grand Duke Leopold of Tuscany was advancing rapidly (fig. 91).[73] When an attack

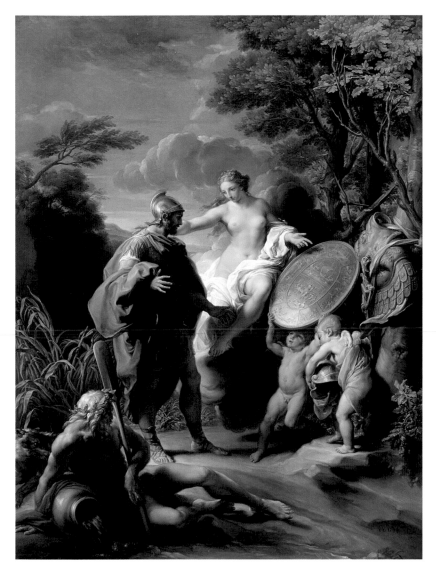

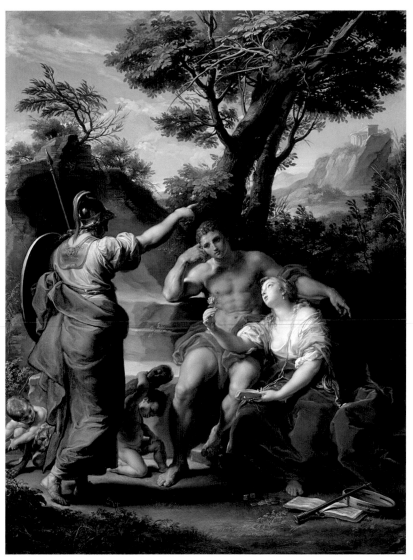

Fig. 87. *Venus Delivering the Arms of Vulcan to Aeneas*, 1748. Oil on canvas, 39 × 29⅛ in. (99 × 74 cm). Sammlungen des Fürsten von und zu Liechtenstein, Vaduz and Vienna.

Fig. 88. *The Choice of Hercules*, 1748. Oil on canvas, 39 × 29⅛ in. (99 × 74 cm). Sammlungen des Fürsten von und zu Liechtenstein, Vaduz and Vienna.

of gout forced Laugier to remain in bed, Batoni visited him every evening with a progress report, and once had the canvas brought to his lodgings. Writing to Maria Theresa on 17 May, Laugier even claimed to have had a share in the composition of the painting. He also reported that the constant stream of visitors to Batoni's studio wishing to see the picture had forced the painter to lock his door in order to finish it, and that the emperor had asked Batoni to keep a copy of the portrait in his studio, so that further copies could be ordered from Vienna.[74]

Spurred on by such close supervision, Batoni took less than three months to finish the painting. There

is a certain irony in the fact that the one patron whose representative displayed an uncommon amount of patience and understanding of Batoni's working practices was the one whose commission was completed with exceptional swiftness—Laugier felt that "one certainly does not lose anything by waiting. He always finds something to retouch here and there, and it only makes the painting more perfect. One can trust that he employs all of his skill in order to perfect a work that should bring him so much honour."[75] This observation is confirmed, in particular, by the superbly drawn and sensitive likeness of the grand duke.

Fig. 89. *Thetis Entrusting Chiron with the Education of Achilles*, 1760–61.
Oil on canvas, 40⅛ × 54⅛ in. (102 × 138 cm). Galleria Nazionale,
Parma.

On 17 June, Batoni reported to the Tuscan minister
Count Franz Xaver von Orsini-Rosenberg (1723–1796),
who had accompanied Joseph II and Grand Duke Leopold
to Rome, that he had consigned the portrait for shipment,
and recounted the reactions of the newly elected Pope
Clement XIV (1705–1774) to the painting: "I believe I am
also obliged to advise Your Excellency that His Holiness
has desired to see it; therefore last Sunday he allowed me to
bring it to the palace, and having greatly praised both the
likeness and the execution, he personally ordered me to exe-
cute one just like it, that is, with both of the royal brothers,
and when it arrives, he wants to place it in a prominent
location in his vicinity, with ornaments of bronze and
precious stones, as a perpetual record. Furthermore, he
wants to obtain a copy in mosaic, executed with the highest
possible refinement, in order to present it in his own name
to the Most August Queen of Hungary [Maria Theresa]
as soon as it is finished. He also asks that I supervise the
mosaic myself, so that it will be well executed."[76] These
copies could easily be executed even after the dispatch of

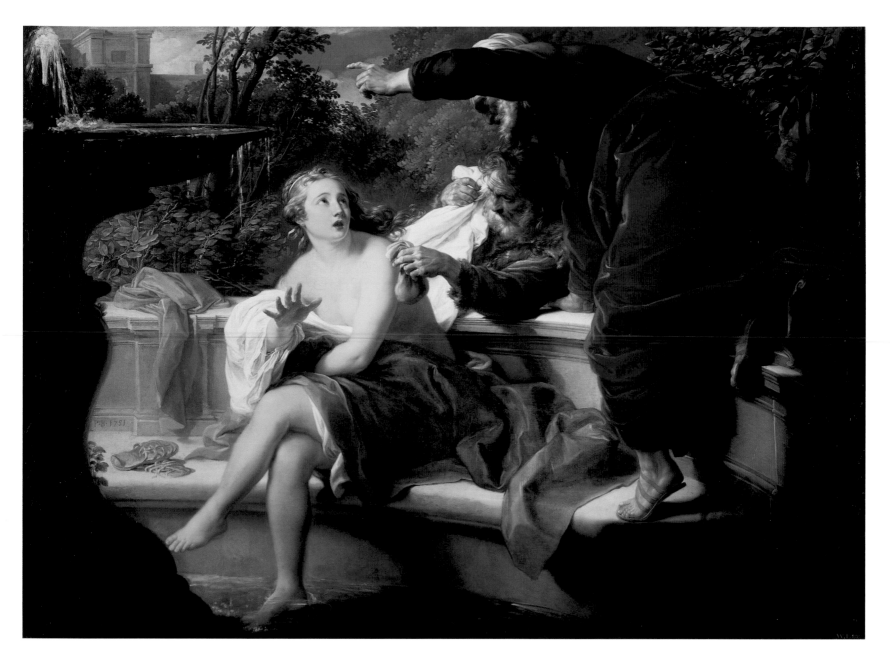

Fig. 90. *Susannah and the Elders*, 1751. Oil on canvas, 39 × 53½ in. (99 × 136 cm). Private collection.

the original as Batoni had "completely finished the two heads of the royal sovereigns, with all of the orders and everything else that is necessary, in order to keep them here as models, in accordance with the orders personally given to me by His Majesty [Joseph II]."[77]

The double portrait does indeed give considerable prominence to the orders worn by the brothers: both of them wear the jewel of the Order of the Golden Fleece and the sash of the Order of Maria Theresa. Underneath this red-and-white sash, Joseph II additionally wears the sash of the Order of Saint Stephen, and the chest of his black coat is decorated with the stars of the two orders. The view of the Castel Sant'Angelo and Saint Peter's in the distance may have been intended to represent these monuments as they appear from the Villa Medici, where the brothers stayed during their visit. The emperor rests his left arm on a statue of Roma—possibly derived from an antique sculpture then in the gardens of the Villa Medici—placed on a marble-topped console table covered with books and an unrolled map held in place by an inkwell.[78]

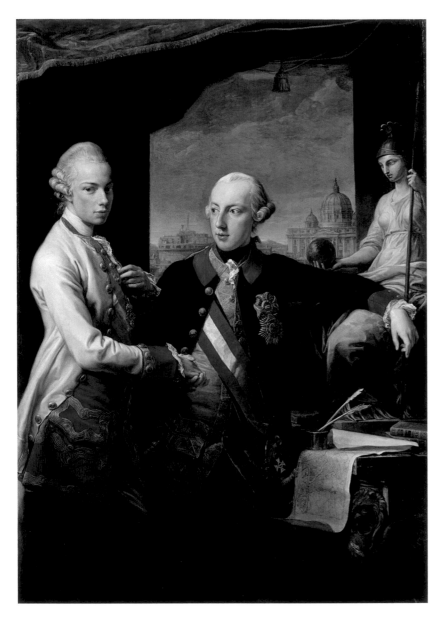

Fig. 91. *Holy Roman Emperor Joseph II (1741–1790) and Grand Duke Leopold of Tuscany (1747–1792)*, 1769. Oil on canvas, 68½ × 48 in. (173 × 122 cm). Kunsthistorisches Museum, Gemäldegalerie, Vienna.

The book towards which Joseph II points is Montesquieu's *L'Esprit des lois* (1748), which had been part of the curriculum of Joseph's education.[79] The work was acclaimed throughout Europe and is shown in a similar position in Maurice-Quentin de La Tour's portrait of Madame de Pompadour (1755; Musée du Louvre, Paris).[80] In a Roman context, however, *L'Esprit des lois* was quite controversial. It had been placed on the index of forbidden books by Pope Benedict XIV, Joseph's godfather, in 1751. The book's prominent position in a portrait that would be

seen by numerous cardinals—and, as it turned out, the current pope as well—cannot have been accidental. Unlike his pious mother, Maria Theresa, who had once asked Clement XIII for a papal dispensation to drink coffee during Lent, the emperor was known for his anticlerical stance.[81] The visit to Rome had given currency to hopes that Joseph might align himself more closely with the Papacy, and during his visit to the conclave, the cardinals had requested his support.[82] But through the presence of *L'Esprit des lois* in the painting, Joseph emphasised that he had no intention of mitigating an agenda of reforms that would clash with the interests of the Church.[83]

The Tuscan envoy in Rome, Mathieu-Dominique Charles Poirot de la Blandinier, Baron de Saint Odile (died 1775), was full of praise for the finished portrait, writing to Orsini-Rosenberg that, in order to bring the painting to the highest degree of perfection, Batoni had employed a great deal more diligence and time than was customary for a picture of this size and price. The envoy also recommended that if Maria Theresa wanted a further autograph version, she should not delay in ordering it, as Batoni had already received numerous commissions for copies.[84] The portrait arrived in Vienna in July 1769, and it was immediately praised for the "striking likenesses" of the brothers, whose "figures detach themselves from the canvas." Maria Theresa pronounced herself "enchanted" with "this admirable work of art," which "leaves absolutely nothing to be desired," and planned to send Batoni "public testimonies of her great gratitude, and of the esteem in which she [held] his exceptional talents."[85] In September, the artist received a diamond ring and twenty-six gold medals worth 3,000 scudi from the empress, together with a personal letter expressing her complete satisfaction with the portrait and commissioning a second, full-length version.[86]

Saint Odile's fears that demand for copies of the portrait would delay the full-length version for Vienna were soon realised, but he had a very attractive carrot to dangle in front of the status-conscious artist: a patent of nobility from the empress, signed by the chancellor Prince Wenzel Anton von Kaunitz-Rietberg (1711–1794). The suggestion to ennoble Batoni had come from Laugier.[87] Having extracted a promise from Batoni to complete the full-length straightaway, Saint Odile presented him with the patent in April 1770.[88] About a week later, the finished canvas was exhibited

in Batoni's studio.[89] In December, Father Thorpe reported that Batoni had been "much disappointed of his expectations from Vienna, instead of a hansome pension for life he has received no more than a present of three hundred Zequins for the last Portraits (whole lengths) of the Emp.r & G.d Duke."[90] However, he was able to console himself with "two more commissions from the Empress Queen."[91]

The first of these was a full-length posthumous portrait of the Holy Roman Emperor Francis I (fig. 92).[92] The likeness of Maria Theresa's deceased husband was copied from a small portrait sent from Vienna, together with the sumptuous embroidered red coat and white waistcoat in which he is shown. Saint Odile handed over the small portrait to the artist on 12 October, but when told that he could keep it only until early November, Batoni immediately protested that, owing to the difficulty of enlarging rather than merely copying the head, he needed more time. Laugier had sent him three letters spelling out Maria Theresa's wishes for the painting, intended for the Vieux-Lacque-Zimmer at the palace of Schönbrunn, where it was hung together with the full-length version of the double portrait of Joseph II and Grand Duke Leopold.[93]

In a columned interior richly decorated with marble, Francis I stands next to a table—apparently derived from a sculpture of the Flavian period in the Palazzo dei Conservatori—incorporating in its base the double eagle of the Habsburg coat of arms.[94] He gestures magniloquently to a pair of allegorical sculptures, identified by inscriptions as personifications of the virtues of Justice and Clemency. In a niche at the rear stands a figure of Fortitude, and behind the sitter at the right is a sculptural personification of Truth, pointing to her usual attribute, the sun, in the form of a radiant disc. Even though only Justice and Fortitude belong to the canon of the four cardinal virtues, Father Thorpe observed that Batoni's composition was "much admired for the noble manner in which he has introduced the Cardinal Virtues."[95] Batoni appears to have been given free rein—in December, Saint Odile merely observed, without any indication of instructions from Vienna, that although the painting was well advanced, with two of the

statues already done, Batoni had decided to "completely change the composition" and therefore needed to keep the small portrait of Francis I for an extra fortnight.[96]

Nonetheless, the artist's envisaged completion date, the following Lent, held firm, because he gave the Habsburg commissions preference over all others, causing Father Thorpe to lament that "if in this manner he is to go on painting the whole Court, he will never have time for any thing else."[97] The finished portrait of the late emperor, praised as a "vivid and animated" likeness, was despatched from Rome on 16 March 1771.[98] Once again, Maria Theresa personally wrote to Batoni, extolling his skill in being able

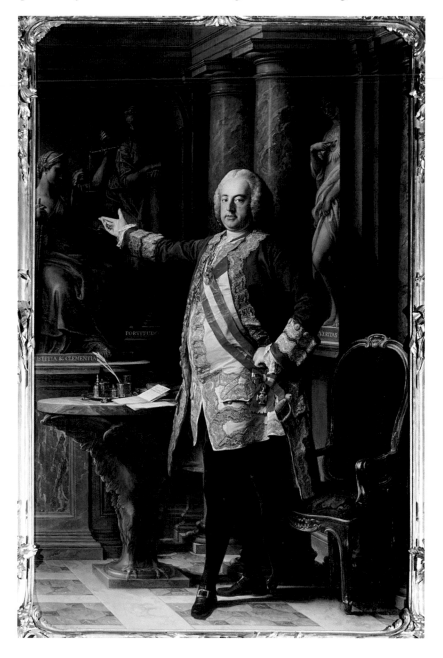

Fig. 92. *Holy Roman Emperor Francis I (1708–1765)*, 1770–71. Oil on canvas, 91 × 56¼ in. (231 × 144 cm). Kunsthistorisches Museum, Gemäldegalerie, Vienna; on loan to Schloß Schönbrunn.

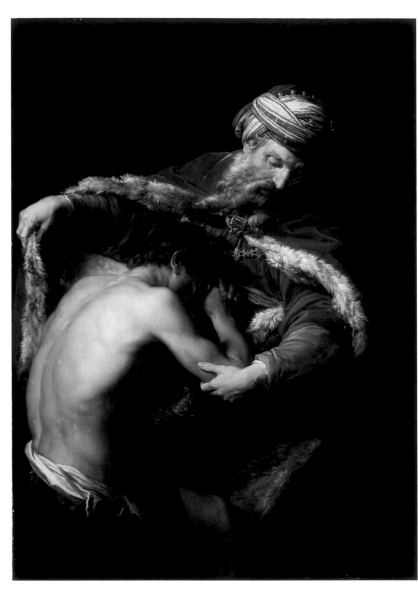

Fig. 93. *The Return of the Prodigal Son*, 1773. Oil on canvas, 54⅛ ×
39⅛ in. (138 × 100.5 cm). Kunsthistorisches Museum, Gemälde-
galerie, Vienna.

to portray her husband so well without ever having met
him.[99] In addition to sending Batoni "a large purse of dou-
ble gold Ducats" and "a great Medal of gold set in a border
of diamond," she also announced her intention of giving
him further commissions.[100] One of these may have been
the *Return of the Prodigal Son* (fig. 93), possibly identical with
the second of the two commissions mentioned by Thorpe
the previous November.[101] As late as July 1777, Puhlmann
mentioned "two large paintings ordered one year ago" by
the empress, but there is no evidence that these were ever
executed.[102]

The Bourbon Court at Naples

Empress Maria Theresa's dynastic policy included a
matrimonial bond with the Bourbons at Naples, for which
she promised the hand of her daughter Johanna Gabriela
to King Ferdinand IV (1751–1825). As bride and groom
were both underage, a wedding was still some way off,
and in 1762, the Habsburg princess died of smallpox at
the age of twelve. Her place was taken by her younger
sister Maria Josepha. The following year, in hopes of a
more felicitous outcome to the second engagement, the
Neapolitan court commissioned a series of tapestry car-
toons based on the theme of the Conjugal Virtues for the
king's bedroom in the royal palace at Naples. Apart from
Batoni, who was selected for the *Allegory of Religion*, 1763
(fig. 94), Corrado Giaquinto (1703–1766), Stefano Pozzi
(1699–1768), Giuseppe Bonito (1707–1789), and Francesco
de Mura (1696–1782) all supplied cartoons for the cycle of
tapestries, woven by Pietro Duranti (died 1799) between
1763 and 1767.[103] It is difficult to identify with precision the
iconographic meaning of Batoni's painting, but it appears to
refer to the advantages to be derived from placing marriage
under the protection of religion. At the left, a personifica-
tion of Religion, holding a cross in one hand and a chalice
with the Host of the Holy Sacrament in the other, receives
the blessing of the dove of the Holy Spirit in the form of
a flame. Two putti at her feet, presenting the Tablets of
the Law and the Book of the Gospels, symbolise the Old
and New Testaments. Seated on a globe, a figure of Divine
Wisdom as protectress of the arts is crowned by Fame.

Like her sister, Maria Josepha did not live to see her
wedding day, perishing in 1767 of the same illness at the
age of sixteen. Ferdinand's third engagement, to yet another
Austrian princess, Maria Carolina (1752–1814), resulted in
marriage in 1768. Once he was finally in a position to put
the conjugal virtues illustrated on his bedroom walls into
practice, the king demonstrated considerable procreative
vigour, siring eighteen children. The scourge of smallpox,
however, took a similarly heavy toll in Naples as it had in
Vienna, successively claiming the lives of the firstborn son
and crown prince, Carlo Francesco (1775–1778), and of his
sister Maria Anna (1775–1780). Their mother, Queen Maria

Fig. 94. *Allegory of Religion*, 1763. Oil on canvas, 145⅝ × 90½ in.
(370 × 230 cm). Palazzo Reale, Caserta.

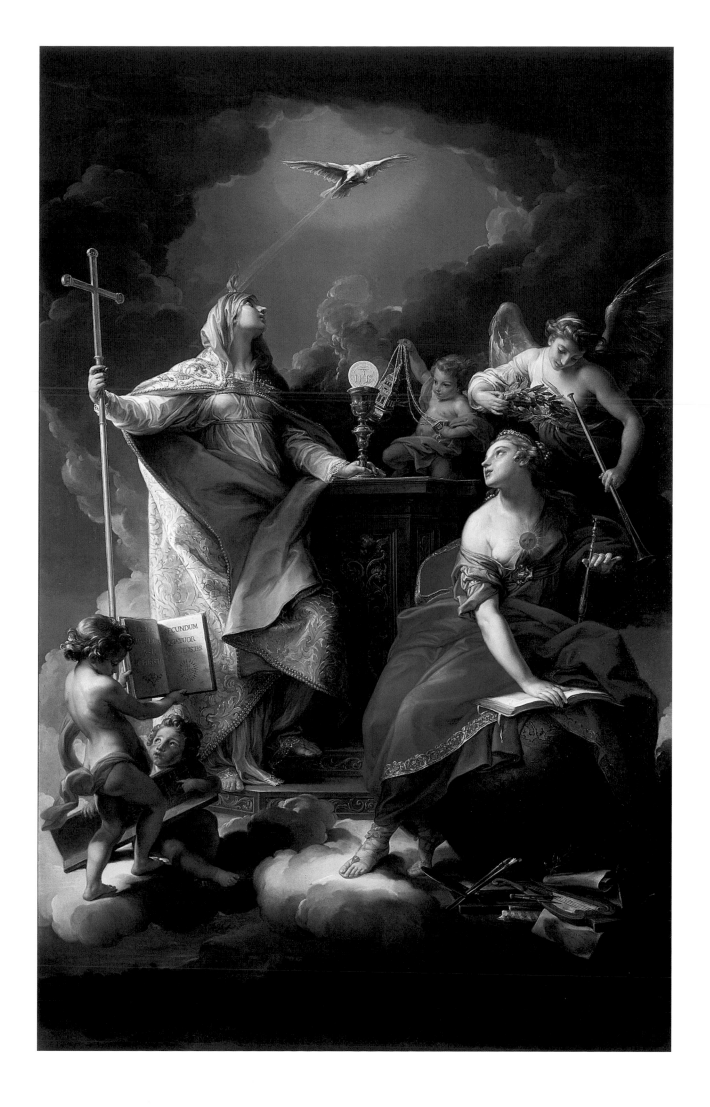

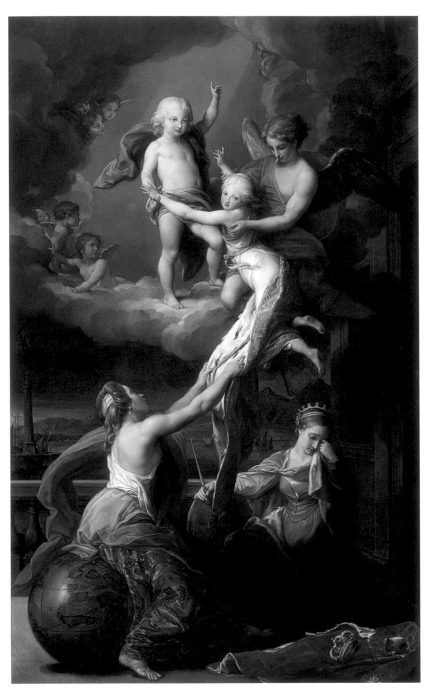

Fig. 95. *Allegory of the Death of Two Children of Ferdinand IV*, 1780. Oil on canvas, 113⅜ × 68⅞ in. (288 × 175 cm). Palazzo Reale, Caserta.

Carolina, who had been visited in Naples by her elder brother Emperor Joseph II immediately after he had sat to Batoni, commissioned a posthumous allegorical depiction of her children from the artist. Her inspiration for the *Allegory of the Death of Two Children of Ferdinand IV*, 1780 (fig. 95), may well have been the posthumous likeness of her father, Francis I, that Batoni had painted for her mother.

She cannot have known the portrait in the original but would certainly have heard about it in letters from Maria Theresa, who had expressed to Batoni that she "derived great comfort from looking at your painting."[104]

In the allegory, an angel transports Maria Anna to Heaven, where her brother awaits her. A personification of Earth vainly seeks to hold on to the young princess, grasping her ermine-lined mantle, while a crowned female figure representing the Kingdom of Naples mourns the death of the prince and his sister. Carlo Francesco's abandoned crown, sceptre, sash of the Order of San Gennaro, and royal mantle are scattered on the ground. A view of the bay of Naples forms the backdrop, with the lighthouse on the Molo at the left and the erupting Mount Vesuvius on the right. The figure of Maria Anna is closely modelled on Correggio's Ganymede (c. 1530; Kunsthistorisches Museum, Vienna). The implications of the theme of Ganymede and Jupiter appear at first sight inappropriate for a picture of this subject, but since the Renaissance, the mythological episode had also been given a Christian interpretation as an allegory of the human soul progressing towards the Almighty, an idea emphasised here by Carlo Francesco's pointing heavenwards, directing his sister's soul towards eternal salvation.

The Romanov Court at Saint Petersburg

The pattern of courtly patronage that can be discerned at the courts of Frederick II and Maria Theresa was repeated at the tsarist court: before the sovereign himself or herself became a Batoni patron, a number of his or her relatives or close associates acquired pictures from the artist. Saint Petersburg was probably the most free-spending court of eighteenth-century Europe, and Batoni reaped rich rewards from his Russian clients, the first of whom was Count Kirill Grigoriewitsch Razumovsky (fig. 96).[105] From humble origins in Ukraine, Razumovsky had risen rapidly to become one of the richest and most powerful men in Russia. His older brother Alexei was the morganatic husband of Empress Elizabeth, to whom Count Kirill owed his position and immense wealth.

Fig. 96. *Count Kirill Grigoriewitsch Razumovsky (1728–1803)*, 1766. Oil on canvas, 117½ × 77⅛ in. (298 × 196 cm). Private collection.

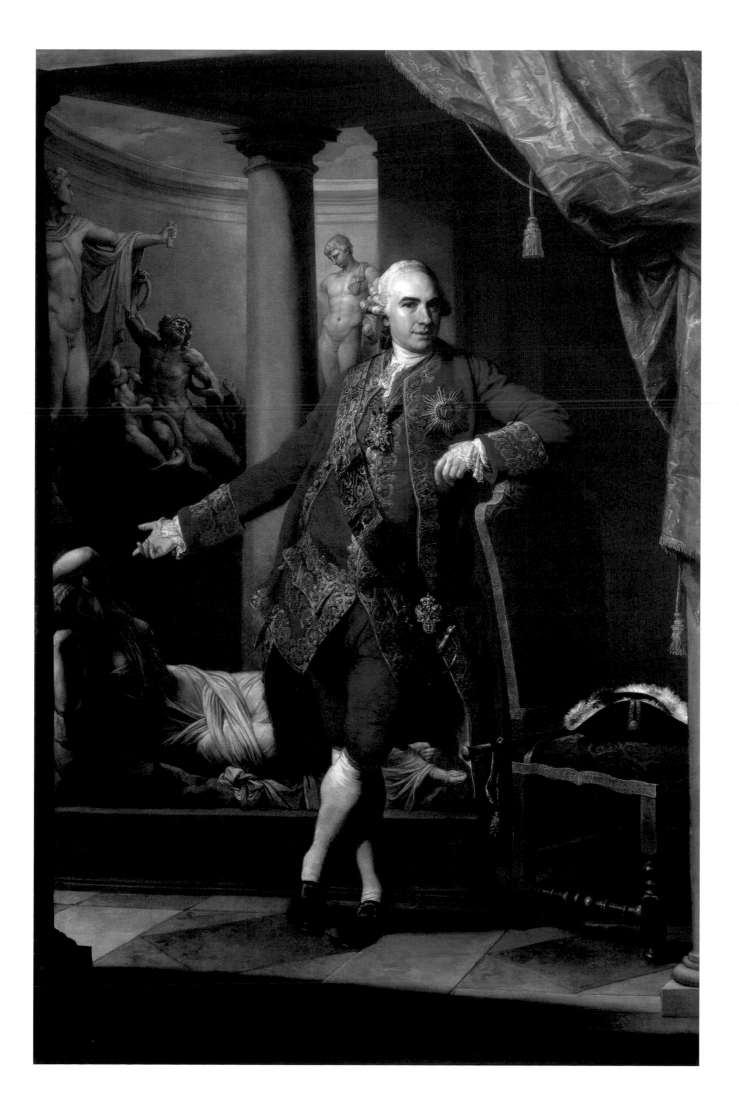

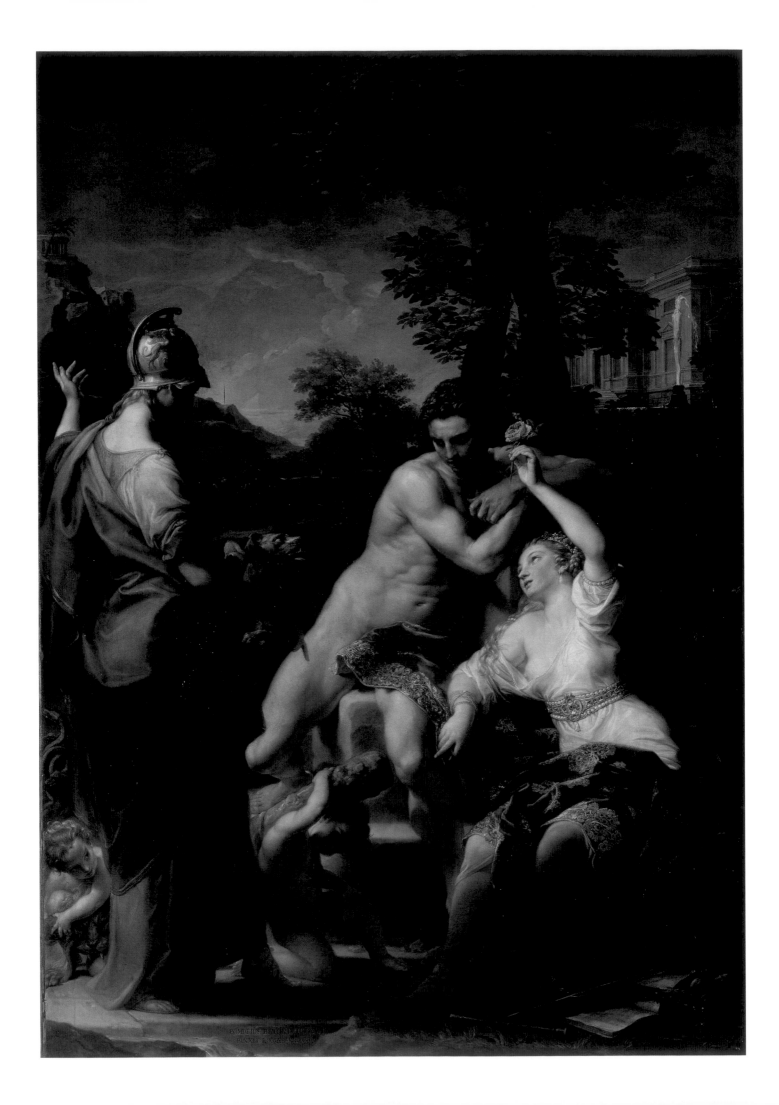

Educated at Königsberg, Berlin, Göttingen, and Strasbourg, he was elevated to the nobility in 1744 and appointed a royal chamberlain the following year. In 1746, he was made a field marshal and president of the Academy of Sciences in Saint Petersburg. Razumovsky served as grand hetman of Ukraine from 1750 to 1764, becoming the de facto ruler of his native province. For his role in the palace revolution of 1762, which brought Empress Catherine II to the throne, he enjoyed a place at her court and an annual pension of 50,000 roubles, which enabled him to lead a life of considerable luxury in Moscow and Saint Petersburg.[106] In her memoirs, Catherine described Razumovsky as a handsome, witty, and extremely charming man, whose intellect greatly surpassed that of his brother, and observed that the most beautiful women at court squabbled over him.[107]

Razumovsky undertook a tour of Europe in the years 1765–67. His first stop was Berlin, where he visited Frederick II, who owned the *Marriage of Cupid and Psyche* and had several Batoni paintings on order. When he arrived in Rome in the spring of 1766, Razumovsky acquired from Batoni the *Choice of Hercules* (fig. 97) as well as a *Holy Family* (untraced) and sat to the artist for his imposing full-length portrait.[108] He is shown wearing the blue sash, star, and badge of the Order of Saint Andrew—the highest civil decoration in tsarist Russia—which he had received from Empress Elizabeth in 1751. On his breast, he wears the Polish Order of the White Eagle. The fictitious arrangement of marbles in the background reassembles the group of four sculptures that Batoni had already depicted in the portrait of Thomas Dundas (see fig. 80): the *Apollo Belvedere*, *Laocoon*, *Belvedere Antinous*, and *Vatican Ariadne*, the latter shown in reverse so that the sitter can indicate her alluring countenance.[109] The fact that Batoni would have charged Razumovsky a considerable premium over his going rate for including the statues was evidently not a matter of concern to the tremendously affluent Russian.

Razumovsky also flaunted his largesse by purchasing the *Choice of Hercules* for 700 zecchini.[110] In a description of the Palazzo Farnese in the *Voyage d'un François en Italie*, Joseph Jérôme Le Français de Lalande (1732–1807) mentioned this

Fig. 97. *The Choice of Hercules*, c. 1763–65. Oil on canvas, 96½ × 67¾ in. (245 × 172 cm). The State Hermitage Museum, Saint Petersburg.

painting in the same breath with the canonical depiction of the theme: "In the cabinet is a beautiful painting by Annibale Carracci, Hercules at the crossroads, that is, between vice and virtue, a beautiful subject that several skilful painters have treated with success, most recently Pompeo Batoni."[111] The French astronomer travelled around Italy in 1765–66 and presumably saw the canvas, which is dated 1765, in the painter's studio.

There is a contemporary but probably apocryphal report that Razumovsky attempted to engage Batoni as court painter for Saint Petersburg.[112] Even from afar, however, the tsarist court soon became one of the artist's most significant sources of patronage. Razumovsky arrived back in Russia in September 1767, and the following year Empress Catherine II decided to order a large pair of mythological paintings from Batoni. The commissions for *Chiron Returns Achilles to Thetis* and the *Continence of Scipio* were handled by the diplomat Count Ivan Ivanovich Shuvalov (1727–1797), himself an avid art collector and resident in Rome at the time (figs. 98, 99).[113] In the customary fashion, work on the pictures soon came to a standstill and only recommenced in June 1770, as the Baron de Saint Odile reported: "Mr. Batoni, having received renewed appeals to finish a superb painting destined for Her Majesty the Empress of Russia, which contains ten life-size figures, has been obliged to resume work on it, which had been interrupted a few years ago. It is coming on well and will confer immortal honour upon the artist."[114]

The remaining work on *Chiron Returns Achilles to Thetis* was completed in a remarkably short time. In August, Shuvalov was granted an export licence for shipping the canvas to Saint Petersburg.[115] The reason for Batoni's sudden dedication to the commission was the Russian's stratagem to pay him in small but continuous instalments, as Father Thorpe noted: "The Empress of Russia is glad to engage him to finish two or three pieces, at the rate of thirty Crowns a week."[116] In total, Batoni received 1,691 scudi each for the two paintings.[117] When Thorpe saw the pendant, the *Continence of Scipio*, in progress in August and again in September 1771, he felt that "Pompeo's painting . . . for the Czarina does not add credit to his talent either of invention or expression. So difficult is it to tell some stories well."[118] The second canvas, dated 1771, was described as "just finished" by the Scottish traveller Patrick Home

(1728–1808) when he visited Batoni's studio in April the following year.[119]

Chiron Returns Achilles to Thetis and the *Continence of Scipio* remained the most expensive paintings sold by Batoni until the visit to Rome of the empress's son Grand Duke Paul of Russia (1754–1801) and his wife, Grand Duchess Maria Feodorovna (1759–1828), generated an even greater windfall for the artist in 1782. The duchess was a Württemberg princess, whose uncle Carl Eugen had sat to Batoni almost thirty years earlier. The couple were accompanied to Rome by Prince Nikolai Borisovich Yusupov (1751–1831), who acquired paintings in Italy for the imperial palaces at Gatchina and Pavlovsk. He was also an important art collector in his own right and later commissioned a pair of pendants from Batoni: *Venus Caressing Cupid* (1784; Museum of Western and Oriental Art, Odessa) and *Venus Instructing Cupid* (1785; State Arkhangelskoye Estate Museum, near Moscow).[120]

By the time the ducal couple departed Rome in March 1782, after a six-week stay, they had spent a total of 5,000 scudi on paintings by Batoni. For a pair of full-length portraits of the grand duke and his wife, the artist was paid 1,000 zecchini, or 2,000 scudi.[121] As a present for his mother, Grand Duke Paul bought a work Batoni had painted in 1777 without a specific commission and that had found plenty of admirers but no takers at the colossal asking price of 1,500 zecchini, or 3,000 scudi: the *Holy Family with Saint Elizabeth and the Infant Saint John the Baptist* (fig. 100).[122] Father Thorpe, seeing the picture soon after its completion, observed that Batoni's *Holy Family* "is his own & every one's favorite piece. It is indeed a fine picture, & at his great age to be done with so much freedom of pencelling & brilliancy of colour, is a surprizing performance. All the figures are as large as life & composed with more dignity than is observed in most paintings of this subject by the greatest masters. This picture is, as he says, made for his own keeping, like the other of Peace & War. Thus

whoever will purchase them, must pay more than a high price."[123]

The price was no deterrent for the grand duke, and the acquisition created quite a stir in Rome, with Chracas reporting that the artist had received 1,500 zecchini for "the most beautiful masterpiece [Batoni] has painted to this day."[124] Together with *Chiron Returns Achilles to Thetis* and the *Continence of Scipio* (pace Father Thorpe), the *Holy Family with Saint Elizabeth and the Infant Saint John the Baptist* is among the finest works of the artist's maturity. All three pictures are prime examples of the delicate colouring, sensitive modelling, and idealised elegance of Batoni's late works. Opulence and sumptuousness are now tempered by a powerful undertone of restraint and gravity, the handling has become softer, the draughtsmanship less precise. The figures show an increasing elongation, and are distinguished by their profound and noble expressions and graceful poses.

The Hanoverian Court at London and the Courts at Brunswick, Mannheim, and Warsaw

Yet another royal family to patronise Batoni, if not as lavishly as the tsarist court, was the House of Hanover. After the end of the Seven Years' War, the Papacy and the British crown moved towards a rapprochement, facilitated by the fact that London no longer considered the Jacobite court in Rome a serious threat. While the Church officially still regarded the ailing James Francis Edward Stuart as the exiled King of England, Pope Clement XIII let it be known privately that "in his heart" he recognised King George III (1738–1820).[125] When the latter's younger brother Edward Augustus, Duke of York, undertook a tour of Italy in 1764, the Anglophile Cardinal Alessandro Albani paved the way not only for a stay in Rome but also for the duke to be received by the pope.[126] A thorny problem of protocol resolved itself when Henry Benedict Stuart, who also used the title of Duke of York and wielded considerable influence as a cardinal and vice-chancellor of the Holy Roman Church, left Rome in protest ahead of his Hanoverian namesake's visit.

After Edward arrived in Rome on 15 April 1764, Clement XIII gave a reception for him in the gardens of the Palazzo del Quirinale, where the guest could have admired Batoni's ceiling painting in the Caffeaus (see fig. 26). Cardinal

Fig. 101. *Prince William Henry, Duke of Gloucester (1743–1805)*, 1772. Oil on canvas, 28⅛ × 24⅛ in. (73 × 61.9 cm). Private collection.

Fig. 102. *Maria, Duchess of Gloucester (1736–1807), with the Infant William Frederick, later 2nd Duke of Gloucester and Edinburgh (1776–1834)*, 1776. Oil on canvas, 29⅛ × 24⅛ in. (74 × 61.5 cm). Private collection.

Albani organised a magnificent ball in the duke's honour at his villa and made him a present of a gold snuffbox decorated with a priceless antique cameo of Alexander the Great. The gift was placed in Edward's hands by Georgiana, Countess Spencer (see fig. 65), who appears to have endeared herself to him in other ways, as well.[127] The twenty-five-year-old duke, already a veteran connoisseur of female charms, dined with the countess, a year his senior, and remarked that he had never known her "so well as at present."[128] The countess sat to Batoni either just before or during Edward's stay in Rome, and their portraits share the view of the Colosseum in the background.[129] The duke wears the undress uniform of a flag officer and the star and sash of the Order of the Garter.

Fig. 100. *The Holy Family with Saint Elizabeth and the Infant Saint John the Baptist*, 1777. Oil on canvas, 89 × 58⅞ in. (226 × 149.5 cm). The State Hermitage Museum, Saint Petersburg.

The next member of the British royal family to commission a portrait from Batoni was Prince William Henry, Duke of Gloucester, younger brother of George III and the Duke of York. During his first visit to Rome in 1772, he was accompanied not by his wife, an illegitimate daughter of Sir Edward Walpole (1706–1784), but by his Dutch mistress, Madame Grovestein. Batoni's pendant portraits of the duke, who is shown wearing the star and sash of the Order of the Garter, and Maria, Duchess of Gloucester, were therefore executed four years apart (figs. 101, 102). Accompanying her husband on his second visit to Italy, the duchess gave birth to a son, Prince William Frederick (1776–1834), in Rome. Her likeness shows her cradling the infant in her arms. A portrait of their daughter Princess Sophia Matilda (1773–1844), also painted by Batoni in 1776, is untraced.[130]

Between the visits of the Dukes of York and Gloucester, the husband of their sister Princess Augusta (1737–1813), Prince Karl Wilhelm Ferdinand, had travelled to Rome in

1766.[131] A nephew of Frederick II's, he served in the Prussian army during the Seven Years' War with great distinction and personal valour, for which he was praised in an ode composed by his uncle. During his Grand Tour, Karl Wilhelm Ferdinand visited Rome twice between October and December 1766. In his portrait (fig. 103), the prince wears the star and sash of the Order of the Garter, and Batoni reused a pose he had previously employed for *John Wodehouse* (see fig. 77). Karl Wilhelm Ferdinand's cicerone, Johann Joachim Winckelmann, praised him as the "Brunswick Achilles" for his industry and his enthusiasm for visiting the sights of Rome.[132] The German archaeologist probably selected the portrait's accessories, both of which he published the following year in his *Monumenti antichi inediti*.[133] The prince rests his left arm on an important Greek krater

(Museo Gregoriano Etrusco, Vatican City)—one of the earliest uses of antique vases in eighteenth-century portraiture—and is flanked by two views of an attic amphora.[134] The krater belonged to Mengs, who was in Spain at the time, and the fact that he would permit Batoni to utilise objects from his collection as studio accessories implies an amicable relationship between the two painters.[135] Not surprisingly, the distinguished collector of Greek vases Sir William Hamilton (1730–1803) commissioned a replica (untraced) of the portrait from Batoni for Palazzo Sessa, his residence in Naples.[136]

Whereas Karl Wilhelm Ferdinand and most other European sovereigns who sat to Batoni desired souvenir portraits containing unmistakable references to their presence in Rome, Karl Theodor, the Elector of the Palatinate and later Elector of Bavaria, requested a formal state portrait (fig. 104).[137] Dressed in the Electoral ermine cape over ceremonial armour, he wears the Orders of Saint Hubert and Saint George. Beside him, resting on a pillow placed on a marble console with a sphinx support, are his electoral bonnet, electoral sword, and the imperial crown, the latter a reference to his status as imperial vicar, or administrator in the case of a vacancy on the imperial throne. Karl Theodor's prolific patronage of the arts and sciences is emphasised by a seated statue of their protectress Minerva in the background.

If the elector, one of Europe's leading art collectors of his day, had not already heard of Batoni before coming to Rome, he certainly would have been told about the painter by the Palatinate's envoy to the Holy See, Marchese Tommaso Antici (1731–1812), in whose palace he was staying.[138] Antici also served the Polish crown in the same function, and he handled the commissions King Stanislas II of Poland had placed with Batoni in 1767: an *Allegory of Clemency and Justice* and its companion, an *Allegory of Prudence and Courage* (both untraced).[139] Karl Theodor visited Batoni's studio on 23 December 1774, and the next day Father Thorpe reported that the artist was "entirely occupied upon the Elector Palatin, of whom he paints two portraits, one very large whole length, the other half."[140] In June 1776,

Fig. 103. *Prince Karl Wilhelm Ferdinand, later Duke of Braunschweig and Lüneburg (1735–1806)*, 1767. Oil on canvas, 53⅞ × 39 in. (137 × 99 cm). Herzog Anton Ulrich-Museum, Braunschweig.

Fig. 104. *Karl Theodor, Elector of the Palatinate and later Elector of Bavaria*
(1724–1799), 1774–75. Oil on canvas, 106¼ × 72⅞ in. (270 × 185 cm).
Bayerische Staatsgemäldesammlungen, Alte Pinakothek, Munich.

when the paintings had arrived in Germany, Karl Theo-
dor sent Batoni a letter expressing his great satisfaction,
together with a gold snuffbox as a present.[141]

The Papal Court at Rome

The greatest portrait commission a Roman painter could
obtain was to paint the pope, and Batoni produced por-
traits of two pontiffs, Clement XIII and Pius VI.[142] The
first official likenesses of Clement XIII Rezzonico were
painted in 1758 by Mengs, who depicted the pope in several
variants of a seated pose.[143] Two years later, Cardinal Carlo
Rezzonico (1724–1799), who had received the red hat and

was appointed vice-chancellor of the Holy Roman Church
soon after his uncle's elevation to the Chair of Saint Peter,
commissioned a further portrait of the pontiff, this time
from Batoni (fig. 105).[144] It represents the corpulent Clement
XIII standing before a papal throne carved with his coat of
arms, a writing table beside him. His right hand is raised
in blessing, while the left is holding a letter. Although the
standing pose has generally been seen as diminishing the
effect and forcefulness expected in a papal portrait, the
"timid" benediction offered to the beholder and the "shy
glance" have been interpreted as embodying perfectly the
character of the pope as described by contemporaries.[145]
Nonetheless, most observers in Batoni's day conceded
primacy to Mengs's likenesses of the pope, for example the
English Grand Tourist Thomas Robinson (1738–1786) in
1760: "I perceived a great difference in the manner in which
these painters shewed them, & in the particular things upon
which they each laid the principal stress. Battoni made
one take notice how well the gold Lace was finished how
transparent the Linnen was, & complained of ye Difficulty
& patience in getting thro' so elaborate a performance.
The likeness was indeed very perfect. Menx on the other
hand, who had neglected no Circumstance which could
render his Picture compleat in respect to the height of it's
finished, did not however point out these Circumstances so
circumstantially. He rather dwelt on the Effect of his whole
picture, on the Composition of it, it's force, & it's Dignity,
none of which things the other with all his accuracy had
ever thought of."[146]

Another *nipote*, Carlo's younger brother Prince Abbondio
Rezzonico (fig. 106), was appointed senator of Rome in
1765.[147] The senator was the city's chief lay magistrate, cho-
sen by the pope from among the noble foreigners resident
in the Papal States—a criterion fulfilled by Prince Abbon-
dio, a Venetian. Batoni's task was to invest the twenty-
four-year-old, whose qualification for the job consisted of
his status as a papal nephew, with the necessary gravitas
and grandeur that his eminent new position required. In
the magnificent full-length portrait, Rezzonico holds a
sceptre and wears the gold chain of the senator's office over
his robes of state. On the marble-topped table at the right
lies the broad-brimmed senatorial hat, its tassels given an
extraordinary plasticity by Batoni's precise and deliberate
application of impasto. Propped against the table is the

senator's ceremonial sword. An allegorical putto displays the attributes of justice: the scales, emblem of impartiality, and the fasces, a bundle of wooden rods enclosing an axe, signifying the Roman magistrates' authority to scourge and behead. The olive branch symbolises the civil peace guaranteed by the senator's acts. Upon completion, the portrait was put on display in the Palazzo Senatorio in the Campidoglio, which is seen in the background together with a statue of Roma.[148] Rezzonico remained in the post long after his uncle's death, becoming one of the most prominent public figures in Rome as well as an important patron of

the arts and a key supporter of his friend and compatriot Antonio Canova (1757–1822).

When Giovanni Angelo Braschi was elected pope in February 1775, taking the name of Pius VI, he immediately chose Batoni for his official likeness (fig. 107). Father Thorpe heard in March that Batoni "will be called as soon as the hurry of business is lessened," and in early April, Puhlmann reported that the artist had already visited the new pope three times and had officially received the commission.[149] For Pius VI, Batoni returned to the traditional pose of the pontiff seated on a throne, upholstered in red velvet and carved with the papal coat of arms. The pope, who holds a letter in his left hand, wears a mozzetta and a gold-embroidered stole as well as the *berrettino*, a white skullcap, instead of the *camauro*, the traditional ermine-lined red velvet cap, which is casually placed on top of the books stacked on the table beside him.[150]

The picture's most prominent and significant accessory is the large table clock, a first in papal portraiture. The French rococo timepiece of polychrome porcelain, decorated with shepherds and shepherdesses, was a gift to Pius VI from the Roman nobleman Prince Rospigliosi. It was included in the painting at the pope's specific request and sent to Batoni's studio for the purpose.[151] The clock reads 8:00 (approximately 3:00 A.M. by today's reckoning), accurately reflecting the habits of the Braschi pope, who slept little and worked late, as the architect and writer Francesco Milizia (1725–1798) noted on 1 April 1775: "I hear he stays up until 8:00 or 9:00 at night, ignoring the grumbles from those in his retinue who can't manage to stay awake with him."[152] Typically the first version of an official pontifical portrait was considered an honorary assignment that did not carry a financial reward, but Pius VI was so delighted with his likeness that he sent Batoni a gift of 500 scudi.[153] The most remunerative aspect of a papal portrait commission, however, lay in the numerous replicas, priced at 100 zecchini, or 200 scudi, each, that the Holy See and various other institutions inevitably required.[154]

Clement XIII and *Pius VI* are the only papal portraits Batoni is known to have painted, but contemporaries such

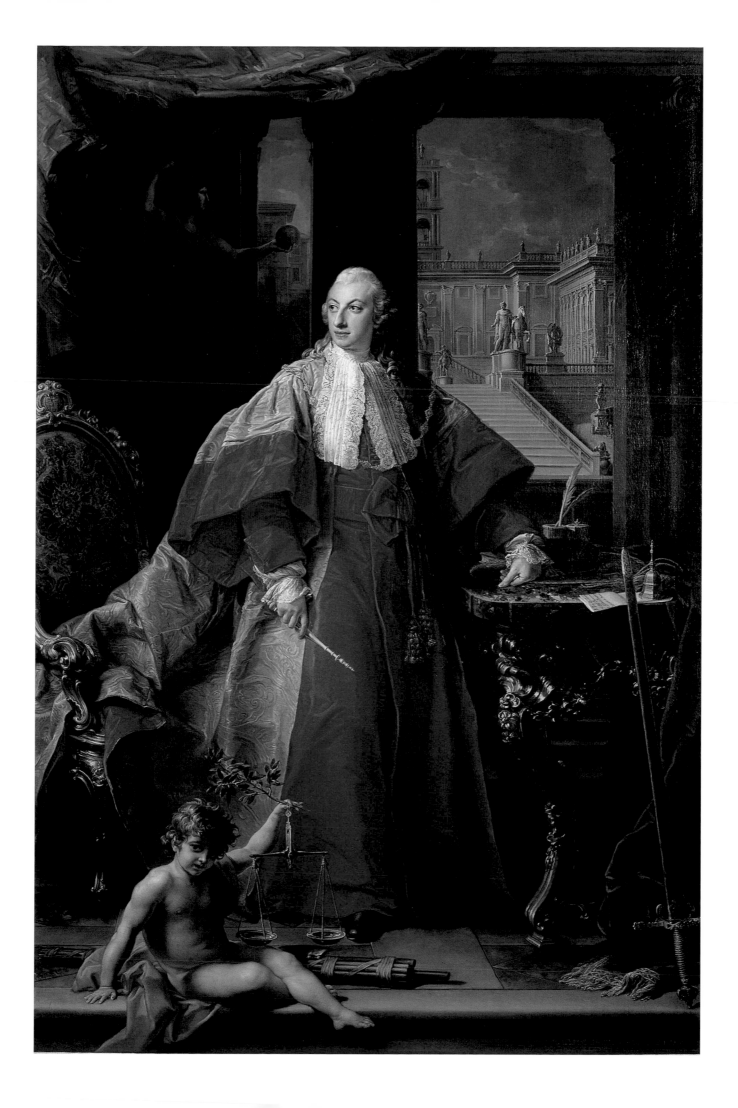

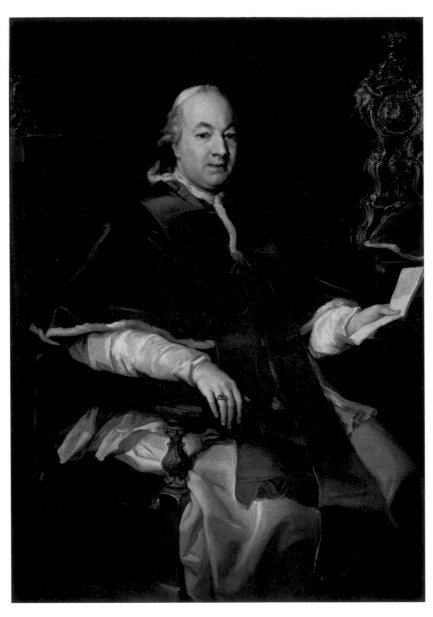

Fig. 107. *Pope Pius VI (1717–1799)*, 1775–76. Oil on canvas, 54⅛ × 37¼ in. (138 × 96 cm). Pinacoteca, Musei Vaticani, Vatican City.

as the art historian Luigi Lanzi (1732–1810) and the painter and writer Johann Dominik Fiorillo (1748–1821) consistently mention a third pope portrayed by the artist: Benedict XIV Lambertini, one of his most important patrons.[155] The commission for the pontiff's official likeness had been awarded to Pierre Subleyras in 1740, when Batoni had yet to make his mark as a portraitist.[156] Towards the end of the Lambertini pontificate, however, Cardinal Domenico Amedeo Orsini d'Aragona (1719–1789) commissioned from Batoni an exceptional work transcending the conventional boundaries of religious history painting, allegory, and

portraiture. *Pope Benedict XIV Presenting the Encyclical "Ex Omnibus" to the Comte de Choiseul*, 1757 (fig. 108), recorded a historical event of 16 October 1756: the presentation to the French ambassador of a papal encyclical that was intended to resolve the deadlock between two opposing factions of the French assembly of bishops—and, ultimately, between the parliament and the crown—over the denial of sacraments to Jansenists.[157] The likeness of the ageing Benedict XIV is rendered as sensitively and accurately as it would be in an independent portrait, but here he is flanked by allegorical personifications, while Saints Peter and Paul survey the scene from a cloud, and the dove of the Holy Ghost is shown inspiring the pope. Before him kneels the Comte de Choiseul, who has taken off his hat and has just kissed the red papal slipper before receiving the encyclical, which is inscribed with the beginning of its original text. The setting is a loggia-type space overlooking Saint Peter's, probably intended to represent the Caffeaus in the gardens of the Quirinale, where the event took place.

Orsini enjoyed the rare distinction of being a cardinal with a legitimate child, having been raised to the purple after the early death of his wife. His daughter, Princess Giacinta Orsini Buoncompagni Ludovisi, Duchess of Arce (fig. 109), was the most celebrated of Batoni's female Italian sitters, the result both of her distinguished position in Roman society and of her achievement as an acclaimed poet and a member of the Accademia dell'Arcadia.[158] Her portrait, which exists in several autograph versions, is one of the most significant images of a *pastorella*, as female members of the academy were known. Batoni alludes to her wide-ranging intellectual interests and her status as an Arcadian (her pastoral name was "Euridice Aiacense") in a variety of ways. Wearing a blue lace-trimmed dress and red ermine-lined cloak, she leans her left arm on a pile of books on a clavichord while holding a lyre and a laurel wreath in her right. One of the volumes is by Petrarch, another is inscribed "ANACRON" (presumably by the Greek classical poet Anacreon); next to these are sheet music, a bust of Minerva, and an armillary sphere. The scene in the background shows Pegasus on Mount Helicon creating the fountain of Hippocrene, which was sacred to the Muses and said to inspire poetry.[159]

Cardinal Orsini himself apparently never sat to Batoni, but quite a few of his fellow princes of the Church

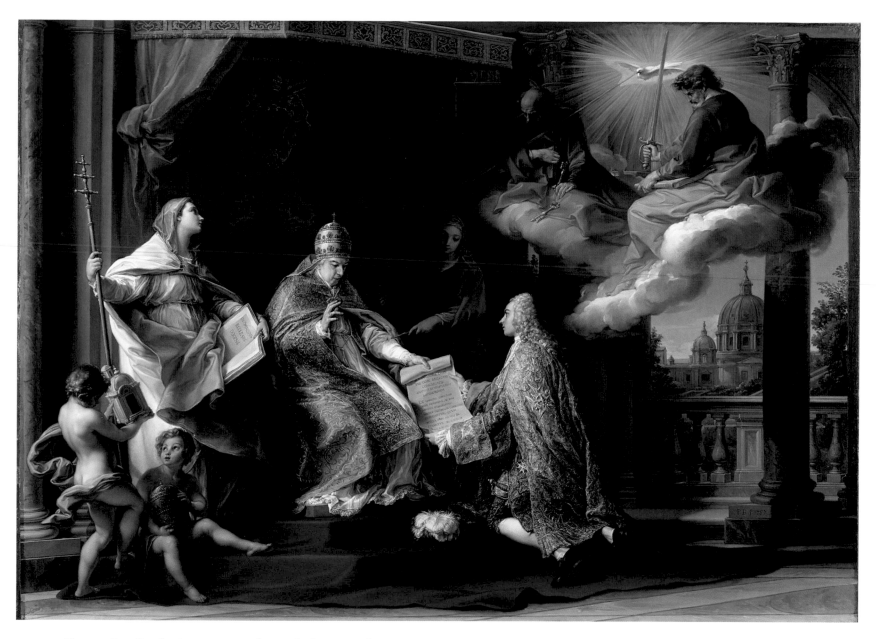

Fig. 108. *Pope Benedict XIV Presenting the Encyclical "Ex Omnibus" to the Comte de Choiseul*, 1757. Oil on canvas, 50¼ × 70⅞ in. (128.9 × 179.5 cm). Minneapolis Institute of Arts; The William Hood Dunwoody Fund.

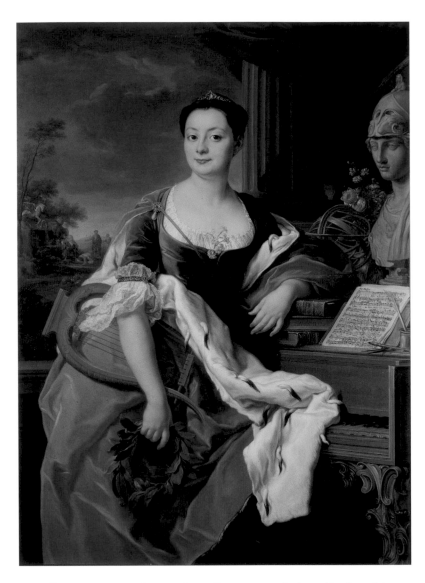

Fig. 109. *Princess Giacinta Orsini Buoncompagni Ludovisi, Duchess of Arce (1741–1759)*, c. 1757–58. Oil on canvas, 53½ × 39 in. (135.9 × 99.1 cm). Collezione Fondazione Cassa di Risparmio di Roma.

did, and the clerical portraits are among the artist's finest creations. Batoni fully understood the conventions of the Roman tradition of ecclesiastical portraiture, based on official portraits from the time of Raphael, established in the early seventeenth century by such painters as Domenichino, and refined more recently by Giovanni Battista Gaulli (1639–1709), Jacob Ferdinand Voet (1639–1689), Maratti, and Trevisani. Austerity, sophistication, and strong likenesses characterised this tradition, and portraits of cardinals and clerics were necessarily more conservative and severe in style than those of rich Protestants on the Grand Tour. Nonetheless, the genre provided a prime

opportunity for the display of Batoni's extraordinary technical skills.

The portrait of Cardinal Prospero Colonna di Sciarra (fig. 110) is more modest in format and less ambitious in conception than some of Batoni's other cardinalate representations, but it is beautifully controlled and exquisitely executed.[160] The painter has invested Cardinal Colonna di Sciarra (identified by the letter held in his left hand) with the dignity and restraint appropriate to his position within the Church hierarchy. To increase attention upon the subject, Batoni often showed no background, and here he has even eliminated the standard Roman ecclesiastical portrait accessories—curtain, table, inkstand, bell, and book. The cardinal's pose and gesture offer the impression that he has been momentarily interrupted while reading, his attention fixed outside the painting and upon the spectator.

Batoni's presentation of Cardinal Jean-François-Joseph de Rochechouart de Faudoas (fig. 111), is far grander than the portrait of Cardinal Colonna di Sciarra.[161] The scion of an illustrious noble family, Rochechouart was elevated to the episcopate while still in his early thirties; Louis XV (1710–1774) nominated him to the See of Laon, one of the most prestigious in the French Church, in 1741. He was selected as the Comte de Choiseul's successor in the post of French ambassador to the Holy See in April 1757. At that point, he was already assured of receiving a red hat, having been promised the King of Poland's nomination to the College of Cardinals.[162] He arrived in Rome in March 1758 and quickly established himself as a respected figure in his new environment.[163] But at the beginning of May, Pope Benedict XIV passed away, and during the ensuing conclave that elected Clement XIII, Rochechouart had to liaise with and provide directions on behalf of the French crown to Cardinal Etienne-René Potier de Gesvres (1697–1774) and Cardinal Paul d'Albert de Luynes (1703–1788), his two compatriots participating in the papal election.[164]

In 1761, King Augustus III of Poland exercised his nomination, and Clement XIII created Rochechouart a cardinal in the consistory of 23 November. For his official portrait marking the occasion, he turned to Batoni, the creator of memorable portraits of two of Rochechouart's closest associates in the Church: Cardinal Colonna di Sciarra, Cardinal Protector of France since 1758, was the ambassador's main

Fig. 110. *Cardinal Prospero Colonna di Sciarra (1707–1765),* c. 1750. Oil on canvas, 39⅝ × 29¹¹⁄₁₆ in. (100.7 × 75.4 cm). The Walters Art Museum, Baltimore.

Fig. 111. *Cardinal Jean-François-Joseph de Rochechouart de Faudoas (1708–1777),* 1762. Oil on canvas, 53¼ × 38½ in. (135.3 × 97.2 cm). Saint Louis Art Museum.

contact in the Roman Curia, while Cardinal de Gesvres had sat to Batoni during his stay in Rome for the conclave of 1758 (1758; San Diego Museum of Art).[165] But Rochechouart's portrait also commemorated a second, no less important, distinction. Louis XV traditionally conferred the Order of the Saint-Esprit upon his French ambassadors to Rome as a reward for a successful diplomatic mission. Having left Rome in April 1762, Rochechouart received the order at Versailles on 30 May, but in Batoni's portrait he is already shown wearing the star of the Order of the Saint-Esprit on top of his watered-silk mozzetta.[166] The explanation for this apparent anachronism is the letter on the table,

inscribed "A Mon Cousin le Cardinal de Rochechouart a Rome." "Cousin" was the traditional form of address employed by princes writing to fellow princes, including princes of the Church, amongst whom Rochechouart now numbered. The portrait therefore displays the letter from Louis XV announcing the award of the order, justifying the fact that its recipient, in spite of still being "à Rome," is wearing the decoration slightly ahead of time. Batoni knew exactly what the order looked like because he had already painted it in the portrait of Cardinal de Gesvres—who, by a similar sleight of hand, is not only shown wearing the order but is also addressed as a "Commandatore del

Fig. 112. *Marqués Manuel de Roda y Arrieta (1708–1782)*, 1765. Oil on canvas, 39 × 29½ in. (99 × 75 cm). Museo de la Real Academia de Bellas Artes de San Fernando, Madrid.

Ordine Dello Spirito Santo" on the letter he holds; the portrait is dated 1758, but Gesvres was only received into the order at Versailles on 2 February 1759. By placing Cardinal de Rochechouart before a neutral background, Batoni emphasises the intensity of his sitter's gaze as well as his own bravura display of brushwork in the description of the shimmering scarlet mozzetta and cassock, and the exquisitely painted lace rochet.

Whether they were clerics or not, many diplomats accredited to the Holy See commissioned a portrait during their mission in Rome, and like Cardinal de Rochechouart, they typically did so as soon as they were informed of their future positions and honours. The Spanish minister

plenipotentiary to the Holy See, Marqués Manuel de Roda y Arrieta (fig. 112), had been in Rome for seven years when he was appointed minister of justice by Charles III in February 1765. In his half-length likeness, the Spaniard is presented with great dignity as an official who has been interrupted while dealing with his correspondence. In a subtle variation on the minor form of time travel in the Gesvres and Rochechouart portraits, the letters to de Roda are not addressed to him in Rome, but to his future position as "Segretario di Grazia e Giustizia S.M.C. Madrid." During de Roda's early days in Rome, he and Batoni had been neighbours in via della Croce. Like his compatriot Don José Moñino y Redondo, Conde de Floridablanca (1728–1808), who sat to Batoni a decade later, de Roda was a staunch opponent of the Jesuits, who were expelled from Spain in 1767.[167] Yet in between portraying two of the most implacable foes of the Society of Jesus, Batoni painted his most influential and widely copied religious image, the *Sacred Heart of Jesus*, 1767 (fig. 113), for Il Gesù, the order's mother church in Rome.

Gaetano II Sforza Cesarini, Duke of Segni, was the son of a former ambassador to the Holy See from the Kingdom of Naples.[168] But rather than following in his father's footsteps, he chose to enter the service of the papal court. Commencing his career as an apostolic protonotary and referendario delle Due Segnature in 1750, he became the head of the administrative council of the Papal States nine years later. Having moved to Perugia as a papal commissioner in 1763, Sforza Cesarini suddenly abandoned his ecclesiastical career the following year after the death of his elder brother, the heir to the title. He nonetheless continued to serve the Papacy and was appointed captain of the papal cavalry guard by Clement XIII in 1766. Portrayed by Batoni two years later, he is shown simply but richly attired, wearing a sword and carrying under his left arm a fur-trimmed tricorne (fig. 114). The artist emphasised the duke's physical presence by placing him against the picture plane and by the muted but deceptively rich colour orchestration—apart from the floridly complexioned flesh tones, the colouring lies mainly in the dark olive of the watered-silk coat and waistcoat and the greyish-blue and silver of its intricate

Fig. 113. *The Sacred Heart of Jesus*, 1767. Oil on copper, 29 × 24 in. (73.7 × 61 cm). Il Gesù, Rome.

"THE RESTORER OF THE ROMAN SCHOOL"

Final Years and Reception

Whilst architects praised the pure proportions of her figure, painters considered her neck, shoulders, and bosom almost too chastely formed; but they all fell in love with her glorious Magdalen hair, and chattered a lot about Batoniesque colouring.

—E. T. A. Hoffmann, "The Sandman" (1817)

On the first Sunday in October 1779, Batoni was summoned to the Palazzo del Quirinale by Pius VI. The pope was keen to see the *Marriage of Saint Catherine with Saints Jerome and Lucy* (fig. 116), and he enthusiastically praised the work.[1] Having painted the official papal portrait to the sitter's great satisfaction, Batoni enjoyed a warm and easygoing relationship with Pius, which included an occasional pontifical patting of the artist's prominent belly or a pinch on the cheek.[2] The altarpiece, like the earlier *Holy Family with Saint Elizabeth and the Infant Saint John the Baptist*, had been painted without a commission. It remained both the most important and the most personal work the seventy-one-year-old artist was to produce for the rest of his life, and his biographer Onofrio Boni did not exaggerate when he praised the *Marriage of Saint Catherine with Saints Jerome and Lucy* as the crowning achievement of Batoni's final years.[3]

In this picture Batoni brought to bear all the experience acquired in five decades of painting, while inserting a number of personal references and reminiscences. With supreme delicacy and tenderness, the central group depicts

Detail, fig. 122

the mystic marriage of Saint Catherine of Alexandria to Christ. As Boni observed, Catherine was the name of Batoni's first wife; Lucy, his second wife's name saint, stands at the left. Jerome, in turn, was the (middle) name saint of Pompeo Girolamo Batoni himself. The figure recalls a depiction of the same saint in an altarpiece by his mentor Francesco Imperiali, the *Virgin of the Rosary with Saints Jerome, Dominic, and Francis* (1723–24; Sant'Andrea, Vetralla), which had influenced the first altarpiece Batoni ever painted (see fig. 1).[4] A variant of this figure appears in an altarpiece of 1780 for Santi Faustino e Giovita in Chiari (fig. 117), a church for which Batoni had already painted an *Immaculate Conception* (see fig. 16) thirty years earlier.[5]

Even if such personal references were lost on the Roman public, people flocked to Batoni's studio in via Bocca di Leone to admire the canvas after its return from

OVERLEAF, LEFT: Fig. 116. *The Marriage of Saint Catherine with Saints Jerome and Lucy*, 1779. Oil on canvas, 89 × 58⅞ in. (226 × 149.5 cm). Palazzo del Quirinale, Rome.

OVERLEAF, RIGHT: Fig. 117. *The Virgin and Child with Saints Jerome, James Major and Philip Neri*, 1780. Oil on canvas, 165⅛ × 86⅛ in. (420 × 220 cm). Santi Faustino e Giovita, Chiari.

the Quirinale, and Chracas commented that Batoni had "painted with art and mastery truly worthy of his renowned brush."[6] When Johann Heinrich Wilhelm Tischbein arrived in Rome in December 1779, his compatriot Puhlmann took him to Batoni's studio, where the new altarpiece remained on display.[7] Recording a conversation with the artist in front of the painting, Tischbein noted in his diary that "the face of Catherine was so beautiful that it can stand side by side with the distinguished old masters. The finger that she holds out for Christ to slip the ring upon was particularly beautiful. 'Should one not believe,' Batoni said, 'that if one touched the thigh of Christ, the flesh would yield?'"[8] Another German visitor to the studio, Friedrich Johann Lorenz Meyer (1760–1844), a lawyer and writer from Hamburg, told Batoni that he admired "in the figure of the Christ Child the veracity of expression, the childish innocence, and the beauty of the skin tone. 'It seems to be alive,' I added. 'It seems to be?' he replied, 'che volete fare, if I had not painted that child there myself, truly I would mistake it for a real one.'"[9]

The critical success of the *Marriage of Saint Catherine with Saints Jerome and Lucy* could not compensate for the fact that no one was prepared to meet Batoni's price, presumably the same 1,500 zecchini he wanted for *The Holy Family with Saint Elizabeth and the Infant Saint John the Baptist,* a picture of similar size and complexity.[10] When the German Protestant theologian and historian Friedrich Münter (1761–1830) visited Batoni's studio seven years after the completion of the altarpiece, he joined Tischbein in praising the saint's physical beauty—a beauty that, alas, still had not attracted a client for the picture: "We saw the Marriage of Saint Catherine, which was truly good. The Saint Catherine has a very beautiful face."[11]

After 1780, as the stream of wealthy tourists visiting Rome dried up, Batoni's bread-and-butter portrait business began to flag, and he found himself increasingly short of money.[12] The most significant commission of his final years was a series of seven monumental altarpieces ordered by Queen Maria I Bragança (1734–1816) for the Carmelite Basilica of the Estrêla in Lisbon, built between 1779 and 1789 and dedicated to the Sacred Heart.[13] The Portuguese ambassadors to the Holy See, Henrique de Meneses (1727–1787), 3rd Marquis of Louriçal, who held the post from 1778 until 1782, and Diogo de Noronha (1747–1806),

his successor for the next four years, closely supervised the execution of the canvases, as is documented in the extensive correspondence between Rome and Lisbon generated by the project.[14]

Having initially demanded 6,000 scudi for the *Allegory of the Universal Devotion to the Sacred Heart of Jesus* (1781; Basilica of the Estrêla, Lisbon), Batoni had to settle for 3,000 scudi and a promise of further commissions from the Portuguese crown. Destined for the Estrêla's high altar, the painting measured a formidable 202 by 101 inches (513 by 257 cm). Pius VI, who continued his routine of personally studying every major picture that Batoni produced, had to visit the studio in order to admire the canvas, instead of having it carried to the Quirinale. On 15 October 1781, the pope arrived on foot, stayed for an hour, and granted Batoni the special honour of offering him his hand rather than his foot to kiss.[15]

Even Batoni's steadfast supporters, however, had to acknowledge that the septuagenarian painter's creative powers were beginning to falter. Father Thorpe, a former Jesuit with a strong personal veneration for the cult of the Sacred Heart, would have been disposed toward this particular subject, but even he, after observing the work in progress, predicted that "the picture will have its beauties, but will scarce escape some just censure in point of composition & expression."[16] Indeed, this prophecy was borne out when the altarpiece had been installed in the church. When visiting Lisbon, the English poet Robert Southey (1774–1843) pointedly noted that in the *Allegory of the Universal Devotion to the Sacred Heart of Jesus,* among the personifications of the four parts of the world, "the figure of Europe is that of a female loosely dressed, on a horse whose hinder parts are foremost on the canvass. A Portugueze remarked, that it was very wrong to place such an altar-piece there, and make people kneel to an half-naked woman, and the rump of a horse."[17]

Late Works and Declining Health

In the early 1780s, Batoni's health appears to have been holding up reasonably well. Thorpe, whose patron Lord Arundell had met the artist in 1760, reported that "the good old man . . . looks as fresh & lively as when Your Lordship saw him," while another contemporary observer, the painter Antonio Longo (1742–1820), was astonished to

Fig. 118. *Prince Benedetto Giustiniani (1757–1793)*, 1785. Oil on canvas, 28¼ × 24 in. (73 × 61 cm). Private collection.

Fig. 119. *Princess Cecilia Mahony Giustiniani (1741–1789)*, 1785. Oil on canvas, 28¼ × 24 in. (73 × 61 cm). National Gallery of Scotland, Edinburgh.

find that "in spite of his advanced age Batoni is toiling with the same diligence and rapidity as ever, and in 1781 he was said to have received, for a large altarpiece for Portugal and a number of portraits, the sum of five thousand zecchini."[18] But in July 1785, Puhlmann remarked that Batoni's eyesight was deteriorating, and that he was not attracting enough commissions to keep him busy: "I don't know how he will occupy himself once the work for Portugal has ended."[19]

Nonetheless, James Byres noted that the likenesses of Prince Benedetto Giustiniani and his wife, Princess Cecilia Mahony Giustiniani (figs. 118, 119), begun in June 1785 and finished within a month, turned out "very like [their sitters], and were seen for eight days at the Giustiniani palace and much approved by the connexions of the family, the Roman nobility and artists."[20] The two portraits are remarkable for their loosened handling and lack of finish as well as for their perceptive characterisation and truthfulness, for instance in the way Batoni recorded the unsightly

effects of the prince's cataract operation. The chromatic contrasts, softened by touches of grey in the hair and costume, the simplicity of composition, and the inherent reserve in the sitters' demeanour all exemplify the qualities of Batoni's late portraiture. The princess's costume is one of the earliest and most beautifully executed examples of a painted depiction of a chemise dress. When it appeared in the 1780s, this sartorial innovation startled many by its connotations of déshabillé, or undress. Derived from the basic undergarment, the shift or chemise, it was a simple linen or cotton dress pulled on over the head, allowing the wearer to dispense with the boned stays and bodices of formal gowns. Fastened by a ribbon at the neck and girdled round the waist by a sash, the chemise dress, with its multiple small folds, gave Batoni an ideal opportunity for free and lively brushwork.

By June 1786, the painter could no longer properly distinguish colours and was described as "a venerable, cheerful

and sprightly old man of eighty-seven years of age," but it was noted that "his recent paintings are no good because he cannot see anymore. A few years ago, however, he was still painting well."[21] After a stroke had left Batoni temporarily incapacitated, he recovered sufficiently to work on a series of seven Madonnas, one for each female member of his household.[22] On 4 February 1787, three days after a second severe stroke, Batoni died at nine o'clock in the morning. Father Thorpe wrote to Lord Arundell: "Above twelve months ago he had been touched by an Apoplexy, which did hinder him from finishing some paintings for the Queen of Portugal, & others. Afterwards he began to decline apace, but insensibly to himself, however he began to paint a Madonna for each of his numerous family, as a Memento of his tender affection for his children by three [sic] wives. He then out of devotion began to paint what he called the Litanies of our B.d Lady, or a picture adapted to the meaning of each invocation; he painted to his last day, but more than a week before his Exit, he mistoke the situation of eyes, noses, & mouth; & put six fingures to a hand."[23]

Batoni was interred at his parish church of San Lorenzo in Lucina, in a grave that no longer exists.[24] In his will of 7 October 1786, he had specified that his wife, Lucia, was to receive the 2,000 scudi her family had paid to him as her dowry forty years earlier, as well as a further 1,000 scudi, a diamond ring given to Batoni by Empress Maria Theresa, and one of the seven Madonnas. With the exception of Maria Chiara and Luisa Maria, who had entered convents, each of his daughters was bequeathed, apart from a Madonna, 1,000 scudi toward her dowry, so that they could "maintain and place themselves according to my and their rank."[25] The remainder of the estate, which included a vineyard on the slopes of Monte Mario, was to be divided evenly between his four sons, Paolo (1733–1787), Felice (1739–1798), Domenico (1760–1806), and Romualdo (1763–1819), and the five daughters, Maria Carlotta (born c. 1749), Maria Angela (born c. 1753), Maria Felice (born c. 1757), Maria Benedetta (born c. 1759), and Marianna (born c. 1762).

The contents of the will quickly became public knowledge and were even reported in a German journal.[26] As his executors, Batoni had named the secretary of the Congregation of the Council, Filippo Carandini (1729–1810), created a cardinal shortly before the artist's death, and James Byres.

When they put the will into effect, however, the estate turned out to be insolvent, as Puhlmann reported: "The trouble is that the funds of his bequest cannot be found, [and the heirs] are already suing each other."[27] In addition to the expense of maintaining a large family in a household that included a cook and two maids, the pious artist's generous almsgiving had further depleted his finances.[28] The estate's main assets, apart from the vineyard, were the stock of pictures and a cache of drawings.[29] The paintings proved to be no easier to sell after Batoni's death than during his lifetime. Notwithstanding the best efforts of Onofrio Boni, whose eulogy of 1787 reads occasionally like a sales prospectus for works in the possession of Batoni's heirs, the two most important pictures remained unsold fifteen years later.[30] An 1802 inventory of private art collections in Rome still listed the *Marriage of Saint Catherine with Saints Jerome and Lucy* and a large *Last Supper* (untraced) as "with the heirs of the late Cav. Pompeo Girolamo Batoni."[31]

Critical Fortunes

In November 1787, Batoni's widow petitioned Leopold, Grand Duke of Tuscany, who had been depicted by the artist in the celebrated double portrait with his brother Joseph II, for financial assistance, describing her family's desperate situation and offering her husband's unfinished self-portrait (fig. 120).[32] On the ground floor of the house at 25 via Bocca di Leone, where Joseph and Leopold, Pope Pius VI, Grand Duke Paul of Russia, and many other members of the highest echelons of European society had sat to Batoni, attended his musical soirées, and admired his paintings, his wife and children now opened a wine tavern.[33] Part of the space was rented out to visiting artists. When the German painter Asmus Jakob Carstens (1754–1798) held an exhibition of his work in April 1795, he advertised it as held "in the house of the late Pompeo Batoni."[34] But not everyone shared Carstens's faith in the posthumous value of the artist's name. Less than two years after Batoni's death, Sir Joshua Reynolds delivered in his Fourteenth Discourse to the Royal Academy the prediction that "two of the last distinguished Painters of that country [the Roman School], I mean Pompeio Battoni, and Raffaelle Mengs, however great their names may at present sound in our ears, will very soon fall into the rank of Imperiale, Sebastian Concha,

Placido Constanza, Massuccio [Agostino Masucci] and the rest of their immediate predecessors; whose names, though equally renowned in their lifetime, are now fallen into what is little short of total oblivion."[35]

The appreciation of Batoni's art in Britain was shaped by the fact that his pictures there were predominantly portraits, as underscored by the English physician and author John Aikin's observation that "it was as a portrait painter that he acquired his principal fame, and few eminent persons visited Rome in his time who were not desirous

Fig. 120. *Self-portrait,* 1773–74. Oil on canvas, 39¼ × 24 in. (75.5 × 61 cm). Galleria degli Uffizi, Florence.

of possessing their likenesses from his pencil."[36] Yet most of these paintings remained out of the public eye, in the private houses of the sitters' families, and only one appears to have been exhibited in London in the artist's lifetime.[37] Batoni thus became a sort of king without a country— praised for pictures few had a chance to see. When Horace Mann the younger (1744–1814) inherited a version of the portrait of the Duke of York, he wrote to Horace Walpole: "It is a most excellent picture, and being given to my uncle by the Duke, I thought it most proper to offer it to the King [George III, the sitter's brother], and in a short time it will ornament an apartment and be invisible."[38] Moreover, the historical interest of the portraits was diminished by

the fact that the majority of the milordi sat to Batoni in their twenties, before they had had a chance to make a mark on British public life.

Rising national pride in the rapid development of British portrait painting during Batoni's lifetime, with Reynolds as its most ardent advocate, further contributed to a decline in Batoni's status. Henry Bankes, when sitting to Batoni in 1779, observed that "his colors stand much better than Sir Joshua's, tho' for forte and everything else I do not think equal to him."[39] Neville Wyndham's evaluation of the artist, while sympathetic, makes a similar point:

Pompeo Battoni is the best Italian painter now at Rome. His taste and genius led him to history painting, and his reputation was originally acquired in that line; but by far the greater part of his fortune, whatever that may be, has flowed through a different channel. His chief employment, for many years past, has been painting the portraits of the young English, and other strangers of fortune, who visit Rome. There are artists in England, superior in this, and every other branch of painting, to Battoni. They, like him, are seduced from the free walks of genius, and chained, by interest, to the servile drudgery of copying faces. Beauty is worthy of the most delicate pencil; but, gracious heaven! why should every periwig-pated fellow, without countenance or character, insist on seeing his chubby cheeks on canvas?[40]

Acknowledging Batoni as a figurehead of the contemporary Italian school, on the other hand, was uncontroversial. Frederick Hervey, Bishop of Derry and later 4th Earl of Bristol, who himself had sat to the painter,[41] dreamed up a scheme for a picture gallery in his house at Ballyscullion, which was to illustrate the history of Italian painting since Cimabue (c. 1240–1302), culminating in Batoni: "I shall have . . . two Galleries, one for a series of German painters, the other for a Chain of Italian painters, and by good luck I have found at Sienna a picture of Guido da Sienna with its date upon it thirty years older than Cimabue, generally supposed to be the restorer of painting in Italy: such an History of the Progress of Painting down to Pompeo Batoni cannot but be amusing: and young geniusses who cannot afford to travel to Italy may come into my home and there copy the best masters."[42]

The collection assembled by the Milltown family, several members of which had been painted by Batoni, was much less ambitious, but unlike the Earl of Bristol's, it progressed beyond the drawing board.[43] The description of Russborough, the family seat, in *The Post-Chaise Companion: or, Travellers Directory Through Ireland* (1786) places Batoni above most of his peers: "a most valuable collection of paintings by Poussin, Both, Wouwerman, Bergham, Guercino, Teniers, C. Maratti, Rubens, Vandyke, Vernet, Barret, Sir Joshua Reynolds, and other eminent masters; amongst which are two celebrated pictures, Benjamin and the Cup, by Poussin; and an antique Venus, by P. Battoni."[44] Batoni was granted the accolade of being "the most eminent Italian painter of the 18th century" with some frequency by both British and continental observers.[45] In his *England und Italien* (1785), which appeared in English translation as *A Picture of Italy* in 1791, the German historian Johann Wilhelm von Archenholz (1743–1812), who had visited Rome in the late 1770s, stated that Batoni was "now universally acknowledged as the premier painter in Italy."[46] Johann Georg Meusel's journal *Miscellaneen artistischen Inhalts*, reporting the artist's death, called him "the most famous Italian painter of our time."[47] But after the turn of the century, Reynolds's prophecy was borne out, and apart from entries in a few reference works, British writers either ignored Batoni altogether or, like the English churchman and antiquary James Dallaway (1763–1834), were superficial in their characterisations of the artist: "Pompeio Battoni was a very excellent copyist, of which talent there are many specimens in England; particularly of the works of Raffaelle, in the Vatican chambers at Northumberland House."[48]

In a revised edition of his *Examen critique des différentes écoles de peinture* (1768), the Marquis d'Argens observed: "Mr. Batoni, who is considered the best painter in Rome today, has correct drawing, but is a little challenged in the contours; his pictures are highly finished, and painted with beautiful brushwork; his colouring is fresh and graceful; his draperies are well arranged, but sometimes too conspicuous. His composition, without being particularly inventive, is ingenious."[49] As a trusted advisor to Frederick II of Prussia, Argens was partly responsible for shaping the monarch's collecting policy, which had undergone a fundamental change. Having favoured the *fêtes galantes* of Antoine Watteau (1684–1721), Nicolas Lancret (1690–1743),

and Jean-Baptiste Pater (1695–1736) in the 1730s and 1740s, the king now primarily acquired Flemish and Italian sixteenth- and seventeenth-century history paintings. In 1764, a year after the end of the Seven Years' War—when Frederick's thoughts had turned from the battlefield back to his art collection—the author Friedrich Nicolai (1733–1811), another member of the royal inner circle, wrote to Christian Ludwig von Hagedorn (1712–1780), the newly appointed director of the Dresden gallery: "The King now loves painting very much and spends at least four hours a day in his new gallery. Between you and me, he has acquired a taste for Correggio and Rubens in Dresden, and has now learnt to assess those masters of which he used to think the world, according to their true worth. The Marquis d'Argens has contributed something to this."[50]

Apart from the influence wielded by his sister Wilhelmine of Bayreuth, the watershed event in the reorientation of Frederick's artistic tastes had been his stay in Dresden, as Nicolai correctly diagnosed.[51] Living in the Palais Brühl from November 1756 until March 1757, with hostilities in the Seven Years' War suspended for the winter, the king found himself with plenty of time on his hands. One of his few pleasures, he told Wilhelmine, was the electoral picture gallery.[52] While Augustus III, Elector of Saxony and King of Poland (1696–1763), had fled to Warsaw, the Saxon crown prince, Friedrich Christian (1722–1763), remained in Dresden. During the Prussian occupation of his hometown, the prince tracked Frederick's movements in his diary, and noted that within a week of his arrival, the king and his brothers had visited the gallery.[53]

The gallery's inspector, Johann Anton Riedel (1736–1816), also recorded the Prussian royal visit: "On 23 November 1756, after the arrival of the Prussian garrison, King Frederick II, the Princes Henry and Ferdinand of Prussia, and their numerous entourage were in the gallery. During a second visit on 22 December, the King ordered a copy of the Magdalen by Batoni, but without the skull, from the court painter Dietrich, which was already handed over . . . to the King of Prussia in his headquarters in the Palais Brühl on 17 March 1757."[54] Among those accompanying Frederick on his gallery visits was the Marquis d'Argens.[55]

If there was one picture more than any other that determined Batoni's critical fortunes, it was the *Saint Mary Magdalene* (formerly Gemäldegalerie, Dresden; see fig. 121).[56]

Executed around 1742 for Count Cesare Merenda, the painting had been sold to Augustus III before 1754, when it was recorded in an inventory of the Dresden gallery compiled by Matthias Oesterreich.[57] A grandson of the painter Godfrey Kneller (1646–1723), Oesterreich made two trips to Italy, in 1745–46 and 1749–50, and may well have met Batoni in Rome, or at least come into contact with his work. Upon his return to Germany, Oesterreich obtained a post in the print room of the Dresden electoral collections before being appointed subinspector of the picture gallery in 1754.[58]

Frederick was looking for an expert to build up his collection in Potsdam, and Oesterreich's knowledge of Italian art appears to have impressed him during one of the gallery visits. In February 1757, the king appointed Oesterreich inspector of the picture gallery at Sanssouci, with overall responsibility for the works of art in the royal palaces at Berlin and Potsdam.[59] For the Saxons, accepting a post from the enemy ruler occupying Dresden was akin to desertion, and when Winckelmann heard about the affair, he dubbed Oesterreich an "idiot" and a "swindler" who "brings shame to the dirt he walks on."[60] Irrespective of his competence, Oesterreich certainly knew on which side his bread was buttered. When describing the *Finding of Moses,* a painting by Batoni that Frederick must have acquired during his tenure, Oesterreich underlined (not entirely accurately) its closeness to the *Saint Mary Magdalene,* the first picture by Batoni the king had seen and which had left a lasting impression on him.[61]

Batoni's inspiration for his depiction of the saint reclining in the wilderness had been a small *Saint Mary Magdalene* (formerly Gemäldegalerie, Dresden) by Correggio.[62] This work was well known from numerous copies, one of which Batoni may have painted himself—in 1782, Grand Duchess Maria Feodorovna purchased from him "an imitation of the Magdalen by Correggio, the original of which is in Dresden."[63] A guide to the Dresden gallery published that same year noted that Batoni "has chiefly distinguished himself by the beautiful melting colours in the taste of Correggio, and by the expressiveness of his paintings."[64] The emulation of the Emilian master, the favourite painter of the king's later years, was probably the main reason why Batoni's penitent Magdalen struck the right chord with Frederick. Significantly, Oesterreich's hanging plan of 1774 for the Blue Chamber—the first anteroom of the king's

private apartments—on the ground floor of the Neues Palais in Potsdam shows the copy painted in Dresden by Christian Wilhelm Ernst Dietrich (1712–1774) in the centre of the wall, underneath a copy of Correggio's *Adoration of the Shepherds* (*La Notte*, 1522–30; Gemäldegalerie, Dresden), also by Dietrich. Batoni's *Alexander and the Family of Darius*, although in fact still unfinished in Rome, and the *Finding of Moses* are shown as installed in the same room.[65]

Frederick was far from alone in his enthusiasm for Batoni's *Saint Mary Magdalene*. The painting continued to win plaudits from German critics and was singled out in the standard art-historical works of the time. Johann Dominik Fiorillo praised the "stunningly lovely picture of the penitent Magdalen in the Dresden gallery," while Johann Heinrich Meyer (1760–1832) noted it as "one of Batoni's most beautiful pictures."[66] In 1788, Karl Heinrich von Heinecken's *Dictionnaire des artistes, dont nous avons des estampes, avec une notice détaillée de leurs ouvrages gravés* already listed four engravings after the painting, by Giuseppe Camerata (1718–1803), Johann Friedrich Bause (1738–1814), Carl von Pechwell (1742–1789), and Johann Conrad Krüger (1733–1791).[67] Innumerable copies were made—Anton Graff alone was said to have reproduced the image fourteen times (fig. 121).[68]

The *Saint Mary Magdalene* achieved such fame in Germany that the author E. T. A. Hoffmann (1776–1822) employed it as a metaphor for female beauty and desirability when describing the character Clara in his short story "The Sandman" (1817): "Whilst architects praised the pure proportions of her figure, painters considered her neck, shoulders, and bosom almost too chastely formed; but they all fell in love with her glorious Magdalen hair, and chattered a lot about Batoniesque colouring."[69] For Friedrich Johann Lorenz Meyer, who visited Batoni in Rome in 1783, the picture remained a milestone in the artist's career:

> Pompeo Batoni experienced . . . envy and disparagement from many of his contemporaries; he was more indulgent and fair to them. . . . He loved and gladly supported every young artist who approached him, provided advice and guidance, noted his talents, and encouraged him to persevere in his progress towards the great goal. Batoni's pictures are not entirely free of errors in drawing and pose; they are accused of a certain tiresome uniformity of tone: but which of his

great predecessors was completely flawless? This great man, with all his merits, did not deserve to be so bitterly reproached in Rome for these shortcomings of his art. His works remain models of emulation, in the veracity and diversity of expression, in the beauty of the draperies, and in the harmony of the colours. . . . Notwithstanding some artist's whims and peculiarities, which in his old age often turned into undue egotism, Batoni possessed a charming goodness and openness of character, and until his death he retained his diligence in the mechanical execution of his paintings and an astonishing rapidity and ease of working. He always preserved his engaging cheerfulness, and even in the paintings of his final years he revealed no decline of his mental faculties. He always remained the same in the considerable degree of artistic skill he had acquired at an early stage. The outstanding Magdalen in the Dresden gallery, painted forty years ago, entirely matched the manner of the pictures I saw him working on: and one could not flatter the old man more highly than by noting this consistency of his brush.[70]

The characterisation of Batoni in the 1779 edition of a dictionary of artists compiled by Johann Rudolf Füssli (1709–1793) appears to have been lifted directly from the Marquis d'Argens's *Examen critique des différentes écoles de peinture*. Instead of the pictures in the collection of Frederick II, the Swiss author extolled the two altarpieces in Santa Maria della Pace, Brescia, and named the ceiling paintings in the Palazzo Colonna, Rome, as Batoni's "best work" (see figs. 2, 25, and 7). Füssli then arrived at the somewhat unexpected conclusion that "Batoni's strength lies primarily in his portraits, which he often painted for Englishmen."[71] But the celebrity of the *Saint Mary Magdalene* ensured that in German-speaking Europe at least, Batoni was judged equally distinguished as a history painter and portraitist. Fiorillo emphasised both genres when acknowledging the artist's "significant talent for portrait painting (which is rarely found united to such a degree with an aptitude for history painting)," and Heinecken (1707–1791) affirmed that Batoni "paints portraits and history pictures with great success."[72]

The archaeologist and historian Aloys Hirt (1759–1836), who lived in Rome from 1782 until 1796 and served as Goethe's and Johann Gottfried Herder's guide, compiled a

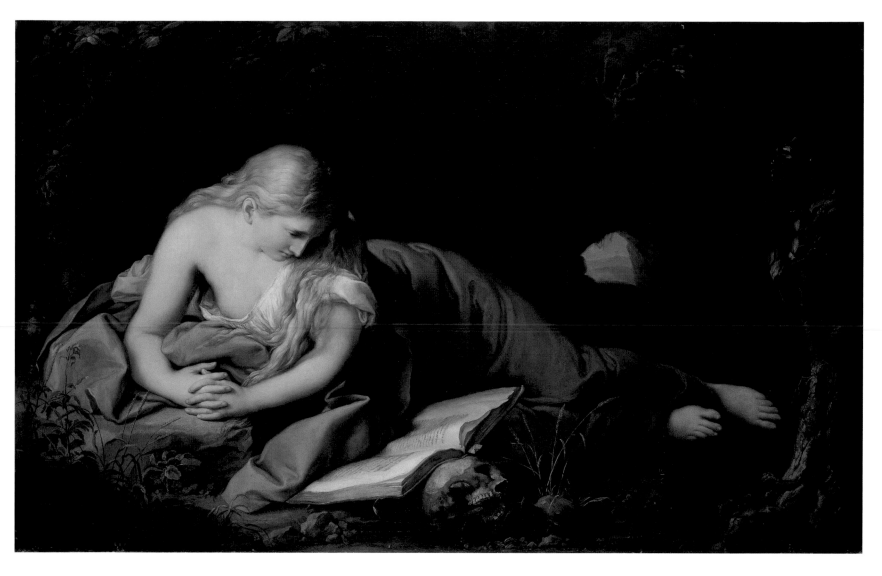

Fig. 121. Anton Graff (1736–1813), *Saint Mary Magdalene* (after Batoni), 1800. Oil on canvas, 46⅞ × 73 in. (119.1 × 185.4 cm). Private collection.

directory of artists working in the city in 1787. He noted that Batoni had "recently passed away in his seventies, with a reputation as one of the premier artists of his time. His pleasing and pure manner of painting is well-known. He was equally strong in portraits as in history paintings."[73] After Britain, Germany had been the most important foreign destination of Batoni's work, and his death was widely noted there. In addition to the obituary in the *Miscellaneen artistischen Inhalts,* the journal *Der Teutsche Merkur* published Onofrio Boni's *Elogio di Pompeo Girolamo Batoni* (1787) in an abbreviated German translation by Christian Joseph Jagemann (1735–1804) in 1789.[74]

A Poet in the Grand Manner

Batoni's posthumous reputation has been affected by the fact that, apart from some personal letters, he left no written legacy. A manuscript on the composition of history pictures, finished in July 1777, remained unpublished.[75] Rome's forum for theoretically inclined artists, the Accademia di San Luca, was largely shunned by Batoni, who attended its monthly meetings only twenty-six times in his forty-five years as a member.[76] He did not feel at home in the world of programmatic speeches and abstract treatises, and when he was nominated (in his absence) for the presidency in 1770, he declined.[77]

Batoni did, however, possess an authoritative pictorial erudition that enabled him to devise highly original literary programmes for his works. The creation of these *concetti* was a matter of the greatest importance for him and is

a frequently recurring theme in his letters. As early as 1740, he emphasised that his depiction of the Prometheus myth "has never been seen before in painting"; in 1744, he described the subjects of *Time Orders Old Age to Destroy Beauty* and the *Allegory of Lasciviousness* as the "offspring of my imagination"; and in 1761, he pointed out that *Thetis Entrusting Chiron with the Education of Achilles* represented a "new, poetic subject, never done by anybody."[78] When Batoni exhibited *Chiron Returns Achilles to Thetis* in 1770, Chracas reported that the work was lauded for its "beautiful poetic composition, which is all new and has never been painted before."[79]

Batoni's formidable ability to conceive and execute arresting history pictures grew out of his thorough engagement with a wide variety of written sources comprising Greek and Roman mythology, ancient history, and Christianity. A case in point is his letter concerning *Thetis Entrusting Chiron with the Education of Achilles.* Following a precise explanation of his concetto, the painter proceeded to list the skills Achilles was taught by Chiron. One of them, described in Statius's *Achilleid* (1:116–17) but rarely depicted in art, was the use of medicinal herbs, which appear both in this picture and in the *Education of Achilles* (see figs. 89, 27).[80] Batoni's broad learning was complemented by his ingenuity in shaping the requirements of the text into a persuasive pictorial narrative. His acute visual intelligence also enabled him to incorporate quotations from antique sculpture into his compositions so convincingly that, while remaining recognisable, they became an integral and natural part of their new environment. In the full-length portrait of *Sir Wyndham Knatchbull-Wyndham* (see fig. 57), a vivacious greyhound jumps to reach its master while balancing itself on the chair with one paw. The lifelike animal persuades the viewer that such a depiction must have been based on the study of a real dog—until it is compared to the dog in the *Endymion Relief* (see fig. 124).[81] The *Younger Furietti Centaur* (see fig. 128) making an appearance in the *Education of Achilles* is another example of an erudite quotation entirely at home in its adoptive setting.[82]

In September 1776, Batoni finished his allegory of *Peace and War* (fig. 122).[83] The concetto was devised by the artist himself, who was said to be "proud of this idea as something new."[84] The picture had been executed without a specific patron in mind, as Father Thorpe noted:

[Batoni] has finished his picture of two figures representing *Peace & War*: it is truely a masterpiece, & shows powers perhaps superior to any master who ever painted at his time of life: it has all the perfection & brilliancy of his best & favourite performances. War is represented in the character of Mars in armour, with his helmet on, & sword drawn rushing to battle. Peace is figured by a most amiable young female with all the charms of beauty & modesty, who meeting Mars with one hand gently presses back his sword hand, while with the other she sweetly offers him her Olive branch. It was not painted by commission, nor will the painter part with it unless tempted by a very high recompence. He intends to make a companion for it, thus, *War* by the persuasion of *Peace*, sheathing his sword smiles upon the *Arts* presented to him by Peace.[85]

Puhlmann observed that the painting "shows War as a young hero, who is held back by Peace, a young, graceful girl. It is one of the most beautiful things he has ever done."[86] An anonymous contemporary writer described it as "representing Peace and War by means of a Venus, who is nude and very tenderly presents herself to Mars, inviting him to embrace her and offering him an olive branch," adding that, because of the Venus, "this is a very scandalous picture."[87] The figure's face, pose, and parts of her body echo Psyche in the *Cupid and Psyche* group, one of the ancient sculptures drawn by Batoni for Richard Topham (see fig. 125).[88]

Boni, in turn, outlined the picture's programme as "Peace and War, in three-quarter-length figures. A graceful and beautiful virgin presents herself to a furious and armoured Mars, sword in hand and about to rush off into battle. Looking at him tenderly and holding him back in his fury, she offers him an olive branch. In the head of Mars, one recognises the ferocious Caracalla, but he is ennobled and improved by the painter's genius."[89] The bust of Caracalla to which Boni referred existed in numerous versions, the most famous of which was on display in the Palazzo Farnese in Rome until 1786.[90] Batoni adopted

Fig. 122. *Peace and War*, 1776. Oil on canvas, 53½ × 39 in. (136 × 99 cm). The Art Institute of Chicago; Gift of the Old Masters Society.

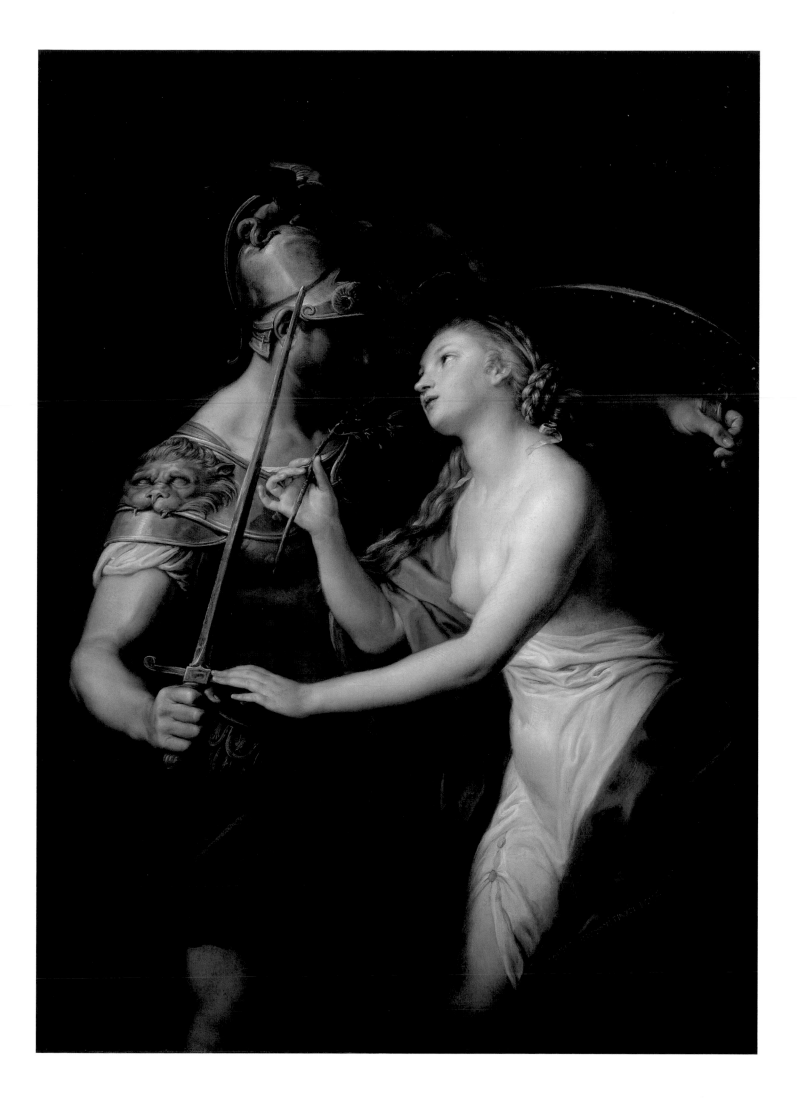

the fierce facial expression, slightly opened lips, dimpled chin, and sparse beard. These citations from antiquity are inserted almost imperceptibly into the painting and provide both visual and contextual references. Visually, they offer the beholder the gratification of identifying two celebrated sculptures, thus confirming his or her own learning; contextually, the connotations of Psyche's tenderness and Caracalla's bloodthirstiness (the tyrant had murdered his wife and brother) amplify the painting's basic concept, the contrast between "two passions so strongly opposed to each other," as the anonymous writer aptly put it.[91]

The four descriptions of *Peace and War* are remarkably similar, even though they were written independent of one another. The parallels are based on the fact that the four authors summarised the same concetto, which Batoni must have explained to each of them in more or less the same words when discussing the painting. Father Thorpe even distinguished between the artist's and his own interpretation: "I do not know whether Pompeo intended it, but he has made a pretty allegory in raising the shield of *War* over the head of Peace, while she is stopping his sword."[92]

The "poetic" originality of Batoni's art was later singled out by Luigi Lanzi, the most important writer on art who had known both Batoni and his works first hand. In his magisterial *Storia pittorica della Italia* (1809), he identified Batoni as "the restorer of the Roman School, where he lived until his seventy-ninth year, and educated many pupils in his profession."[93] Lanzi was one of the few critics to penetrate to the heart of Batoni's art and resolve the ostensible conflict between his disregard of theoretical writings on one hand and the deeply learned character of many of his pictures on the other: "Although he was not a man of letters, he showed himself a poet both in the grand and the graceful manner."[94]

Paradoxically, an objective assessment of Batoni's artistic achievement is often prevented by the exceptionally high level of craftsmanship in his paintings, which eclipses their intellectual content. Whereas critics such as Lanzi and the two (unrelated) Meyers, having met the artist and studied a number of his paintings, understood and acknowledged Batoni's pictorial erudition, many later writers did not. When Henry Fuseli (1741–1825) revised Matthew Pilkington's *Dictionary of Painters* for its 1805 edition, he added an entry for Batoni, who had not appeared in the first edition

of 1770: "He was not a very learned artist, nor did he supply his want of knowledge by deep reflection. His works do not bear the appearance of an attentive study of the antique, or of the works of Raphael, and the other great masters of Italy. . . . He was not wanting either in his delineation of character, in accuracy, or in pleasing representation; and if he had not a grand conception, he at least knew how to describe well what he had conceived. He would have been, in any age, reckoned a very estimable painter: at the time in which he lived, he certainly shone conspicuously."[95]

But rather than reflecting Fuseli's own conclusions, the text was in fact a word-for-word translation of an entry in the 1792 *Dictionnaire des arts de peinture, sculpture et gravure* by Claude-Henri Watelet (1718–1786) and Pierre-Charles Lévesque (1736–1812), eliminating only the affirmation that Batoni was "the most celebrated painter Italy has produced in this century."[96] In 1816, Michael Bryan's *Biographical and Critical Dictionary of Painters and Engravers* offered an evaluation broadly in line with Watelet and Fuseli: "His works [do not] exhibit any proof of his having bestowed much attention on the theory of the art. Without possessing much genius or academic learning, his pleasing style of colouring, and a certain agreeable character in the airs of his heads, rendered his pictures exceedingly popular, and his works were held in considerable estimation all over Europe."[97] In some cases, such superficial judgements persisted into the second half of the twentieth century, and Batoni's subject pictures were dismissed as art in which "almost nothing is said, but the means of expression are exquisitely competent" and deemed "essentially decorative and unlearned," while his portraits have been characterised as "superlatively good furniture-pieces, . . . well-mannered and excellently made."[98]

Batoni certainly considered himself first and foremost a history painter, and he was described as a *celebre pittore istorico* even in the notice reporting the completion of the grand full-length portraits of Carl Eugen, Duke of Württemberg, and Duchess Elisabeth Friederike Sophie.[99] Like numerous artists before him, he looked for ways to extend the prestige attached to history painting into the lucrative portrait business through the introduction of allegorical elements, resulting in the hybrid genre of the portrait historié, or *ritratto istoriato*, as one of Batoni's works was designated in an export permit of 1767.[100] In addition to

their full-lengths, the Duke and Duchess of Württemberg commissioned a pair of allegorical portraits of this type, leaving the choice of subject to Batoni, who selected War and Peace.[101] The portrait historié played an important part in Batoni's output throughout his career, stretching from the series of half-lengths of the Fetherstonhaugh family and their relations as deities and personifications in 1751 to the pendants of Aleksandra and Isabella Lubomirska as the muses Melpomene and Euterpe (1780; National Museum, Warsaw).[102] In a number of instances, the distinctions between subject pictures and portraits are blurred to the extent that it becomes difficult to assign a painting to one or the other group.[103]

Of course, not every client appreciated the idea of being depicted as an allegorical or a historical figure. When the Duchess of Gloucester sat to Batoni with her newborn son in 1776 (see fig. 102), Father Thorpe reported that "Pompeo would have put her in the character of Pharaoh's daughter, & the child, like a little Moses, in a cradle of rushes, but the proposal was not received."[104] In the likeness of Princess Sophia Matilda (untraced), the three-year-old daughter of the Duke and Duchess of Gloucester was intended to be shown as "throwing a yoke upon a Lion. The idea is very pretty, but may gave [sic] offence in England if it be as it very likely will be taken in an allegorical meaning as if this girl would in time, or some of her relations actually had enslaved the nation. But Pompeo had a much more harmless

intent in putting the little creature in this attitude: he did it to express the uncommon fearlessness which the child contrary to the custom of her age & sex always shows at the sight of a Lion. It was first observed at Venice, where I am assured that she went up to a living Lion, stroked & patted the beast, & shewed herself to be more pleased with him than if he had been a lapdog."[105] When the picture was completed in January 1777, Father Thorpe was relieved to find that "the impropriety of her laying a yoke on the Lyon's neck, has been noticed, & a riband is painted instead of the yoke."[106]

The yoke that Batoni himself threw off early in his career, at the beginning of the 1740s, was the constraint of a literary programme stipulated by the patron. Successful and sought-after, he was—by eighteenth-century standards—able to work largely on his own terms, creating his own concetti for the majority of his history paintings. In one of his letters, he identified poetry as "the soul of painting" and alluded to the famous aphorism that "painting is mute poetry, poetry a speaking picture."[107] For an artist like Batoni, whose written means of expression could not match his mastery as a painter, his pictures were the sole manifestation of his "poetic" originality. Over the course of several decades, patrons clamoured for the products of this pictorial erudition, with one eager client declaring: "It is infuriating that this skilled man has but two arms, and can only paint with one of them."[108]

CHAPTER 5

DRAWINGS, WORKING METHODS, AND STUDIO PRACTICES

It is necessary to use a great deal of attention to attain the maximum perfection in a work of art; by nature I am never satisfied with what I do, but rather I always feel that something is missing in the painting and I continue working.

—Pompeo Batoni to Lodovico Sardini, 5 May 1742

Batoni's achievement as a painter is inextricably linked to his skills as a draughtsman, for his art epitomises the traditional Roman concept of *disegno* as the essence of painting. "The practice of drawing remained central to Batoni's activity as an artist," Hugh Macandrew has observed. "Never was it regarded by him in practical terms only, a necessary but nevertheless subordinate process in the production of a painting. For Batoni drawing remained an act of renewal and regeneration because it was the foundation of his art and the source of its inspiration."[1] The artist's "motherless, miserable, and disfigured childhood" was made more tolerable by his pleasure in drawing, which was said to have been insatiable, and he drew extensively in his youth in Lucca.[2] His father, Paolino (fl. 1700–1752), was so determined to prepare the boy for the family profession of goldsmith that he forbade him to draw or paint outside his workshop, but Batoni's early biographers provide romanticised accounts of the child's evasions of his father's prohibitions.[3] Allegedly, the boy drew secretly at night with improvised materials fashioned from a variety of substances found around the house; he also studied figures modelled

in clay spirited from his father's shop, a method of working that he may have incorporated later into his studio practice in Rome.[4] The result was that Batoni had become a competent draughtsman at a very early age and was said by his fifteenth year to have copied prints by Guercino (1591–1666) and a Madonna by Ventura Salimbeni (1568–1613) "with such miraculous skill that only with the greatest effort could the copy be distinguished from the original."[5] He may also have had some experience in drawing from the life model in the studios of Lucca's two leading masters, Giovanni Domenico Lombardi (1682–1752) and Domenico Brugieri (1678–1744).[6]

From the moment of his arrival in Rome in May 1727, Batoni plunged into the traditional activities of young artists newly arrived in the city: namely, studying the antique sculptures on display in the Vatican's Belvedere courtyard and in other collections in Rome; copying Raphael's frescoes in the Vatican Stanze and his *Transfiguration* (1518–20) in San Pietro in Montorio, the ceiling frescoes by Annibale Carracci and his students in the Palazzo Farnese, and other acknowledged masterpieces of modern painting; and drawing from the life models in the private academies of local artists. By means of these experiences, the young

Detail, fig. 126

artist developed in the "correct" manner and, in the words of a biographer, mastered the "true" sources of the Roman School: antiquity, Raphael, and nature.[7]

Batoni's existing drawings generally fall within the traditional categories of seventeenth- and eighteenth-century draughtsmanship, including copies after the antique and of older artists' works, initial rough sketches of compositions in the planning stage, finished designs for whole compositions, preparatory studies for single figures and individual groups, and highly detailed drawings from the studio model.[8] Individual preparatory studies of heads, hands, feet, limbs, whole figures, and drapery related to figural compositions predominate within Batoni's graphic œuvre. It is these drawings in particular that reveal the exacting creative methods Batoni followed and the painstaking effort he made to relate the characters in his paintings to one another by means of attitude and gesture, clearly delineating and distinguishing each figure so that it contributes effectively to the narrative or allegorical content of the whole.

Drawings After the Old Masters and the Antique

In eighteenth-century Rome, the ability to faithfully reproduce the work of another artist was considered a critical component of a young painter's training. Not only did the student learn manual skills and acquire dexterity through copying, he also gained knowledge of other styles, materials, and techniques. In order for a young painter to develop in the correct manner, he was instructed to copy only from the most learned, beautiful, and respected models, from antiquity to Raphael to Domenichino. For Batoni, as for many young artists in Settecento Rome, this above all meant the paintings of Raphael, which were considered the embodiment of perfection in art. As he wrote to one patron, "I hope to be able to equal the divine painter Raphael, greatly loved by me, and revered above all others."[9] Onofrio Boni described at length the young Batoni's tireless and passionate study of the works of Raphael in the Vatican and the ground-floor loggia in the Villa Farnesina, drawing the heads and figures in the *Disputà* as well as doing more ambitious copies in oil after the *School of Athens* (c. 1510–12).[10] Through such training Batoni, like so many artists at the time, developed an awareness of the role of older art in his own artistic production and, equally impor-

Fig. 123. *Portrait of Alessandro Farnese (1520–1589)* (after a portrait formerly attributed to Titian), 1730. Red chalk on paper, 14⅞ × 10¼ in. (37.8 × 27.3 cm). Gabinetto Nazionale delle Stampe, Rome.

tant, of art that was held to embody an objective standard of excellence. For the remainder of his life Batoni extolled the advantages to be obtained from studying the works of Raphael and, appropriately, in 1768 he was appointed successor to Stefano Pozzi (1699–1768) as keeper of the Stanze di Raffaelle in the Vatican.[11]

A polished red-chalk copy after a portrait of Alessandro Farnese (fig. 123), believed in the eighteenth century to have been a work of Titian, provides an example of Batoni's study of the Old Masters.[12] The evident care and exactitude with which the portrait was reproduced and the elaborate ornamental frame surrounding the image of the cardinal suggest that the sheet was intended either for presentation or as a model for an engraver. The drawing reveals an almost obsessive attention to detail, notably in the beautiful

hatching that captures the richness of the silk mozzetta and the texture of the sitter's hair and beard. The striking quality of Batoni's youthful graphic style—decisiveness of line—is amply demonstrated, as well as his consummate control of light and shade, which establish the powerful sculptural quality of the figure and costume and impart a convincing appearance of three-dimensional form.

Batoni's early biographers all comment upon his success in the ranks of the professional copyists of classical statuary who worked for antiquarians, amateurs, and engravers. His drawings after the antique quickly came to the attention of British antiquarians and collectors in Rome and provided both a source of income and the basis of his earliest local reputation. Francesco Benaglio makes clear in his account of Batoni's life that it was the artist's copies of the classical sculptures in the Belvedere courtyard of the Vatican that first attracted his English patrons.[13] He appears to have obtained this entrée to British collectors in Rome through Francesco Imperiali, who served as an antiquary and a specialist in guiding British visitors on their excursions around the sights of Rome. Imperiali knew at first hand the Roman collections of antiquities of this period and played the role of agent and entrepreneur for those amateurs who wished to obtain drawings of the classical sculptures they had admired during their visit to the city.[14]

The most significant of Imperiali's clients to come to light is Richard Topham, who was sufficiently well known in his day as a collector to be mentioned by Alexander Pope (1688–1744) in his fourth "Moral Essay."[15] Many of Topham's Eton schoolfellows spent time in Italy in the 1690s, and there is evidence that he also made the Grand Tour at about this time. Following Topham's death, his executor, Richard Mead (1673–1755), selected the newly finished library of Eton College as the repository for his collection of books and prints, his watercolour copies of antique Roman paintings by Francesco Santi Bartoli (1675–1730), and the drawings of classical antiquities in Rome produced by a variety of Italian artists, some from the sixteenth and seventeenth centuries but the majority from the eighteenth, including Giovanni Domenico Campiglia (1692–1775), Stefano Pozzi, and the twenty-two-year-old Batoni. Topham's collection of copies constitutes a major survey of the classical sculptures contained in Roman collections around 1725–30 and is a unique visual record, of

significant value in view of the sale, dispersal, and removal from Rome of many collections that began shortly after this survey was assembled. The importance of Batoni's contributions to Richard Topham's "paper museum" and his employment as a professional copyist in eighteenth-century Rome should not be underestimated. The work of Batoni, Campiglia, and numerous other, often anonymous, draughtsmen, "whether directed to producing drawings for the wealthy amateur, or for publication through the work of the engraver, was vital for the dissemination of knowledge of classical antiquity, and contributed substantially to the development of neo-classical taste."[16]

Batoni's activity as a copyist of classical sculpture played a critical role in his artistic development because in the course of making hundreds of drawings after ancient marble statues, busts, and sarcophagi, he acquired an extraordinary grasp of the problems of conveying three-dimensional form on a two-dimensional surface, and he developed the ability to endow the forms in his drawings and paintings with a powerful and vigorous sculptural quality that was to serve him for the remainder of his career. The fifty-three drawings by Batoni at Eton College, nine of which are signed, have been praised as "the most breathtakingly beautiful professional copies after classical antiquity to survive."[17] The pictorial qualities of these exquisite red-chalk drawings can be readily summarised: their beauty of line, precision of cross-hatching, careful tonal control, vivid lighting, and sensitive indications of a shaded background against which the figures are placed. These carefully preserved sheets reveal that by 1730 Batoni was a remarkably polished and mature draughtsman.[18] His later drawings exhibit a loosening of technique and a greater breadth of handling, but the refinement and precision that are the hallmarks of his drawing style remain as much in evidence, if never again so intense and deliberate as in these copies.

Several of the most celebrated pieces in the collections of Alessandro Albani were drawn by Batoni before the cardinal sold a significant group of antiquities in 1733–34 to Pope Clement XII (1652–1740), who made it the nucleus of a new museum on the Campidoglio.[19] Among these was the *Endymion Relief* (fig. 124), found on the Aventine in the early eighteenth century and later acquired by Albani and displayed in the Palazzo Albani del Drago at the Quattro Fontane.[20] Batoni copied other ancient marbles in the Villa

Fig. 125. *Cupid and Psyche*, c. 1730. Red chalk on white paper, 19 × 14½ in. (48.2 × 36.8 cm). The Provost and Fellows of Eton College, Windsor.

Ludovisi, Palazzo Ruspoli, Palazzo Farnese, Palazzo Barberini, and Villa Casale, among other collections in Rome. He also drew in the Palazzo Fiorenza in Campo Marzio, which housed the collection of Count Giuseppe Fede (c. 1700–1777), who owned and excavated much of the land that constituted Hadrian's Villa near Tivoli.[21] One of Fede's most important finds was a marble statue thought to represent Cupid and Psyche (fig. 125), described by Jean-

OPPOSITE: Fig. 124. *Endymion Relief*, c. 1730. Red chalk on white paper, 18½ × 14½ in. (47 × 36 cm). The Provost and Fellows of Eton College, Windsor.

RIGHT: Fig. 126. *"The Cannibal,"* c. 1730. Red chalk on white paper, 18⅞₆ × 13¾ in. (46.8 × 34.9 cm). The Provost and Fellows of Eton College, Windsor.

François de Troy in 1740 as "one of the most beautiful morcels of the antique," that was much admired by travellers and connoisseurs in the middle of the century and often copied and cast.[22]

Over the course of the eighteenth century, a number of the celebrated marbles belonging to important Roman families were sold from their villas and palaces, including the so-called *"Cannibal"* (fig. 126), a marble fragment of a group of two boys quarrelling over a game of knucklebones, which had been housed in the Palazzo Barberini, where Batoni copied it, since its discovery in the seventeenth century.[23] The piece achieved great contemporary notoriety on the strength of Winckelmann's erroneous identification of it as a copy of a bronze original by the classical Greek sculptor Polykleitos, and it was acquired in 1767 from the Barberini family by Thomas Jenkins, who in turn sold it the following year to the English collector and antiquary Charles Townley (1737–1805) during his first Grand Tour.[24]

Beauty of line is common to all of Batoni's drawings, but the Topham sheets epitomise this quality, and many of the marbles depicted therein are enclosed by contours that are especially elegant and purposeful. A drawing characterised by exceptional poise and precision is Batoni's copy of a celebrated marble lion carved by the sculptor Flaminio Vacca (1538–1605) as a pendant to a genuine antique lion in the Villa Medici, where both were placed on either side of the main staircase leading into the gardens (fig. 127). Vacca's lion held a very high place in the pantheon of "honorary"

Fig. 127. *Lion, After Flaminio Vacca (1538–1605)*, c. 1730. Red chalk on white paper, 10⅞ × 16⁵⁄₁₆ in. (27.7 × 41.4 cm). The Provost and Fellows of Eton College, Windsor.

antiques, and in the eighteenth century many visitors to Rome seem to have preferred it over the antique lion.[25]

Even after the Topham commission of about 1730, Batoni continued his activities as a professional copyist. The proof for this exists in the engravings after Batoni's drawings of two famous sculptures discovered at Hadrian's Villa in 1735 and 1736, respectively. The first, a beautiful half-length marble relief depicting Antinous in profile, was discovered by Count Fede and acquired shortly thereafter by Cardinal Albani, who gave it pride of place in his villa outside the Porta Salaria.[26] Engraved by Miguel Sorello (c. 1700–1765) and published in Ridolfino Venuti's *Collectanea antiquitatum romanarum* (1736), the sculpture was acclaimed a masterpiece from the moment it was discovered, and by virtue of Winckelmann's great estimation of the piece, it enjoyed a reputation that endured well into the following century.[27] The inclusion by Batoni of the relief twenty-five years later in a full-length portrait of an unidentified Grand Tourist in Rome underscores the importance of this early experience with the antique for the later development of his art (see fig. 81), not least for widening the repertory of classical references and accessories deployed in his portraits of Grand Tourists.[28] That Batoni was asked to record one of

Fig. 128. Giovanni Girolamo Frezza (1659–after 1741). *The Younger Furietti Centaur (after Batoni)*, 1739. Engraving, 19⅛ × 13⅛ in. (49.3 × 33.4 cm). Private collection.

the famous pair of centaurs unearthed during Monsignor Alessandro Furietti's excavations at Hadrian's Villa in December 1736 at about the time he was engaged in the execution of the altarpiece that Furietti had commissioned for the Roman church of Santi Celso e Giuliano confirms how closely intertwined were his activities as a painter and a copyist in the early stages of his career.[29] Batoni's bold depiction of the young centaur, the basis of the reproductive engraving by Giovanni Girolamo Frezza (fig. 128), is extraordinarily faithful to the original and remarkable for the handling of contour, silhouette, and tonality.[30]

Academy Drawings

By the middle of the eighteenth century, it had long been an established tradition for artists to travel to Rome to

complete their education. The city remained unrivalled as a training ground for young artists, especially as a place where they could improve their ability to draw. Rome was known as the Academy of Europe, in part because of the opportunities offered there for instruction in life drawing. Artists could study from the model under the auspices of the two "official" academies, the Académie de France à Rome and the Accademia di San Luca, or in one of the local evening drawing academies held by Rome's leading masters, or they could—and often did—organise their own independent life-drawing classes.[31] The Accademia del Disegno—widely known as the Accademia Capitolina del Nudo—was established under the aegis of the Accademia di San Luca in 1754 by Benedict XIV in a large room below the Pinacoteca Capitolina in the Palazzo dei Conservatori. Batoni's participation involved supervision of the life-drawing exercises, whose direction was entrusted on a rotating basis to various academicians appointed by the president.[32]

Antique marbles did not offer Batoni the variety of poses and versatility of movement provided by the live model, and life drawing became an indispensable part of his training in understanding the human form and obtaining a mastery of anatomy. He made these accomplished studies throughout his life, both to maintain and sharpen his skills as a draughtsman and to demonstrate his ability to draw from the life model. As suggested above, Batoni probably had some instruction in life drawing as a youth in Lucca, and in Rome he attended Sebastiano Conca's evening life classes shortly after his arrival in 1727. He drew continually as an adult during the life-drawing classes he supervised at the Accademia Capitolina del Nudo and in the private classes in his own studio. He is even known to have participated in the informal academies of his contemporaries in Rome, such as those organised by the French painter Laurent Pécheux and his friends in 1753–54 near Piazza della Trinità de' Monti, and in competition with other painters such as Mengs.[33]

Batoni's surviving academy drawings—studies of male nudes drawn from studio models in poses not specifically related to a planned composition (figs. 129, 130)—date largely, for reasons that are not clear, from the 1760s and 1770s.[34] He generally favoured black and white chalks and blue prepared paper, but a few red-chalk academy drawings survive to confirm that he occasionally employed that

Fig. 129. *Academic Nude*, 1765. Black chalk heightened with white chalk, on blue-grey paper. 20⅞ × 15⅛ in. (53.1 × 39.1 cm). The Museum of Fine Arts, Houston; The Rienzi Collection, gift of Mr. and Mrs. Harris Masterson III.

medium.[35] His drawings of the male nude are characterised by consummate technique and faultless anatomical description. The realism is deliberate and purposeful; rarely does one encounter the aggressive or exaggerated poses characteristic of Roman academy drawings of the first half of the century. The subtly contoured cross-hatching Batoni employed to define the model's musculature was probably achieved by reworking, smoothing, and refining rapid, less precise sketches from life. It is evident that Batoni endeavoured to create as brilliant an impression as possible through the cold precision of these drawings,

Pompeo Batoni 1765.

investing them with the monumental and severe qualities that increasingly characterise the style of his history paintings over the years. The extreme detail and polish of these late academy drawings confirm that they are not the common product of a day's work in the studio but are instead demonstration pieces—virtuoso examples of his skill as a draughtsman. Batoni obviously regarded his academy drawings with great esteem, for they are generally remarkably well preserved. Most are signed and dated, and he frequently gave them to patrons and others as tokens of appreciation.[36]

In the 1770s, artists seeking a private drawing academy in Rome could choose from at least a dozen, but among the best-known were those offered by Batoni and by Mengs.[37] The letters of Puhlmann provide a vivid (and often amusing) glimpse into Batoni's life classes. They were usually held one evening a week from November to Maundy Thursday, although Batoni apparently did not hold regular classes between 1768 and 1774 or after 1781. The sessions were open to all for a small fee, and their primary purpose was drawing the life model in a variety of poses. In a letter of 20 January 1775, Puhlmann describes his experience as a pupil in Batoni's drawing academy: "In our living room we now have an iron brazier, and thus have a warm room when we come home from the academy, where I have the good fortune of sitting to the left of Cavalier Pompeo, who points out my mistakes and is satisfied with my work. I have now drawn ten figures from life and copied twenty-two drawings. The dear man gives us everything that we ask of him, and when the academy has concluded he discourses informally about some aspects of painting. When I get home I write down these lectures since he never wastes a word."[38] The extemporaneous remarks following each session probably included rudimentary instruction in anatomy, geometry, perspective, and related topics of interest to the aspiring young artists. In addition to his quasi-public academy, Batoni appears to have occasionally given private instruction to selected students, perhaps as a favour to friends; John Ramsay, the fifteen-year-old son of the

Scottish artist, for example, received drawing lessons from the painter every morning for two hours after breakfast in February 1783.[39]

With respect to the various artists often described as "pupils" of Batoni, however, neither those attending the life-drawing sessions on the Capitoline, who often numbered more than a hundred at a single session, nor those in Batoni's private classes should be confused with the very small group of painters who served more or less as apprentices in the studio. It is this group of painters who were with the artist on a daily basis and received regular, one-to-one personal instruction, not only in drawing but also in composition, iconography, and the techniques and materials of painting.[40] They would have been the only ones to assist him with the execution of his own paintings. Thus many of the artists labelled "pupils" or "assistants" of Batoni in the art historical literature were in fact only attendees at his life-drawing classes and were neither instructed at length in the techniques of painting nor involved in the completion of his paintings.[41]

Working Drawings and Oil Sketches

Batoni's activity as a draughtsman is of critical importance for understanding his methods as a painter. He was a conscientious artist, as careful as he was inventive, for whom drawing from the model performed a decisive role in the preparation of the final work. Drawings provided Batoni with the means to fashion his figures, define their attitudes and expressions, and organise his compositions. He composed his paintings strictly within the Bolognese-Roman academic tradition, and the types of drawings he produced in the course of working out a particular design may be more or less categorised according to their method and function. Although a full range of studies for any single work is lacking, enough survive from different preparatory stages to illuminate Batoni's approach to pictorial invention, from swiftly sketched compositional ideas to carefully finished figure studies to details of hands, heads, and drapery.

Within a normal preparatory sequence, the first ideas were expressed in summary sketches on a small scale, often hastily executed, indicating the basic composition with little attention to detail. Like most Italian painters of his day, Batoni spent a great deal of time in the planning

Fig. 130. *Academic Nude*, 1765. Black chalk heightened with white chalk, on blue-grey paper. 21¼ × 15⅞ in. (54 × 39.5 cm). The Museum of Fine Arts, Houston; The Rienzi Collection, gift of Mr. and Mrs. Harris Masterson III.

Fig. 131. *The Holy Family with the Infant Saint John the Baptist*, 1747. Oil on canvas, 53⅛ × 46½ in. (135 × 118 cm). Kunstsammlungen Graf von Schönborn, Schloß Pommersfelden; on loan to the Art Gallery of Ontario, Toronto.

stage, rethinking his conception of a work mentally and visually through drawings. A rapid red-chalk notation on a sheet from a now-dismembered pocket sketchbook in Philadelphia reveals a preliminary idea for *The Holy Family with the Infant Saint John the Baptist* of 1747 (fig. 131).[42] At a later stage, he worked out the composition in greater detail on a larger scale (fig. 132).[43] In the painting, the infant Baptist, who plays with a goldfinch on a string, is shown restrained by Saint Joseph from disturbing the sleeping Virgin and Child. The main elements of the circular composition are indicated in the upper half of the sheet, with the notable difference that the Virgin is shown awake. In the lower half of the drawing, Batoni's chief concern is with the attitude and gesture of the young Saint John. Several studies of his raised right arm and hand are interspersed with those of

Fig. 132. *Studies for the Pommersfelden "Holy Family,"* c. 1747. Red chalk, touches of white chalk, on greyish-green prepared paper, 15⅛⁄₁₆ × 9⅞ in. (38.8 × 25 cm). Philadelphia Museum of Art; bequest of Anthony M. Clark, 1978.

his left arm and head. The lower half of the child's body is obscured in the finished painting and was, therefore, omitted in the sketch at the right of centre.

The second stage in Batoni's usual preparatory sequence appears to have been the production of a highly finished compositional layout drawing, the equivalent of a modello in chalk. A fine example is a compositional sketch in Edinburgh for *The Visitation* (see fig. 6) commissioned by one of Batoni's early Roman patrons, Prince Nicolò Pallavicini.[44] Because the sheet is squared for

transfer onto a larger scale, the design might appear to represent a late stage of Batoni's thoughts regarding the composition (fig. 133). But the numerous minor differences between the drawing and the finished painting suggest instead that he may have produced it to show his patron an advanced version of his design for the painting. The Edinburgh drawing establishes the format of the Pallavicini painting down to the number and placement of the figures, but the discrete differences, mostly in the disposition of the figures, confirm that Batoni continued to refine and adjust the poses and gestures of individual figures and their costumes after the elaboration of the composition, in many instances probably making such changes directly on the canvas itself.

Batoni next produced whole-figure studies from the life model to establish or adjust the poses and gestures of individual figures; these are often the most brilliant examples of his skill as a draughtsman. Such studies abound in Batoni's graphic œuvre, for he relied extensively on models in preparing his compositions. This ability to remain close to nature throughout the process of pictorial invention explains both the meticulous naturalism admired in his work by contemporary and modern critics and why, at least until the last few years of his life, his history paintings remain remarkably convincing. Batoni's strict adherence to the classical principle of composing with a few powerfully conceived figures and focusing attention on their attitudes and gestures served him well. One reason that he could achieve such persuasive naturalism in his art is that by using relatively few figures in most of his subject paintings, he could study and articulate in detail the roles they were expected to play in his pictorial dramas.

Batoni established with great precision in red chalk the poses of three of the apostles (fig. 134) in the painting in the ceiling of the Caffeaus of the Palazzo del Quirinale, *Christ Delivering the Keys to Saint Peter* (see fig. 26).[45] Knowing that an accurate presentation of a clothed figure required a solid grasp of its underlying human anatomy, Batoni studied the poses of the figures, who wear heavy draperies in the painting, from nude models. Another drawing (fig. 135), a red-chalk study for the figure of Seleucus in *Antiochus and Stratonice* (see fig. 18), fulfils a similar function and demonstrates his exacting approach to the problem of formal articulation of human anatomy, as well as the intensity with which the principal figures in his compositions were studied

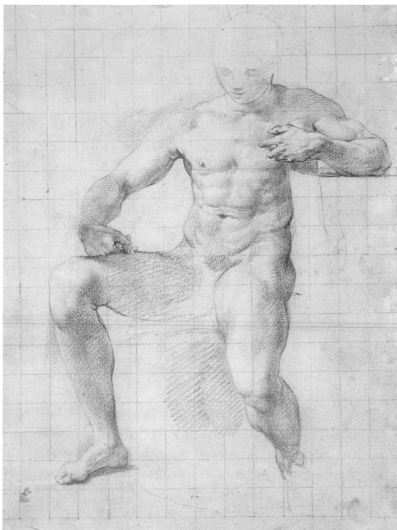

Fig. 135. *Study of Seleucus for "Antiochus and Stratonice,"* c. 1746. Red chalk, squared in red, on brown paper, 11 × 8⅛ in. (28 × 20.9 cm). Collection of John D. Reilly; on loan to the Snite Museum of Art, University of Notre Dame, South Bend, Indiana.

Fig. 136. *Study of Hercules for "The Choice of Hercules,"* 1740–42. Red chalk, squared in red, on beige laid paper, mounted down, 11⅛ × 8⅛ in. (28.4 × 21.2 cm). Philadelphia Museum of Art; bequest of Anthony M. Clark, 1978.

from nude models. Here, Batoni arranged the model in a pose quite close to that which he adopted in the painting; satisfied with the solution, he then lightly squared the sheet with red chalk for transfer to the canvas.[46]

OPPOSITE, TOP: Fig. 133. *Study for "The Visitation,"* 1736–37. Red chalk, squared in red, on paper, 10⅛ × 13⅝ in. (25.9 × 34.8 cm). National Gallery of Scotland, Edinburgh.

OPPOSITE, BOTTOM: Fig. 134. *Studies for "Christ Delivering the Keys to Saint Peter,"* c. 1742. Red chalk on paper, 8¼ × 11¹⁵⁄₁₆ in. (20.9 × 30.4 cm). The Metropolitan Museum of Art, New York; bequest of Harry G. Sperling, 1971.

For the central figure in *The Choice of Hercules* (1740; Palazzo Pitti, Florence) commissioned by Marchese Andrea Gerini, Batoni selected a muscular model, young and beardless (fig. 136), to assume the pose of the seated Hercules.[47] The squared-for-transfer red-chalk study was presumably made from the model at a relatively late date in the evolution of the composition, because the pose corresponds closely to that of Hercules in the painting. In a letter of April 1742 to one of his Lucchese patrons, Batoni complained of the unseasonable cold in Rome that prevented the models from posing nude for extended periods of time. This seriously delayed his progress in finishing

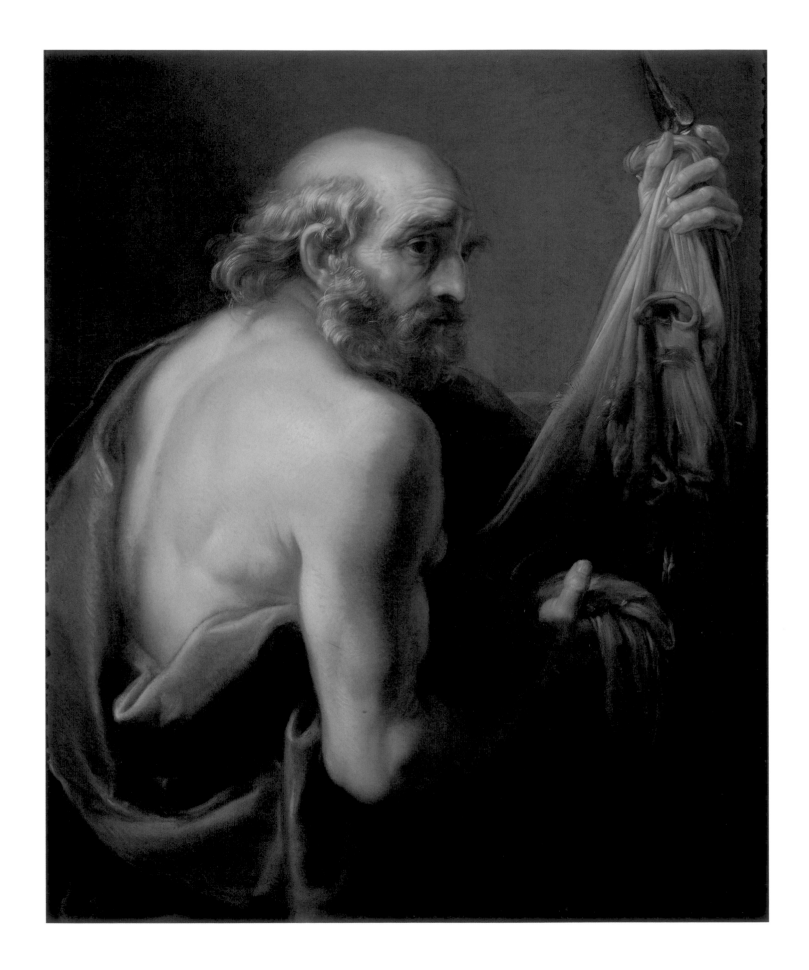

commissions on his easel, he explained, as it was his practice "to complete each painting with the live model in front of my eyes."[48] In another letter he explained that "a painting that illustrates a story for which all the necessary sketches must be made in advance, and *afterwards must be perfected from reality,* requires a few months of work" (emphasis added).[49] The figure of Hercules is a paradigm of Batoni's confident command of human anatomy that was such an important part of the Roman and Bolognese tradition of disegno. Batoni's predilection for squaring his drawings can be seen also on a red-chalk study for *Saint Bartholomew* (figs. 137, 138), one of the apostles commissioned by Count Cesare Merenda for his gallery at Forlì.[50] Such drawings were inevitably preceded by rather loose compositional sketches for a figure or motif; in this particular instance, a drawing

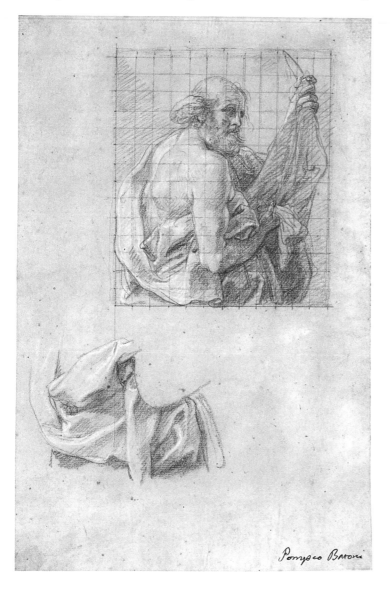

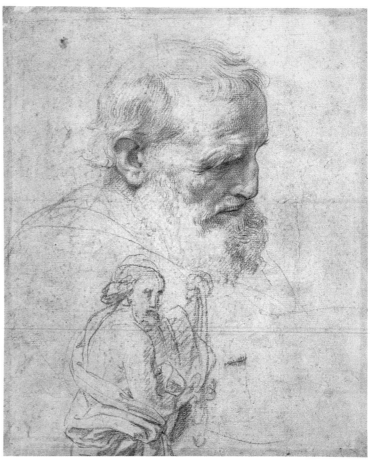

Fig. 139. *Studies for the "Allegory of the Republic of San Marino" and for "Saint Bartholomew,"* c. 1740–43. Red chalk, heightened with white, on ochre-tinted paper, 8½ × 6⁹⁄₁₆ in. (21 × 16.7 cm). The Royal Collection, Windsor.

in the Royal Collection at Windsor Castle records Batoni's initial idea for the pose of the saint (fig. 139), though it may also have been followed by further articulation of the model's pose through additional studies.[51]

A fourth type of drawing—figure, drapery, hand, and head studies in red chalk to refine or adjust a pose—abounds in numerous examples. One such sheet contains studies for the Virgin's drapery and the sleeping

LEFT: Fig. 137. *Study of Saint Bartholomew for "Saint Bartholomew,"* c. 1740–43. Red chalk, heightened with white chalk, on beige paper, the main study squared, 11³⁄₁₆ × 7⅛ in. (28.4 × 18.1 cm). Promised gift of Dorothy Braude Edinburg to the Harry B. and Bessie K. Braude Memorial Collection at the Art Institute of Chicago.

OPPOSITE: Fig. 138. *Saint Bartholomew,* c. 1740–43. Oil on canvas, 28½ × 24 in. (72.4 × 61 cm). Lemme Collection, Rome.

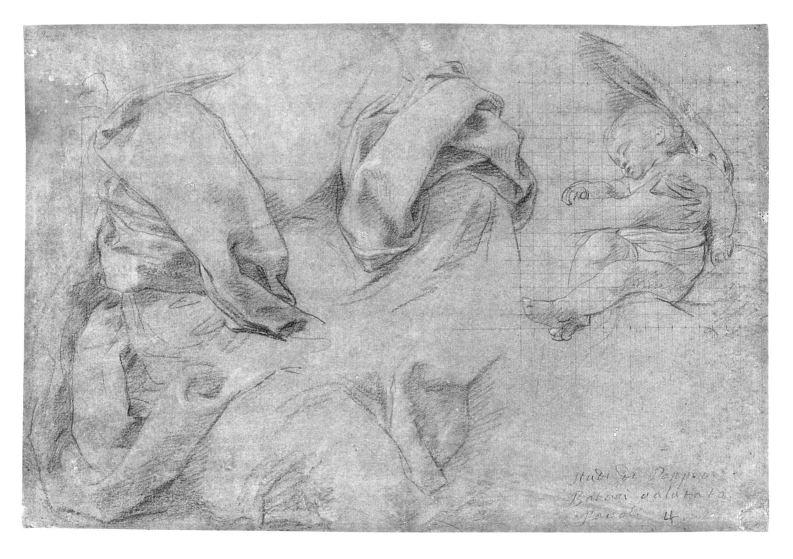

Fig. 140. *Studies of Drapery and the Sleeping Christ Child for the Merenda "Holy Family,"* c. 1740. Red chalk, a few touches of white chalk, partially squared in red, on yellow prepared paper, 8¹⁄₁₆ × 12 in. (20.7 × 30.5 cm). Philadelphia Museum of Art; bequest of Anthony M. Clark, 1978.

Christ Child in a Holy Family painted for Merenda in the early 1740s (fig. 140).⁵² On the left is a detailed study of the mantle that covers the Virgin's right shoulder and the dress on her right thigh, while the study in the centre of the sheet corresponds to the drapery around her left knee, the folds of which Batoni altered slightly in the finished painting. A drawing in Berlin reveals how Batoni, working from the model, painstakingly studied arm and hand gestures and bodily attitudes (fig. 141)—in this instance, making a series of sensitive and discrete adjustments to the pose of the young Achilles in *Thetis Entrusting Chiron with the*

Education of Achilles (see fig. 89)—to ensure the success of his figures in conveying their narrative roles in his paintings.⁵³ Such refined drawings would have been preceded by other studies, some rougher and more summary in nature; and, indeed, Batoni established the initial pose of Achilles sheltered by his mother as she introduces the shy little boy to the centaur Chiron in a black-chalk drawing made at an earlier stage of preparation.⁵⁴

Batoni paid close attention to the faces and heads of the figures in his subject paintings. One especially fine example (fig. 142) is the study for the head and hands of the personification of Religion in the *Allegory of Religion* (see fig. 94),

Fig. 141. *Studies of Achilles for "Thetis Entrusting Chiron with the Education of Achilles,"* 1760–61. Black and white chalk on blue prepared paper, 17⅛ × 11 in. (44.8 × 28 cm). Staatliche Museen zu Berlin, Kupferstichkabinett.

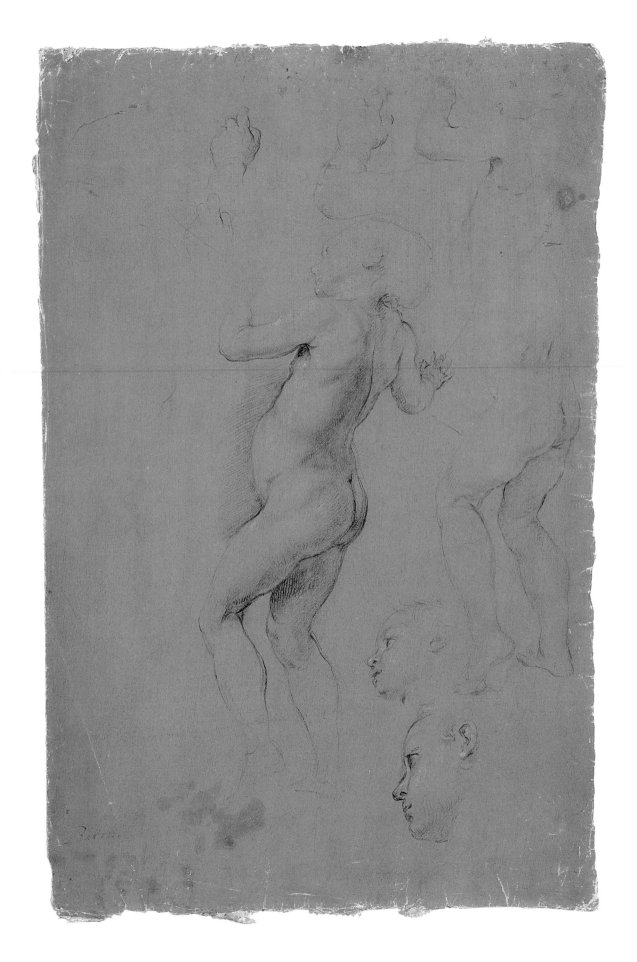

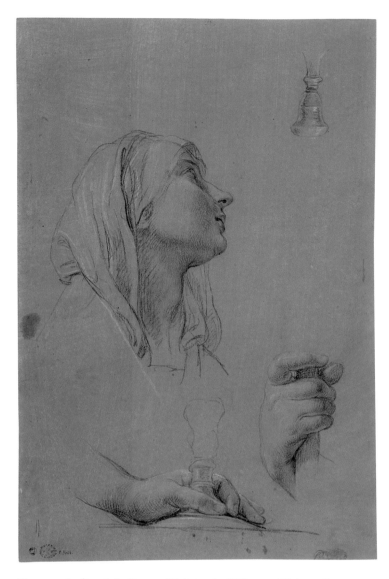

Berlin; a black-chalk study in Besançon (fig. 143) shows how Batoni began the process of expressing the fear of a woman who plays a similar role in the *Martyrdom of Saint Lucy* (1759; Museo de la Real Academia de Bellas Artes de San Fernando, Madrid).[56]

Important or difficult details called for quite careful elaboration, such as the exquisite shield (fig. 144) fashioned for Aeneas by Vulcan that Venus presents to her son in a painting commissioned by Prince Joseph Wenzel von Liechtenstein (see fig. 87).[57] Although in the painting the shield is shown turned slightly, in the drawing Batoni depicts it full face in order to delineate precisely Virgil's description of the shield's decoration, which provides a pictorial history of Aeneas's descendants all the way to Augustus. Batoni followed the text of the *Aeneid* (8:608–731) meticulously, omitting only a few details and occasionally condensing the action of the various episodes into a single scene. This sharply defined drawing demonstrates just how carefully Batoni developed the individual elements in his paintings and how deliberately he prepared his compositions in the 1740s.

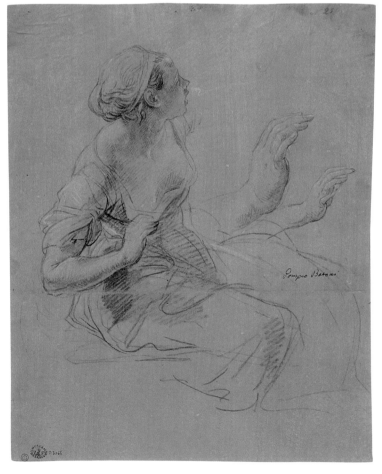

Fig. 142. *Studies of the Figure of Religion for "Allegory of Religion,"* c. 1763. Black chalk, heightened with white chalk, on grey prepared paper, 15¹⁄₁₆ × 9¹⁵⁄₁₆ in. (38.3 × 25.3 cm). Musée des Beaux-Arts et d'Archéologie, Besançon.

painted as a modello for a series of tapestries commissioned for the bedroom of King Ferdinand IV in the royal palace at Caserta.[55] Other sheets reveal a more explicit concern with the affetti and the emotional states of his figures such as the head of a terrified woman in the foreground of the *Fall of Simon Magus* (see fig. 35) in a red-chalk drawing in

Fig. 143. *Studies of a Frightened Woman for the "Martyrdom of Saint Lucy,"* c. 1759. Black chalk, heightened with white chalk, on grey prepared paper, 13¼ × 10½ in. (33.7 × 26.6 cm). Musée des Beaux-Arts et d'Archéologie, Besançon.

Fig. 144. *Study for the Shield of Aeneas in "Venus Delivering the Arms of Vulcan to Aeneas,"* c. 1748. Red chalk on cream laid paper, 8⅛₆ × 8⅛ in. (20.8 × 20.6 cm). Philadelphia Museum of Art; bequest of Anthony M. Clark, 1978.

Studies of costume are relatively rare among Batoni's extant drawings because he painted his sitters' features from life and seems to have sketched the details of their dress directly onto the canvas. Approximately a dozen drawings that relate to the costumes in the portraits are known, but the function of these sheets within Batoni's creative process is not entirely clear—that is, whether they were made as records of, rather than preparatory studies for, a painting.[58] A costume study in the Witt Collection, London, for *Sir Sampson Gideon, later 1st Lord Eardley, and an Unidentified Companion* (see fig. 63), for example, is presumably a quick sketch from life, recording the essentials of Sir Sampson's pose and costume as he is seated in the chair he occupies in the painting.[59] All the important costume details are included: the suit trimmed with rows of braid, the lace stock frill,

Fig. 145. *Study of Drapery for the Portrait of Pope Clement XIII,* c. 1760. Black chalk, with touches of white chalk, on blue prepared paper, 17⅞ × 10⅛₆ in. (45.5 × 25.6 cm). Philadelphia Museum of Art; bequest of Anthony M. Clark, 1978.

and the solitaire ribbon. Another example is a black-chalk preparatory study (fig. 145) for the vestments worn by Pope Clement XIII (see fig. 105).[60] In the finished canvas, as in the drawn study, the pope is shown standing; his right hand is raised in blessing while his left holds a letter. Batoni was primarily interested in the arrangement of the pontiff's stole, his mozzetta, and his rochet. The face, which would have been painted directly on the canvas, has been disregarded and the hands are only summarily indicated.

It is not difficult to establish a chronology for Batoni's drawings because the majority of surviving sheets can be connected to his work in progress and specifically relate to finished compositions. Over the years his graphic style loosened considerably in the direction of a softer, more "painterly" handling of the medium. This change can be observed in a delicate black-chalk study for the figures of Christ and two of the apostles in the late *Last Supper* in Lisbon (fig. 146).[61]

Fig. 146. *Studies of Christ and Apostles for "The Last Supper,"* 1782–83. Black and white chalks with traces of brown chalk on blue prepared paper, mounted down, 16⅞ × 11¼ in. (42.8 × 28.5 cm). Philadelphia Museum of Art; bequest of Anthony M. Clark, 1978.

Batoni's touch can be seen to have lightened appreciably in his maturity, and the soft, delicate hatching employed to render the model's body and drapery creates a heightened effect of atmosphere that is usually absent in his earlier drawings.

Working drawings predominate in Batoni's graphic output, and during the course of his long career he must have produced preparatory studies of this sort in the thou-

sands. Puhlmann confirmed Batoni's practice of retaining these sheets in the studio for reference and future use or for sale when he described a drawing of a Dead Christ that Batoni presented to him as a gift: "This was rare for him, since he keeps all his studies, even those that are only a few strokes on paper, for which he finds admirers who pay him well."[62] That so few of Batoni's drawings are known today—only about four hundred drawings by his hand, dating throughout his long career, survive—suggests that many more remain unaccounted for. Only a single preparatory drawing is known for such a complex composition as the *Sacrifice of Iphigenia* (see fig. 14), in which Batoni would have studied with consummate care the gestures, attitudes, and expressions of the more than two dozen figures represented therein, and only slightly more than a dozen sheets survive to document the long and arduous preparation of the *Fall of Simon Magus* (see fig. 35) for Saint Peter's; this can be explained by the dispersal or even destruction of a great part of the studio contents following his death in 1787.[63]

Batoni often relied upon oil sketches at various stages in the preparatory process of a painting. The function of these studies varies greatly from tentative *bozzetti* intended to provide the most prominent features of a composition to carefully finished modelli produced to enable a patron to evaluate a project at an advanced stage of its development. The breadth between Batoni's initial idea for a composition and his final resolution of the design is suggested by a sketch in oils (fig. 147) for the *Antiochus and Stratonice* of 1746 (see fig. 18).[64] The basic compositional scheme laid out on the small canvas anticipates the final picture and presents the principal characters—the court physician Erasistratus and Antiochus at the left and a very youthful King Seleucus and his consort, Stratonice, at the right—before a background of draped curtain and classicising architecture. In the sketch, Erasistratus grips Antiochus's arm and appears to restrain the youth rather than take his pulse in accordance with the ancient literary text. The meaning of the gesture is clarified in the finished painting as Erasistratus indicates the nature of the prince's malady as his passion for Stratonice, his beautiful young stepmother. There, Seleucus is properly characterised as an older, bearded, and more powerful figure appropriate to his status as the founder of the dynasty that ruled the Asian provinces after the death of Alexander the Great. In the preliminary oil

sketch, the gestures and expressions of the protagonists appear timid and hesitant; in the finished composition they make clear the depth of Batoni's creative engagement with, and interpretation of, his chosen theme following its initial articulation. Seleucus's anguish and his gesture with the sceptre toward his son leave the viewer in no doubt that this is the moment when he has decided to abdicate the throne and turn over both his kingdom and Stratonice to his son. The initial, summary sketch provides scarcely a hint either of the superb finish that characterises the handling of the final painting or of its magnificent colour.

Fig. 147. *Antiochus and Stratonice,* c. 1746. Oil on canvas, 9½ × 12 in. (24.1 × 30.5 cm). Private collection.

The opposite end of the preparatory process for Batoni is represented by several highly finished compositions executed in oils, such as the finished model (fig. 148) for the 1746 altarpiece in the Oratorian church of Santa Maria della Pace, Brescia (see fig. 25).[65] The precision and finish of the Vatican sketch suggest that it served as a modello for Batoni's final design and was intended for presentation to the client, Marchese Pietro Emanuele Martinengo (1687–1746), or perhaps to the Oratorian fathers of Santa Maria della Pace, to provide an approximation of the appearance of the projected work. Discrete differences between the two compositions, such as the number of stars encircling Saint John Nepomuk's head and modifications to the architecture, document Batoni's close attention to

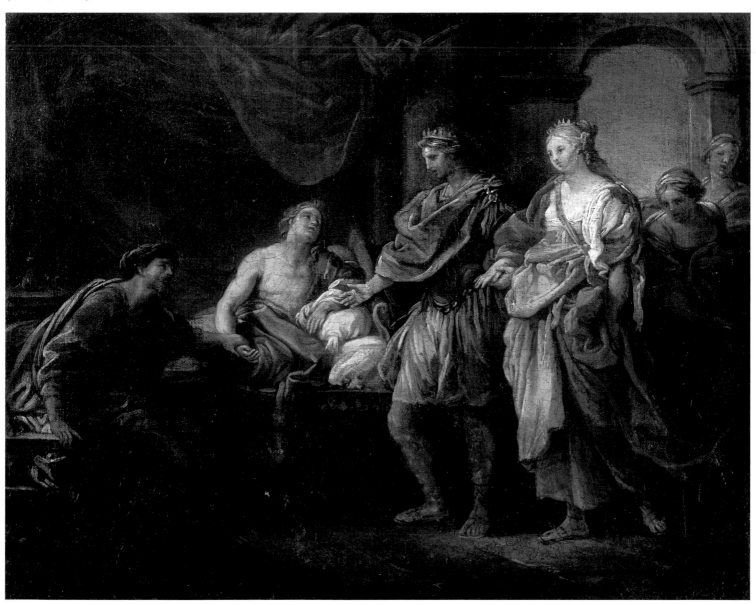

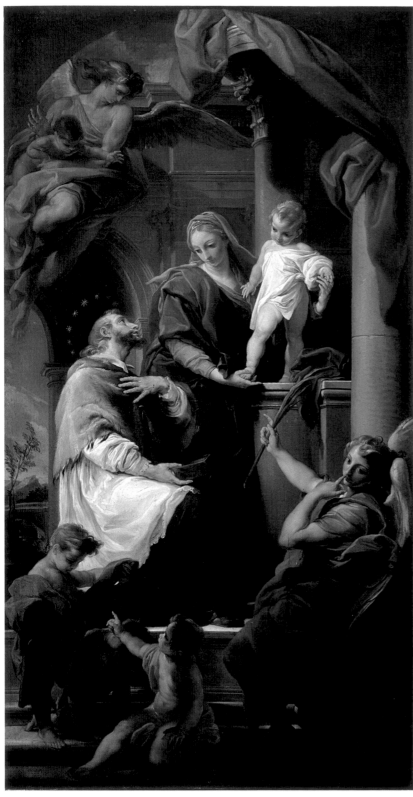

Fig. 148. *The Virgin and Child with Saint John Nepomuk*, c. 1743. Oil on canvas, 47¼ × 25 in. (120 × 63.5 cm). Pinacoteca, Musei Vaticani, Vatican City.

his designs throughout the creative process. Such painted modelli were usually produced by Batoni only for important altarpieces, where the submission of a proposed design was required for approval, and for multiple-figure subject paintings of some complexity.[66] Nonetheless, even a highly finished sketch such as this would have been followed by additional chalk studies from the model, for the purpose of refining a pose or adjusting a gesture, as part of Batoni's meticulous working procedures that ensured attention to even the smallest details. The original function of certain of Batoni's oil sketches remains uncertain, however, such as the *Virgin and Child in Glory* (fig. 149), one of his most beautiful small canvases, which could have been conceived either as an independent devotional painting or as a model for a larger, unexecuted altarpiece.[67]

Painting Materials, Methods, and Techniques

One of the unanswered questions relating to Pompeo Batoni's development as an artist is from whom he learned the art of painting. He was a fine craftsman with an obviously sound knowledge of the tools and materials of his profession—his surviving paintings, when properly cleaned, are nearer to their original appearance than those of any comparable eighteenth-century painter, with little or no *craquelure*. Moreover, as a painter he possessed an extraordinary breadth of technical skills that enabled him to conceive and execute work ranging in size from miniatures on ivory (fig. 150) to altarpieces exceeding twenty feet in height. But there is no documentary or anecdotal evidence that he ever served an established master in the traditional role of pupil, apprentice, or assistant, or even that he worked with an experienced painter for a sustained period in either Lucca or Rome. Nonetheless, he must have been instructed by someone in how to handle the tools and equipment of the painter's studio and taught the skills relevant to the production of a painting, from the grinding of pigments to the preparation of his canvases to the application of varnishes.

Fig. 149. *The Virgin and Child in Glory*, c. 1747. Oil on canvas, 46½ × 24 in. (118 × 61 cm). Toledo Museum of Art; Purchased with Funds from the Libbey Endowment, Gift of Edward Drummond Libbey.

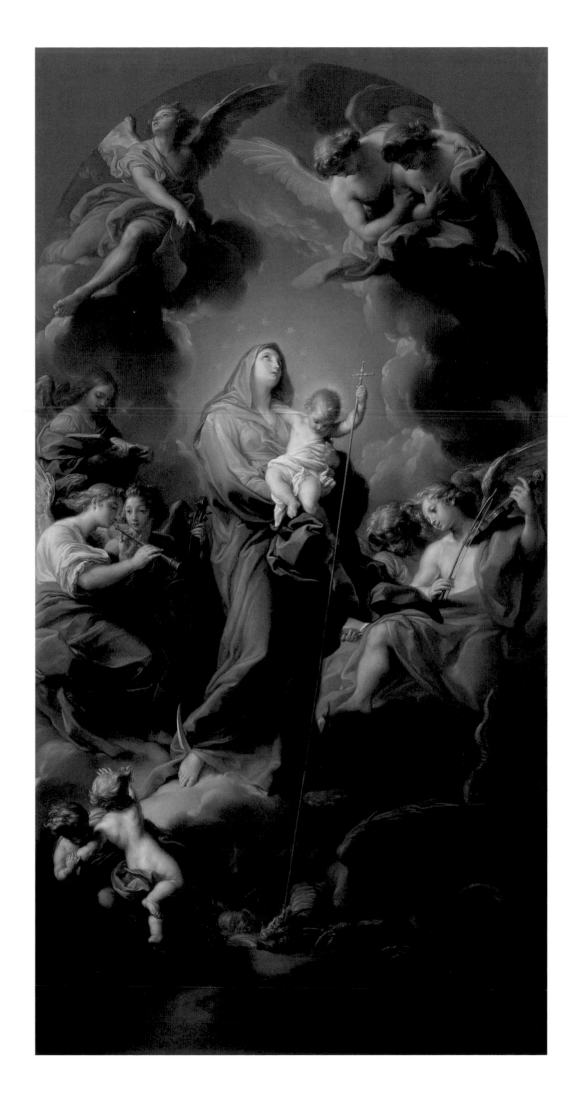

Onofrio Boni, in his account of the artist's early years in Rome, suggests that the painters Sebastiano Conca and Agostino Masucci, each among the most celebrated painters in the city in the 1720s, were recommended to Batoni as possible masters but that he avoided choosing either.[68] Masucci, who operated one of the most important studios in Rome at the time and whose life-drawing classes Batoni probably attended, would appear to have been an ideal mentor, and certainly a painting such as the *Virgin Mary Presenting the Habit to the Seven Founders of the Servite Order* (1727; San Marcello al Corso, Rome) provided an exemplary model for the young painter by virtue of its classical seren-ity and balance, impeccable draughtsmanship, and finesse of handling. But neither Masucci nor Francesco Imperiali, whom Anthony Clark considered "Batoni's advisor and, in a literal but limited sense, his teacher" and who was known for his conscientious and thorough instruction of a variety of Italian and British pupils, appears to qualify for the role of master in the strict sense of instructing Batoni in a range of artistic procedures or of providing significant tutelage in the practice of painting.[69]

Although little is known about Batoni's artistic training, it is possible to shed light on several aspects of his painting technique from visual examination of his canvases and with the help of X-radiographs and infrared reflectography. Most of the stretchers that Batoni employed have been replaced with modern expandable stretchers, but at least two original surviving examples have been identified; *Saint Andrew* (fig. 151) and *Allegory of Time, Justice, and the Arts* (early 1740s; The Art Institute of Chicago).[70] These simple, utilitarian struc-tures are constructed of light, soft-wood slats, half-lapped and pegged at the corners without the cross members that provide scope for further stretching of the cloth support. The fabric of the support itself was attached to the edges of the stretchers with hand-forged iron tacks or nails. Batoni generally painted on relatively fine-textured, closely woven, good-quality linen canvases with the threads of warp and weft more or less equal in weight and strength.[71]

It may be assumed that Batoni's canvases were stretched and prepared in his studio, although Puhlmann once mentioned that he had bought for himself a "coloured" canvas; that is, one prepared with the ground, suggesting that commercially prepared, preprimed canvases may have been available in Rome at the time.[72] The dimensions of the canvases Batoni used for his history paintings vary considerably, although certain patterns of standardisation are discernible. For small devotional paintings and single-figure subjects such as the series of apostles painted for the Merenda family (see figs. 138, 151), Batoni preferred supports measuring roughly 29 × 24 inches, or 74 × 61 cm.[73] A larger size of approximately 4 × 3 Roman palmi (about 38 × 29 inches, or 97 × 74 cm) was used for compositions of one or two figures and compositions of multiple figures on a small scale (see figs. 46, 47, and 87, 88).[74] The format that Batoni seems to have selected most consistently for his important history paintings is the *tela d'imperatore*, about 53⅛ × 37⅛ inches, or 135 × 95 cm (see figs. 23, 24, 90, 122).[75] This approximates the size he employed for his three-quar-ter-length portraits of British sitters and also for the papal portraits (see figs. 76, 105). Any attempt to categorise the dimensions of Batoni's altarpieces is impossible by virtue of the fact that the requirements for each varied so widely, with the result that these canvases range in size from eight feet by six feet (244 × 183 cm) for the *Preaching of Saint John the Baptist* (1777; Sant'Antonio Abate, Parma) to greater than twenty by thirteen feet (610 × 396 cm) for *Saint James Major Condemned to Martyrdom* painted for the Chiesa delle Anime del Purgatorio, Messina, in 1752.[76]

The supports for Batoni's portraits were usually stretched to standard sizes, the dimensions of which correspond more or less to those employed by eighteenth-century British artists, although these formats were also by no means standardised. Batoni's smallest normal size for a commissioned head-and-shoulders or bust-length portrait was a standard Roman format, approximately 29 × 24 inches (74 × 61 cm), which corresponds to its English, so-called three-quarter length, counterpart of 30 × 25 inches (76 × 64 cm). His half-length portraits (see figs. 41,

Fig. 150. *Richard Milles (c. 1735–1820)*, c. 1758. Watercolour on ivory, 1¼ × 1¹⁄₁₆ in. (3.2 × 2.7 cm). The Fitzwilliam Museum, Cambridge.

Fig. 151. *Saint Andrew*, c. 1740–43. Oil on canvas, 28½ × 24 in. (72.4 × 61 cm). The Art Institute of Chicago; Gift of Mrs. Joseph Regen-stine through the Joseph and Helen Regenstine Foundation, 1960.

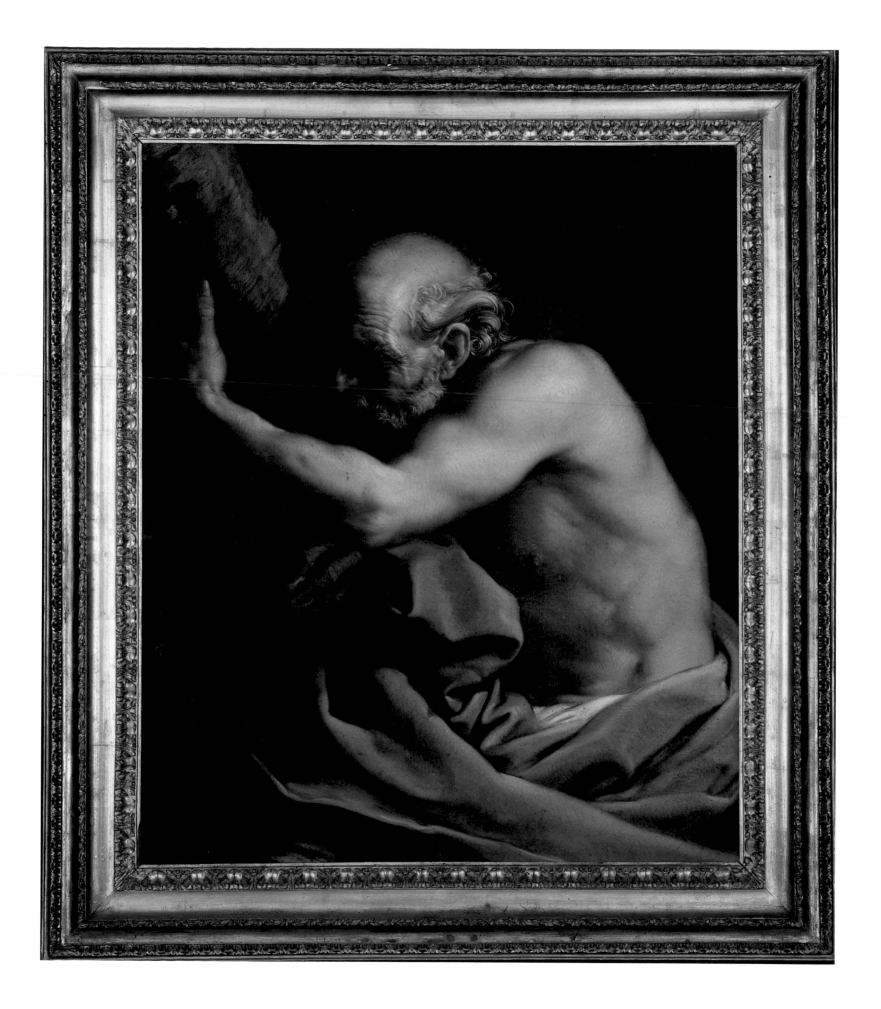

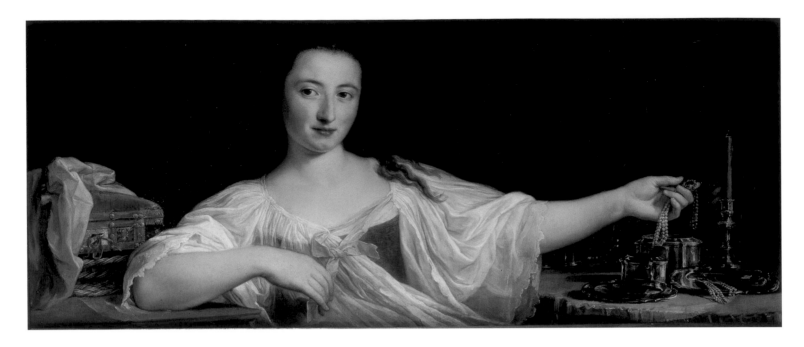

Fig. 152. *Duchess Girolama Santacroce Conti*, c. 1760. Oil on canvas, 19¼ × 47¼ in. (49 × 120 cm). Pinacoteca Capitolina, Rome; on loan to the Museo di Roma.

69) were painted in a standard format of about 38 × 28 inches (97 × 71 cm), analogous to the English "kit-cat" size. Three-quarter-length portraits (see figs. 39, 64, 103) consistently measured about 54 × 38 inches (137 × 97 cm), only slightly different from the standard English "50/40s." The full-lengths varied in size over the years, measuring approximately 93 × 58 inches (236 × 147 cm) in the 1750s and 1760s (see figs. 92, 56) but increasing by the 1770s to canvases of about 97 × 67 inches (246 × 170 cm) or larger (see figs. 78, 79). The few instances of a portrait of outsized dimensions were due to the need to accommodate more than a single sitter (see fig. 68) or a sitter with numerous or large accessories such as marble sculptures (see figs. 80, 96).

Occasionally, the shape of a canvas was dictated by the need to fill a particular position in a room, such as the pair of portraits of Lord and Lady Headfort (1782; Sarah Campbell Blaffer Foundation, Houston), intended to occupy plaster frames in the dining room at Headfort House, County Meath, which had been recently fitted out to Robert Adam's design.[77] In the case of one of Batoni's most unusual portraits, the format and dimensions, unique within his œuvre, were determined by its purpose as an overdoor. Girolama Santacroce Conti is depicted

unfastening her peignoir with her right hand while holding a strand of pearls before a mirror in her left (fig. 152).[78] The canvas, probably commissioned by her husband, Duke Michelangelo Conti, shortly after their marriage in 1759, was intended for an anteroom adjacent to her bedroom in their apartments in Palazzo Poli near the Fontana di Trevi.[79]

Batoni usually primed his canvases with a smooth pink-red ground consisting of lead white, vermilion, quartz, and natural ultramarine mixed in an oil medium. In the majority of paintings, the ground is normally visible only in discrete, small areas. This is usually detectable in areas of deterioration of the paint film, although occasionally Batoni left unpainted margins at the edges of his canvases, or reserves around the figures. His use of a red ground that helps to mute and unify the colours is consistent with the practice of other eighteenth-century Roman painters.[80] He appears to have employed red grounds (although not exclusively) throughout his career, for they are readily visible to the unaided eye in the early *Triumph of Venice* (see fig. 3) of 1737; in the portraits *John Woodyeare* (1750; Minneapolis Institute of Arts), *A Lady of the Milltown Family as a Shepherdess* (1751; National Gallery of Ireland, Dublin), and *Sir Wyndham Knatchbull-Wyndham* (see fig. 57); the full-length *Count Razumovsky* (see fig. 96); the full-length *John Staples* (1773; Museo di Roma); and *Mrs. James Alexander* (see fig. 72).[81] In each of these paintings he used the ground extensively both as a colour in itself and as a warm base under transparent

glazes. *John Wodehouse, later 1st Baron Wodehouse* (see fig. 76) reveals a more complicated double ground that consists of a cream-coloured layer applied upon the canvas superimposed with a darker red upper layer.[82]

The pigments Batoni used have been identified as lead white, bone white, lead-tin yellow, Naples yellow, burnt sienna, vermilion, red lake, terre verte, natural ultramarine, (possibly) Prussian blue, and bone black. The prevalence of Naples yellow in his pigments may explain the blonde tonality and softness of colour which is such a striking feature of his paintings.[83] Batoni's remarkable grasp of the physical and optical properties of the pigments he employed enabled him to depict his sitters' flesh tones and the colours of their dress with extreme accuracy. Even a portrait the size of *Count Kirill Grigoriewitsch Razumovsky* reveals in a detailed inspection numerous passages of delicate and virtuoso handling—the details of Razumovsky's costume and the orders he wears; the hilt of his sword and head of his cane; and the description of the surfaces of the marble sculptures in the background are all distinctive (see fig. 96). It is not only Batoni's faultless draughtsmanship but also his fluent handling of oil paint that sets his pictures apart from those of most of his European contemporaries.

Batoni's handling varies considerably, from a rich paste to transparent pigmented glazes, and in his finest pictures results in an intrinsic beauty of surface in and of itself. He painted rapidly in one or two layers, wet-into-wet, and although the texture of the brush strokes is evident throughout, his handling is economical, precise, and controlled. He employed a consistent method of working, varied but certain, direct, and confident, which his contemporaries admired.[84] The paint on most canvases is usually applied in an opaque layer, but Batoni frequently brushed it sufficiently thin to allow the ground to influence tone and colour.[85] Generally speaking, the paint layer is of uniform thickness, comprised of a soft paste that typically carries low brush-marking. Nonetheless, in many paintings there are variations in the paint texture; for example, the highlights on the forehead, shoulder, and elbow of Saint Andrew (see fig. 151) are conveyed with a thicker impasto, and in the portrait of *Frederick, Lord North, later 2nd Earl of Guilford* (see fig. 52), the handling is surprisingly loose and the action of the brush is visible in passages defining the cuffs and waistcoat. Batoni did not rely upon the accidents

of the brushstrokes to convey optical effects, however; the highlights are very carefully applied and precise in their role within the overall composition. Areas of costume trim, lace, and fur are usually brushed in somewhat higher relief than the surrounding surfaces. Batoni was clearly interested in "finish" and in the attractiveness of the surface of his paintings, perhaps deriving from his early training as a goldsmith. He was strongly inclined to produce dazzling pictorial effects, and he certainly intended to elicit admiration for his virtuoso handling of paint. This is made clear by Thomas Robinson's account of the painter pointing out precisely this aspect of his portrait of *Pope Clement XIII* (see fig. 105): "Battoni made one take notice how well the gold Lace was finished how transparent the Linnen was, & complained of ye Difficulty & patience in getting thro' so elaborate a performance."[86]

Batoni worked in a very organised fashion, laying out his compositions on the canvas and proceeding methodically. Examination of several of his canvases under infrared reflectography did not reveal any evidence of underdrawings.[87] The lack of any visible underdrawing may be misleading, however, because white and red chalk lines disappear when saturated with oil during the painting process and cannot be detected under infrared reflectography.[88] Thus, he may have employed some other means to transfer the rudiments of his compositions onto the canvas, perhaps an apparatus of strings or a similar means of squaring. Even in a small oil sketch like the *Allegory of Time, Justice, and the Arts* (early 1740s; The Art Institute of Chicago), X-radiographs reveal a composition developed in all of its details, with no significant changes and no laboured or reworked passages. The paint layer in the little sketch has a consistent, "buttery" texture that reveals no hesitation on the part of Batoni as he proceeded; moreover, the colours exhibit a beautiful clarity, each overlaying or abutting adjacent passages with no muddiness or confusion, the result of a well-conceived and executed design.[89]

This is not to suggest that Batoni's canvases are characterised by an absence of pentimenti, or changes in composition. A notable example of a subject painting in which numerous passages that were overpainted at a subsequent stage have become visible is the Brera *Holy Family* (see fig. 4), particularly in the head of the Infant Saint John and the Virgin's bosom. The X-radiographs of *Truth and Mercy* (see

fig. 33) show that the head of Mercy was originally closer to the left arm of the figure of Truth. In order to obtain sufficient room for her arm and hand, Batoni moved the head of Mercy to the right, as an examination of the actual canvas reveals.[90] In the case of those paintings that remained in Batoni's studio over a period of years, X-radiographs might well reveal numerous and significant compositional changes. In *Peace and War* (see fig. 122), for example, technical analysis reveals considerable reworking of the head of Peace, the drapery of War, and War's right leg, which is given greater exposure in the finished painting. Notably, although both breasts of Peace are entirely bare, X-rays show that the right breast was originally covered by her robe; similarly, the folds of heavy drapery covering her abdomen were subsequently replaced by an almost translucent sheet revealing the shape of her body beneath.[91]

The brilliance of Batoni's handling of paint in his portraits is exemplified by *Sir Wyndham Knatchbull-Wyndham* (see fig. 57), which is marked by a surprisingly subtle and silvery colour scheme that stands in contrast to the bolder, high-keyed palette that Batoni usually employed for his Grand Tour portraits.[92] The play of light around and through the composition, the way in which it enters the picture in subtle layers and degrees, defining highlights and shadows, is highly sophisticated. Batoni's brushwork is deft, and his direct application of paint onto the canvas and the resulting surface texture can be admired with the unaided eye. The variation in his handling can be seen, for example, in the contrast between the sketchy manner in which he created the shadows on the floor and the thicker application of paint in long, sinuous strokes to define the white drapery over Sir Wyndham's arm. In these passages Batoni employed glazes only minimally; the purplish shadows of this white drapery are not created by glazes but by directly applied paint.

Batoni appears to have begun the painting with Sir Wyndham's face, the foundation of which is a layer of green paint. He painted directly onto the canvas (*alla prima*), apparently without elaborate underdrawing, a method he seems to have followed throughout his career; this assumption is supported by examination of his canvases with infrared reflectography, which does not reveal any visible sketches. The blue sky is painted subsequent to the face; the white collar is painted after the flesh and sky, but the white clouds were executed after the collar. The

architecture appears to have been laid in before the sky, and the curtains after both the architecture and the sky. Batoni was very deliberate in the assembly of his portrait compositions, although pentimenti are occasionally visible, most frequently in details of the costume and in slight adjustments to the arrangements of his sitters' hands and wrists. These alterations show that Batoni worked over such passages, correcting outlines and enhancing particular details. Here several slight adjustments are visible to the naked eye, including the hind legs of the dog, the outline of Sir Wyndham's head, and the front leg of the chair.

A later full-length portrait, *Wills Hill, 1st Earl of Hillsborough, later 1st Marquess of Downshire* (see fig. 62), also confirms Batoni's consistent manner of working and reveals only a few visible pentimenti: an area around the sitter's head, indicating that Lord Hillsborough was once meant to have worn a hat; the position of his feet; the dog's head; and the fingers of Hymen's right hand. It is worth noting that for a painting of such large dimensions, these passages represent relatively few changes of intention—a testament to Batoni's deliberate planning and assembly of his compositions.[93] Indeed, in his Fourteenth Discourse, Sir Joshua Reynolds, who praised Gainsborough's "manner of forming all the parts of his picture together; the whole going on at the same time, in the same manner as nature creates her works," by contrast condemned the methods of Batoni, "who finished his historical pictures part after part; and in his portraits completely finished one feature before he proceeded to another. The consequence was, as might be expected; the countenance was never well expressed; and, as the painters say, the whole was not well put together."[94] While today one may not agree with his conclusions, Reynolds's observations about Batoni's working methods are perceptive and are confirmed both from accounts by his sitters and by inspection of the canvases themselves.

Batoni frequently supplied the frames for his paintings (see figs. 23, 24), and his preferred style was a design commonly referred to in Italy as a "Salvator Rosa" frame.[95] The period of greatest popularity for this frame extended from about the 1680s to the 1760s, but it remained in use well into the early nineteenth century. The "Salvator Rosa" is a relatively simple hollow-section frame without centre or corner projections that is very effective in leading the eye into the picture. The profile is made up of alternating con-

cave and convex surfaces which could be articulated for a wide variety of styles and subjects of paintings, with a further variation of the acanthus leaf ornament possible in the concave elements.[96] So many paintings by Batoni from the 1740s have retained their original frames in this style that it has been suggested that the pattern might be more properly designated a "Batoni" frame.[97] For example, nearly all of the extant pictures painted for Count Cesare Merenda were placed in frames uniformly carved and gilded in this basic pattern. Several canvases in the series of apostles bear their original frames, such as the *Saint Andrew* (see fig. 151).[98] The pattern was familiar to British Grand Tourists and artists visiting the Roman picture galleries during the eighteenth century—it was practically a "house frame" for the pictures in the Barberini, Doria-Pamphili, Colonna, and Spada collections—and was exported to England, where it came to be known as a "Carlo Maratta" frame and remained popular, particularly for portraits, until about 1820.[99] Thus, Richard Kaye appears to have arranged for the portrait of David Garrick (see fig. 45), given to him by the actor in exchange for a cameo, to be framed in England in a pattern closely modelled on a Roman prototype of about 1740.[100]

Studio Practices

What little is known of the organisation of Batoni's studio derives from the accounts of Johann Gottlieb Puhlmann. During the later years of his association with Batoni, Puhlmann emerged as an active assistant, together with the painter's sons Felice, Domenico, and Romualdo. The number of assistants employed in the studio was small and probably restricted at any given time to a few advanced pupils like Nathaniel Dance and Puhlmann and to the members of the painter's family.[101]

With regard to Batoni's studio practices, more is known about his approach to portrait painting than about his approach to history painting, for the obvious reason that his sitters observed him at work. In the actual sessions with his clients in the studio, Batoni concentrated on producing a likeness of the facial features, which he himself recorded directly on the canvas. The earliest reference to a likeness by Batoni is a chalk "portrait" commissioned by Marco Foscarini in 1737, and as Puhlmann and others in the 1780s referred to various visits by sitters to the studio for a "Por-

trätzeichnung" (for which the artist charged three zecchini), he was clearly at ease capturing a sitter's features with chalk or pencil.[102] In order to release his clients from the tedium of multiple sittings, Batoni no doubt developed the practice of recording their likenesses directly on the canvas itself in their presence. At a later time he resolved the questions of pose, costume, and lighting from a model wearing the appropriate clothes or by draping them on a lay figure, or he simply adopted one of the several stock portrait patterns that he had previously developed and repeated over the years.

The experience of George Lucy (see fig. 44) is typical. In a letter dated 12 April 1758, he wrote, "I have shown my face and person to the celebrated Pompeo Battoni, to take the likeness thereof; I have sat twice, and am to attend him again in a day or two. . . . When I asked my operator what time he would require, his answer was, a month or five weeks, and that he would not undertake to do me in less time; so I was forced to comply with him."[103] Batoni usually required two or three sittings for a portrait, although the actual number seems to have varied considerably from two sessions for the half-length *Hon. James Bucknall Grimston, later 3rd Viscount Grimston* (1772; Gorhambury, Hertfordshire), to six consecutive mornings in the studio for Emperor Joseph II and his brother (see fig. 90), to a reported twelve sittings of two and a half hours each for David Garrick.[104]

Almost without exception, the portraits were completed after the sitters had departed Rome. Douglas, 8th Duke of Hamilton, left the city on 19 May 1776 with only the face of his full-length completed (1775–76; Inverary Castle, Argyll).[105] On Sir Sampson Gideon's departure in 1766, only his features, painted from life, had been recorded and the remainder of the picture was finished subsequently, in part with the aid of a chalk study of his clothes. The rarity of preparatory drawings related to Batoni's portraits appears to confirm further his practice of painting directly onto the canvas and working only on the head with the sitter present, although it must be kept in mind that preparatory working drawings and notations of this kind were part of the studio paraphernalia and frequently re-used, and consequently would have been worn out and discarded.

The ease with which Batoni could orchestrate his sitters' poses, accessories, and settings—reversing a sculpture or the direction of a staircase so that it could be displayed at the left or right of a composition—accounts in large

measure for his ability to fashion the likenesses of so many visitors to his studio into pleasing and agreeable portraits that enabled each to believe that his or hers was an original, independent artistic creation. As Batoni became faced in the 1760s and 1770s with a great rise in the number of clients, he relied increasingly on a studio routine by which he could manipulate his sitters into easily repeatable attitudes. Throughout his career he employed a series of basic poses, which he made use of with few really exact repetitions. Clark traced the specific pose assumed by John Wodehouse in 1764 (see fig. 77) through a dozen variations.[106] In the portrait of John Monck (1764; Geffrye Museum, London) the pose is identical to Wodehouse's, except for the turn of the head, and it is repeated in *Thomas Peter Giffard* (1768; Chillington Hall, Staffordshire); the pose was used in reverse for Douglas, 8th Duke of Hamilton, and with minor variations in two other full-lengths, *John, Lord Mountstuart, later 4th Earl and 1st Marquess of Bute* (1767; private collection) and *George Gordon, Lord Haddo* (see fig. 78).[107] One of Batoni's most important sitters, Prince Karl Wilhelm Ferdinand (see fig. 103), was also painted in this pose in 1767, with only the change in position of one hand and different accessories.

Batoni's efficient use of poses and attitudes can be demonstrated by a host of such comparisons, including the identical articulation and disposition of his sitter's hands. Lord Thanet's pose (see fig. 51) was repeated almost exactly for the portraits of Charles John Crowle (1761–62; Musée du Louvre, Paris), Lord Haddo (see fig. 78), and, with the right arm extended, Francis Basset (see fig. 73), as well as for the three-quarter-length *Sir John Armytage, 2nd Bt.* (1755; private collection).[108] But no comparison reveals his economy of means as succinctly as that of *John Chetwynd Talbot* (1773; J. Paul Getty Museum, Los Angeles) and *Henry Peirse* (1775; Galleria Nazionale d'Arte Antica, Rome), in which the sitters' poses and that of the marble statue of the *Ludovisi Mars* are reversed, the flight of stairs altered to ascend in different directions, and the dogs and marble urns changed from one side to the other, so that the one becomes almost the mirror image of the other.[109] Batoni occasionally orchestrated the portraits of travelling companions in complementary poses: Thomas Orde, later 1st Baron Bolton (1773; private collection), is depicted in his half-length portrait leaning against a pedestal at the left with a book in his hand and facing right; his friend, Richard Aldworth

Neville, later 2nd Baron Braybrooke (1773; High Museum of Art, Atlanta), is shown leaning against a pedestal at the right holding a hat and facing left.[110] Even the furniture in Batoni's portraits was used subsequently in various portrait compositions over the years, notably an ornate carved and gilded wood console table, the various elements of which he subtly varied (see figs. 40, 81), and a chair that is positioned at various angles (and occasionally re-covered in a different fabric) in nearly a dozen portraits (see figs. 57, 96).[111]

Batoni used and re-used motifs and poses of the figures in his subject pictures with equal ease and effect. The figure of Sculpture in an *Allegory of the Arts* (see fig. 21) becomes a personification of Vice in a *Choice of Hercules* (1742; Galleria d'Arte Moderna, Palazzo Pitti, Florence), reversed and with some variations in the limbs. Apollo (see fig. 20) becomes Christ in a *Risen Christ* (1748; private collection, Rome); the poses of the Virgin and Child are easily re-employed (see figs. 131, 17, and the *Holy Family with the Infant Saint John the Baptist*, 1758; San Luigi dei Francesi, Rome); a female personification of Religion appears more than once (see figs. 94, 108); and the pose of Achilles in a painting of 1761 is re-employed two decades later in a sacred painting (see figs. 89, 116). These borrowings did not go unnoticed by Batoni's contemporaries: Father Thorpe observed Batoni's re-use of the model for Hagar in a similar pose in the *Preaching of Saint John the Baptist* (1777; Sant'Antonio Abate, Parma) and informed Lord Arundell, "Your Lordship's Agar but without her tears is introduced in the Altarpiece going to Parma, & is the most engaging figure in it."[112]

According to Puhlmann and others, Batoni painted with exceptional speed, and he himself boasted that he could finish a half-length devotional painting in fifteen days, citing as an example a painting of Saint Luigi Gonzaga.[113] A useful measure of the time Batoni may have required to finish a multifigured history painting of a standard size (tela d'imperatore) is provided by *Susannah and the Elders* and *Thetis Entrusting Chiron with the Education of Achilles*, each of which required four months to complete (see figs. 90, 89).[114] But by his own admission he was never satisfied with his work in progress, and he continued to adjust and refine the surfaces of his pictures long after they were "completed" in the conventional sense of the word. "I always give the last touches to my paintings when framed," he wrote to one patron, explaining that when he had to deliver some paint-

ings to England but could not send them with their frames because of the shipping expense, he prepared gold-coloured frames in order to finish the canvases according to their eventual appearance.[115] On another occasion he confessed, "By nature I am never satisfied with what I do, but rather I always feel that something is missing in the painting and I continue working."[116] Batoni's "whimsical genius," which, in his words, "is not easily pleased with what it creates, and which always feels that something more could be added," explains why his clients were so frequently driven to despair in their efforts to prise their commissions from his studio.[117]

Batoni's reputation for dilatoriness is a dominant and recurring theme in accounts of his work.[118] "He never keeps his promise," lamented Sir Horace Mann to Horace Walpole, and certainly the length of time Batoni required to complete a painting varied widely.[119] A bust-length portrait of James Bruce (1762; Scottish National Portrait Gallery, Edinburgh) required four months, and the half-length of Lord Charlemont may have taken two years to complete.[120] The portraits of Lord North and William Legge, 2nd Earl of Dartmouth (1752–56; Hood Museum of Art, Dartmouth College, Hanover, New Hampshire), may have remained in the studio for as long as three years before Thomas Jenkins, the sitters' agent, could remove them.[121] That a small bust-length portrait, *George, Lord Herbert, later 11th Earl of Pembroke* (1779; private collection), could require ten weeks for completion helps to explain why Sir Watkin Williams-Wynn had to wait three years for his large group portrait and even longer for the subject painting he had commissioned.[122] And no less a patron than Pope Pius VI may have had to wait seven months for his official likeness to be finished.[123]

Although occasionally Batoni dispatched his obligations with astonishing speed, as in the case of *John, Lord Brudenell, later Marquess of Monthermer*, which was completed within four months, all too frequently his sitters were required to leave Rome without their painting in hand and to prod him to finish it.[124] In spite of the inscribed date of 1767 on the reverse of the canvas, the portrait of Lady Mary Fox apparently remained unfinished after the sitter had returned home from Italy. In an undated letter, written from Rome before 7 January 1769, Gavin Hamilton mentioned the painting to Lady Mary's father: "Agreeable to your Lordship's desire I have desired Sigr Barazzi [Francesco Barazzi (c. 1710–1785), the Roman banker] to speak to Pompeo

to induce him to finish immediately Lady Mary Fox's portrait, we have accordingly his solemn promise to deliver it finished in a few days and hope he will be as good as his word." In this instance at least, Batoni kept his word, as Gavin Hamilton was able to write on 7 January 1769, referring to the dispatch of the canvas.[125]

One explanation for Batoni's failure to deliver his paintings on time is simply that he accepted almost every commission that came his way. In 1743, he wrote to one patron, "I have six paintings on my easels, all of the highest urgency and commitment."[126] Father Thorpe informed Lord Arundell in a letter of 2 October 1768 that Batoni had more work in progress than he could possibly finish. On 28 August 1771 he wrote: "Pompeo has done nothing, and if as I fear, never will; he has so many pieces begun, two, three if more years ago, and has so many commissions & so great encouragement from the Empress Queen and the Czarina that even the Prince of Brunswick is much obliged to him for finishing a half-length portrait which was begun two years ago; all other work has been at a stand, except a few heads of travelling gentlemen which will not perhaps be finished in ten years time."[127] Many paintings were simply never brought to completion because, as Father Thorpe told Lord Arundell, "[Anton von Maron] is become almost as bad as Pompeo in neglecting old or dead commissions."[128]

Copies and Replicas

In spite of Batoni's distinguished reputation and the steady stream of important commissions he received from the early 1730s, he accepted work that to modern eyes appears beneath his standing as the most celebrated painter in Rome—for example, supplying the figures in the landscapes of Hendrik Frans van Lint (1684–1763), Andrea Locatelli (1695–1741), Paolo Anesi (1697–1773), and Jan Frans van Bloemen (1662–1749) and making copies of the works of others.[129] Batoni was no different from many other painters of independent rank in the eighteenth century in his willingness to produce copies of famous works of art. The importance of the works of Raphael as an ingredient in Batoni's artistic development and the esteem in which he held the great Renaissance painter is underscored repeatedly by his biographers, and so it is natural to find him joining the numerous contemporary artists who executed copies for foreign visitors of the paintings

they had most admired in Rome. The period of the Grand Tour saw the height of such activity, and besides the many skilful copyists who specialised in this work were painters of greater stature like Batoni who from time to time would copy the work of others upon request.

The British were Batoni's best clients for such commissions, and from the outset of his career he painted copies for them of famous Old Masters in Rome. In 1733, the first foreigner to commission oil paintings from Batoni, Captain John Urquhart (1696–1756) of Cromarty, ordered copies of Guido Reni's ceiling of the *Ascension of Christ* in the Vatican, his *Christ on the Cross* in San Lorenzo in Lucina, and Federico Barocci's *Rest on the Flight into Egypt* in Palazzo Pamphili, none of which can be identified today.[130] Batoni painted numerous copies after the works of Reni, who was held in nearly as high esteem as Raphael by English collectors and cognoscenti of this period. Italian churches and private collections were scoured by the agents of English aristocrats on the Grand Tour for works by the artist, with the result that many of Reni's finest pictures found their way into English collections.[131] The most celebrated commission for copies in eighteenth-century Rome was the series of full-scale replicas after Raphael, Reni, and Carracci, now dispersed, on which Batoni and Mengs collaborated with Agostino Masucci and Placido Costanzi for Northumberland House in London.[132] For other works that were particularly admired but could not be acquired, copies were ordered, and Batoni readily complied with such requests throughout his career, to judge from the existing copies known from his hand and others recorded in eighteenth-century sales.[133]

The attitude towards copying in the eighteenth century was quite different from that of today, and Batoni copied on commission relatively minor portraits whose significance would now scarcely raise an eyebrow.[134] The earliest record of such a commission involves a miniature after a portrait by Domenico Dupra of Prince Henry Benedict Stuart, commissioned in 1744 by Prince Charles Edward Stuart when he was in Paris. Perhaps Batoni hoped that this small commission would lead to more important things. Eager for portraits of his family, the prince had asked for copies to be made of existing likenesses: "Get them," he wrote, "to be done by Pompeo, that's to say coppid from the likest pictures." When Prince Henry replied to his brother's request later in the year, it was to say: "Pompeo at last has

finished my Picture, it is finely done, but to tell you the Truth it is not well copied from the Original." The miniature, which is today untraced, was promptly paid for and the bill receipted by the painter on 21 September 1744.[135] Further light is thrown upon Batoni's activities as a copyist by Father Thorpe's attempt in 1769 to commission Batoni to produce replicas of a pair of ancestral portraits for Lord Arundell. Thorpe informed his patron that "in regard of Copies it cannot be expected that he either will or can make them entirely with his own hand, tho' he undertakes to do them: his Assistants will do the greatest part of the work, which he will only afterwards finish & perfect, but will exact the whole price as if he had done it all."[136]

The majority of copies produced by Batoni were of course the many autograph replicas of his own paintings, in particular the portraits. A wealthy or important sitter, for instance, might order a copy of a portrait to hang in another of his houses; copies might be ordered for relatives or friends of the sitter; and, in at least one instance, for the mistress of a sitter.[137] More than a dozen of Batoni's British sitters commissioned replicas of their portraits, and in most instances Batoni painted these canvases himself rather than delegating them to studio assistants.[138] Illustrious sitters such as Emperor Joseph II required multiple versions of their portraits and these could easily be executed even after the dispatch of the original as Batoni, in his words, had "completely finished the two heads of the royal sovereigns, with all of the orders and everything else that is necessary, in order to keep them here as models, in accordance with the orders personally given to me by His Majesty [Joseph II]."[139] James Martin noted the popularity of the Duke of York's portrait (see fig. 39) during a visit to the painter's studio in 1764: "Went to Pompeia Battoni's saw there several portraits. He has made a Copy from that of the Duke of York & rec'd orders for One or Two more."[140] Like the English artists who painted conversation pieces of their compatriots in Italy, Batoni must have found it extremely tedious when called upon to produce replicas and variants of his portraits.[141] Yet such commissions were lucrative, and Batoni rarely refused to comply with his patrons' wishes for additional likenesses.

For clients of lesser means, additional replicas were produced in the studio by Batoni's assistants, although under his supervision, and possibly with his co-operation.

In 1756, one visitor to Batoni's studio reported the presence of young assistants precisely copying, under the master's supervision, his paintings to the exact dimensions of the original canvases.[142] In 1769, Batoni responded to a request from Lodovico Sardini for a copy of *Holy Roman Emperor Joseph II and Grand Duke Leopold of Tuscany* with an offer to have the picture painted by "one of my best students" for 100 scudi, "which is a good price, considering the great amount of work involved," adding, "Not only will I make sure that they are made very well, but I will touch up the heads myself."[143] And in the early 1780s, Puhlmann painted replicas of *Aleksandra, Countess Potocka* and *Izabella, Countess Potocka* (both 1780; Wilanów Palace, Warsaw), as well as numerous copies in various formats of *Grand Duke Paul I, later Emperor Paul of Russia,* and *Grand Duchess Maria Feodorovna, later Empress of Russia* (both 1782; formerly Gatchina Palace, St. Petersburg).[144]

More problematical is the degree of studio participation in the execution of paintings that Batoni signed and dated and which left the studio as his own. Puhlmann, for example, informed his parents he had spent a week painting the background in a work of Batoni's that remains unidentified.[145] It seems certain, however, that after 1760 Batoni increasingly delegated to assistants the execution of at least part of most second versions of portraits, and that after 1780 he required their assistance in the completion of very large canvases.[146] In the end, however, the problem of determining how much of a particular canvas was executed by Batoni himself will remain largely a matter of connoisseurship.

Prices

Batoni's elevated social and professional contacts with European princes and sovereigns resulted in his becoming difficult and demanding in his business affairs, particularly in the 1770s. Edmund Henry Pery, later Viscount and Earl of Limerick (1758–1844), noted in his Grand Tour journal of 1777–78, "He is exceedingly interested & mean in his Dealings and one must keep a strict Eye over him otherwise he will impose."[147] Father Thorpe in his letters to Lord Arundell frequently reported the complaints of Batoni's clients over his behaviour toward them. In 1774 he wrote, "Pompeo works only for those who pay him the most, & at the same time he is meanly raising his price."[148] On another

occasion he observed, "He would be glad to receive part of the money before he begins, several do advance one third or one half of the prices & they are commonly the soonest served. Perhaps there will be no other way of dealing with him."[149] Batoni even "gave some disgust to their Royal Highnesses," the Duke and Duchess of Gloucester, Father Thorpe related, "when upon their sending for the pictures, he refused to give them until he had received the full of his demands for painting them."[150]

Batoni's prices for paintings of sacred, mythological, and historical subjects were always greater than for portraits and increased steadily over the years.[151] The ecclesiastical commissions provide a rough impression of the development of Batoni's prices, beginning with the 200 scudi he received in 1733 for his altarpiece in San Gregorio al Celio (see fig. 1), the same amount as the older and more experienced painter Francesco Imperiali received for his painting *Death of Saint Romuald* in the same church. In 1738, Batoni was paid 350 scudi for *Christ in Glory with Saints Celsus, Julian, Marcionilla, and Basilissa* commissioned for the high altar of Santi Celso e Giuliano. For the decoration of Benedict XIV's Caffeaus in the gardens of the Palazzo del Quirinale (see fig. 26), he received 400 scudi, the same amount as Agostino Masucci was paid for his ceiling paintings in the same building.[152] The *Annunciation,* one of a series of oval paintings commissioned by Benedict XIV during his campaign to refurbish the interior of the basilica of Santa Maria Maggiore, brought 250 scudi in 1746.[153] Batoni was paid 1,200 scudi (with 300 more for expenses) for the *Fall of Simon Magus* for Saint Peter's (see fig. 35), and for a late altarpiece, *The Preaching of Saint John the Baptist* (1777; Sant'Antonio Abate, Parma), although considerably smaller in size, he is known to have been paid at least 500 scudi, though in light of the number of figures within the composition it is likely that it was more.[154] He received 3,000 scudi for the large high altar for the Basilica of the Estrêla at Lisbon in 1781.[155]

In the 1740s, Batoni typically received 100 to 150 scudi for history paintings in the tela d'imperatore format (see figs. 23, 24), although there were always certain paintings for which he was paid substantially more; for example, he received 200 scudi for the larger *Saint Mary Magdalene* (c. 1742; formerly Gemäldegalerie, Dresden) painted for Count Cesare Merenda. The same pattern prevailed in the

1750s: Batoni received 160 scudi for *Susannah and the Elders* and 800 scudi for *Pope Benedict XIV Presenting the Encyclical "Ex Omnibus" to the Comte de Choiseul*, commissioned by Cardinal Domenico Orsini (see figs. 90, 108).[156] Starting in the 1760s, however, the amounts Batoni received for his history paintings varied considerably and increased dramatically: 600 scudi for *Diana and Cupid* (see fig. 59); 1,000 scudi for a pair of allegories, *Clemency and Justice* and *Prudence and Temperance* (untraced) commissioned by King Stanislas II of Poland in 1767.[157] He obtained 650 scudi for the *Bacchus and Ariadne* (1769–73; private collection, Rome) commissioned by Sir Watkin Williams-Wynn; 1,000 scudi for a *Holy Family* (untraced) purchased by Thomas Dundas; and 1,600 scudi for *Alexander and the Family of Darius* (see fig. 86).[158] The sums paid by the succession of exceedingly wealthy Russians coming to Rome beginning in the 1760s, however, appear astronomical when compared to those offered by Batoni's Italian patrons and the Church: 1,400 scudi for the *Choice of Hercules* acquired in 1766 by Count Kirill Razumovsky (see fig. 97); 1,691 scudi each for *Chiron Returns Achilles to Thetis* and *The Continence of Scipio* commissioned by Count Shuvalov in 1768 for Catherine II (see figs. 98, 99); and 3,000 scudi for the *Holy Family with Saint Elizabeth and the Infant Saint John the Baptist* purchased by Grand Duke Paul of Russia in 1782 (see fig. 100). (In October 1778, an English visitor to Rome, Philip Yorke, who sat to Batoni the following year, found the *Holy Family* too expensive and its colours "too glaring.")[159] Generalisations about Batoni's prices, however, must always be treated with caution, as a passage from a letter of Father Thorpe in December 1776 makes clear: "Pompeo does not offer his painting of Peace & War to sale: it is one of those pieces which he makes every two or three years with more than ordinary attention, & then pretends to keep for himself until he suffers it to be wrested from him for the sake of a double price: this is an old trick of him & others."[160] Seven months later, Thorpe added, Batoni "demands . . . six hundred Zequins [1,200 scudi], for his Peace & War."[161]

By contrast, in the 1750s and 1760s a half-length portrait by Batoni cost 60 scudi and a miniature of the sitter could be obtained for half that amount.[162] This was the equivalent of approximately 15 guineas, or about three-fifths of the price that Sir Joshua Reynolds and Allan Ramsay were then charging in London.[163] In 1769, Father Thorpe reported

that Batoni was charging the equivalent of 50 guineas for a half-length portrait, which was also less than Reynolds's price at the time.[164] Five years later, Puhlmann reported Batoni's charges at the equivalent of 30 guineas for a bust-length portrait, 40 for a half-length, and 125 to 250 for a full-length, which was still less than Reynolds was asking in London.[165] Moreover, for the wealthy milordi inglesi in Rome, Batoni's portraits, in addition to being livelier and better drawn than similar works by the vast majority of English (and Italian) contemporary artists, appear to have enjoyed the added advantage of being relatively inexpensive compared to other costs incurred on the Grand Tour. This is emphasised by the observation of the Rev. Norton Nicholls (c. 1742–1809) in 1772 that while a course in Roman antiquities with James Byres cost fifteen to twenty guineas, he could obtain a half-length portrait by Batoni for twenty.[166] Sir William Forbes (1755–1816) noted in his *Journal of a Continental Tour* (1793): "To mark the difference of prices in London and Rome, Pompeio charged but 20 zechins, or ten guineas for a head, at the time when Sir Joshua Reynolds was getting five and thirty guineas for the same size."[167]

There were, nonetheless, those who took exception to the notion that Batoni's portraits represented some sort of bargain. Father Thorpe complained, "Pompeo has raised his price most extravagantly, but he must even be courted to get a Portrait from him at any rate."[168] Moreover, it should be observed that by the 1770s certain middle-class travellers making the Grand Tour found Batoni's prices expensive. On 28 September 1773 the Norwich merchant Robert Harvey (1753–1820) recorded in his journal: "Went to Pompeio Battonis the best modern painter very fat, working abt. several english portraits, which are well done but uncommonly dear. 60 sequins [about 30 guineas] ye least then 75 & for a whole length 200." (In Batoni's studio Harvey also saw "two excellent fancy pieces of his, of Bacchus & Ariadne an extremely fine face said to be one of his daughters, the other Alexander receiving Darius family & nobly done too, for ye King of Prussia & ye price 1000 sequins.")[169] Certain commissions—such as the group portrait of Sir Watkin Williams-Wynn (see fig. 69), for which Batoni received 900 scudi, or the portrait of *Pope Pius VI* (see fig. 107), for which he was paid 500—were of course more lucrative, but in the main Batoni was less expensive and more consistent in his prices than were British portrait painters.

LIST OF WORKS IN THE EXHIBITION

1. *The Vision of Saint Philip Neri*, c. 1733–34
Oil on canvas, 78¼ × 55⅛ in. (200 × 140 cm)
Galleria Nazionale d'Arte Antica, Palazzo Barberini, Rome

2. *The Triumph of Venice*, 1737
Oil on canvas, 68⅛ × 112⅛ in. (174.3 × 286.1 cm)
North Carolina Museum of Art, Raleigh; Gift of the Samuel H. Kress Foundation (60.17.60)

3. *Allegory of the Arts*, 1740*
Oil on canvas, 68⅛ × 54⅛ in. (174.8 × 138 cm)
Städel Museum, Frankfurt (731)

4. *The Sacrifice of Iphigenia*, 1740–42*
Oil on canvas, 60¼ × 75 in. (153 × 190.6 cm)
Private collection; on loan to the National Gallery of Scotland, Edinburgh

5. *The Death of Meleager*, 1740–43
Oil on canvas, 53⅛ × 37⅛ in. (135 × 95 cm)
Private collection

6. *Prometheus Fashioning Man from Clay*, 1740–43
Oil on canvas, 53⅛ × 37⅛ in. (135 × 95 cm)
Private collection

7. *God the Father*, c. 1740–43
Oil on canvas, 28¼ × 23¼ in. (73 × 60.3 cm)
The Iliffe Collection, Basildon Park (The National Trust)

8. *Saint Paul*, c. 1740–43
Oil on canvas, 28¼ × 23¼ in. (73 × 60.3 cm)
The Iliffe Collection, Basildon Park (The National Trust)

9. *Saint Peter*, c. 1740–43
Oil on canvas, 28¼ × 23¼ in. (73 × 60.3 cm)
The Iliffe Collection, Basildon Park (The National Trust)

10. *Saint Philip*, c. 1740–43
Oil on canvas, 28¼ × 23¼ in. (73 × 60.3 cm)
The Iliffe Collection, Basildon Park (The National Trust)

11. *The Ecstasy of Saint Catherine of Siena*, 1743
Oil on canvas, 110¼ × 86⅛ in. (280 × 220 cm)
Museo Nazionale di Villa Guinigi, Lucca (302)

12. *The Virgin and Child with Saint John Nepomuk*, c. 1743
Oil on canvas, 47¼ × 25 in. (120 × 63.5 cm)
Pinacoteca, Musei Vaticani, Vatican City (40415)

13. *The Blessed Bernardo Tolomei Attending a Victim of the Black Death*, 1745❖
Oil on canvas, 102¼ × 68⅛ in. (261 × 173 cm)
San Vittore al Corpo, Milan

14. *Peace and Justice*, c. 1745
Oil on canvas, 47¼ × 35½ in. (120 × 90 cm)
The Montreal Museum of Fine Arts; Purchase, Horsley and Anne Townsend Bequest, special replacement fund and gift of Mr. and Mrs. Neil B. Ivory (1979.21)

15. *Truth and Mercy*, c. 1745
Oil on canvas, 47¼ × 35½ in. (120 × 90 cm)
The Montreal Museum of Fine Arts; Purchase, Horsley and Anne Townsend Bequest, special replacement fund and gift of Mr. and Mrs. Neil B. Ivory (1979.20)

16. *Time Orders Old Age to Destroy Beauty*, 1745–46
Oil on canvas, 53¼ × 38 in. (135.3 × 96.5 cm)
The National Gallery, London (NG 6316)

17. *Achilles and the Daughters of Lycomedes*, 1746
Oil on canvas, 62⅛ × 49¼ in. (158.5 × 126.5 cm)
Galleria degli Uffizi, Florence (544)

18. *The Education of Achilles*, 1746
Oil on canvas, 62⅛ × 49¼ in. (158.5 × 126.5 cm)
Galleria degli Uffizi, Florence (549)

19. *Antiochus and Stratonice*, 1746
Oil on canvas, 74¼ × 91¼ in. (190 × 233 cm)
Museo de Arte de Ponce, Fundación Luis A. Ferré, Ponce, Puerto Rico (58.0064)

20. *Achilles Comforted by Thetis*, 1747*
Oil on canvas, 36 × 27½ in. (91.5 × 69.8 cm)
Collection of the late Sir Brinsley Ford

* Exhibited in London only
❖ Exhibited in Houston only

21. *Aeneas Abandoning Dido,* 1747*
Oil on canvas, 36 × 27½ in. (91.5 × 69.8 cm)
Collection of the late Sir Brinsley Ford

22. *The Virgin and Child in Glory,* 1747
Oil on canvas, 46½ × 24 in. (118 × 61 cm)
Toledo Museum of Art; Purchased with Funds from the Libbey
Endowment, Gift of Edward Drummond Libbey (1963.5)

23. *The Immaculate Conception,* 1750*
Oil on canvas, 141¼ × 76¼ in. (360 × 195 cm)
Santi Faustino e Giovita, Chiari

24. *George Damer,* c. 1750*
Oil on canvas, 38 × 24 in. (96.5 × 61 cm)
Private collection

25. *Sir Matthew Fetherstonhaugh, 1st Bt.,* 1751
Oil on canvas, 39 × 29 in. (99 × 73.7 cm)
The Fetherstonhaugh Collection, Uppark (The National Trust)

26. *Sarah, Lady Fetherstonhaugh,* 1751
Oil on canvas, 39 × 29 in. (99 × 73.7 cm)
The Fetherstonhaugh Collection, Uppark (The National Trust)

27. *Susannah and the Elders,* 1751
Oil on canvas, 39 × 53½ in. (99 × 136 cm)
Private collection

28. *Meekness,* 1752
Oil on canvas, 39 × 29 in. (99 × 73.7 cm)
The Fetherstonhaugh Collection, Uppark (The National Trust)

29. *Purity of Heart,* 1752
Oil on canvas, 38½ × 29 in. (97.8 × 73.7 cm)
The Fetherstonhaugh Collection, Uppark (The National Trust)

30. *Robert Clements, later 1st Earl of Leitrim,* c. 1753–54
Oil on canvas, 39¼ × 28¾ in. (101 × 73 cm)
Hood Museum of Art, Dartmouth College, Hanover, New Hamp-
shire; Purchased through a gift from Barbara Dau Southwell, Class
of 1978, in honor of Robert Dance, Class of 1977, a gift of William
R. Acquavella, and the Florence and Lansing Porter Moore 1937
Fund (2002.6)

31. *Carl Eugen, Duke of Württemberg,* 1753–54*
Oil on canvas, 107⅝ × 67¼ in. (273.5 × 172 cm)
Württembergische Landesbibliothek, Stuttgart

32. *James Caulfeild, 4th Viscount Charlemont, later 1st Earl of Charlemont,*
c. 1753–55*
Oil on canvas, 38½ × 29 in. (97.8 × 73.7 cm)
Yale Center for British Art, Paul Mellon Collection, New Haven,
Connecticut (B 1974.3.26)

33. *Frederick, Lord North, later 2nd Earl of Guilford,* c. 1753–56
Oil on canvas, 36¼ × 29¾ in (92.1 × 75.6 cm)
National Portrait Gallery, London (NPG 6180)

34. *The Marriage of Cupid and Psyche,* 1756
Oil on canvas, 33½ × 46⅞ in. (85 × 119 cm)
Staatliche Museen zu Berlin, Gemäldegalerie (504)

35. *Pope Benedict XIV Presenting the Encyclical "Ex Omnibus" to the Comte
de Choiseul,* 1757*
Oil on canvas, 50¼ × 70⅝ in. (128.9 × 179.5 cm)
Minneapolis Institute of Arts, The William Hood Dunwoody
Fund (61.62)

36. *Charles Compton, 7th Earl of Northampton,* 1758*
Oil on canvas, 93½ × 58¾ in. (237.5 × 149.2 cm)
The Fitzwilliam Museum, Cambridge (PD.4-1950)

37. *John, Lord Brudenell, later Marquess of Monthermer,* 1758*
Oil on canvas, 38 × 28 in. (96.5 × 71.1 cm)
The Duke of Buccleuch & Queensberry KT, Boughton House,
Northamptonshire

38. *William Fermor,* 1758*
Oil on canvas, 39⅛ × 28¹⁵⁄₁₆ in. (99.4 × 73.1 cm)
The Museum of Fine Arts, Houston; Gift of the Samuel H. Kress
Collection (61.76)

39. *Richard Milles,* c. 1758
Oil on canvas, 53 × 38 in. (134.6 × 96.5 cm)
The National Gallery, London (NG 6459)

40. *Richard Milles,* c. 1758*
Watercolour on ivory, 1¼ × 1¹⁄₁₆ in. (3.2 × 2.7 cm)
The Fitzwilliam Museum, Cambridge (PD.9-1954)

41. *The Rest on the Flight into Egypt,* c. 1758*
Oil on canvas, 29⅛ × 39⅛ in. (74.5 × 100 cm)
Private collection; on loan to the Museum of Fine Arts, Houston

42. *Edward Dering, later 6th Bt.,* 1758–59*
Oil on canvas, 53¼ × 39½ in. (136.5 × 99.5 cm)
Private collection; on loan to the Art Institute of Chicago

43. *Sir Wyndham Knatchbull-Wyndham, 6th Bt.*, 1758–59✢
Oil on canvas, 91¼ × 63½ in. (233 × 161.3 cm)
Los Angeles County Museum of Art; Gift of the Ahmanson Foundation (1994.128.1)

44. *Pope Clement XIII*, 1760
Oil on canvas, 53 × 36⅝ in. (134.6 × 93 cm)
Galleria Nazionale d'Arte Antica, Palazzo Barberini, Rome (1925)

45. *Holy Family*, c. 1760
Oil on canvas, 38¼ × 29 in. (98.5 × 73.5 cm)
Pinacoteca Capitolina, Rome (PC 359)

46. *Duchess Girolama Santacroce Conti*, c. 1760
Oil on canvas, 19¼ × 47¼ in. (49 × 120 cm)
Pinacoteca Capitolina, Rome (PC 278); on loan to the Museo di Roma (Dep. MC 138)

47. *Thetis Entrusting Chiron with the Education of Achilles*, 1760–61
Oil on canvas, 40⅛ × 54⅛ in. (102 × 138 cm)
Galleria Nazionale, Parma (5)

48. *Diana and Cupid*, 1761
Oil on canvas, 49 × 68 in. (124.5 × 172.7 cm)
The Metropolitan Museum of Art, New York; Purchase, The Charles Engelhard Foundation, Robert Lehman Foundation Inc., Mrs. Haebler Frantz, April R. Axton, L. H. P. Klotz, and David Mortimer Gifts; and Gifts of Mr. and Mrs. Charles Wrightsman, George Blumenthal, and J. Pierpont Morgan, Bequests of Millie Bruhl Fredrick and Mary Clark Tompson, and Rogers Fund, by exchange, 1982 (1982.438)

49. *Louisa Grenville, later Countess Stanhope*, 1761*
Oil on canvas, 41 × 26½ in. (104.2 × 67.3 cm)
The Administrative Trustees of the Chevening Estate, Kent; Gift of the 7th Earl Stanhope KG

50. *Sir Humphry Morice*, 1761–62
Oil on canvas, 46¼ × 68 in. (117.5 × 172.8 cm)
Sir James and Lady Graham, Norton Conyers, North Yorkshire

51. *Cardinal Jean-François-Joseph de Rochechouart de Faudoas*, 1762✢
Oil on canvas, 53¼ × 38½ in. (135.3 × 97.2 cm)
Saint Louis Art Museum (135.1972)

52. *Cleopatra and the Dying Mark Antony*, 1763
Oil on canvas, 29⅞ × 39⅛ in. (76 × 100 cm)
Musée Municipal, Brest (66-188-1)

53. *Thomas Dundas, later 1st Baron Dundas*, 1763–64
Oil on canvas, 117½ × 77½ in. (298 × 196.8 cm)
The Marquess of Zetland, Aske Hall, North Yorkshire

54. *Alexander Gordon, 4th Duke of Gordon*, 1763–64
Oil on canvas, 115 × 75½ in. (292 × 192 cm)
National Gallery of Scotland, Edinburgh (NG 2589)

55. *John Wodehouse, later 1st Baron Wodehouse*, 1763–64✢
Oil on canvas, 53¼ × 39 in. (136.5 × 99.1 cm)
Allen Memorial Art Museum, Oberlin College, Ohio; Mrs. F. F. Prentiss Fund, 1970 (70.60)

56. *The Choice of Hercules*, c. 1763–65
Oil on canvas, 96½ × 67¼ in. (245 × 172 cm)
The State Hermitage Museum, Saint Petersburg (4793)

57. *Edward Augustus, Duke of York*, 1764✢
Oil on canvas, 54 × 39¼ in. (137 × 99.5 cm)
Private collection

58. *Edward Augustus, Duke of York*, 1764✢
Oil on canvas, 54¼ × 39½ in. (137.8 × 100.3 cm)
Private collection

59. *David Garrick*, 1764
Oil on canvas, 30 × 24¼ in. (76 × 63 cm)
The Ashmolean Museum, Oxford (WA 1845.61)

60. *Marqués Manuel de Roda y Arrieta*, 1765*
Oil on canvas, 39 × 29½ in. (99 × 75 cm)
Museo de la Real Academia de Bellas Artes de San Fernando, Madrid (709)

61. *Colonel the Hon. William Gordon*, 1765–66
Oil on canvas, 102 × 74 in. (259 × 187.5 cm)
The National Trust for Scotland, Fyvie Castle, Aberdeenshire

62. *Count Kirill Grigoriewitsch Razumovsky*, 1766✢
Oil on canvas, 117½ × 77⅛ in. (298 × 196 cm)
Private collection

63. *Prince Abbondio Rezzonico*, c. 1766
Oil on canvas, 117 × 77⅛ in. (297.5 × 196.5)
Private collection; on loan to the Museo Biblioteca Archivio di Bassano del Grappa

64. *Lady Mary Fox, later Baroness Holland*, 1767–68*
Oil on canvas, 48 × 36 in. (121.9 × 91.4 cm)
Private collection

65. *Sir Gregory Turner (later Page-Turner), 3rd Bt.,* 1768–69*
Oil on canvas, 53 × 39 in. (134.5 × 99.5 cm)
Manchester Art Gallery (1976.79)

66. *Sir Watkin Williams-Wynn, 4th Bt., Thomas Apperley, and Captain Edward Hamilton,* 1768–72
Oil on canvas, 113¼ × 77⅛ in. (289 × 196 cm)
Amgueddfa Cymru—National Museum Wales, Cardiff (NMW A 78)

67. *The Hon. John Dawson, later 2nd Viscount Carlow and 1st Earl of Portarlington,* 1769*
Oil on canvas, 38 × 28 in. (96.5 × 71.1 cm)
Private collection

68. *The Hon. Arthur Saunders Gore, later 2nd Earl of Arran, with His Wife, Catherine,* 1769*
Oil on canvas, 43½ × 32½ in. (110.5 × 82.5 cm)
The Trustees of the Will of the 6th Earl of Arran

69. *Prince William Henry, Duke of Gloucester,* 1772*
Oil on canvas, 28⅛ × 24⅛ in. (73 × 61.9 cm)
Private collection

70. *The Appearance of the Angel to Hagar in the Desert,* 1774–76
Oil on canvas, 39¼ × 59¼ in. (100 × 151 cm)
Galleria Nazionale d'Arte Antica, Palazzo Barberini, Rome (2374)

71. *Peace and War,* 1776*
Oil on canvas, 53½ × 39 in. (136 × 99 cm)
The Art Institute of Chicago; Gift of the Old Masters Society (1998.152)

72. *Mrs. James Alexander,* 1777*
Oil on canvas, 39¼ × 29⅛ in. (99.5 × 74.6 cm)
Private collection

73. *Baron Carl Adolph von Plessen,* 1778*
Oil on canvas, 54¼ × 40½ in. (139 × 103 cm)
Private collection

74. *Francis Basset, later Baron de Dunstanville,* 1778
Oil on canvas, 87 × 61¼ in. (221 × 157 cm)
Museo Nacional del Prado, Madrid (49)

75. *Henry Swinburne,* 1779*
Oil on canvas, 27⅞ × 22⅝ in. (70.8 × 57.5 cm)
Laing Art Gallery, Newcastle upon Tyne (Tyne & Wear Museums)

76. *The Marriage of Saint Catherine with Saints Jerome and Lucy,* 1779*
Oil on canvas, 89 × 58⅞ in. (226 × 149.5 cm)
Palazzo del Quirinale, Rome

77. *Allegory of the Death of Two Children of Ferdinand IV,* 1780*
Oil on canvas, 113⅛ × 68⅞ in. (288 × 175 cm)
Palazzo Reale, Caserta (398)

78. *Mrs. Robert Sandilands,* 1781
Oil on canvas, 27 × 22½ in. (68.6 × 57.2 cm)
English Heritage (The Iveagh Bequest, Kenwood, London)

79. *Prince Benedetto Giustiniani,* 1785
Oil on canvas, 28¼ × 24 in. (73 × 61 cm)
Private collection

80. *Princess Cecilia Mahony Giustiniani,* 1785
Oil on canvas, 28¼ × 24 in. (73 × 61 cm)
National Gallery of Scotland, Edinburgh (NG 2369)

NOTES

Unless otherwise identified, all translations are by the authors.

CHAPTER I. INVENTIVE STORYTELLING

 Epigraph: ASL, no. 920, p. 305.

1. Archivio di Stato, Rome, 30 Notai Capitolini, Ufficio 3, busta 354, notaio Carlo Antonio Oddi, 1730, fol. 526 (transcribed by Olivier Michel): rental agreement between Barone Pietro Paolo Mantica and Pompeo Batoni, 9 October 1730, for a four-room apartment in Palazzo Mantica in Piazza di Macel de' Corvi. The entire quarter was razed in the late nineteenth century to make way for the Monumento Vittorio Emanuele II. Today the building's former location at the bottom of the monument's steps is marked by the remains of the tomb of Caio Publicio, then incorporated into the Palazzo Mantica, as can be seen in the engraving of the Piazza di Macel de' Corvi by Giuseppe Vasi. See also Borsi 1993, p. 274 (Palazzo Mantica is no. 110 in the Nolli map of 1748).

2. Clark and Bowron 1985, no. 2.

3. For Imperiali's painting, see Philadelphia 2000, pp. 364–65, no. 215.

4. Benaglio 1894, pp. 48–57.

5. Clark and Bowron 1985, no. 5.

6. Clark and Bowron 1985, no. 106.

7. Morpurgo 1880, p. 352.

8. Foscarini's first despatch from Rome to the Venetian Senate is dated 6 April 1737; see Gandino 1894, p. 3.

9. Chracas 1716–1836, no. 2849, 5 November 1735. See also Chracas 1997–99, vol. 1, p. 99.

10. The commission for Foscarini's portrait went to Pierre Subleyras (c. 1737–40; Museo Correr, Venice); see Paris 1987, p. 234, no. 60.

11. Clark and Bowron 1985, no. 13.

12. For example, Johann Gottlieb Puhlmann reported in a letter to his parents that he had attended a performance of "'Artaserse' by Metastasio" at the Teatro Argentina on 4 February 1777. He did not mention the composer, Pietro Alessandro Guglielmi (Puhlmann 1774–87, p. 125).

13. Benaglio 1894, p. 62: "Lo stato florido della repubblica, quando estinte le guerre, eccitate dalla famosa lega di Cambrai, cominciarono colla pace a rifiorire in Venezia le belle arti, richiamate e nodrite dal doge Lionardo Loredano"; "Mare, continente, prospettive di città, architettura, personaggi eccelsi per dignità, figure di ogni età, d'ogni sesso, genii, simboli delle lettere e delle belle arti."

14. For a summary of previous discussions of the painting's ico-nography and visual quotations, see Raleigh 1994, pp. 236–41, no. 45.

15. For van Wittel's painting, see Briganti 1996, p. 245, no. 301; Olszewski 2004, p. 93, no. 220.

16. Libby 1973, pp. 7–8.

17. The treatise, divided into five books, was published posthumously (Paris, 1543). It was translated into several languages and went into numerous editions in the sixteenth, seventeenth, and early eighteenth centuries.

18. Contarini 1578, p. 309: "Sed dijs bene iuvantibus omnes eorum impetus sunt repressi, resque pene collapsa in integrum restitua est."

19. Foscarini 1721, pp. 117–18: "I disegni di tutti quegl'antichi Filosofi, i quali s'immaginarono a talento varie forme di governo, come fecero ne' loro libri Teofrasto, Demetrio Falerio, Platone, Cicerone, Zenofonte, Socrate, e molti altri e antichi, e moderni ancora, sono restati di gran lunga superati dalla vera, e pratica costituzione della nostra Repubblica." In the note following this sentence, the reader is referred to the discussion of the reign of Doge Leonardo Loredan in book 8 of Francesco Guicciardini's *Storia d'Italia* (1537–40). Foscarini continues, "Né mi sarei di propria autorità avanzato a un tal paragone senz'un giudizio gravissimo del cardinal Gasparo Contarini, nel cui libro sulla forma della Repubblica così trovo," and cites from *De magistratibus et republica Venetorum:* "Quin asserere ausim, neque monumentis insignium philosophorum, qui pro animi voto formas Reipublicæ effinxere, tam recte formatam atque effictam ullam contineri" (Contarini 1578, p. 264).

20. Foscarini 1721, p. 155: "Questo stato della pace, come confacevole alla Repubblica . . . non è poi da stupirsi, che fiorisca la nostra Patria di tutti quei comodi, ed ornamenti, che accompagnano la tranquillità, e sicurezza del vivere."

21. See Clark 1963, p. 11, n. 4. In order to underscore the superiority of the political system described in Contarini's *De republica* to the one outlined by Plato in his work of that title, Foscarini may deliberately have asked Batoni to insert this abbreviated form of the title instead of the full *De magistratibus et republica Venetorum.* The shortened title had already been used for several printed editions of the work: *De republica Venetorum libri quinque* (Leiden, 1626; Leiden, 1628; Amsterdam, 1636). The Italian translations appeared under the title *Della republica e magistrati di Venetia libri cinque* (Venice, 1591; Venice, 1630; Venice, 1650; Venice, 1678).

22. See Libby 1973, pp. 11–12, 17; Contarini 1578, pp. 318–19. Navagero's text, easily accessible in a recent edition of the author's

Opera omnia (edited by Giovanni Antonio Volpi and Gaetano Volpi, Padua, 1718), would certainly have been known to a specialist of Venetian history such as Foscarini. The real subject of the funeral oration was not Loredan himself but Venice, and Navagero touched on many of the same themes Contarini then developed more fully.

23. Nonetheless, the picture was received positively when it was exhibited in the portico of the Pantheon in 1739; see Valesio 1977–79, vol. 6, p. 212 [19 March 1739]: "Festa del glorioso s. Gioseppe, nella chiesa della Rotonda solennizzata, nel cui portico furono esposti alcuni quadri d'autori moderni e fra gli altri uno fatto fare dall'ambasciatore di Venezia al Battoni con la figura della Repubblica ed altre cose simboliche, che fu assai piaciuto."

24. Clark and Bowron 1985, no. 29.

25. Clark and Bowron 1985, no. 15. For Batoni's drawings for Furietti, see p. 148 in this book.

26. See Boni 1787, p. 23. For a Batoni drawing after the head of Saint Augustine in the *Disputà,* see Clark and Bowron 1985, p. 378, no. D16, pl. 5.

27. Boni 1787, p. 36.

28. See Posner 1971, vol. 2, p. 74, no. 178[S], pl. 178a; p. 45, no. 103, pl. 103a. The latter painting could have been known to Batoni through a print by G. Marcucci.

29. Clark and Bowron 1985, no. 3; Rome 1995a, pp. 580–81, no. 137.

30. For Sacchi's painting, see Harris 1977, p. 82, no. 50, pl. 88.

31. Clark and Bowron 1985, no. 6.

32. Clark and Bowron 1985, nos. 24–28.

33. Roettgen 1988, p. 569. For Reni's *Aurora,* see Pepper 1984, pp. 228–29, no. 40, pl. 67.

34. For Reni's painting, see Pepper 1984, pp. 276–77, no. 166A, pl. 193.

35. Ramdohr 1787, vol. 2, p. 71: "Diejenige, welche die Lampe hält, ist eine der besten, und hat etwas von der Manier des Guido"; Boni 1787, p. 54.

36. The copies include *Salome with the Head of the Baptist,* copy after Guido Reni (c. 1740; National Trust, Stourhead, Wiltshire), Clark and Bowron 1985, no. 31; *Aurora,* copy after Guido Reni (untraced, formerly Wardour Castle, Wiltshire), Clark and Bowron 1985, p. 376.

37. Malvasia 1678, p. 134.

38. The picture was in the Gerini collection in Florence from 1677 until 1825; see Pepper 1984, pp. 285–86, no. 185, col. pl. 14.

39. Clark and Bowron 1985, no. 223; Guarino and Masini 2006, p. 217 (as before 1756).

40. Clark and Bowron 1985, nos. 76–85; Bowron 1987; Laing 1995, nos. 54a–d.

41. Clark and Bowron 1985, no. 74.

42. See Russell 1981, p. 36. Seven of these are now in the Galleria Nazionale d'Arte Antica, Rome.

43. Bowron 2000, pp. 356–58.

44. For Reni's paintings, see Pepper 1984, pp. 249–50, no. 96, pl. 121; pp. 250–51, no. 100, pl. 129.

45. See p. 172.

46. Clark and Bowron 1985, no. 59; Russell 1985; Philadelphia 2000, pp. 307–8, no. 163.

47. Susinno 2001, p. 10.

48. Clark and Bowron 1985, no. 71.

49. Clark and Bowron 1985, no. 102.

50. For the engraving, see Wildenstein 1957, pp. 176–77, no. 115.

51. Clark and Bowron 1985, no. 44.

52. Clark and Bowron 1985, no. 41; Philadelphia 2000, pp. 306–7, no. 162.

53. Susinno 2001, p. 11, has suggested that Mercury, in his role as the god of commerce, refers to the "extraordinary economic importance" of the arts in eighteenth-century Rome.

54. De Juliis 1981, pp. 61, 66.

55. Cochrane 1973, p. 436.

56. For the engraving of the *School of Drawing,* see Rome 2000a, vol. 2, p. 483, no. 2. For Batoni's drawing, see Philadelphia 2000, pp. 474–75, no. 316. For the engraving after Batoni, see Costamagna 1990, pp. 304–6, fig. 5.

57. Riccardi was married to Maria Maddalena Ortensia Gerini, a relative of the Florentine nobleman Andrea Gerini, who, almost simultaneously with Riccardi, commissioned the pendant pictures *The Choice of Hercules* (1742; Palazzo Pitti, Galleria d'Arte Moderna, Florence) and *The Infant Hercules Strangling the Serpents* (1743; Palazzo Pitti, Galleria d'Arte Moderna, Florence); see Clark and Bowron 1985, nos. 67, 68.

58. For the Riccardi collection, see De Juliis 1981, pp. 72–73. For the modello, see Clark and Bowron 1985, no. 105.

59. See Cochrane 1965, pp. 54, 57.

60. Cited in Cole 1973, p. 455.

61. ASL, no. 873, p. 261, 29 July 1740; no. 875, p. 263, 22 October 1740: "Ho terminato il quadro del Sig. Mar.se Riccardi quale è riuscito bene"; no. 876, p. 264, 17 December 1740: "Ho dovuto perfezionare il quadro per cotesto Sig. Marchese Riccardi."

62. For Batoni's first Roman lodging, see Boni 1787, p. 32.

63. ASL, no. 870, p. 258, 8 May 1740; no. 121, p. 317, Sardini to Batoni, 9 October 1769: "Qual consolazione per essere stato uno delli sei nobili nostri, che ha procurato il farlo conoscere al Mondo tutto con riportare quella gran gloria ed applauso." For the paintings, see Clark and Bowron 1985, nos. 69, 70.

64. ASL, no. 874, pp. 262–63, 24 September 1740: "E fo Prometeo che è una figura ben muscolata il quale sta formando buono, ed acanto ce Minerva la quale vi infonde lanima figurata da una farfalla, essendo sogetto composto di tre figure e nobile et eroico in essa si puole esprimere una figura robusta per Prometeo, laltra giovanile e di bella forma come sara la figura che esso sta formando che deve farsi bellissima e di belle forme, questo e un sogetto non mai visto, in pittura onde

spero che sarà bello; l'altro quadro, come che il primo allude al nascere de la vita, cosi questo altro vorei che alludese alla morte ma non con idea oribile e spaventosa, e per ciò vorei figurare il fatto di Meleagro il quale secondo le antiche favole di Ovidio"; "... il furoro govanile uccise i suoi tre zii, di che sdeniata la madre, infuriata senza pensare ha quello che faceva, getto il fatale tizo nel fuoco ed ha quella proporzione che si andava brugiando andavasi terminando la vita ha Meleagro e perciò io stimerei fare nel quadro tre sole figure, dove si rappresentasse Meleagro moribondo in un letto fatto alla guisa deli antichi ed accata del quale vi fosse la sua spada lo scudo e la lancia, e dopo assisa vi farei Atalanta in atto mesto e piangente vestita in abito di cacciatrice come figurasi Diana ed ha suoi piedi il suo cane diletto per uso de la caccia e poi in una parte un poco distante vi farei la madre Altea che getta il tizione nel fuoco ma con un atto di averzione." The subsequent quotes are also drawn from this passage.

65. Meleager gains an extra uncle to slay; a blinding rage replaces Althaea's fourfold hesitation.

66. Macandrew 1978, p. 148, no. 35, pl. 15. For the Topham commission, see p. 145 in this book.

67. For the sarcophagus fragment, see Raggio 1958, p. 48, pl. 6b.

68. See, for example, ASL, no. 871, p. 259, 28 May 1740; no. 910, p. 297, 2 January 1744.

69. For the *Belvedere Antinous*, see Haskell and Penny 1981, pp. 141–43, fig. 73.

70. For the sarcophagus, see Koch 1975, pp. 120–21, no. 116, pls. 106, 107a.

71. Richardson 1722, p. 156. For the *Meleager*, see Haskell and Penny 1981, pp. 263–64, fig. 137.

72. ASL, no. 890, pp. 276–77, 6 October 1742: "Agli occhi miei non sembra finito ancora, desiderando di fargli i quadri superiori all'opere che hà già visto del mio; ... Sv. Ill.ma può assicurarsi che ogn'ulteriore remora ridonderà alla fine in mag/r perfezione dell'opere."

73. ASL, no. 903, p. 291, 14 September 1743: "Siccome ogni cosa in questo mondo ha il suo fine così anche sono giunti finalmente al loro termine e compimento li due quadri."

74. ASL, no. 904, p. 291, 21 September 1743: "Supplico Vs. Ill.ma a contentarsi che si ritenga in mia casa due altre settimane per farli vedere à molti Sig.ri miei amici, e padroni che già hanno incominciato a favorirmi; ed infatti se vi furono a vederli ils.r Inviato di S.A.R. di Toscana e la Sig.ra Duchessa di Caserta." For Sardini's consent, see ASL, no. 906, p. 293, 12 October 1743.

75. See p. 98.

76. ASL, no. 909, p. 296, 23 November 1743: "per farli vedere a quei virtuosi, e dilettanti che verranno da lei a tal fine collocarli per qualche giorno sotto gli occhi sopra di due cavalletti in due diverse stanze acciò uno non tolga il lume all'altro ... e non troppo alti da terra."

77. ASL, no. 904, p. 292, 21 September 1743: "un invito (sono le sue parole precise) apposta di Nobili e Professori per ammirare al solito le mie bellissime opere."

78. Archivio di Stato, Lucca, Archivio Sardini, vol. 83, 286.

79. For Batoni's election to membership on 19 December 1741, see Accademia di San Luca, Rome, Archivio Storico, Libro originale delle Congregazioni o verbali della medesime, vol. 50, 1738–51, p. 48.

80. ASL, no. 906, p. 293, 12 October 1743: "Ho avuto l'onore di avere in mia casa tutta la primaria nobiltà di questa corte."

81. ASL, no. 904, p. 292, 21 September 1743: "In avvenire niuno potrà sperare di aver da me quadri di tal misura per minor prezzo di s. 200 l'uno." For Batoni's signed receipt for 290 scudi, dated 11 October 1743, see Lucca 1967, p. 294.

82. Pierre Berton to John Clephane, 3 August 1742, Scottish Record Office, Edinburgh, Rose of Kilravock MSS., GD 125/22/1(5): "Il Luy [Batoni] sonts arrivez quelque incident qu'il Luy onts donnez de l'ocupation, et la principale Cest la Mort de sa famme." Transcribed in Russell 1985, p. 893. See also ASL, no. 889, p. 276, 7 September 1742: "Con renderle copiose grazie per l'uffizio di condoglianza che si compiace passar meco per la patita disgrazia delle perdita della consorte."

83. Sardini, for example, made a down payment of 100 scudi, plus an intermediate payment of 60 scudi, and paid the balance of 130 scudi on delivery; see ASL, no. 893, p. 279, 2 February 1743; Lucca 1967, p. 294.

84. ASL, no. 920, p. 305, 19 December 1744: "L'onor mio esigge di non dare fuori opera alcuna che non sia travagliata colla mag.r attenzione e diligenza e ciò per la ragione che una sola opera strapazzata potrebbe farmi perdere tutto il credito acquistato finora."

85. ASL, no. 896, p. 282, 20 April 1743: "Sei quadri ho sul cavalletto tutti di somma premura, e d'impegno, e sono i due di Vs. Ill.ma, uno del S.r Marchese Gerini, S. Caterina per costì, un quadro di altare per Brescia, ed il consaputo mio ritratto per Firenze."

86. See Stoschek 1999, pp. 10–17, 55–63, 148–59.

87. "Minuto Ragguaglio del Ricevimento fatto in Roma lì 3. Novembre 1744 per ordine della Santità di N.ro Sig.re Papa Benedetto XIV della Maestà di Carlo P.mo, Re delle due Sicilie," Biblioteca Centrale Vittorio Emanuele, Rome, 4042, MSS. varia, int. 5, fols. 28r–54r, at fols. 43r–44v. Cited in Stoschek 1999, p. 163. For the painting, see Clark and Bowron 1985, no. 62.

88. For the print, see Wildenstein 1957, p. 237, no. 102. See also Pantanella 1993, p. 297.

89. Clark and Bowron 1985, nos. 63–66.

90. Archivio Segreto Vaticano, Sacri Palazzi Apostolici, Computisteria, 3202. Transcribed in Pantanella 1993, p. 316.

91. Antonio Circignani, called Pomarancio (c. 1568–1629) painted the pendant fresco at left, *Christ Delivering the Keys to Saint Peter,*

which was destroyed at the end of the seventeenth century to make way for the papal monument; see Rice 1997, pp. 123–24. It is uncertain how the two painters sharing the commission for the Caffeaus ceilings could have known Pomarancio's fresco, but the close correspondence between their canvases and the pair of overdoors suggests that a visual record of the composition may have been available to them. In Batoni's *Christ Delivering the Keys to Saint Peter*, as in the Pomarancio, Peter is kneeling to the left of Christ, who points upwards to heaven; in Masucci's *Pasce oves meas*, as in the Sacchi, Peter is kneeling on the opposite side, his right hand on his chest, while Christ points downwards.

92. See Harris 1977, pp. 56–57, no. 15, pl. 21.

93. For the seascape in Sacchi's composition, see Rice 1997, p. 275.

94. ASL, no. 887, p. 274, 19 May 1742: "Mi spiace ancora che avendo avuto da Sua S.tà l'ordinazione di un quadro per Palazzo ap.lico Quirinale, ed essendo stato appunto questa settimana da me Mons. Mag. Domo di Mo. [*sic* for No.] Sig.re e vedendo che non ancora incominciato abbenché per esso abbia già fatto qualche studio, mi disse che Sua B.ne lo desiderava per il ritorno dalla prossima villeggiatura."

95. ASL, no. 888, p. 275, 2 June 1742: "le continue premure che mi si fanno da Mon/r Mag/r Domo per il disbrigo del quadro Pontificio"; no. 889, p. 276, 7 September 1742: "Si ricerca con fretta dalla S.tà S. che ha tutta l'autorità di comandare in questo Paese, onde ho dovuto lasciare in dietro tutt'altro per servire il Principe Regnante."

96. ASL, no. 891, p. 277, 15 December 1742: "Per le feste del prossimo Santo Natale ho pensiero di consegnare il detto quadro non ostante sia molto grande di larghezza de venti palmi, e copioso di 13 figure al naturale."

97. See Stoschek 1999, p. 17.

98. ASL, no. 901, p. 289, 10 August 1743: "Se all'impensata il nostro sommo Pontefice non mi avesse ordinato di dare l'ultima mano a quattro Evangelisti che già avevo ridotto quasi al suo termine per la Sta Sua." For the final payment on 29 July 1743, see Archivio Segreto Vaticano, Sacri Palazzi Apostolici, Computisteria, 995B, fols. 1–5. Transcribed in Pantanella 1993, p. 315.

99. Clark and Bowron 1985, no. 86.

100. Benaglio 1894, p. 15.

101. ASL, no. 874, p. 261, 24 September 1740; no. 917, p. 302, 4 July 1744. For another version of the picture, see Clark and Bowron 1985, no. 89.

102. Clark and Bowron 1985, nos. 103, 104.

103. Clark and Bowron 1985, nos. 231, 340.

104. See Dempsey 1966, pp. 68, 70.

105. For the Galleria Farnese fresco, see Posner 1971, vol. 2, p. 49, no. 111, pl. 111t. The iconography of this fresco has been variously described as *Thetis and Peleus*, *Galatea*, and *Venus*. For a summary of the discussion, a list of the interpretations from the seventeenth century to the present, and additional bibliography, see Marzik 1986, pp. 171–73.

106. For the *Younger Furietti Centaur*, see Haskell and Penny 1981, pp. 178–79, fig. 92.

107. See Heartz 2003, pp. 24–32.

108. Metastasio 1953, pp. 783–84: [Achille:] "In questa mano lampeggi il ferro. Ah! ricomincio adesso a ravvisar me stesso."[Ulisse, piano ad Arcade:] "Guardalo." See also Heller 1998, pp. 562, 567.

109. For the 1738 production of *Achille in Sciro*, see De Angelis 1951, p. 159. For Batoni's penchant for opera, see Puhlmann 1774–87, pp. 123, 161, 165; Missirini 1823, p. 221: "[Batoni's] primario diletto fu il teatro, ove era sempre il primo a prender seggio."

110. ASL, no. 924, p. 307, 28 January 1747: "Insieme con i quadri del Sig.re Buonvisi ho terminato ancora i due di Vs. Ill.ma." For the Mazzarosa family, who had also contributed to the pension, Batoni painted a pair of small devotional pictures, *Saint Joseph* and the *Virgin Reading* (both c. 1740; whereabouts unknown); see Clark and Bowron 1985, nos. 33, 34.

111. ASL, no. 917, p. 302, 4 July 1744: "due opere non solam.te non inferiori ma di gran lunga superiori a quante altre Vs. Ill.ma ne ha vista fin'ora del che tanto più mi lusingo, quanto che il soggetto è parto della mia fantasia."

112. ASL, no. 918 bis, p. 303, 18 July 1744: "di invenzione mia"; "figli della mia fantasia."

113. Clark and Bowron 1985, nos. 108, 109.

114. ASL, no. 924, p. 307, 28 January 1747: "Puol'Ella sulla mia parola accertarsi che non aurà motivo d'invidiare il soprad.o Sig.re Buonvisi."

115. Bellori 1672, p. 229.

116. ASL, no. 918 *bis*, p. 303, 18 July 1744: "La Lascivia che discaccia da se l'amante ridotto senza ricchezze, quale verrà nello stesso tempo abbracciato dalla Povertà figlia della Lascivia. Questa sarà una donna, che ostenterà la Vanità e Pompe del mondo nelle vesti nella gioie, e nell'abbigliamento del capo. . . . L'Amante sarà di un'età giusta, vestito compostamente all'uso Greco col Palio sù la spalla; e la Povertà sarà un'altra donna, che dimostrerà nel volto, e nel vestito d'essere povera, e meschina."

117. ASL, no. 923, p. 306, 24 July 1745: "Con piacere sento che Vs. Ill.ma sia rimasta capacitata della ragioni da me addottele per cagione della mancanza usatale e che volentieri pazienti di vedere preferito altro soggetto sul riflesso, che il med.mo anteriore e Vs. Ill.ma nell'avanzarmi la sua commissione."

118. ASL, no. 924, p. 307, 28 January 1747: "Questi quadri sono ambedue vaghi, e spiritosi, ma specialmente uno che rappresenta la lascivia."

119. ASL, no. 918 *bis*, p. 304, 18 July 1744: "La verità che in questo ho inteso d'esprimere non istà à me à spiegarla perchè parla da se, e meglio parlerà in Pittura. L'uno e l'altro Pensiero che

forse ambedue faranno conoscere che senza entrare in favole o Istorie si possono inventar cose non più da altri pensate o almeno non vedute dipinte o scolpite di eguale proprietà e verità che non invidijno alle tavole della Grecia e che non sieno egual.te di diletto e d'imi[tazione] per la vita civile."

120. Clark and Bowron 1985, nos. 107, 110.

121. See Rome 2003, pp. 208–9, no. 103.

122. ASL, no. 918 *bis*, p. 303, 18 July 1744: "sarà in modo coperta, che non riuscirà scandalosa."

123. Clark and Bowron 1985, nos. 95, 94.

124. Cardinal Francesco Barberini to Conte Carlo Rossetti, 8 September 1640: "Il quadro mi pare lascivo." Cited in Madocks 1984, p. 546, n. 7. For Frey's engraving, see Frankfurt 1988, p. 430, no. C18.

125. Philadelphia 1980, pp. 48–49, no. 36; Clark and Bowron 1985, p. 386, no. D173.

126. See Maguire 1965, pp. 174, 188, n. 10.

127. In its supreme form, art is an exact imitation of truth (*Laws* 2:668a) and thus able to rise above Plato's own criticisms of its deceptive falsity (*Republic* 10:597b–599a) and complicity in the production of pleasure (*Laws* 2:667d–e). See also Milan 2002, pp. 443–44, no. VI.5.

128. An instructive comparison is Placido Costanzi's *The Arts Guided by Mercury to the Temple of Glory*, signed and dated 1750 (Sotheby's, London, 29 October 1986, no. 36), showing the three Visual Arts, Mercury, Time, a putto with a torch, and the Temple of Glory, but no personification of Philosophy; illustrated in Sestieri 1994, vol. 2, pl. 369.

129. Clark and Bowron 1985, no. 123.

130. Clark and Bowron 1985, no. 122.

131. Clark and Bowron 1985, p. 386, no. D175. For an identification of the individual scenes, see Philadelphia 1980, p. 50, no. 38.

132. Levey 1966, p. 177.

133. Clark and Bowron 1985, no. 184.

134. For Rosa's painting, see Scott 1995, p. 195, fig. 208.

135. See the documents transcribed in Belli Barsali 1973, pp. 368–70, docs. 1–8.

136. Chracas 1716–1836, no. 5886, 5 April 1755. See also Chracas 1997–99, vol. 2, p. 107.

137. Resolution of the Fabbrica di San Pietro, 29 March 1756: "Essendo il quadro del Vanni, che rappresenta la Caduta di Simon Mago in molto buono stato, bramerebbero molti, che non si proseguisse l'incominciato lavoro del Battoni, l'opera di cui da qualche intendente vien reputata troppo inferiore all'altra applaudita del sud.o Vanni. Sia sospeso il lavoro moderno del Pittore Battoni . . . e intanto non si pensi a rimuovere il quadro del Vanni." Cited in Belli Barsali 1973, p. 370. For the copy after Vanni by Trémolières, see Belli Barsali 1973, p. 366, n. 4.

138. Puhlmann 1774–87, p. 82.

CHAPTER 2. BRITISH PATRONS AND THE GRAND TOUR

Epigraph: Walpole 1937–83, vol. 23, p. 349, Horace Walpole to Sir Horace Mann, Strawberry Hill, 18 November 1771.

1. Clark and Bowron 1985, no. 174; London 2001a, pp. 140–42, no. 16; Thurber 2003, pp. 12–14.

2. Thorpe Letters, 25 May 1774.

3. Clark and Bowron 1985, no. 386; Vivian-Neal 1939, pp. 13–16.

4. Letter, dated Rome, 31 August 1769, from "J. Hamilton," to Miss Hay, at the house of the Lady March, Milns Square, Edinburgh, in Hay of Cromlix Papers, Scottish National Portrait Gallery, cited in Clark and Bowron 1985, p. 369.

5. Clark and Bowron 1985, p. 293, nos. 269, 266, 268. For Mrs. Macarthy, see Ford and Ingamells 1997, p. 620.

6. Clark and Bowron 1985, no. 164; New York 1986, pp. 29–31, no. 9.

7. Ribeiro 2000, p. 15.

8. Batoni's command of the various types of military dress in which his sitters asked to be painted is equally remarkable; see, for example, Clark and Bowron 1985, nos. 249, 255, 261, 273, 343, 413.

9. Thurber 2003, p. 14. fig. 4 (Museo Archeologico Nazionale, Naples). For busts of "ancient worthies," see Haskell and Penny 1981, p. 52. Contemporary interest in heads of the ancient poet among Batoni's British patrons in the first half of the eighteenth century is confirmed by its inclusion in various contemporary guidebooks (Richardson 1722, p. 132, "*Homer; the Famous one*"; Nugent 1756, vol. 3, p. 252, "Among the busts of the *Greek* philosophers and poets, the most admired are those of *Socrates* and *Homer*") and by the presence of the bust on a marble chimneypiece in the Saloon at Uppark carved by Thomas Carter for Sir Matthew Fetherstonhaugh (Rowell 2004, p. 19, repr.)

10. Clark and Bowron 1985, nos. 247, 346.

11. For the British and the Grand Tour, see Black 1992 and 2003, and London 1996.

12. Boswell 1791, vol. 2, p. 61.

13. Fothergill 1974, p. 51; Clark and Bowron 1985, no. 402. For the Bishop Earl of Bristol, see Ford and Ingamells 1997, pp. 126–31.

14. The typescript of Clements's manuscript Grand Tour journal at Celbridge, Ireland, Killadoon Papers, S/I, gives the date as 1754, which is followed by Thurber 2003. Ford and Ingamells 1997, p. 214, however, cites several references that place the traveller in Italy in 1753, and this is the date followed here. The typescript was kindly furnished by Anne Stewart, who is evaluating Clements's journal as part of a general study of Ulster Grand Tourists.

15. Clements's manuscript Grand Tour journal at Celbridge, Ireland, Killadoon Papers, S/I.

16. Caw 1903, p. 42; Miller 1777, vol. 2, p. 283, letter of 14 May 1771; Thorpe Letters, 26 October 1771.

17. Skinner 1959, p. 349.

18. One experienced observer of the contemporary Italian scene, the physician and man of letters Dr. John Moore (1729–1802), noted in his *View of Society and Manners in Italy*, "With countenances so favourable for the pencil, you will naturally imagine, that portrait-painting is in the highest perfection here. The reverse, however, of this is true; that branch of the art is in the lowest estimation all over Italy. In palaces, the best furnished with pictures, you seldom see a portrait of the proprietor, or any of his family. A one-quarter length of the reigning Pope is sometimes the only portrait of a living person, to be seen in the whole palace." "The Italians," he added, "in general very seldom take the trouble of sitting for their pictures. They consider a portrait as a piece of painting, which engages the admiration of nobody but the person it represents, or the painters who drew it. Those who are in the circumstances to pay the best artists, generally employ them in some subject more universally interesting, than the representation of human countenances staring out of a piece of canvas" (Moore 1780, p. 62).

19. Clark and Bowron 1985, no. 446 (1783; Utah Museum of Fine Arts, University of Utah, Salt Lake City).

20. Johns 2000, p. 19. Valentine 1970, vol. 1, p. x, observes that "prominence in one area of influence was likely to lead to prominence in other areas." Nearly every member of the most influential 1 percent of British citizens of the period was connected with other members by birth, schooling, marriage, club or military life, financial interests, political oppositions, and alliances. Most of Batoni's British sitters appear among Valentine's three thousand entries.

21. Walpole 1937–83, vol. 13, p. 206, Horace Walpole to Richard West, Rome, 26 March 1740.

22. Letter, dated Rome, 31 August 1769, from "J. Hamilton," Hay of Cromlix Papers, cited in Clark and Bowron 1985, p. 369.

23. Clark and Bowron 1985, nos. 193, 195, 255.

24. Clark and Bowron 1985, nos. 189, 312, 327, 413.

25. Clark and Bowron 1985, nos. 188, 239, 242, 276, 312, 343.

26. Clark and Bowron 1985, nos. 273–75; London 1996, no. 35.

27. Clark and Bowron 1985, nos. 349, 350, 395. See also p. 113 in this book.

28. See Clark and Bowron 1985, nos. 204, 272, 322, 366, for the law; 158, 160, 379, 402, for the Church; and 175, 187, 188, 244, 261, 276, 279, 298, 349, 413, for the army.

29. Clark and Bowron 1985, nos. 266, 257, 414.

30. Clark and Bowron 1985, nos. 306, 338 (sold at Christie's, London, 6 July 2006, lot 39).

31. Clark and Bowron 1985, nos. 154, 305.

32. Clark and Bowron 1985, nos. 362, 296, 384.

33. Clark and Bowron 1985, nos. 208, 190, 188.

34. Clark and Bowron 1985, nos. 195, 347, 402.

35. Clark and Bowron 1985, no. 97.

36. For Weddell, see Clark and Bowron 1985, no. 293; Ford and Ingamells 1997, pp. 986–87; Scott 2003, pp. 129–34.

37. Clark and Bowron 1985, no. 239; Turin 2003, no. IV.25.

38. Clark and Bowron 1985, nos. 379, 133.

39. Clark and Bowron 1985, no. 418, 312, 255, 411.

40. Four of Batoni's sitters are included in Reynolds's pair of *Portrait Groups of Members of the Society of Dilettanti* (1777–78; Society of Dilettanti, London); Mannings 2000, vol. 1, pp. 166–67, nos. 510, 511, figs. 1235, 1237.

41. For the Batoni sitters included in these caricatures, see Benedetti 1997, pp. 51–57, no. 19; Mannings 2000, vol. 1, pp. 491–93, nos. 1962–69.

42. Russell 1973, p. 1610; Clark and Bowron 1985, nos. 132, 134, 135, 202, 208. On the various patterns of Batoni's patronage by the English and Irish, see also Francis Russell in London 2001b, p. 137.

43. Clark and Bowron 1985, nos. 154–63.

44. Clark and Bowron 1985, nos. 87, 146; 134, 344A; 154, 389; 175, 413; 259, 260; and 320, 450 (fathers and sons); and 180, 419; 216, 301 (fathers-in-law and sons-in-law).

45. Clark and Bowron 1985, nos. 155, 160, 161; 162, 187, 188; 261, 333; 321, 360 (siblings); 133, 133A, 133B; 134, 135; 154, 155; 158, 159; 414, 415; 439, 440 (husbands and wives).

46. Russell 1973, p. 1610; Clark and Bowron 1985, p. 369, nos. 192, 195, 216.

47. Clark and Bowron 1985, nos. 321, 322, 400, 414–16, 257.

48. Lucy 1862, p. 103; for the portrait, see Clark and Bowron 1985, no. 212; London 1992, no. 28.

49. Clark and Bowron 1985, no. 266; Whistler 1997, pp. 329–30; Casley, Harrison, and Whiteley 2004, p. 10.

50. Quoted in Ford and Ingamells 1997, p. 565, and Whistler 1997, p. 329, with slight differences in orthography and punctuation.

51. Clark and Bowron 1985, nos. 321, 322.

52. Russell 1985, pp. 890–93; Benedetti 1997, p. 20. For Clephane, see Ford and Ingamells 1997, pp. 214–16.

53. For Albani, see Haskell and Penny 1981, pp. 62–73; Roettgen 1982, pp. 123–52.

54. Clark and Bowron 1985, nos. 185, 186 (Collezione della RAI, Venice), and Wood 1999, pp. 394–417. Among the several portrait sitters Albani probably brought to Batoni were Sir Robert Davers, the Earl of Essex, and the Earl of Cholmondeley (Clark and Bowron 1985, nos. 197, 176, 343).

55. William Patoun, "Advice on Travel in Italy," c. 1766 (MS. in the Exeter Archives at Burghley House), quoted in Ford and Ingamells 1997, p. liii.

56. Clark and Bowron 1985, nos. 165, 212, 244; for Russel, see Ford and Ingamells 1997, pp. 830–32, citing his export license for four portraits by Batoni on 30 March 1763.

57. For Jenkins, see Ford and Ingamells 1997, pp. 553–56; Vaughan 2000.

58. Clark and Bowron 1985, nos. 195, 192, 291–93.

59. Jones 1946–48, p. 94. For Byres, see Ford 1974a; Ford and Ingamells 1997, pp. 169–71; Coen 2002.

60. Each group survives in two versions, Ford 1974a, p. 454, figs. 6, 7, attributed to Philip Wickstead (active 1763–c. 1790), one at Audley End, Essex (English Heritage), and at Springhill, Co. Londonderry (The National Trust, by which attributed to John Brown); the other at Ham House, London (The National Trust, as attributed to John Brown), and in a private collection. For the sitters, see Clark and Bowron 1985, nos. 362, 364, 366–68.

61. Clark and Bowron 1985, nos. 414, 415, 416, 411.

62. Clark and Bowron 1985, nos. 454, 456, 457.

63. Clark and Bowron 1985, nos. 347, 456, 457, 429.

64. Batoni's will is in Archivio di Stato, Roma, 30 Notai Capitolini, Ufficio 27, busta 375, notaio Lelio Amaducci, fols. 184–85, 211–12 (transcribed by Olivier Michel).

65. Ford 1974a, p. 459.

66. Walpole 1937–83, vol. 20, p. 490, 16 August 1755.

67. Puhlmann 1774–87, pp. 30, 48, 79.

68. Puhlmann 1774–87, p. 166, 13 March 1781: "Wenn nur Fremde nach Rom kämen, dass Hoffnung wäre, etwas zu verdienen. So lässt sich niemand sehn, und da der Krieg anhält, so haben die Künstler nichts zu tun. Ein Glück vor Batoni, dass er vor Portugal malt, denn es kommt niemand, nicht mal um ein Porträt zu haben."

69. Clark and Bowron 1985, nos. 59, 222, 235, 353.

70. For *Meekness* and *Purity of Heart*, see Clark and Bowron 1985, nos. 167, 168; Laing 1995, pp. 148, 213–14, nos. 55a and 55b. Alastair Laing has suggested (letter to Edgar Peters Bowron, 10 July 2004) that Sir Matthew commissioned the paintings and gave them to his brother, the Rev. Utrick Fetherstonaugh (who may have been responsible for the selection of the subjects), along with the portraits of himself and his wife.

71. For the *Holy Family*, see Clark and Bowron 1985, pp. 296, 368; for *The Appearance of the Angel to Hagar in the Desert*, see Clark and Bowron 1985, no. 396, and Philadelphia 2000, no. 174.

72. Walpole 1937–83, vol. 21, p. 309; for Lord Arundell's acquisitions of other paintings by and after Batoni, see Clark and Bowron 1985, p. 341.

73. For examples of Trevisani's Grand Tour portraits, see DiFederico 1977, figs. 102–12; on David, see Jacob 1975, fig. 8, and London 1960b, no. 23, and Christie's, London, 22 April 1983, lot. 71, repr.; on Dupra, see Skinner 1958, p. 25, repr.; on Casali, see Sestieri 1994, vol. 2, figs. 223–25; on Stern, see Sotheby's, London, 24 November 1999, lot 21; on Blanchet, see Philadelphia 2000, nos. 183–84; on Masucci, see Rudolph 1983, pl. 466, and Christie's, London, 20 November 1987, lot 85; on Benefial, see Christie's, London, 29 October 1954, lot 25; on Subleyras, see Paris 1987, no. 114.

74. Ford 1955, p. 372. For Lely's portrait, see London 1960a, no. 168; for Maratti's, see Petrucci 2005, fig. 52.

75. For Procaccini, see Rudolph 1983, pl. 595; for Trevisani, see Moore 1985, p. 115, no. 45, and Redford 1996, p. 85, pl. 30. The sitters' dress, the draped pilaster, the chair and Baroque console table, the references to classical antiquity, and, significantly, Trevisani's bright palette, underscore the importance of these portraits as precedents for Batoni's Grand Tour portraits.

76. Redford 1996, p. 85, pl. 31; Russell 1994, p. 439, fig. 42.

77. See London 1960b, no. 123, and Christie's, London, 22 April 1983, lot 71, repr.

78. London 1996, no. 11.

79. Clark and Bowron 1985, pp. 370, 236; no. 87. For the portrait of Leeson, see also Wynne 1986, pp. 5–6; Benedetti 1997, p. 21, no. 7; Ford and Ingamells 1997, pp. 593–94, which gives the sitter's dates as 1711–1783; Cullen 2004, pp. 86–87.

80. See Clark and Bowron 1985, nos. 132, 134, 135, 139.

81. See Clark and Bowron 1985, nos. 146, 147; Benedetti 1997, nos. 8, 9.

82. Francis Russell has suggested that the Batoni portraits now at Uppark originally constituted two separate series, some intended for Uppark and others for Fetherstonhaughs' brother-in-law Benjamin Lethieullier (Russell 1989, p. 152, n. 3). When the Fetherstonhaughs' son Sir Henry Fetherstonhaugh, the 2nd baronet, sat to Batoni twenty-five years later for a portrait (now at Uppark), it is worth noting that he elected to be shown leaning against a pedestal with a classical marble urn (Clark and Bowron 1985, no. 389).

83. See Clark and Bowron 1985, nos. 135, 155, 157, 159. Gervase Jackson-Stops identified Sir Matthew and Lady Fetherstonhaugh "as Endymion and Diana" (Jackson-Stops 1989, p. 217). For the female members of the Leeson family, see Clark and Bowron 1985, nos. 148, 149; Benedetti 1997, pp. 28–30, nos. 8, 9; Finaldi and Kitson 1997, p. 30, no. 4. For Trevisani, see DiFederico 1977, figs. 105, 106. Ellis Waterhouse described the Fetherstonhaugh portraits as possessing the air of a "fancy-dress picnic" and "a light-hearted and somewhat jokey quality, clearly something demanded by the sitters," arguing that "enterprising young Englishmen traveling abroad had, for some years, liked to commission something entirely different, and a convention grew up that one did this in Rome" (Waterhouse 1978–80), p. 83.

84. Russell 1994, p. 440, fig. 44; Ford and Ingamells 1997, p. 271.

85. Clark and Bowron 1985, nos. 134, 135.

86. Holloway 1989, p. 3, fig. 1.

87. Holloway 1989, p. 5.

88. Clark and Bowron 1985, no. 190; Redford 1996, pp. 85–86; Sydney 1998, no. 32; Cullen 2004, pp. 87–88.

89. See Wethey 1971, figs. 40, 60, 71, 82, 83, 85, 90, 160.

90. For general remarks on the importance of Titian's and Van Dyck's portraits for British portraiture, see Simon 1987, pp. 56–68, passim.

91. See Antwerp 1999, pp. 294–95, figs. 11, 12.

92. Luitjen 1999, pp. 73–91.

93. For Van Dyck sitters in armour, see Barnes, De Poorter, Millar, and Vey 2004, nos. II.54, II.89. For the portrait of Legard, see Clark and Bowron 1985, no. 180. Van Dyck's *Self-Portrait* (Barnes, De Poorter, Millar, and Vey 2004, no. II.26) was engraved in 1682 by Jan van der Bruggen; the composition was also engraved with minor variations in the portrait of Adam de Coster (Antwerp 1999, pp. 180–85, no. 23).

94. Clark and Bowron 1985, no. 177.

95. Walpole 1937–83, vol. 20, p. 435.

96. For Vandyke and masquerade dress, see Nevinson 1964; Ribeiro 1984, pp. 192–200; Ribeiro 2002, pp. 278–80.

97. Clark and Bowron 1985, no. 197. Other examples of Vandyke dress include nos. 209, 218, 357, 377, 438.

98. Wood 1982, p. 251; Wood also observed the differences between Batoni's and Van Dyck's portraits in the treatment of architecture and the placement of the figure within the picture.

99. Gore 1986, p. 306, quoting a letter from Henry Bankes (Clark and Bowron 1985, no. 418) to his mother. For the pedestals in Van Dyck's portraits, see Barnes, De Poorter, Millar, and Vey 2004, nos. IV.221, IV.230, IV.247.

100. Clark and Bowron 1985, no. 377; Moore 1985, no. 106; London 1992, p.120, no. 29, in which the source of the portrait is said to be "a late portrait by [Van Dyck] of an unknown gentleman wearing a cuirass" (Ringling Museum of Art, Sarasota); Redford 1996, p. 86; Rome 2005, no. 69. For *Robert Rich, 2nd Earl of Warwick*, see Barnes, De Poorter, Millar, and Vey 2004, pp. 610–11, no. IV.235, repr. col.; for the dog, compare the spaniel in Van Dyck's *Three Eldest Children of Charles I* (1635; Galleria Sabauda, Turin) in ibid., repr. p. 477, no. IV.60.

101. Waterhouse 1965, p. 15.

102. Haskell and Penny 1981, pp. 266–67, fig. 138; pp. 209–10, fig. 108.

103. Smart 1999, p. 96, no. 108, fig. 130; London 1979, no. 27, repr. Joyce Boundy noted that Hudson was one of the first painters in the eighteenth century to revise the cross-legged pose and observed the importance of the pose for conveying what might be termed "studied nonchalance" or "aristocratic carelessness" and as a sign of good breeding and elegance (Boundy 1978, p. 248).

104. Alastair Smart described Ramsay's half-length portrait *Samuel Torriano* (1738; private collection, Scotland) as "virtually an exercise in Batoni's manner" (Smart 1992, p. 30, pl. 25).

105. Smart 1999, col. pls. 8, 13, 18, 19, 21; figs. 76, 81, 119, 130, 131.

106. Waterhouse 1994, p. 203.

107. Clark and Bowron 1985, no. 192; Rogers 1992, p. 40; Ingamells 2004, pp. 219–20.

108. Walpole 1894, vol. 4, p. 78.

109. Ribeiro 2000, p. 122.

110. Ribeiro 2002, p. 29.

111. Clark and Bowron 1985, nos. 317, 374.

112. Clark and Bowron 1985, no. 202; Washington 1985, no. 173; Russell 1996, pp. 8–9. Lord Brudenell sat to both Batoni and Mengs; for a discussion of their respective interpretations, see Roettgen 1999, pp. 264–65.

113. Fleming 1958, pp. 137–38.

114. The manuscript copy of sonata 6 from Corelli's opus 5 shows the end of the final movement, measures 40–74; see Urchueguía 2006, pp. 107–8.

115. Clark and Bowron 1985, no. 216. Batoni used this pose in reverse in *Henry Willoughby, later 5th Lord Middleton*, 1754 (no. 179) and later, with variations, for *Sir Brook Bridges*, 1758 (no. 203), *Sir Richard Lyttelton*, 1762 (fig. 60), *Other Hickman Windsor, 5th Earl of Plymouth*, 1772 (no. 348), and several others.

116. See Washington 1985, no. 138, in which Francis Russell notes the importance of the painting for the subsequent "conventions of Grand Tour portraiture, which would reach fruition in the work of Batoni"; Rome 2000a, vol. 2, no. 16.

117. Smart 1992, p. 129.

118. Ribeiro 1979, pp. 226–31; Ribeiro 1995, pp. 43, 45; Ribeiro 2002, pp. 124–25.

119. Clark and Bowron 1985, no. 378.

120. Clark and Bowron 1985, no. 205; Raleigh 1994, no. 46; Bowron and Morton 2000, pp. 112–14.

121. For Northampton, see Clark and Bowron 1985, no. 208; Washington 1989b, pp. 122, 123, no. 15; for Sir Wyndham, see Clark and Bowron 1985, no. 218.

122. Montagu 1965–67, vol. 3, p. 195, letter to Lady Bute, 31 December 1758.

123. Clark and Bowron 1985, pp. 272, 379, D45; Flick 2003a, pp. 83–84, fig. 1; Flick 2003b, pp. 65–72.

124. Clark and Bowron 1985, no. 218; Redford 1996, p. 86; Philadelphia 2000, no. 169; Winckelmann 1952–57, vol. 2, p. 53, letter to Philip von Stosch, 28 November 1759.

125. The pose was repeated exactly in *Frederick Augustus, 5th Earl of Berkeley*, 1765 (Clark and Bowron 1985, no. 287) and with variations in nos. 333, 340.

126. Allen 1987, nos. 7, 27, 18.

127. Clark and Bowron 1985, nos. 187, 188, 197.

128. Ford and Ingamells 1997, p. 181.

129. Haskell and Penny 1985, pp. 263–64, fig. 137. For the use of Meleager's dog in one of Batoni's history paintings, see p. 24 in this book.

130. Clark and Bowron 1985, no. 242; York 1994, no. 30.

131. Clark and Bowron 1985, no. 235; Frankfurt 1999, no. 7.

132. Haskell and Penny 1981, pp. 184–87, fig. 96.

133. Clark and Bowron 1985, no. 244; Russell 1973, p. 1755.

134. Walpole 1937–83, vol. 31, p. 505.

135. Clark and Bowron 1985, no. 298; Edinburgh 1985, no. 16; Washington 1985, no. 176; London 1988, no. 93; Johns 2004.

136. For a black-chalk drawing for or after Colonel Gordon's

costume that has been attributed to Batoni, see Rouen 1999, no. 9.

137. Clark and Bowron 1985, no. 300; Belfast 1999, no. 21; Rome 2005, no. 67; London 2007, no. 57. For another portrait of sitters in mourning, see Clark and Bowron 1985, no. 133.

138. Duncan 1973, p. 579.

139. Clark and Bowron 1985, no. 305; Trumble 1998; Cincinnati 2000, no. 49. Waagen noted the painting at Belvedere, Kent: "This picture is proof that this master was well adapted for this class of painting. The arrangement is happy, the heads animated, and the whole carefully executed in a fresh colouring" (Waagen 1857, p. 284).

140. Trumble 1998, p. 86.

141. Clark and Bowron 1985, no. 319; Redford 1996, pp. 86–87.

142. Redford 1996, p. 86.

143. See, for example, London 1979, no. 29, and Smart 1999, nos. 412, 468, 525. For the portrait of Countess Spencer, see Clark and Bowron 1985, no. 269; Friedman 1993, pp. 51, 54–55, 63; Ford and Ingamells 1997, pp. 644, 883, citing the Grand Tour journal of James Martin, who saw the finished painting in Batoni's studio on 6 May 1764 and thought "it a very strong likeness."

144. Friedman 1993, p. 55.

145. Clark and Bowron 1985, p. 313, no. 323; Walpole 1937–83, vol. 33, p. 22; Philadelphia 2000, no. 173.

146. Piranesi profitably dedicated a number of plates to visitors to Rome and influential persons, including nearly a dozen Batoni sitters in the late 1760s and 1770s; see Wilton-Ely 1994, vol. 2, nos. 914, 915, 923, 932, 933, 937, 938, 947, 998, 999.

147. Clark and Bowron 1985, no. 238; Philadelphia 2000, no. 170, wherein the elaborately carved giltwood rococo frame, supplied after the painting reached England, is discussed.

148. Wethey 1971, fig. 106; Barnes, De Poorter, Millar, and Vey 2004, p. 183, no. II.37.

149. Clark and Bowron 1985, no. 347; Evans and Fairclough 1993, pp. 48–49, no. 54; Lord 2000, p. 118.

150. Ford 1974b, p. 436.

151. Roettgen 1999, no. 111; Clark and Bowron 1985, no. 353.

152. Russell 1994, pp. 440–41, fig. 43.

153. Clark and Bowron 1985, no. 335. For a possibly conflicting view of the identity of the sitters, see Ford and Ingamells 1997, p. 412.

154. Clark and Bowron 1985, no. 365; Ford and Ingamells 1997, p. 792.

155. Clark and Bowron 1985, pp. 370–71; Ford and Ingamells 1997, pp. 461–62, noting that Sir William Hamilton was much struck by Lady Hampden's beauty.

156. Thorpe Letters, 26 October and 25 December 1771. Patrick Home noted among the other portraits in Batoni's studio on 30 April 1772, "Mr. and Mrs. Hampden, but tolerable" (Home Journal, cited in Clark and Bowron 1985, p. 371). One

of Reynolds's most celebrated portraits showed Lady Elizabeth Keppel, one of the bridesmaids to George III and Queen Charlotte, sacrificing to Hymen (1761, Woburn Abbey; Mannings 2000, p. 291, no. 1052, fig. 567 and col. pl. 45).

157. Clark and Bowron 1985, no. 401; Belfast 1999, no. 19, in which the branch is described as olive, "an attribute of the Goddess Minerva and a symbol of both wisdom and peace." See Russell 1973, p. 1755, which notes the reticence of the late portraits including nos. 408, 409, and 414–16.

158. Clark and Bowron 1985, no. 406; Ford and Ingamells 1997, p. 58; Luzón Nogué 2000, p. 25, pl. 4, identified as Francis Basset; Sánchez-Jáuregui 2001; Murcia 2002, no. 51. For Basset's Grand Tour, see further Sánchez-Jáuregui Alpañés 2002.

159. For the *Westmorland,* see Murcia 2002. For another 1778 Batoni portrait (Clark and Bowron 1985, no. 405) carried on board the ship and now identified as that of George Legge, Viscount Lewisham (1755–1810), see Murcia 2002, no. 48; Suárez Huerta 2006.

160. Two later full-lengths, Clark and Bowron 1985, nos. 438, 450, appear to have been painted with studio assistance.

161. Haskell and Penny 1981, pp. 288–91, fig. 152.

162. Clark 1981, p. 106.

163. Clark and Bowron 1985, no. 429, Bryant 2003, pp. 108–11; Clark and Bowron 1985, nos. 456, 459.

164. Bryant 2003, p. 108.

165. Bryant 2003, p. 108.

166. Clark and Bowron 1985, p. 364; information from Aileen Ribeiro, letter to Edgar Peters Bowron, 12 April 1984.

167. See Waterhouse 1958, pls. 174, 176, 209.

168. Richardson 1722, pp. 109, 114.

169. Clark and Bowron 1985, no. 296; Beckford 1805, pp. 134, 250, 252.

170. See p. 145.

171. Haskell and Penny 1981, pp. 269–71, fig. 140.

172. For examples of Batoni's use of the sculpture, see Clark and Bowron 1985, nos. 177, 218, 316, 319.

173. Haskell and Penny 1981, p. 270.

174. See Clark and Bowron 1985, nos. 295, 305, 336, 338.

175. Clark and Bowron 1985, no. 211; for the identity of the sitter, see Russell 1998, pp. 682–83. For the bust, see Wright 1730, vol. 1, p. 314, and Jones 1912, vol. 1, p. 103, no. 28, pl. 28.

176. Wright 1730, vol. 1, p. 302.

177. Clark and Bowron 1985, nos. 219, 240, 268.

178. Clark and Bowron 1985, nos. 300, 312, 321.

179. Clark and Bowron 1985, nos. 374, 385, 405, 406. For the identity of the portrait of George Legge, Viscount Lewisham (no. 405), see Ana María Suárez Huerta, in Murcia 2002, pp. 292–95, no. 48; Suárez Huerta 2006, pp. 252–56. For the bust of Faustina, see London 1996, nos. 158, 159.

180. Clark and Bowron 1985, nos. 174, 296, 384, 385.

181. Clark and Bowron 1985, nos. 367, 368, 384, 419, 438. Haskell and Penny 1981, pp. 260–62, fig. 135.

182. Haskell and Penny 1981, pp. 148–51, fig. 77; 141–43, fig. 73; 243–47, fig. 125; 184–87, fig. 96.

183. Haskell and Penny 1981, pp. 184–87.

184. Clark and Bowron 1985, no. 278; York 1994, no. 31.

185. Clark and Bowron 1985, no. 299; Philadelphia 2000, no. 171.

186. Clark and Bowron 1985, no. 230; for the drawing, see p. 148 in this book.

187. Clark and Bowron 1985, p. 235, no. 230: the books appear to be Niccola Roisecco's *Roma antica, e moderna . . .* (1750, 1765).

188. Dering's gem cabinet was acquired by Charles Spencer, 4th Duke of Marlborough (1738–1817), but the whereabouts of the cameo, which is recorded by casts in the Victoria and Albert Museum in London and the Deutsches Archäologisches Institut in Rome, remains unknown. For Dering as a gem collector, see Clark and Bowron 1985, p. 274, and Winckelmann 1760, p. 380. For gem collecting by the English in Italy, see Kagan and Nemerov 1984, p. 114.

189. Clark and Bowron 1985, no. 266; Whistler 1997, p. 329; Casley, Harrison, and Whiteley 2004, p. 10.

190. See Clark and Bowron 1985, nos. 351, 356, 362; Grand Duke Paul, later Emperor Paul I of Russia (no. 432), is shown gesturing to a ground plan of the Pantheon.

191. For the Capitoline sculpture, see Jones 1912, vol. 1, p. 83, no. 2, pl. 17. The winged lion was first employed as part of the throne in *Esther Before Ahasuerus* (c. 1738–39, Philadelphia Museum of Art); Clark and Bowron 1985, p. 216, no. 22, pl. 25.

192. Brosses 1991, vol. 2, letter 40, pp. 725–26: "L'argent que les Anglois dépensent à Rome et l'usage d'y venir faire un voyage, qui fait partiede leur éducation, ne profite guères à la pluspart d'entr'eux. . . . J'en vois tels qui partiront de Rome sans avoir vu que des Anglois et sans sçavoir où est le Colisée."

193. Clark and Bowron 1985, no. 279; Edinburgh 2000, p. 55; Johns 2004, pp. 390–91; Winckelmann 1952–57, vol. 2, no. 543, pp. 297–98.

194. Helbig 1963–72, vol. 2, pp. 194–95, no. 1388; Rome 2000b, p. 71, repr.

CHAPTER 3. PAINTER OF PRINCES AND PRINCE OF PAINTERS
Epigraph: Thorpe Letters, 11 May 1776.

1. Thorpe Letters, 6 June 1769.

2. Burney 1773, p. 221. The visit took place on 5 October 1770. Burney continues: "We were then introduced to his lady and two daughters. The eldest is a scholar of Signor Santarelli's, and sings divinely; with more grace, taste and expression than any female in public or private I ever heard. She was so obliging as to sing six or eight capital airs in different styles, and all delightfully; but her *fort* is the pathetic. She has a good shake and well toned voice, an admirable portamento, with great compass and high finishing in all she attempts. Indeed she does infinite credit to her master, for he has contrived to unite so well the falset with the real voice, that it is very difficult to say where it begins or ends." Giuseppe Santarelli (1710–1790), director of the papal choir, was the voice teacher of Batoni's daughter Rufina (1755–1784) and later sat to Batoni (1779; Pinacoteca e Musei Comunali, Forlì); see Clark and Bowron 1985, no. 417. For Batoni's musical soirées, see also Puhlmann 1774–87, pp. 27, 76, 86; Boni 1787, pp. 62–63.

3. Puhlmann 1774–87, p. 146: "Batoni habe ich niemal vergnügter gesehn als er vom Papst zurückkam, der ihn mit Lob und Ehre überhäuft und sich 5 Viertelstunden mit ihm unterhalten."

4. Clark and Bowron 1985, no. 178.

5. Benedict XIV to Pierre Guérin de Tencin, 23 May 1753: "Fra queste [statues at Villa d'Este] vi è una bella Venere nuda, ed in una nattica d'essa si è ritrovato impresso colla punta d'un diamante il nome del principe di Württemberg, e nell'altra quello della principessa moglie, operazioni fatte dall'uno, e dall'altra, quando prima di partire da Roma, furono a Tivoli." Transcribed in Benedict XIV 1955–84, vol. 3, p. 51, no. 572.

6. An example of a male sitter is Nattier's *Maurice de Saxe Crowned by Time* (1720; Gemäldegalerie Alte Meister, Dresden).

7. Hauptstaatsarchiv, Stuttgart, Württembergisches Hausarchiv, G 230, Büschel 37, Alessandro Miloni to Carl Eugen, Rome, 24 September 1755: "Il Battoni mi disse, che l'Altezze Loro Ser.me desideravano detti Ritratti rappresentati e vestiti con qualche idea, cosi egli ha stimato di formare il Ritratto di V. A. Ser.ma in qualità di Guerriero con spada nuda in mano con il suo grazioso spirito e bella avvenenza, rappresentante la Guerra, ed il Ritratto della Serenissima Duchessa in abito pacifico con il Ramo di Oliva nella mano, che rappresenta la Pace." The portrait of Carl Eugen was sold at Christie's, London, 13 December 1985, lot 35.

8. See p. 138.

9. For Titian's painting, see Wethey 1971, pp. 191–92, figs. 48–50.

10. Hauptstaatsarchiv, Stuttgart, A 19 a Bd. 50, "Rechnungsbuch" [by Johann Christoph Knab], fol. 39r, nos. 172–73: "Dem Mahler Batoni vor die gefertigte Portraits, innhalts Copialiter anliegenden Accords bezahlt, und Herrn Tresorier Bermudez in Händen gelaßen, wofür die behörige Quittung nach folgen wird: 799 Scudi 50 baj."

11. Hauptstaatsarchiv, Stuttgart, Württembergisches Hausarchiv, G 230, Büschel 37, Alessandro Miloni to Carl Eugen, Rome, 24 September 1755: "Un Ritratto in miniatura ad uso di Tabacchiera della di Lei Serenissima Persona, quale con la mia continua assistenza fu con tutta prestezza terminato, e lo mandai per la Posta al detto Sig.re Barone [Hardenberg] il di 17 Maggio scorso con la ricevuta di scudi cinquanta da me pagati del proprio al detto Battoni"; "Tutti questi Ritratti [i.e., the half-lengths] con li due grandi da me mandati e spediti prima con

mia special cura erano già interamente pagati . . . ; hora resta-
vano due altri Ritratti parimenti ordinati da V. A. Ser.ma, che
dovevano ricavarsi da detti Ritratti originali, e sono nel fine
di essere terminati, rimanendo solo il ritoccarli con la dovuta
perfezzione da me veduti, osservati, e sollecitati, e questi rap-
presentano parimenti le sovrane Serenissime Persone. . . . E
ben inteso che il pagamento di questi due ultimi Ritratti non
è compreso nel foglio et Apoca fatta in Roma, come ordinati
doppo, e perciò per questi si deve mandare il danaro, che sono
trenta zecchini l'uno." For the currency equivalents, see below,
chap. 5, n. 151.

12. Chracas 1716–1836, no. 5802, 21 September 1754. See also
Chracas 1997–99, vol. 2, p. 104. For the shipment, see Haupt-
staatsarchiv, Stuttgart, Württembergisches Hausarchiv, G 230,
Büschel 37, copy of Alessandro Miloni's accounts for 1754,
part of letter from Alessandro Miloni to Carl Eugen, Rome,
24 September 1755: packing charges for "due Ritratti grandi
da me spediti per espresso."

13. Hauptstaatsarchiv, Stuttgart, Württembergisches Hausarchiv,
G 230, Büschel 37, Alessandro Miloni to Carl Eugen, Rome,
24 September 1755: "Io condussi meco nella mia Carozza il
Battoni con li sudetti due Ritratti originali dalla Serenissima
Margravia di Bareit, che li volle vedere con molta attenzione, e
con grandissimo piacere."

14. Geheimes Staatsarchiv, Berlin, Brandenburg-Preußisches
Hausarchiv, Rep. 46 W, no. 17, vol. 3/6, fol. 58r, Wilhelmine
to Frederick II, Rome, 23 May 1755: "Batoni est aussi un grand
Peintre et point cher, il est fort au dessus de Pesne."

15. For *Cleopatra Before Augustus*, see Clark and Bowron 1985, no.
252; Lyon 2000, pp. 211–12, no. 82; Starcky 2002, p. 88; Mainz
2003, pp. 318–20, no. 219 (erroneously described as commis-
sioned by Maria Theresa in c. 1773); Geneva 2004, pp. 229–31,
no. 49. For Mengs's *Semiramis Called to Arms*, see Roettgen 1999,
pp. 174–76, no. 113; Philadelphia 2000, pp. 406–7, no. 252.
Mengs 1786, vol. 1, p. 118: "[*Semiramis Called to Arms*] wurde in
dem neuen Schloß zu Bayreuth über die Thür eines Zimmers
des Marggrafen aufgestellt, und hatte ein Gemälde von Pom-
peo Battoni zum Gegenbilde."

16. See n. 19, below.

17. Krückmann 2004, pp. 24–25, 27–30.

18. Geheimes Staatsarchiv, Berlin, Brandenburg-Preußisches
Hausarchiv, Rep. 46 W, no. 17, vol. 3/6 [without folio no.],
Wilhelmine to Frederick II, [Rome], 17 June 1755: "J'ai lu hier
un sonnet Italien fait sur vous mon tres cher Frere que j'ai
trouvé charmant. C'est votre Paralele avec Jules Cesar."

19. Wilhelmine to Carl Heinrich von Gleichen, Bayreuth, 9 April
1756: "Je vous prie de faire, en sorte que Pompée Battoni fin-
isse le tableau du Margrave et qu'il soit envoyé tout-de-suite.
Pour ce qui est du portrait du duc et de ma fille, je ferai écrire
à Stuttgard." Cited in Gleichen 1847, p. 10.

20. Carl Heinrich von Gleichen to Wilhelmine, Albano, 15 August

1756: "Monsieur Battoni a fini le tableau de son Altesse et vient
de l'envoyer en Allemagne." Cited in Gleichen-Rußwurm 1907,
p. 48.

21. Hauptstaatsarchiv, Stuttgart, Württembergisches Hausarchiv,
G 230, Büschel 37, Alessandro Miloni to Carl Eugen, Rome,
28 August 1756: "Erano già terminati le tre Ritratti comprati
nell'epoca da potersi subito spedire, e questi erano già
interamente pagati." Carl Eugen to Alessandro Miloni, 23
October 1756 [copy]: "Il me reste à vous instruire au sujet des
5 Portraits achevés par le Peintre Battoni suivant votre lettre
du 28 aout dernier. Mon intention est, que vous vous fassies
remettre ces portraits, et que vous me les envoyiés incessament,
en prenant soin qu'ils soyent bien emballés. Je vous fais part
en meme tems que j'ai ordonné á Ma chambre des finances de
vous faire payer la somme de 209 Scudi, pour absorber les 1)
60 Sequins, qui sont encore dus au Peintre Battoni pour les
2 derniers Portraits, 2) les 50 Scudis, que vous lui avés remis
pour mon Portrait en Mignature, et enfin 3) les 36 Scudis pour
vos déboursés de l'année passée."

22. Hauptstaatsarchiv, Stuttgart, Württembergisches Hausarchiv,
G 230, Büschel 37, Alessandro Miloni to Carl Eugen, Rome, 20
November 1756: "Tout aussi tôt je fus chez du Peintre Battoni;
il me fit voir les cinq Portraits touts prets, et achevés." Ales-
sandro Miloni to Carl Eugen, Rome, 31 December 1756: "Sono
già all'ordine li cinque Ritratti terminati con tutta perfezione,
e ben imballati, ed hora procuro l'occasione propria e pronta
per inviarli."

23. Frederick II to Wilhelmine, 17 [May 1755]: "Vous trouverez
l'Italie comme une vieille coquette qui se croit aussi belle qu'elle
le fut dans sa jeunesse. . . . Si vous y joignez les chefs-d'œuvre
des arts, autrefois florissants sous Auguste et sous Léon X, et,
pour le présent, messieurs les soprani, de mauvais maîtres de
musique, des peintres misérables, des sculpteurs encore au-
dessous de ceux-là . . . en un mot, le siècle d'aujourd'hui, pour
l'Italie, n'est plus comparable à celui de César ou d'Auguste, et si
on le compare à celui de Léon X, c'est comme un mauvais dessin
fait au crayon d'un beau tableau du Guide." Transcribed in
Frederick II 1846–57, vol. 27/1, pp. 265–66, no. 295.

24. Geheimes Staatsarchiv, Berlin, Brandenburg-Preußisches
Hausarchiv, Rep. 46 W, no. 17, vol. 3/6, fol. 60r, Wilhelmine
to Frederick II, Rome, 23 May 1755: "J'ai vu les Tableaux des
Peintres modernes depuis un siecle parmi lesquels il y en a de
tres beaux, entre autre de Carlo Dolci, de Concha, et de Carlo
Marat."

25. Geheimes Staatsarchiv, Berlin, Brandenburg-Preußisches
Hausarchiv, Rep. 46 W, no. 17, vol. 3/6, fol. 24r, Wilhelmine
to Frederick II, Erlangen, 11 August 1755: "Les deux Peintres
Minx et Batoni sont reputé de la première Classe, ils prenent
100 sequins pour une Figure le premier est un Composé de
Raphael et du Guide. Le second de Carlo Marat mais son
Colori est plus beau."

64. Österreichisches Staatsarchiv, Vienna, Allgemeines Verwaltungsarchiv, Harrachsches Familienarchiv, Kt. 202, fols. 18, 22, Crivelli to Harrach, 15 January 1752 and 26 May 1753. Transcribed in Ferrari 2000, pp. 116, 138–41.

65. Haus-, Hof- und Staatsarchiv, Vienna, Kabinettsarchiv, Nachlaß Zinzendorf, Tagebücher, vol. 11, 23 May 1766.

66. Joseph II to Maria Theresa, 18 March 1769: "Il y aura bien de la peine de pouvoir me faire peindre par Batoni, puisqu'il lui faut au moins douze heures à différentes reprises de séances, et cela sera difficile à trouver dans ces peu de jours que je serai ici." Transcribed in Arneth 1867–68, vol. 1, p. 245. See also Schmitt-Vorster 2006, p. 79.

67. For the political background and ceremonial aspects of Joseph's trip, see Garms-Cornides 2003, esp. pp. 316–22, 330.

68. See Yonan 2001, pp. 124–26; Schmitt-Vorster 2006, pp. 39, 77–78; Yonan 2007, p. 32.

69. Joseph II to Maria Theresa, 18 March 1769: "Nous avons vu le Conclave. Priés par tous les cardinaux, nous nous sommes laissés persuader à y entrer." Transcribed in Arneth 1867–68, vol. 1, p. 243.

70. Chracas 1716–1836, no. 8049, 15 April 1769. See also Chracas 1997–99, vol. 2, pp. 169–70.

71. Thorpe Letters, 15 April 1769.

72. For Laugier, see Jenkins 1996.

73. Clark and Bowron 1985, no. 332; Philadelphia 2000, pp. 317–18, no. 172; Schmitt-Vorster 2006, catalogue, no. 34; Yonan 2007.

74. Haus-, Hof- und Staatsarchiv, Vienna, Alte Kabinettsakten, Ital. Korr. 1769–70, Ktn. 35, Alexandre-Louis Laugier to Maria Theresa, 17 May 1769: "Il s'agit du Portrait de S.M. l'Empereur, et de S.A.R. Mgr Le Grand Duc par Batoni. Depuis leur depart jusqu'a cette attaque de goute, je n'ai pas manqué d'aller journellement chez ce Peintre en de veiller a l'execution d'un portrait qui doit fixer a jamais l'epoque memorable du voyage de ces deux Auguste Freres a Rome, en les representer a V. Mté avec une verité a laquelle l'art seul d'un aussi grand Peintre que Batoni peut atteindre. Depuis que je suis retenu au logis, ce peintre est venu tous les soirs me rendre compte de son travail, et il vient enfin de seconder l'emressement que j'avois de le voir, en le faisant porter chez moi. Je puis assurer V. Mté que j'ai eté frappé de la beauté de ce Portrait que je n'avois vû qu'ebauché, exceptez les têtes. outre une parfaite ressemblance, les attitudes sont si naturelles, les figures se détachent tellement de la toile, tous les details sont executés avec tant de verité et de perfection, qu'on y croit voir la nature elle même. je ne dis rien a V. M. de la Composition du tableau, a laquelle j'ai eû quelque part; elle en aura sans doute eté dejà informée. il n'y manque plus que quelques petits accessoirs qui seront terminés dans peu de jours; mais il en faudra encore une quinzaine au moins, le tableau fini, pour qu'il seche parfaitement avant de l'envoyer, sans quoi il risqueroit de se gâter en route, ou de s'alterer dans la couleur.

Batoni aura d'ailleurs besoin de ce tems pour en tirer la copie que S.M. L'Empereur lui a ordonné d'en garder pour pouvoir lui en commander d'autres. L'empressement de tout Rome pour voir au moins en effigie deux Princes qu'on y adore a si juste titre en realité, a fait perdre quelques heures au Peintre; il a eû beau vouloir remettre La foule après que le portrait seroit fini, on n'a pas voulu differer, et il a eté obligé enfin de fermer sa porte, sans quoi il n'auroit pas terminé sitôt l'ouvrage." Transcribed in Schmitt-Vorster 2006, Quellenanhang, p. 28.

75. Haus-, Hof- und Staatsarchiv, Vienna, Alte Kabinettsakten, Ital. Korr. 1769–70, Ktn. 35, Alexandre-Louis Laugier to Baron de Neny, 17 June 1769: "Il est sur qu'on ne perd rien pour attendre. il trouve toujours de quoi y retoucher par-ci, par-là, et ne fait que rendre le tableau plus parfait. On peut croire qu'il employe tout son art a perfectioner un ouvrage qui doit lui faire tant d'honneur." Transcribed in Schmitt-Vorster 2006, Quellenanhang, p. 31.

76. Pompeo Batoni to Franz Xaver von Orsini-Rosenberg, 17 June 1769: "Ho consegnato il detto quadro per essere a codesta volta spedito"; "Mi credo anche in obbligo di avisare Vostra Eccelenza come Sua Stà hà voluto vederlo; onde la scorsa domenicha mi concesse portarlo a Palazzo; e doppo averne molto lodato e la somiglianza, e il lavoro, con somma clemenza di sua propria boccha mi ordinò di farne subbito uno del tutto consimile, cioè con anbedue i Reali Germani, e tale come questo si trova, volendo collocarlo preso di sè, in luogo magnifico, con ornamenti di bronzo, e pietre presiose a perpetua memoria; ed in oltre ricavarne da questo stesso uno parimente simile in Mosaico lavorato con la maggior fineza possibile, per poi subbito che sia terminato farne in proprio nome un presente alla Augustissima Regina d'Ungheria, volendo di più che io stesso sopra intenda a detto mosaico perchè sia bene eseguito." Transcribed in Viviani della Robbia 1940, p. 18. For another account, see Haus-, Hof- und Staatsarchiv, Vienna, Alte Kabinettsakten, Ital. Korr. 1769–70, Ktn. 35, Batoni to Alexandre-Louis Laugier, 17 June 1769 (as quoted in a letter from Laugier to Baron de Neny, 20 June 1769): "E per La Corona dell'opera avendo bramato sua Santità di vederlo, dovetti la scorsa Domenica portare il quadro a Palazzo, ove doppo averlo sua Beatitudine per lungo tempo osservato, e degnato di molto lodarlo, si conpiacque di propria bocca ordinarmente uno totalmente consimile volendolo ritenere presso di se, per colocarlo in luogo magnifico, a perpetua memoria della venuta di questi Sovrani in Roma, ornandolo di Bronzi, e pietre preziosi, con famosa iscrizione: di più vole che se ne faccia uno simile in mosaico con la mia assistenza, per poi terminato mandarlo in dono alla loro Real Genitrice." Transcribed in Schmitt-Vorster 2006, Quellenanhang, p. 32. For the visit to the Palazzo del Quirinale, see also Chracas 1716–1836, no. 8066, 17 June 1769, and Chracas 1997–99, vol. 2, p. 172. The fate of the replica painted for Clement XIV remains

unknown. For the mosaic copy executed by Bernardino Regoli (1772; Kunsthistorisches Museum, Sammlung für Plastik und Kunstgewerbe, Vienna), see Clark and Bowron 1985, p. 317, pl. 303; Schmitt-Vorster 2006, catalogue, no. 37. The fame of Batoni's original portrait is confirmed by the nearly two dozen copies of it that exist today in various formats. An unfinished half-length portrait showing only Joseph II (National Gallery, Bratislava) has been tentatively attributed to Batoni on the basis of an inscription "P. Batoni"; see Schmitt-Vorster 2006, catalogue, no. 35. However, neither the painting nor the inscription are by the hand of the artist.

77. Pompeo Batoni to Franz Xaver von Orsini-Rosenberg, 17 June 1769: "Ho terminato perfettamente le due teste de i Reali Sovrani, con tutti li ordini, ed altro più necessario, per tenerle in modello presso di me, secondo l'ordine avutone dalla istessa boccia della Maestà Sua." Transcribed in Viviani della Robbia 1940, p. 18.

78. See Yonan 2001, p. 135. Mario Bevilacqua proposes that the map is Giovanni Battista Nolli's *Nuova pianta di Roma* (1748), because Leopold was given a copy of it during his stay in Rome (Bevilacqua 1998, p. 61). However, apart from being much too large, the original Nolli plan lacks the inscription across the top. Instead, the map shown in the portrait appears to be the one published by Joseph Jérôme Le Français de Lalande in his *Voyage d'un François en Italie, fait dans les années 1765 & 1766* (1769), a sheet derived from the Nolli plan and measuring 10⅛ × 14¹⁵⁄₁₆ in. (26.3 × 38 cm). Its inscription "Plan de Rome" across the top and the light hatching of the blocks of buildings also match the map in the portrait, whereas in most other versions of the Nolli plan the blocks are shaded in dark grey. The Lalande version is illustrated in Bevilacqua 1998, p. 175, fig. 5. For a later edition of the Lalande version and additional bibliography, see London 1996, p. 111, no. 66.

79. See Beales 1987, p. 59.

80. See Debrie and Salmon 2000, pp. 106–10, fig. 46.

81. For Maria Theresa's dispensation, see Burkhardt 1985, p. 46, n. 63.

82. See Pastor 1925–33, vol. 16/2, pp. 13–14.

83. For Joseph's reforms, see Beales 2003, pp. 179–228, esp. p. 201 for the refusal of Giuseppe Garampi (1725–1792), the papal nuncio in Vienna, to administer the Easter sacrament to Joseph in 1781. Garampi reported to Rome that the emperor's measures revealed him to be a Jansenist heretic.

84. Haus-, Hof- und Staatsarchiv, Vienna, Alte Kabinettsakten, Ital. Korr. 1769–70, Ktn. 35, Baron de Saint Odile to Franz Xaver von Orsini-Rosenberg, 17 June 1769 [copy]: "In quest' occasione non devo mancare di vendere al Sig. Pompeo Battoni quella giustizia che merita, con assicurare, l'E.V., che per ridurre il d. Quadro alla maggior perfezzione possibile si è data un'attenzione molto maggiore, e vi ha impiegato assai

maggior tempo di quel che è solito per Quadri di tal grandezza di tal prezzo. . . . Qualora S. A. R. ne desiderasse uno [an autograph version], come me ne diede un cenno in Roma, con divini che mi avrebbe poi fatti giungere i suoi ordini, farebbe opportuno che non tardassero questi ad arrivarmi, per poterne prevenire il S. Battoni, a cui molte sono le commissioni che ne vengono date." Transcribed in Schmitt-Vorster 2006, Quellenanhang, p. 23 [erroneously designated as a letter from Orsini-Rosenberg].

85. Haus-, Hof- und Staatsarchiv, Vienna, Alte Kabinettsakten, Ital. Korr. 1769–70, Ktn. 35, letter from Schönbrunn to Baron de Saint Odile, 17 July 1769: "Monsieur, Les portraits réunis de S. M. l'Empereur et de Mgr. l'archiduc Grand-Duc par Mr. Battoni, sont enfin arrivés à Schönbrunn Vendredi dernier; Ce Tableau memorable represente les deux Augustes freres avec une Verité frappante, les attitudes ne sauroient etre plus naturelles; les figures se detachent tellement de la toile, l'ordonnance en est si belle, et les details sont exécutés avec tout de perfection, en un mot tout est si complettement achevé dans cette admirable production de l'art, qu'Elle ne laisse absolument rien à desirer; aussi mon auguste Souveraine en est enchantée, et Vous ferez Cher Ami, une chose des plus agreables à Sa Majesté, en Vous pendant [rendant?] de Sa part[,] d'abord à la Reception de la presente, chez Mr. Battoni, pour Lui faire connaitre à quel point. Sa Majesté est contente de Son ouvrage, en attendant qu'elle puisse le Lui marquer Elle même comme Elle se le propose, en Lui faisant parvenir des temoignages publics de Sa haute gratitude, et du cas qu'Elle fait de Ses rares talens." Transcribed in Schmitt-Vorster 2006, Quellenanhang, p. 25. The identity of Saint Odile's correspondent at Schönbrunn, presumably a private secretary to Maria Theresa, is unknown.

86. Maria Theresa to Pompeo Batoni, 26 July 1769: "Dopo che io possiedo il quadro, col quale voi avete saputo celebrare così superiormente l'arrivo a Roma di S. M. L'Imperatore, e dell'Arciduca Granduca, miei cari Figli, questa rara Produzione della vostra Arte mi da tanta soddisfazione, che nel farvene indirizzare alcuni contrasegni ho voluto attestarvela anch'io stessa colla presente. Del resto io non saprei contentarmi ancora di quella prima Opera, che ho della vostra mano, non ostante tutta la perfezione che vi regna, e mi sarebbe molto gradevole, che vi prendeste la pena di farmi per la seconda volta questo bel Quadro, in grande rappresentante i Personaggi interi, aspetterò dunque con ansietà questa prova reiterata del vostro zelo con la quale voi acquisterete in contracambio dei novi titoli alla mia gratitudine ed alla mia benevolenza." Transcribed, together with a description of the presents, in Chracas 1716–1836, no. 8096, 30 September 1769, and in Chracas 1997–99, vol. 2, pp. 172–73.

87. Haus-, Hof- und Staatsarchiv, Vienna, Alte Kabinettsakten, Ital. Korr. 1769–70, Ktn. 35, Alexandre-Louis Laugier to Baron

129. The Duke of York left Rome on 25 April. Countess Spencer stayed until June but her portrait was already on view in Batoni's studio by 6 May; see MS. journal of James Martin in Italy 1763–65, private collection, 6 May 1764. Cited in Ford and Ingamells 1997, p. 883.

130. Clark and Bowron 1985, nos. 349, 395. For details of the visits to Rome, see Ford and Ingamells 1997, pp. 402–4.

131. Clark and Bowron 1985, no. 310; Jacob and König-Lein 2004, pp. 23–25, col. pl. 35, with additional bibliography. For the version at Fürstenhaus Herrenhausen, Hanover, see Clark and Bowron 1985, no. 309; London 1996, p. 82, no. 39.

132. See Justi 1923, vol. 3, p. 351.

133. Winckelmann 1767, vol. 1, pls. 159, 200.

134. See Greifenhagen 1963, p. 90; Jenkins and Sloan 1996, pp. 52, 85.

135. See Roettgen 1981, pp. 129–31; Roettgen 2003, p. 221.

136. Clark and Bowron 1985, p. 308.

137. Clark and Bowron 1985, no. 381. The portrait's status as Karl Theodor's official likeness is confirmed by the numerous copies of it executed by German painters.

138. See Ebersold 1999, p. 232.

139. See Clark and Bowron 1985, no. 283; Wronikowska 2002, pp. 127–28, nn. 51, 53.

140. Bayerische Staatsbibliothek, Munich, Cod.germ. 1980, Römisches Reisetagebuch, p. 25; Thorpe Letters, 24 December 1774. For the half-length portrait, see Clark and Bowron 1985, no. 380.

141. Chracas 1716–1836, no. 152, 15 June 1776. See also Chracas 1997–99, vol. 2, p. 197; Puhlmann 1774–87, p. 114, 8 June 1776.

142. Clark and Bowron 1985, nos. 227, 391–93; Paris 2000, pp. 30–31, no. 2 (*Pope Clement XIII*). For a preparatory drawing (fig. 145) for the vestments of the Clement XIII portrait, see p. 161 in this book.

143. Roettgen 1999, pp. 227–31, nos. 156, 158; Philadelphia 2000, pp. 408–9, no. 255; Roettgen 2003, pp. 609–11, no. NN 158, col. pl. 14.

144. Collection Conte Masetti-Torrini, Rome, Benigno Saetta to an unknown recipient, 15 January 1760: "Monsieur Mengs et il C.r Battoni sono di presente li migliori Pittori che siano in Roma. Il primo si ritrova in Napoli per fare il Ritratto del nuovo Re, ma se incontra come quello del Santo Padre si farà poco onore. Il secondo è famoso p[er] Ritratti e presentemente d'ordine dell'Emo Sig. Cardinal Nipote travaglia il ritratto del Santo Padre che riesce a maraviglia." Transcribed in Roettgen 2003, p. 488.

145. Johns 2000, p. 30: "The warm hues and soft lighting underscore the mood of benevolent paternalism that permeates the image."

146. West Yorkshire Archive Service, Leeds, Grantham correspondence, VR 12325, Thomas Robinson to his father William Robinson, 1st Baron Grantham, 9 August 1760. Transcribed in Beard 1960, pp. 23–24, and Roettgen 2003, p. 489. See also Ford and Ingamells 1997, p. 817.

147. Clark and Bowron 1985, no. 297; Pavanello 1998, pp. 91–92, 101–3; Pavanello 2000, pp. 53, 55; Bassano del Grappa 2003, p. 132, no. I.13; Rome 2005, pp. 184–85, no. 66.

148. The portrait was noted by Puhlmann in the senator's rooms on 20 May 1775; see Puhlmann 1774–87, p. 59.

149. Thorpe Letters, 18 March 1775; Puhlmann 1774–87, p. 47.

150. See Collins 2004, p. 32: the precedent for showing the pope wearing the berrettino was established in a slightly earlier portrait of Pius VI by Giovanni Domenico Porta (1775; Château de Versailles).

151. Thorpe Letters, 11 May 1776: "[Batoni] has nothing more to do in the picture than to put the fine Table Clock in it, which Prince Rospigliosi presented to his Holiness, who will now have it painted there." Archivio Segreto Vaticano, Vatican City, Sacri Palazzi Apostolici, Dispensiere, 1776, vol. 97, ristretto 12–15 luglio, no. 3 (transcribed by Olivier Michel): "A di 13 mag.o. Pagato al Sig.re Giuseppe orloggiaro per aver fatto portare l'orologgio brillantato dal Vaticano al Sig.re Battoni pittore e dalli alla sua bottega e riportato al Vaticano."

152. Collins 2004, pp. 34–36. In the old Italian system, the hours were counted beginning at sunset; see Talbot 1985.

153. Chracas 1716–1836, no. 160, 13 July 1776. See also Chracas 1997–99, vol. 2, p. 197.

154. See Roettgen 1999, p. 230.

155. Fiorillo 1798–1808, vol. 1, pp. 222–23; Lanzi 1809, vol. 1, p. 420. For Benedict's patronage of Batoni, see pp. 25–27 in this book.

156. For the portrait by Subleyras, see Paris 1987, pp. 248–53, no. 69, col. pl. 13; Philadelphia 2000, pp. 436–37, no. 284.

157. Clark and Bowron 1985, no. 200; Philadelphia 2000, p. 312, no. 168.

158. Clark and Bowron 1985, no. 206; Rome 1999, p. 92, no. 26; Milan 2002, pp. 462–63, no. VII.6; Rome 2005, p. 183, no. 65.

159. Barroero and Susinno 2000, p. 53, cites several examples of Batoni's closeness to Arcadian circles, including the fact that his biographer Francesco Benaglio was a member of the academy, the portrait of Giacinta Orsini, and the membership of his daughter Rufina, a musician and poet.

160. Clark and Bowron 1985, no. 140; Philadelphia 2000, pp. 310–11, no. 166.

161. Clark and Bowron 1985, no. 251; Mann 1997, pp. 14–16.

162. Pierre Guérin de Tencin to Benedict XIV, 14 April 1757: "Mons. vescovo di Laon sarà il successore del sig. conte de Stainville presso la S. V. Sa ella, ch'egli ha la nomina del re di Polonia per la Promozione delle Corone. Quel prelato è d'un naturale sommamente dolce, e tranquillo; e spero, che la S. V. ne sarà molto contento." Transcribed in Benedict XIV 1955–84, vol. 3, p. 440, no. 12.

163. François-Joachim de Pierre de Bernis to Louis XV, 11 May 1758: "[Rochechouart] jouit déjà à Rome d'une considération universelle." Cited in Rogister 1997, p. 118.

164. See Recueil 1724–91, p. 337.

165. Clark and Bowron 1985, no. 213.

166. See Recueil 1724–91, pp. 341–42, n. 7.

167. See Pastor 1925–33, vol. 16/1, pp. 725–27.

168. Clark and Bowron, 1985, no. 325; Hoff 1995, p. 8.

169. Clark and Bowron 1985, no. 263; Lyon 2000, pp. 212–13, no. 83; Geneva 2004, pp. 226–28, no. 48.

CHAPTER 4. FINAL YEARS AND RECEPTION

Epigraph: Hoffmann 1817, vol. 3, p. 28.

1. Clark and Bowron 1985, no. 421; Puhlmann 1774–87, p. 160.

2. Puhlmann 1774–87, p. 152.

3. Boni 1787, pp. 48, 50.

4. For Imperiali's altarpiece, see Philadelphia 2000, pp. 364–65, no. 215. For Batoni's San Gregorio altarpiece, see p. 1 in this book.

5. Clark and Bowron 1985, nos. 426, 142.

6. Chracas 1716–1836, no. 500, 16 October 1779: "dipinto con arte, e maestria veramente degna del di lui rinomato pennello." See also Chracas 1997–99, vol. 3, p. 15.

7. Puhlmann 1774–87, p. 161.

8. Tischbein 1956, p. 245: "Das Gesicht der Katharina war so schön, daß man es den Bildern der ausgezeichneten alten Maler zur Seite stellen kann. Besonders schön war der Finger, den sie hinhält, damit Christus den Ring darauf stecke. 'Sollte man nicht glauben,' sagte Battoni, 'wenn man den Schenkel des Christus berührte, das Fleisch würde nachgeben?'"

9. Meyer 1792, p. 131: "Ich bewunderte einst auf einem eben fertig gewordnen Gemälde, welches das Verlöbniß der heil. Katharina vorstellte, in der Figur des Christuskindes die Wahrheit des Ausdruckes, der kindischen Unbefangenheit, und die Schönheit der Färbung des Nackenden:—'es scheint zu leben,' setzte ich hinzu. 'Es scheint?' antwortete er; 'che volete fare, wenn ich dieses Kind da nicht selbst gemalt hätte, wahrlich! ich würde es für ein lebendiges halten.'"

10. Puhlmann 1774–87, p. 140. Philip Yorke, later 3rd Earl of Hardwicke, was quoted the same price (£700): Yale University, Beinecke Library, New Haven, Osborn MS. C.332, October 1778. Cited in Black 2003, p. 189. For Batoni's portrait of Yorke, see Clark and Bowron 1985, no. 411.

11. Münter 1937, vol. 2, p. 167 [18 June 1786]: "Wir sahen die Vermälung der h. Catherina, die wirklich gut war. die h. Cath. ist ein sehr schönes Gesicht."

12. See Puhlmann 1774–87, pp. 166–67.

13. See Clark and Bowron 1985, nos. 430, 444, 445, 449, 455, 461, 462; Seydl 2003, pp. 266–78, 284–90; Delaforce 2002, pp. 372–75.

14. Transcribed in Averini 1973, pp. 94–102.

15. Puhlmann 1774–87, p. 168; Chracas 1716–1836, no. 710, 20 October 1781: "[Pius VI] andò allo studio di Pittura del celebre s. cav. Pompeo de Battoni ove si trattenne circa un'ora in osservare minutamente l'eccellente pitture fatte dal detto

cavaliere ma più in particolare volle osservare il quadro rappresentante il SS.mo Cuore di Gesù ordinato da S. Maestà Fedelissima per esser posto nel Monastero che la M. S. ha fatto erigere a proprie spese nella città di Lisbona." See also Chracas 1997–99, vol. 3, p. 24.

16. Thorpe Letters, 21 October 1780.

17. Southey 1799, p. 307. See also Averini 1973, p. 87, for a text written for the Espectador Portuguez of 12 October 1784 criticising the figure of Europe and the horse as "indecorous" and "lacking in decency."

18. Thorpe Letters, 21 October 1780; Antonio Longo to Ambrogio Rosmini, 25 March 1782: "Cosi pure Battoni nell'avvanzata età in cui si trova travaglia con una valenzia, e rapidità sempre eguale e nell'anno [1]781 si dice che per un gran quadro d'Altare per Portogalo e molti Ritratti abbia conseguito in questo cinquemila zechini." Cited in Ferrari 1984, p. 210.

19. Puhlmann 1774–87, p. 206: "Wenn die Arbeit vor Portugal geendigt, so weiß ich nicht, was er anfangen wird."

20. Humberside County Archives, Beverley, Chichester-Constable MSS., DD/CC/145/6, James Byres to William Constable, 10 August 1785 (information from Geoffrey Beard). See also Ford and Ingamells 1997, p. 236. For the portraits, see Clark and Bowron 1985, nos. 456, 457; Brigstocke 1993, pp. 31–33, pl. 11; Rome 2001, pp. 208, 210, nos. A 14, A 15.

21. Münter 1937, vol. 2, p. 167 [18 June 1786]: "ein ehrwürdiger heiterer u. rüstiger 87 Jähriger Greis. seine izigen Gemälde taugen nichts mehr, weil er nicht mehr sehen kann. Vor einigen Jahren malte er aber noch gut."

22. Boni 1787, p. 68; Puhlmann 1774–87, p. 214: "Jetzo malt er vor seine Familie vor jeder von seinen Töchtern eine Madonna." One of these is probably the Virgin and Child (1786; private collection, Rome); see Clark and Bowron 1985, no. 464.

23. Thorpe Letters, 10 February 1787.

24. Chracas 1716–1836, no. 1264, 10 February 1787. See also Chracas 1997–99, vol. 3, p. 45; Puhlmann 1774–87, p. 218; Thorpe Letters, 10 February 1787: "He was buried with distinction by the Academy [of Saint Luke] in S. Lorenzo in Lucina."

25. Archivio di Stato, Roma, 30 Notai Capitolini, Ufficio 27, busta 375, notaio Lelio Amaducci, fols. 184–85, 211–12 (transcribed by Olivier Michel): "per mantenersi e per allocarsi secondo il mio, e loro grado." The seventh Madonna was intended for the chambermaid, together with 100 zecchini.

26. Meusel 1787, p. 373: "[Batoni] hinterläßt eine Frau und eine sehr zahlreiche Familie, mit einem nicht unbeträchtlichen Vermögen, wovon er der erstern 3000 Scudi, jeder Tochter 1000 zur Ausstattung, und den Ueberrest seinen neun [sic] Söhnen vermacht hat."

27. Puhlmann 1774–87, p. 218: "Das Üble ist, daß sich die Fonds zu dem Vermächtnis nicht finden, sie haben schon einen Prozeß unter sich."

28. Puhlmann 1774–87, p. 27; Tischbein 1956, p. 246: "so hatte er doch nichts erübrigt, weil er so mitleidig war und alles an die Armen gab."

29. Lucia Batoni to Giuseppe Pelli, 17 November 1787: "La perdita di un uomo da cui dipendeva l'unica nostra sussistenza e che non ha lasciato che un residuo di quadri." Transcribed in Prinz 1971, p. 209.

30. Boni 1787, pp. 39–41, 50–51.

31. "Assegna de quadri che si trovano presso gli Eredi del fù Cav. Pompeo Girolamo Batoni," 9 November 1802: "un quadro alto palmi 9 largo 6 rappresentante lo Sposalizio di Santa Caterina dipinto dal detto Pompeo Batoni"; "un quadro alto palmi 17½ largo palmi 8 rappresentante la Cena di Nostro Signore non finito dipinto dal medesimo." Transcribed in Borghese 1995, p. 99 [fol. 85].

32. Lucia Batoni to Giuseppe Pelli [agent of Grand Duke Leopold], 17 November 1787. Transcribed in Prinz 1971, pp. 209–10. For the self-portrait, see Clark and Bowron 1985, no. 369.

33. Puhlmann 1774–87, p. 218.

34. Fernow 1795, p. 161, citing Carstens's advertisement for the exhibition: "Nachstehende Kunstwerke sind im Hause des verstorbenen Pompeo Battoni zur öffentlichen Beurtheilung ausgestellt." See also Büttner 1996, p. 195.

35. Reynolds 1975, pp. 248–49.

36. Aikin 1799–1815, vol. 2, p. 45. In France, Pierre-Jean Mariette (1694–1774) noted in his *Abécédario* that Batoni was "surtout fort occupé a faire des portraits, qu'il se fait payer fort chère-ment." See Mariette 1851–62, vol. 1, p. 80.

37. "A Portrait of a Nobleman, whole length," exhibited at the Society of Artists in 1778.

38. Walpole 1937–83, vol. 25, p. 673. For this version of the duke's portrait, see Clark and Bowron 1985, no. 273.

39. Dorset Record Office, Dorchester, Kingston Lacy MSS., Henry Bankes to his mother, Margaret Bankes, 28 September 1779 (information from National Trust files).

40. Wyndham 1790, p. 289.

41. Clark and Bowron 1985, no. 402.

42. Frederick Hervey to Lady Erne. Cited in Rankin 1972, p. 54 (without date).

43. For the portraits of members of the Milltown family, see Clark and Bowron 1985, nos. 87, 146, 148, 149.

44. Wilson 1786, col. 264. The *Venus* by Batoni is untraced.

45. See Aikin 1799–1815, vol. 2, p. 45.

46. Archenholz 1785, vol. 2, p. 271: "Dieser Künstler, der einstim-mig nunmehr für den ersten Maler in Italien erkannt wird"; Archenholz 1791, vol. 2, p. 109: "He stands confessed the best painter in Italy.'

47. Meusel 1787, p. 373: "[Batoni] war der berühmteste Italienische Maler unsrer Zeit."

48. Dallaway 1800, p. 482. See also Haskell 1967, pp. 70–71. The analysis in Johns 2000, pp. 17–20, regarding the nineteenth- and twentieth-century reception and historiography of Roman Settecento art in general is equally valid for Batoni, its fore-most exponent, in particular.

49. Boyer 1768, pp. 32–33: "Mr. Batoni, qui passe aujourd'hui pour le meilleur peintre qui soit à Rome, a un dessein correct, mais un peu gené dans les contours, ses tableaux son très-finis, & peints d'un beau pinceau, son coloris est frais & gracieux, ses draperies bien jetées, mais quelquefois trop voyantes. Sa composition, sans être bien savante, est ingénieuse."

50. Friedrich Nicolai to Christian Ludwig von Hagedorn, 12 Octo-ber 1764: "Der König liebt jetzt die Mahlerey sehr, und bringt täglich wenigstens vier Stunden in seiner neuen Gallerie zu. Unter uns; er hat aus Dresden den Geschmack an Correggio und Rubens mitgebracht, und hat die Meister, welche er sonst für alles hielt, nunmehr nach ihrem wahren Werthe schätzen gelernt. Der Marquis d'Argens hat etwas dazu beigetragen." Transcribed in Hagedorn 1797, p. 263.

51. For Wilhelmine's influence, see p. 92.

52. Frederick II 1879–1939, vol. 14, p. 109, no. 8402, Frederick II to Wilhelmine, Dresden, 6 December 1756: "J'ai entendu un beau motet, j'ai vu la galerie de tableaux, voilà tout."

53. Friedrich Christian 1751–57, p. 337 [22 November 1756]: "Tous les princes frères du roi et lui-même furent à notre église pour entendre la musique et ils virent auparavant la galerie des tableaux." See p. 332 for the king's arrival in Dresden (14 November) and his residence; p. 383 for his departure (24 March 1757).

54. Diary by gallery inspector Johann Anton Riedel, 1744–60: "Den 23. Novbr. 1756, nach Einmarsch der preussischen Garnison, war König Friedrich II. mit den Prinzen Heinrich und Ferdinand von Preussen und zahlreicher Suite auf der Gallerie. Bei einem zweiten Besuche am 22. Decbr. bestellte der König eine Copie der Magdalena von Battoni, jedoch ohne den Totenkopf, bei dem Hofmaler Dietrich, die bereits am 17. März 1757 . . . an den König von Preussen in dessen Hauptquartier im Brühl'schen Palais abgegeben wurde." Cited in Hübner 1856, p. 56.

55. See Seifert 2004, p. 269.

56. Clark and Bowron 1985, no. 60. For the copy by Anton Graff, 1800 (fig. 121), see Christie's, London, 13 December 1996, lot 53.

57. "Inventarium von der Königlichen Bilder-Galerie zu Dresden, gefertiget Mens: Julij et August: 1754," I, no. 262. MS., Gemäl-degalerie, Dresden.

58. See Eckardt 1974, vol. 2, pp. 165–66; Puhlmann 1774–87, p. 233.

59. Friedrich Christian 1751–57, p. 365 [12 February 1757]: "Oester-reich est entré au service de Prusse."

60. Johann Joachim Winckelmann to Leonhard Usteri, 20 Febru-ary 1763: "Der König in Preußen hat einen großen Esel und Ertz-Betrüger von der Dreßdner Gallerie weg und in seine

Dienste genommen. Er heißt Oesterreich. Dieser Mensch macht dem Dreck, worauf er tritt, Schande." Transcribed in Winckelmann 1952–57, vol. 2, pp. 293–94.

61. Oesterreich 1773, p. 11, no. 18: "Er hat dieses Stück 1746. zu eben der Zeit verfertiget, da er die schöne Magdalena, so sich in der Dreßdener Gallerie befindet, gemahlet hat."

62. See Gould 1976, pp. 279–80, pl. 97C.

63. Puhlmann 1774–87, p. 175, fig. 74: "Die Großfürstin kaufte von Batoni eine Nachahmung von der Magdalena von Correggio, das Original zu Dresden." The authorship of this copy (copper, 11⅛ × 14¹⁵⁄₁₆ in., or 28.3 × 38 cm), presently at Pavlovsk Palace, near Saint Petersburg, is uncertain.

64. Lehninger 1782, p. 50: "[Batoni] s'est préférablement distingué par la belle fonte des couleurs dans le goût du Correge, & par l'expression de ses tableaux."

65. Potsdam 1986, vol. 1, p. 98, no. VII.36, fig. VII.36.

66. Fiorillo 1798–1808, vol. 1, p. 221: "sein hinreißend liebliches Bild der reuigen Magdalene in der Dresdener Galerie"; Meyer 1809–15, p. 298: "Eins der schönsten Gemälde von Batoni ist seine büßende Magdalene in der Dresdner Galerie."

67. Heinecken 1778–90, vol. 2, pp. 228–29.

68. Berckenhagen 1967, p. 411, no. 1746.

69. Hoffmann 1817, vol. 3, p. 28: "Doch lobten die Architekten die reinen Verhältnisse ihres Wuchses, die Maler fanden Nacken, Schultern und Brust beinahe zu keusch geformt, verliebten sich dagegen sämtlich in das wunderbare Magdalenenhaar und faselten überhaupt viel von Battonischem Kolorit." Hoffmann had seen the painting in the Dresden gallery in 1798 and expressed his admiration for it in his correspondence; see Hohoff 1988, p. 258.

70. Meyer 1792, pp. 128–30: "Pompeo Battoni erfuhr . . . die Mißgunst und Verkleinerungssucht vieler seiner Zeitgenossen; er war duldsamer und billiger gegen sie. . . . Er liebte und unterstützte jeden sich an ihn wendenden jungen Künstler gern, mit Rath und Leitung, bemerkte seine guten Anlagen, und ermunterte ihn zur Beharrlichkeit in den Fortschritten zum großen Ziel. Battoni's Gemälde sind nicht ganz fehlerfrei in der Zeichnung und Haltung; man beschuldigt sie einer gewissen ermüdenden Einförmigkeit des Tons: wo aber war einer seiner großen Vorgänger ganz fehlerfrei? Er hatte es nicht verdient, dieser große Mann, daß man ihm, bei seinen Vorzügen, jene Mängel seiner Kunst in Rom so bitter vorwarf. Seine Werke bleiben Muster der Nachahmung, in der Wahrheit und Mannigfaltigkeit des Ausdruckes, in der Schönheit der Gewänder, und in der Harmonie der Farben. . . . Neben mancher Künstlerlaune und Eigenheit, die in seinem hohen Alter oft in übertriebne Selbstsucht ausartete, besaß Battoni eine liebenswürdige Guthmütigkeit und Offenheit des Charakters, und bis an seinen Tod einen Fleiß in der mechanischen Ausführung seiner Gemälde, und eine Schnelligkeit und Leichtigkeit im Arbeiten, die in Erstaunen setzten. Er erhielt

sich immer eine anziehende Heiterkeit des Geistes, und verrieth selbst in den Gemälden seiner letzten Jahre keine Abnahme der Geisteskräfte. In dem schon früh erworbnen bedeutenden Grad seiner Kunstgeschicklichkeit, blieb er sich immer gleich. Die vor vierzig Jahren gemalte treffliche Magdalena in der Dresdner Gallerie, glich in der Manier vollkommen den Bildern, die ich unter seinen Händen sah: und man konnte dem alten Mann nichts Schmeichelhafteres sagen, als wenn man diese Gleichheit seines Pinsels bemerkte."

71. Füssli 1779, p. 57: "Battoni war um 1760 einer der besten Mahler zu Rom. Man siehet von ihm zwey vortrefliche Stücke, von schöner Zusammensetzung, lieblicher Färbung und vielem Feuer in der Kirche della Pace zu Brescia. Seine beste Arbeit ist die Decke der Gallerie Colonna zu Rom, sie stellet einige Tugenden in verschiedenen Abtheilungen vor. Dieser Künstler besizet eine richtige Zeichnung, obgleich seine Umrisse etwas gezwungen sind. Seine Gemählde sind sehr wohl ausgearbeitet; die Gewänder sind wohl geworfen, aber zuweilen allzuflatternd. Seine Zusammensetzung ist zwar nicht regelmäßig aber sinnreich. Des Battoni Stärke bestehet vornehmlich in Bildnissen, die er häufig für Engländer mahlte." Compare the text of Boyer 1768, pp. 32–33, quoted in n. 49, above. Significantly, the overlapping passages did not yet appear in the 1760 and 1767 editions of Füssli's text. In Ludwig von Winckelmann's *Neues Mahlerlexikon* (1796), Füssli's text shrunk to this entry: "[Batoni] mahlte ums Jahr 1760. zu Rom vortrefliche Historienstücke und Bildnisse, in welchen seine Hauptstärke bestund"; see Winckelmann 1796, p. 14.

72. Fiorillo 1798–1808, vol. 1, p. 221: "ein entschiednes Talent für Porträtmahlerey (das sich selten in dem Grade mit den Anlagen zum Geschichtsmahler vereinigt findet)"; Heinecken 1778–90, vol. 2, p. 227: "Il peint le Portrait & l'Histoire avec grand succès."

73. Stiftung Weimarer Klassik, Goethe- und Schiller-Archiv, Weimar, Nachlaß Johann Heinrich Meyer, 111/1: "Seit kurzem gestorben in den siebzigern mit dem Ruhm eines der ersten Künstler seiner Zeit. Seine gefällige und reine Manier zu malen, ist bekannt. War gleich stark im Portrait wie in der Geschichte." Transcribed in Puhlmann 1774–87, pp. 331–39, at p. 336. While Hirt had hardly a kind word to say about the next generation of Italian painters such as Domenico Corvi (1721–1803), Antonio Cavallucci (1752–1795), and Giuseppe Cades (1750–1799), he applauded Jacques-Louis David's *Oath of the Horatii* (1784; Musée du Louvre, Paris). For an Italian translation of Hirt's list, see Meyer and Rolfi 2002 (Batoni on p. 251).

74. Meusel 1787; Jagemann 1789.

75. Puhlmann 1774–87, pp. 113–14, 135. The manuscript is lost.

76. Clark 1981, p. 111.

77. Batoni was nominated in a meeting on 18 November 1770, receiving four votes, ahead of three for Mengs and two for

Charles-Joseph Natoire (1700–1777). At the following meeting on 16 December 1770, Batoni was no longer a candidate, and Mengs was elected president for 1771 with five votes, ahead of Natoire with four. Batoni was not present at either meeting; see Accademia di San Luca, Rome, Archivio Storico, Libro de' Decreti, vol. 52, fols. 172v, 174r. Cited in Roettgen 2003, p. 533.

78. ASL, no. 874, p. 262, 24 September 1740: "Questo e un soggetto non mai visto, in pittura onde spero che sarà bello"; ASL, no. 918 bis, p. 303, 18 July 1744: "figli della mia fantasia"; Pompeo Batoni to Carlo Innocenzo Frugoni, 1 April 1761: "Ho fatto un soggetto nuovo, poetico, non mai fatto da nissuno." Transcribed in Copertini 1949–50, p. 137.

79. Chracas 1716–1836, no. 8186, 11 August 1770: "la bella composizione Poetica del tutto nuova, e non mai dipinta." See also Chracas 1997–99, vol. 2, p. 177.

80. Pompeo Batoni to Carlo Innocenzo Frugoni, 1 April 1761: "li strumenti de le arti che [Chiron] gli insegnerà, che sono il tirare il dardo . . . poi vi è la lira e la musica, poi le lance e la guerra, e poi l'erbe e la medicina." The entire description is transcribed in Copertini 1949–50, p. 137. For another example of Batoni describing a concetto, see ASL, no. 874, pp. 262–63, 24 September 1740.

81. See p. 62.

82. See p. 27.

83. Clark and Bowron 1985, p. 369; Bowron 2000, pp. 359–60; Gedo 2002.

84. Pietro Giuseppe Graneri to an unknown recipient, 14 February 1778: "Nel quadro più piccolo l'autore pretese di rappresentare la pace e la guerra. Egli si pregia di questa idea come di cosa nuova." Cited in Claretta 1893, p. 229.

85. Thorpe Letters, 28 September 1776. The companion allegory remains untraced.

86. Puhlmann 1774–87, p. 121 [24 September 1776]: "Mit Herrn Maurer und einigen Pensionären bei Batoni gewesen, um das Gemälde zu besehn, was er jetzt fertig gemacht und das den Krieg als einen jungen Held vorstellt, der vom Frieden, einem jungen, reizenden Mädchen zurückgehalten wird. Eins der schönsten Sachen, die er je gemacht."

87. Biblioteca Governativa, Lucca, MS. 3300, Miscellaneo, 19 August 1778: "Un quadro mezzano . . . che rappresentava la Pace, et la Guerra per mezzo di una Venere, che nuda e tutta tenerezza nel presentarsi a Marte, e invitarlo ad abbracciarle il suo seno, gli presenta un ramo d'olivo"; "questo è un quadro assai scandoloso perché la Venere sembra viva e rilevata compare dalla tela." Cited in Belli Barsali 1964, pp. 75–76, n. 22.

88. See Gedo 2002, p. 603; Haskell and Penny 1981, pp. 189–91, fig. 98. For the Topham commission, see p. 145 in this book.

89. Boni 1787, p. 55: "Il quadro detto della Pace, e della Guerra, in figure fin sopra il ginocchio. A Marte furibondo, e armato, con una spada in mano, in atto di correre risolutamente alla guerra, si presenta una leggiadra bellissima vergine, che

affettuosamente guardandolo, a trattenerlo dalle sue furie, gli presenta un ramo di olivo. Nella testa di Marte vedesi il feroce Caracalla, ma più nobilitato, e abbellito dal genio del Pittore."

90. See Haskell and Penny 1981, pp. 172–73, fig. 89.

91. Biblioteca Governativa, Lucca, MS. 3300, Miscellaneo, 19 August 1778: "due passioni tanto opposte fra loro." Cited in Belli Barsali 1964, pp. 75–76, n. 22.

92. Thorpe Letters, 28 September 1776.

93. Lanzi 1809, vol. 1, p. 421: "Il Batoni ancora dee considerarsi come ristauratore della scuola romana, ove dimorato fino all'anno 79 della sua vita ha incamminati molti giovani alla professione."

94. Lanzi 1809, vol. 1, p. 420: "Benché non fosse uomo di lettere, comparve poeta nel carattere grandioso, e più nel leggiadro."

95. Pilkington 1805, p. 34.

96. Watelet and Lévesque 1792, vol. 4, p. 597: "Pompeo Battoni, de l'école Florentine, né à Lucques en 1702, est le plus célèbre des peintres que l'Italie ait produits en ce siècle. Ce n'étoit point un artiste très-savant, ni qui eût suppléé au défaut de ses connoissances par de profondes réflexions. Ses ouvrages ne se sentent ni d'une étude assidue de l'antique, ni de celle des ouvrages de Raphaël & des autres grands maîtres de l'Italie: mais la nature l'avoit fait peintre & il avoit suivi l'impulsion de la nature. Il ne manquoit ni de caractère, ni de correction, ni d'agrément; & s'il n'avoit pas de très-grandes conceptions, il savoit du moins bien rendre ce qu'il avoit conçu. Il auroit été dans tous les temps un peintre très-estimable; dans le temps où il vécut, il devoit répandre un grand éclat."

97. Bryan 1816, vol. 1, p. 90.

98. Levey 1966, pp. 175–76; Steegman 1946, p. 59.

99. Chracas 1716–1836, no. 5802, 21 September 1754. See also Chracas 1997–99, vol. 2, p. 104.

100. Bertolotti 1877, p. 220: "1767 24 7bre. Francesco Barazzi: un ritratto istoriato di Pompeo Battoni." The picture has not been identified.

101. See p. 90.

102. For the Fetherstonhaugh series, see p. 53 and Clark and Bowron 1985, nos. 154–62. For the Lubomirska portraits, see Clark and Bowron 1985, nos. 423, 424.

103. See, for example, Clark and Bowron 1985, nos. 23, 88, 94.

104. Thorpe Letters, 13 July 1776. For the portrait of the duchess and her son, see Clark and Bowron 1985, no. 395.

105. Thorpe Letters, 11 May 1776.

106. Thorpe Letters, 8 January 1777.

107. Pompeo Batoni to Carlo Innocenzo Frugoni, 1 April 1761: "siccome l'è Eccellentissimo poeta, la prego a voler difendere la parte della poesia che è l'anima de la pittura, che è la naturalezza de la espressiva secondo le diverse passioni e si intende Pittura animata capace di muovere i riguardanti quello appunto che fa il Poeta con la poesia parlante e questo con la poesia muta." Transcribed in Copertini 1949–50,

p. 138. "Painting is mute poetry, poetry a speaking picture" was attributed to Simonides of Ceos by Plutarch in *De gloria Atheniensium* 3:346F.

108. Haus-, Hof- und Staatsarchiv, Vienna, Alte Kabinettsakten, Ital. Korr. 1769–70, Ktn. 35, letter from Baron de Saint Odile to an unknown recipient at Schönbrunn, 9 June 1770: "Il est facheux que cet habile homme n'ait que 2. Bras, et ne puisse peindre qu'avec un seul." Transcribed in Schmitt-Vorster 2006, Quellenanhang, p. 37.

CHAPTER 5. DRAWINGS, WORKING METHODS, AND STUDIO PRACTICES

Epigraph: ASL, no. 886, p. 273, letter of 5 May 1742 to Lodovico Sardini: "Poiché per ridurre un'opera all'ultima sua perfezione è di mestieri di usarvi molta attenzione, ed io per ome sono di un naturale che mai contentandomi di quel che faccio sempre mi sembra vi manchi qualche cosa e ritorno à faticarvi attorno."

1. Macandrew 1978, p. 140.
2. Clark 1981, p. 107.
3. Benaglio 1894, pp. 16–23; Pascoli 1737, pp. 179–81.
4. A letter of 23 October 1741 from John Clephane to Lord Mansell regarding the *Sacrifice of Iphigenia* includes a tantalising reference to Batoni's use of "Clay-models" in the preparation of the painting (Russell 1988, p. 854). Puhlmann 1774–87, p. 127, reported in 1777 that Batoni employed small wax figures from which to study poses and draperies and instructed him in their use.
5. Benaglio 1894, p. 23.
6. Lanzi 1809, vol. 1, pp. 204–5.
7. Boni 1787, p. 23.
8. For an overview of the role of drawing in eighteenth-century Roman artistic practice, see Hiesinger 1980 and Percy 2000.
9. ASL, no 872; Lucca 1967, p. 260: "che io abia adegualiare al divino Raffelo pittore da me molto amato, e venerato sopra tutti li altri."
10. Boni 1787, pp. 23, 26–27. For a drawing after the head of Saint Augustine in the *Disputà*, see Clark and Bowron 1985, p. 378, no. D16, pl. 5; for a sheet recording the female personification illustrating Jurisprudence in the Stanza della Segnatura, see Paris 1990, no. 132.
11. The document recording Batoni's appointment to this office on 16 June 1768 is in the Archivio Segreto Vaticano, Sacri Palazzi Apostolici, Giustificazioni del Ruolo, 1768, no. 41 (transcribed by Olivier Michel). Further evidence that Batoni was something of an "expert" on the art of Raphael is provided by an incident in which several academicians at the Accademia di San Luca, including Mengs, Anton von Maron (1731–1808), and Domenico Corvi, deferred to his judgment in determining the authenticity of a painting attributed to the artist. The meeting took place on 3 May 1772, a year when Batoni was not

serving as one of the academy's *stimmatori di pittura* nominally responsible for deciding such issues; see Accademia di San Luca, Rome, Archivio Storico, Libro de' Decreti, vol. 53, fols. 11r–12r; cited in Roettgen 2003, p. 541.

12. Macandrew 1978, p. 142, fig. 8; Clark and Bowron 1985, p. 386, D206. For the painting (Galleria Nazionale, Rome; on loan to the Villa d'Este, Tivoli), see Wethey 1971, p. 161, no. X-33, pl. 130.
13. Benaglio 1894, pp. 41–42.
14. For Imperiali, see Bowron in Philadelphia 2000, pp. 363–65.
15. Macandrew 1978, p. 142, n. 8. For the Topham Collection at Eton College, see Connor 1993; Connor 1998; Connor Bulman 2002, pp. 59–61; Connor Bulman 2006.
16. Macandrew 1978, p. 140.
17. Waterhouse 1982, p. 517. For the Batoni drawings at Eton College, the fundamental study is Macandrew 1978.
18. Batoni's drawings were among the last drawings that Topham acquired, and as the collector had not annotated all of them, it appears probable that these must have reached Windsor after his death; information from Louisa M. Connor, letter of 25 May 1999.
19. For the founding of the Musei Capitolini, see Haskell and Penny 1981, pp. 63–66.
20. Helbig 1963–72, vol. 2, no. 1331; for the Eton drawing, see Macandrew 1978, p. 147, no. 20; Philadelphia 2000, no. 310. The drawing of the relief by Sempronio Subissati (?1680–1758?) at Eton (Lyon 1998, no. 30) must have been made before Subissati left Italy for Spain in 1721, indicating that the relief was thus already in Albani's hands some time before then.
21. For Count Fede, see Macdonald and Pinto 1995, pp. 230–32, 290–91.
22. Macandrew 1978, p. 150, no. 47; Lyon 1998, no. 34. Haskell and Penny 1981, pp. 190–91, citing de Troy and noting that the male figure in the group had been restored so that he turned his head away and repelled his companion with his hand. For copies and casts after the group, which is today untraced, and for questions regarding the accuracy of Batoni's drawing, see Avery 1983, pp. 317–18.
23. Macandrew 1978, p. 149, no. 43.
24. London 1996, pp. 264–66, nos. 218–20.
25. Macandrew 1978, p. 145, no. 1. Haskell and Penny 1981, pp. 247–50, figs. 126–27. In 1787 the pair was taken to Florence and two years later installed at the entrance to the Loggia dei Lanzi.
26. Macdonald and Pinto 1995, p. 291, fig. 177.
27. Winckelmann 1776, p. 805: "Die Ehre und die Krone der Kunst dieser sowohl als aller Zeiten sind zwey Bildniße des Antinous, das eine erhoben gearbeitet, in der Villa Albani, das andere ein colossalischer Kopf in der Villa Mondragone über Frascati; und beyde befinden sich in meinen alten Denkmalen in Kupfer gestochen." See Macandrew 1978, p. 137, fig. 3, for

the engraving; Haskell and Penny 1981, pp. 144–46, fig. 75, for the relief in the Villa Albani, Rome.

28. Clark and Bowron 1985, no. 230.

29. For the Furietti Centaurs, see Macandrew 1978, p. 138, fig. 4, also pp. 137, 143, n. 19; Haskell and Penny 1981, pp. 178–79; Macdonald and Pinto 1995, pp. 291–92; Philadelphia 2000, no. 147.

30. Macdonald and Pinto 1995, p. 292. Batoni later inserted this centaur into a subject picture, the *Education of Achilles;* see pp. 27–28 in this book.

31. For life drawing in eighteenth-century Rome, see Bowron 1993; Susinno 1998; and Roettgen 2003, pp. 303–11.

32. Batoni supervised the models in 1756, 1758, 1759, and 1762.

33. For Pécheux's informal academy, see Bollea 1942, p. 367; Fleming 1962, p. 164. See Clark and Bowron 1985, p. 388, D296, and Chappell 1998, pp. 81–83, nn. 14, 25, fig. 4, for a male academy drawing (Martin von Wagner Museum, Würzburg) inscribed "Accademia di Pompeo Battoni che La fece/ in confronto del Cavaliere Mengs in Campidoglio." For the "rivalry" between Batoni and Mengs generally, see Roettgen 2003, pp. 311–18.

34. Clark and Bowron 1985, pp. 378–89.

35. Catherine Legrand has suggested the similarity of certain Batoni figure studies to sixteenth-century Florentine drawings on prepared paper and described some as reminiscent of the manner of Michelangelo (Legrand 1990, p. 502).

36. In a letter of 18 July 1744, Batoni promised to send an academy drawing to Bartolomeo Talenti (ASL, no. 918, p. 303); Puhlmann 1774–87, p. 109, reported Batoni's gift to him of an academy drawing representing a Dead Christ. See Chappell 1998, p. 83, fig. 4, for the identification of this sheet with an academy drawing in the Martin von Wagner Museum, Würzburg (Clark and Bowron 1985, p. 388, D296).

37. Tischbein reported finding as many as ten private academies in operation in Rome in 1779, including Batoni's (1956, pp. 251–52). Even a partial list of those who attended Batoni's drawing classes over the years includes a surprising variety of artists of all nationalities, from the obscure to those, like Giuseppe Cades, who achieved a significant reputation of their own: Domenico de Angelis, John Astley, Angelo Banchero, Henry Benbridge, Vincenzo Cannizzarro, Adamo Chiusole, Antonio Concioli, Edward Francis Cunningham, Carlos Espinosa, Johann Dominik Fiorillo, Giovanni Gottardi, Franz Hillner, Gaspare Landi, Andrea Lazzarini, Antonio Longo, Teodoro Matteini, Niccola Monti, Bernardo Nocchi, Pietro Pedroni, Matthew William Peters, Frediano Dal Pino, Giuseppe Pirovani, Matvei Ivanovich Puchinov, Johann Gottlieb Puhlmann, John Ramsay, Ambrogio Rosmini, Jean Pierre Saint-Ours, Stepan Serdiukov, Peter Sobolovski, and Giuseppe Maria Taddei.

38. Puhlmann 1774–87, p. 29: "In der Stube haben wir jetzt eine eiserne Kohlenpfanne, vom Trödel gekauft, und finden also eine warme Stube, wenn wir aus der Akademie kommen, wo ich das Glück habe, linker Hand beim Cavalier Pompeo zu sitzen, der mir meine Fehler sagt und mit mir zufrieden ist. Jetzt habe ich zehn Figuren nacht der Natur gezeichnet und 22 Zeichnungen kopiert. Der liebe Mann gibt uns alles, was wir verlangen, und wenn die Akademie geendigt, hält er eine Art von Vorlesung über einige Teile der Malerei, die ich mir, wenn ich zu Hause, aufschreibe, denn er sagt kein Wort unnütz." For another anecdote that provides an intimate glimpse into Batoni's private drawing academy, see Puhlmann 1774–87, p. 33, for an account of a model forbidden by his confessor to pose for Batoni.

The pedagogical exercises Batoni employed involved copying his own drawings. When the young Gaspare Landi (1756–1830) entered Batoni's studio in 1781 he was given several of the master's academy drawings to copy as a first assignment; Landi 1781–1817, p. 18. For a copy after an academy drawing by Batoni by the Russian Matvei Ivanovich Puchinov, see Chappell 1998, pp. 79–85, fig. 1, and for Puhlmann's copies after Batoni's "Studien und Akademien," see Puhlmann 1774–87, p. 92. For Ambrogio Rosmini's copies and adaptations after Batoni's academy drawings, see Ferrari 1987.

It should also be noted that while the *Alexander and the Family of Darius* (fig. 85) for Potsdam remained in his studio, Batoni set his students before it to draw selected passages from the composition as pedagogical exercises. Several of these sheets have turned up on the modern art market as by Batoni, although they are in fact copies by these students.

39. Smart 1992, p. 266.

40. Thus when Batoni writes of a young Lucchese artist, Frediano Dal Pino, in a letter of 23 March 1759 to Bartolomeo Talenti (ASL, no. 935, p. 315), he is probably referring to a pupil that he may have taken on in the studio as an apprentice or assistant rather than merely one in attendance in his life classes.

41. Marianne Menze noted that Johann Dominik Fiorillo cannot be considered one of the artist's pupils because he was only thirteen to sixteen years old at the time and that his "studies" were inevitably limited to sessions at the Accademia del Nudo when Batoni posed the model (Menze 1997, p. 117).

42. Clark and Bowron 1985, no. 113; for the drawing, see Philadelphia 1980, p. 51, no. 39B, repr. Batoni's draughtsmanship is seen at its most spontaneous in the pages of this sketchbook from the 1740s once owned by Anthony Clark (Clark and Bowron 1985, p. 386, D181–D201). It consists mainly of quick red or black chalk sketches from everyday life, studies from the model, records of the papal tombs in Saint Peter's, architecture, landscape studies, and preliminary ideas for commissions initiated in the early 1740s. In spite of the ephemeral nature of these sketches, Batoni's energetic and economical handling reveals itself as capable of producing powerful descriptive effects with a few strokes of the chalk,

affirming his contemporaries' admiration for his natural gifts as a draughtsman.

43. Philadelphia 1980, no. 37; Clark and Bowron 1985, p. 385, D169.

44. Clark and Bowron 1985, no. 6; for the drawing, see Clark and Bowron 1985, p. 380, D63; Philadelphia 2000, no. 314.

45. Clark and Bowron 1985, p. 228, no. D144 (with incorrect accession and plate numbers), pl. 60; Bean and Griswold 1990, p. 27, no. 5.

46. Clark and Bowron 1985, p. 381, D84; Christie's, London, 4 July 2006, lot 39.

47. Clark and Bowron 1985, no. 67; for the drawing, see Clark and Bowron 1985, p. 385, D165; Philadelphia 2000, no. 315.

48. ASL, no. 885, p. 272: "il mio costume nell'ultimazione di ogni quadro è tenere sempre il vivo d'avvanti agli'occhi." In other letters, Batoni complained that because of the cold weather it had been "impossible to find models who would want to pose nude, as they feared to fall sick" (ASL, no. 895, p. 280) and that another model fell sick (ASL, no. 893, p. 278). Puhlmann 1774–87, p. 166, also noted in a letter of 13 March 1781 that the weather was too cold for the models to pose.

49. ASL, no. 912, p. 298, letter of 23 January 1745 to Lodovico Sardini.

50. Clark and Bowron 1985, no. 77; Paris 1998, no. 5; for the drawing, see Clark and Bowron 1985, p. 378, no. D2, and Sotheby's, London, 5 July 2006, lot 39.

51. Clark and Bowron 1985, p. 388, no. D288. The sheet also contains a study for the *Allegory of Saint Marinus Reviving the Republic of San Marino After the Siege of Cardinal Alberoni* (Clark and Bowron 1985, no. 49).

52. Clark and Bowron 1985, no. 53; for the drawing, see Philadelphia 1980, no. 31, and Clark and Bowron 1985, pp. 385–86, D171.

53. Clark and Bowron 1985, p. 378, D19.

54. Clark and Bowron 1985, p. 381, D69.

55. Clark and Bowron, 1985, no. 262; p. 380, D53 (erroneously described as a study for the figure of Religion in fig. 108); Paris 1990, no. 139; Legrand 1990, p. 503 (identifying the sheet as studies for the Naples painting: "Nous avons ici un exemple intéressant de dessin d'après une première réalisation, et probablement inspiré de dessins conservés dans l'atelier, ce que explique le caractère plus froid, plus précis de la feuille"); Besançon 2003, p. 91 (described as a preparatory study for fig. 108).

56. Clark and Bowron 1985, p. 378, D10, pl. 172; p. 380, D54, pl. 203; Toulouse 2006, no. 99.

57. Clark and Bowron 1985, p. 386, D175; see Philadelphia 1980, no. 50, for a more detailed discussion of the iconography of the drawing.

58. Five such sheets were published as autograph in Clark and Bowron 1985, D102, D142, D159, D161 and D174. An additional seven black-chalk drawings related to the sitters' dress in a variety of portraits have been advanced as autograph drawings by Batoni in Rouen 1999, pp. 7–14, nos. 1–7, and Rouen 2003, pp. 237–38.

59. Clark and Bowron 1985, p. 382, no. D102.

60. Philadelphia 1980, no. 41; Clark and Bowron 1985, no. 227; for the drawing, see Clark and Bowron 1985, p. 386, no. D174.

61. Clark and Bowron 1985, no. 444; for the drawing, see Clark and Bowron 1985, p. 386, D178; Philadelphia 1980, no. 43.

62. Puhlmann 1774–87, p. 109: "Eine Sache, die selten von ihm, denn er verwahrt alle Studia, wenn nur ein paar Striche auf dem Papier sind, und findt Liebhaber, die sie ihm teuer bezahlen."

63. For example, the sculptor, restorer, and collector Vincenzo Pacetti (c. 1745–1820), whose collection of drawings formed the foundation for the baroque holdings in the Berlin Kupfer-stichkabinett, purchased three academy drawings from one of Batoni's sons on 19 June 1795 and on 27 June acquired several more as well as "vari studi" from the same source (Cassirer 1922, p. 95). The majority of the Batoni drawings in Berlin (see Clark and Bowron 1985, pp. 378–79, D10–28) are from Pacetti's collection.

64. Clark and Bowron 1985, nos. 101, 102. Other examples of this type of preliminary oil sketch include Clark and Bowron 1985, nos. 40, 111, 125, 126, 170, 182, and 199. A sketch for the *Sacrifice of Iphigenia* (no. 58) was retouched by Batoni himself in 1742, with the result that in effect it serves as much as an autograph reduction of the larger composition as an actual bozzetto.

65. Clark and Bowron 1985, nos. 105, 106.

66. For another highly finished study in oils, see Clark and Bowron 1985, no. 4.

67. Clark and Bowron 1985, no. 112; Philadelphia 2000, no. 165.

68. Boni 1787, p. 22.

69. Clark 1981, p. 108. For Imperiali's role as a teacher in the early 1730s, see Smart 1992, p. 29, and Philadelphia 2000, p. 364.

70. Clark and Bowron 1985, nos. 76, 42. The authors are grateful to Frank Zuccari and Kurt Vuillemont for examining and discussing with them the paintings in the Art Institute of Chicago. The stretcher for the *Saint Andrew* is constructed of poplar wood, and its individual members are attached by means of interlocking bridle joints. Batoni was very frugal in his use of materials; the tacking margins of the support, for example, are extremely narrow.

71. The authors are grateful to Frank Zuccari and Kim Muir for conducting a thread count of the paintings in the Art Institute of Chicago: *Saint Andrew*, approximately 19 warp threads by 19 weft threads per centimetre; *Edward Dering, later 6th Bt.*, 17 × 21 per cm; *Don José Moñino y Redondo, Count of Floridablanca* (Clark and Bowron 1985, no. 394), 12 × 12 per cm; *Peace and War*, 19 × 17 per cm. This may be compared to the support for the portrait of *John Wodehouse, later 1st Baron Wodehouse*, which has 20 warp threads by 15 weft threads per centimetre.

72. Puhlmann 1774–87, p. 130.

73. Clark and Bowron 1985, nos. 33–36, 76–85.

74. Clark and Bowron 1985, nos. 88, 90–93, 122, 123, 167, 168, 223, 224.

75. In the receipt Batoni wrote for the Prometheus and Meleager pair (ASL, included with no. 906, p. 294), he refers to their size as "tela d'imperatore." For other examples, see Clark and Bowron 1985, nos. 108, 109, 117–119, 231, 354, 370, 452.

76. Clark and Bowron 1985, nos. 397, 171.

77. Clark and Bowron 1985, nos. 439, 440.

78. Clark and Bowron 1985, p. 249, no. 43; Benocci 2002, pp. 40–43; Turin 2005, p. 108, no. 47 (entry by Rossella Leone).

79. Benocci 2002, p. 40, citing one of two overdoor portraits of the sitter described as "rappresentante altro ritratto della signora duchessa donna Girolama alla toletta fatto da Pompeo Battoni" (Rome, Archivio di Stato, Archivio Sforza Cesarini, parte I, busta 160).

80. Allan Ramsay owed his distinctive technique of first modelling the sitter's head in a vermilion underpainting to his study of the work of the Roman painter Benedetto Luti (1666–1724); see Smart 1964, p. vii.

81. For *A Lady of the Milltown Family as a Shepherdess*, see Finaldi and Kitson 1997, p. 30, no. 4. The ground in the Milles portrait is of a warm light-brown colour, darker than salmon; Batoni employed a thick, pale red-brown ground in the portrait of Mrs. Alexander.

82. The painting was examined in 1970 by Richard D. Buck, director of the Intermuseum Laboratory, and again in 1970 by Sarah Fisher, from whose reports this information is derived. With respect to the ground, Buck further noted: "A thin paste of red ochre tone has been applied with a broad brush which has left a system of brushmarks which are independent of the paint. The layer is thick enough to hide the fabric texture of the support."

83. Information from David C. Goist, drawn from a microscopic examination of *Saint James Major* (Clark and Bowron 1985, no. 78).

84. Boni 1787, p. 66.

85. The paint layer was varied according to the overall desired effect: although the paint is usually in an opaque layer in the Wodehouse portrait (fig. 77), there are passages of thin dark washes in the hair and black neckpiece that are sufficiently thin to allow the red ground to influence the tone slightly.

86. West Yorkshire Archive Service, Leeds, Grantham correspondence, VR 12325, Thomas Robinson to his father William Robinson, 1st Baron Grantham, 9 August 1760. Transcribed in Beard 1960, pp. 23–24, and Roettgen 2003, p. 489. See also Ford and Ingamells 1997, p. 817. Batoni was generally not reticent about promoting the virtues of his talent: the painter James Northcote (1746–1831) reported that when Benjamin West (1738–1820) visited Batoni's studio, the master touched the canvas in front of him with his brush, saying, "Go! young man; now you have it in your power to say that you have seen Batoni paint!" (Northcote 1901, p. 175.)

87. See, for example, *Richard Milles* (fig. 76) and *John Chetwynd Talbot, later 1st Earl Talbot* (1773; J. Paul Getty Museum, Los Angeles); information from David Bomford and Mark Leonard, respectively, personal communication.

88. Berry 2002, p. 101.

89. Observations by Frank Zuccari, the Art Institute of Chicago, personal communication.

90. Clark and Bowron 1985, p. 235. The presence of such a major pentimento would ordinarily establish chronological order among competing replicas produced by an artist and thus suggests that the Montreal paintings preceded the signed and dated 1745 versions at the Archabbey of Pannonhalma (Clark and Bowron 1985, nos. 92, 93). There are other instances in Batoni's œuvre, however, in which pentimenti are evident in canvases clearly identifiable as his own autograph repetitions of earlier works. Chronological precedence can usually be given to the canvases Batoni signed and dated, thus, in this sequence, to the pair at Pannonhalma.

91. The authors wish to thank Frank Zuccari and Kim Muir at the Art Institute of Chicago for interpreting and discussing with them the technical analysis of the painting.

92. Information from Joseph Fronek at the Los Angeles County Museum of Art, who has generously shared his observations (letter of 7 January 1999) on Batoni's painting technique and methods of working.

93. The authors are grateful to Simon Howell and Tom Caley for sharing their observations on the material aspects of the painting. Pentimenti are also visible in the portrait of *John Wodehouse* (fig. 77), the most obvious of which occur in the lace over the subject's left wrist and in the classical vase which was changed from a simpler, more straight-sided, volute krater form to its present shape.

94. Reynolds 1975, p. 251.

95. See ASL, no. 902, pp. 289–90, for the artist's letter of 31 August 1743 to Lodovico Sardini with the details of procurement of the frames and payments to the framer and gilder, Agostino Fanucci and Antonio Maggi, respectively. ASL, no. 899, p. 286, letter of 6 July 1743, indicates that Batoni paid these expenses for framing and gilding in advance and expected to be reimbursed later.

96. For "Salvator Rosa" frames, see Mitchell and Roberts 1996b, pp. 29–30, and Mitchell and Roberts 1996a, pp. 262–91, pls. 204, 206.

97. Mitchell and Roberts 1996a, p. 267.

98. Chicago 1986, pp. 69, 75, no. 23; see also Clark and Bowron 1985, pls. 80, 81, 84.

99. Simon 1996, pp. 64–66.

100. Newbery 2002, pp. 48–49, no. 19, repr. col.

101. For Dance, whose association with Batoni led to the printing of a travel card in 1762, "Rome, Sigr. Pompeo Batoni & Mr. Dance, for Portrait & History Painting," see Skinner 1959; London 1977; Ford and Ingamells 1997, pp. 274–76.

102. Benaglio 1894, p. 61; Puhlmann 1774–87, p. 168. Meyer 1792, p. 132: "Battoni kannte keinen Eigennutz. Als ich meinen Wunsch, eine Handzeichnung von ihm zu besitzen, äußerte, erbot er sich, weil er keine vorräthig hatte, mich selbst zu zeichnen. Es war zu vermuthen, daß das: 'Pompeo Battoni fecit,' unter der Zeichnung, theuer bezahlt werden mußte; aber er forderte, als sie fertig war, nur drei Zechinen." This visit to the artist's studio occurred in 1783.

103. Lucy 1862, p. 103.

104. Clark and Bowron 1985, nos. 342, 332, 266; Whistler 1997, p. 329.

105. Clark and Bowron 1985, p. 338.

106. Clark 1972, pp. 8, 11.

107. Clark and Bowron 1985, nos. 271, 320, 312, 385.

108. For the portrait of Armytage, see Clark and Bowron 1985, no. 191.

109. See Clark and Bowron 1985, nos. 368, 384.

110. Clark and Bowron 1985, nos. 366, 364. It is less certain whether the similarities in Batoni's sitters' dress—the exact flowered waistcoat worn by Richard Neville appears a year later worn by John Peachey, later 2nd Baron Selsey (no. 376)—is due to efficiency on the painter's part or coincidence and the vagaries of fashion.

111. For the table, see Clark and Bowron 1985, nos. 230, 239, 240, 248, 251, 273, with variations in the apron, supports, and stretcher. A similar Roman table is discussed in Philadelphia 2000, no. 55.

112. Thorpe Letters, 10 December 1777. Giovanni Copertini believed that such borrowings represented "una certa stanchezza creativa" (Copertini 1949–50, p. 143).

113. ASL, no. 912, p. 298, letter of 23 January 1745 to Lodovico Sardini. For a possible version of the painting, see Clark and Bowron 1985, no. 89.

114. Clark and Bowron 1985, nos. 152, 231.

115. ASL, no. 883, p. 271, letter of 24 February 1742 to Lodovico Sardini.

116. ASL, no. 886, p. 273, letter of 5 May 1742 to Lodovico Sardini.

117. ASL, no. 889, p. 276, letter of 7 September 1742 to Lodovico Sardini.

118. See Clark and Bowron 1985, nos. 185, 186, 190, 347, 396.

119. Walpole 1937–83, vol. 22, p. 255.

120. Clark and Bowron 1985, nos. 258, 190.

121. Clark and Bowron 1985, nos. 192, 195.

122. Clark and Bowron 1985, no. 413, p. 323.

123. Clark and Bowron 1985, no. 391.

124. That the portrait was completed forthwith is suggested by a letter from Henry Lyte to Brudenell's father on 1 March 1758, informing him that "Mengs and Batoni have both begun my Lord Brudenell's portrait, the former a full-length and the other a half-length. They have promised to finish them out of hand and they will both be fine portraits, the more so as there is a great emulation between those two celebrated painters" (Fleming 1958, pp. 136–37).

125. Clark and Bowron 1985, p. 313.

126. ASL, no. 896, p. 282, 20 April 1743: "Sei quadri ho sul cavalletto tutti di somma premura, e d'impegno, e sono i due di Vs. Ill.ma, uno del S.r Marchese Gerini, S. Caterina per costì, un quadro di altare per Brescia, ed il consaputo mio ritratto per Firenze."

127. Thorpe Letters, 28 August 1771.

128. Thorpe Letters, 26 October 1771.

129. For Batoni's collaboration in the early years of his career with these Roman landscape painters, see Clark and Bowron 1985, pp. 52–54, nos. 7–8, 12, 16–21.

130. Holloway 1989, p. 5.

131. See London 1973, nos. 42–49.

132. For Batoni's copies of Raphael's *Council of the Gods* and Raphael and Giulio Romano's *Wedding of Cupid and Psyche* (both copies 1753–55; Collezione della RAI, Venice) commissioned from Sir Hugh Percy, later Duke of Northumberland, for his house in London, see Clark and Bowron 1985, nos. 185, 186; Wood 1999, pp. 409–15.

133. See Russell 1975–76; Clark and Bowron 1985, no. 31, pp. 367–68.

134. See Clark and Bowron 1985, no. 428.

135. Levey 1964, pp. 25, 53, citing a receipt in the Stuart Papers, Windsor; Corp 2001, p. 83; Nicholson 2002, p. 47. For other commissions for copies, see Clark and Bowron 1985, nos. 454, 456, 457, p. 341.

136. Thorpe Letters, 10 October 1769. Thorpe wrote on 10 January 1770: "Pompeo Battoni insists upon having a hundred & twenty five Zequins for making each of the two Portraits . . . , and will not touch them for less: in his own writing, which I have, he had first required 150 each: the figure of the black Page holding a helmet is one reason that he brings for heightening his demands."

137. *Prince Karl Wilhelm Ferdinand, later Duke of Braunschweig and Lüneburg* (fig. 100; Clark and Bowron 1985, no. 310). The portrait was painted for Maria Antonia Pessina von Branconi, whom the prince met in Naples and brought to Braunschweig.

138. See Clark and Bowron 1985, nos. 137, 138, 189, 243, 245, 273–75, 343, 350.

139. Pompeo Batoni to Franz Xaver von Orsini-Rosenberg, 17 June 1769, transcribed in Viviani della Robbia 1940, p. 18. For the Italian, see p. 195, n. 77, in this book.

140. Clark and Bowron 1985, p. 294.

141. Brinsley Ford noted the unhappiness of artists such as Nathaniel Dance when forced to make copies for each of the

sitters depicted in one of their groups such as Dance's *Sir James Grant, Mr. Mytton, Hon. Thomas Robinson, and Mr. Wynn* (1760–61; Philadelphia Museum of Art; Ford 1974a, p. 454). Another English artist, Richard Brompton (1734–1783), protested at being underpaid for the replicas he had to undertake of his conversation piece *The Duke of York with his Friends in Venice* (Royal Collection, London; Millar 1969, p. 13, no. 689).

142. Belli Barsali 1964, pp. 73, 80, n. 10, citing a letter in the Archivio di Stato di Lucca (Archivio Bottini, no. 18, fasc. 4) of 23 March 1756 from Count Petroni to Count Filippo Bottini in Lucca.

143. ASL, no. 914, p. 300, letter of 21 October 1769.

144. Clark and Bowron 1985, nos. 431, 432; 423, 424.

145. Puhlmann 1774–87, p. 166.

146. See Clark and Bowron 1985, nos. 445, 461, 462. The evidence of occasional studio participation in Batoni's portraits notwithstanding, it is incorrect to suggest that Batoni merely painted his sitter's faces and left the remainder of the portraits to be completed by assistants, as does, for example, Francesco Petrucci: "Molti ritrattisti professionisti infatti, come Ferdinand Elle o Pompeo Batoni, spesso si limitavano ad eseguire il viso, mentre lasciavano ai collaboratori la realizzazione delle vesti" (Petrucci 2005, p. 101).

147. Information from Brinsley Ford, letter to Edgar Peters Bowron, 8 August 1984.

148. Thorpe Letters, 1 January 1774.

149. Thorpe Letters, 20 March 1771.

150. Thorpe Letters, 11 May 1776.

151. For the currency equivalents employed here (1 zecchino = 2 scudi romani or Roman crowns; 1 guinea = 2 zecchini or 4 scudi), see Thorpe Letters, 6 November 1771; Roettgen 1999, p. 561; Black 2003, p. viii.

152. Clark and Bowron 1985, p. 228.

153. Barroero 1987, p. 250.

154. Clark and Bowron 1985, pp. 261, 342.

155. Clark and Bowron 1985, p. 355.

156. Biblioteca Universitaria, Bologna, MS. 4331, vol. 8, fols. 401r–v.

157. Clark and Bowron 1985, no. 283. In an issue of 22 April 1769 (no. 8051), Chracas mentions "il prezzo stabilito di sc. 500 per cadauno" (see Chracas 1997–99, vol. 2, p. 170). See also Bertolotti 1877, p. 221: "1768 14 marzo. Marchese Antici: un

quadro con dentro due mezze figure rappresentanti la Giustizia e la Misericordia di longhezza di palmi 7 di larghezza 5 dipinte da Pompeo Battoni, valutato scudi 400." The extra 100 scudi may have been an additional present from the king, or the export valuation was not entirely truthful.

158. Clark and Bowron 1985, p. 296; for *Alexander and the Family of Darius*, see p. 95 in this book.

159. Black 2003, p. 189. For the portrait of Yorke, see Clark and Bowron 1985, no. 411.

160. Thorpe Letters, 7 December 1776.

161. Thorpe Letters, 12 July 1777.

162. See Clark and Bowron 1985, nos. 164, 165, 260. During a visit to Batoni's studio in May 1766 Count Karl Zinzendorf saw three portraits—*Colonel the Hon. William Gordon* (fig. 61); "celui du jeune Paar" (untraced); and *Wills Hill, 1st Earl of Hillsborough, later 1st Marquess of Downshire* (fig. 62), and noted his portrait prices as follows: "grands" 150 zecchini; "moindres" 50 zecchini; "les plus petits" 30 zecchini (Haus-, Hof- und Staatsarchiv, Vienna, Kabinettsarchiv, Nachlaß Zinzendorf, Tagebücher, vol. 11, 23 May 1766).

163. For Reynolds's prices, see Mannings 2000, p. 21; for Ramsay's, see Smart 1999, p. 418.

164. Thorpe Letters, 10 October 1769: "[Batoni] has augmented his price upon occasion of the late great increase of his reputation; he will not now do any half length under one hundred Zequins."

165. Puhlmann 1774–87, p. 27.

166. Black 2003, p. 99. Ford and Ingamells 1997, p. xlv, cites William Patoun (fl. 1761–died 1783), c. 1766, as suggesting that the gratuity given "by any private Gentleman" to Byres for serving as cicerone "is twenty sequins for the Course, and thirty if two Companions."

167. Haskell 1967, p. 77.

168. Thorpe Letters, 9 December 1769.

169. Moore 1985, p. 16. It is uncertain whether Batoni himself inflated what he was receiving for the group of Alexander and the family of Darius or Harvey was mistaken. See also Archenholz 1785, vol. 2, p. 271, c. 1778–79: "Der Preiß ist für einen Kopf sechzig Zechinen, erstreckt sich die Abbildung bis zum Untertheil des Leibes hundert, und der ganze Körper zweyhundert Zechinen."

BIBLIOGRAPHY

Abbate 1996
Abbate, Vincenzo. "Per il collezionismo antiquario nella Sicilia del Settecento. Salvadore Maria Di Blasi e Bartolomeo Cavaceppi." In *Artisti e mecenati. Dipinti, disegni, sculture e carteggi nella Roma curiale.* Edited by Elisa Debenedetti. Rome, 1996: pp. 207–30.

Aikin 1799–1815
Aikin, John. *General Biography; or, Lives, Critical and Historical, of the Most Eminent Persons of All Ages, Countries, Conditions, and Professions, Arranged According To Alphabetical Order.* 10 vols. London, 1799–1815.

Allen 1987
Allen, Brian. *Francis Hayman.* Published to coincide with the exhibition held at the Yale Center for British Art, New Haven, and The Iveagh Bequest, Kenwood, London. New Haven and London, 1987.

Antonov 1977
Antonov, Victor. "Clienti russi del Batoni." *Antologia di belle arti* 1 (1977): 351–53.

Antwerp 1999
Depauw, Carl, and Gert Luitjen, eds. *Anthony van Dyck as a Printmaker.* Exh. cat. Museum Plantin-Moretus, Antwerp, and Rijksmuseum, Rijksprentenkabinet, Amsterdam. Antwerp and New York, 1999.

Archenholz 1785
Archenholz, Johann Wilhelm von. *England und Italien.* 2 vols. Leipzig, 1785.

Archenholz 1791
Archenholz, Johann Wilhelm von. *A Picture of Italy.* Translated by Joseph Trapp. 2 vols. London, 1791.

Arneth 1867–68
Arneth, Alfred von. *Maria Theresia und Joseph II: Ihre Correspondenz sammt Briefen Joseph's an seinen Bruder Leopold.* 3 vols. Vienna, 1867–68.

ASL
Archivio di Stato, Lucca. Archivio Sardini, filza 143, nos. 870–935 (letters of Batoni to Lodovico Sardini and Bartolomeo Talenti); filza 144, nos. 121–23, and filza 81, no. 1056 (letters of Lodovico Sardini to Batoni). Full transcriptions in Lucca 1967: pp. 258–319.

Averini 1973
Averini, Riccardo. "I dipinti di Pompeo Batoni nella Basilica del Sacro Cuore all'Estrela." *Estudos italianos em Portugal* 36 (1973): 75–102.

Avery 1983
Avery, Charles. "Laurent Delvaux's Sculpture at Woburn Abbey." *Apollo* 118 (October 1983): 312–21.

Barnes, De Poorter, Millar, and Vey 2004
Barnes, Susan J., Nora De Poorter, Oliver Millar, and Horst Vey. *Van Dyck: A Complete Catalogue of the Paintings.* New Haven and London, 2004.

Barroero 1987
Barroero, Liliana. "La basilica dal Cinquecento all'Ottocento." In *La basilica romana di Santa Maria Maggiore.* Edited by Carlo Pietrangeli. Florence, 1987: pp. 215–259.

Barroero and Susinno 2000
Barroero, Liliana, and Stefano Susinno. "Arcadian Rome, Universal Capital of the Arts." In Philadelphia 2000: pp. 46–75.

Bartoschek 1983
Bartoschek, Gerd. *Die Gemälde im Neuen Palais.* Potsdam, 1983.

Bassano del Grappa 2003
Androsov, Sergej, Mario Guderzo, and Giuseppe Pavanello, eds. *Canova.* Exh. cat. Museo Civico, Bassano del Grappa, and Gipsoteca, Possagno. Milan, 2003.

Beales 1987
Beales, Derek. *Joseph II.* Vol. 1: *In the Shadow of Maria Theresa, 1741–1780.* Cambridge, 1987.

Beales 2003
Beales, Derek. *Prosperity and Plunder: European Catholic Monasteries in the Age of Revolution, 1650–1815.* Cambridge, 2003.

Bean and Griswold 1990
Bean, Jacob, and William Griswold. *Eighteenth-Century Italian Drawings in the Metropolitan Museum of Art.* New York, 1990.

Beard 1960
Beard, Geoffrey. "Batoni and Mengs." *Leeds Art Calendar* 44 (1960): 23–24.

Beckford 1805
Beckford, Peter. *Familiar Letters from Italy to a Friend in England.* 2 vols. Salisbury, 1805.

Belfast 1999
Stewart, Anne Millar. *James Stewart of Killymoon: An Irishman on the Grand Tour, 1766–1768.* Exh. cat. Ulster Museum. Belfast, 1999.

Belli Barsali 1964
Belli Barsali, Isa. "Pompeo Gerolamo Batoni (1708–1787)." *La Provincia di Lucca* 4 (January–March 1964): 73–80.

Belli Barsali 1973
Belli Barsali, Isa. "Documenti vaticani per il Batoni." *Studi Romani* 21, no. 3 (1973): 366–72.

Bellori 1672
Bellori, Giovan Pietro. *The Lives of the Modern Painters, Sculptors and Architects.* 1672. Translated by Alice Sedgwick Wohl. Cambridge, 2005.

Benaglio 1894
Benaglio, Francesco. "Abbozzo della vita di Pompeo Batoni pittore." In *Vita e prose scelte di Francesco Benaglio.* Edited by Angelo Marchesan. Treviso, 1894: pp. 15–66.

Benedetti 1997
Benedetti, Sergio. *The Milltowns: A Family Reunion.* Dublin, 1997.

Benedict XIV 1955–84
Benedict XIV: Le lettere di Benedetto XIV al Card. de Tencin. Edited by Emilia Morelli. 3 vols. Rome, 1955–84.

Benocci 2002
Benocci, Carla. "L'inventario del 1808 del palazzo Poli a fontana di Trevi ed un ritratto di Pompeo Batoni." *Strenna dei Romanisti* 63 (2002): 31–45.

Berckenhagen 1967
Berckenhagen, Ekhart. *Anton Graff. Leben und Werk.* Berlin, 1967.

Berlin 1996
Die Kunst hat nie ein Mensch allein besessen. Exh. cat. Akademie der Künste, Berlin. Berlin, 1996.

Berry 2002
Berry, Claire. "The Painting Technique of Anne Vallayer-Coster: Searching for the Origins of Style." In Dallas 2002: pp. 95–113.

Bertolotti 1877
Bertolotti, Antonio. "Esportazione di oggetti di belle arti da Roma nei secoli XVII e XVIII." *Archivio storico artistico archeologico e letterario della Citta e Provincia di Roma* 2 (1877): 209–24.

Besançon 2003
Soulier-François, Françoise, and Claire Stoullig. *Les dessins du Musée des Beaux-Arts et d'Archéologie de Besançon.* Exh. cat. Musée des Beaux-Arts et d'Archéologie, Besançon. Paris, 2003.

Bevilacqua 1998
Bevilacqua, Mario. *Roma nel secolo dei lumi. Architettura, erudizione, scienza nella pianta di G. B. Nolli "celebre geometra."* Naples, 1998.

Black 1992
Black, Jeremy. *The British Abroad: The Grand Tour in the Eighteenth Century.* Stroud, Gloucestershire, 1992.

Black 2003
Black, Jeremy. *Italy and the Grand Tour.* New Haven and London, 2003.

Bollea 1942
Bollea, Luigi Cesare. *Lorenzo Pecheux. Maestro di Pittura nella R. Accademia delle Belle Arti di Torino.* Turin, 1942.

Boni 1787
Boni, Onofrio. *Elogio di Pompeo Girolamo Batoni.* Rome, 1787.

Borghese 1995
Borghese, Daria. "L'editto del cardinale Doria e le assegne dei collezionisti romani." In Rome 1995a: pp. 73–116.

Borsi 1993
Borsi, Stefano. *Roma di Benedetto XIV. La pianta di Giovan Battista Nolli, 1748.* Rome, 1993.

Boswell 1791
Boswell, James. *The Life of Samuel Johnson, LL.D. Comprehending an Account of His Studies and Numerous Works . . .* 2 vols. London, 1791.

Boundy 1978
Boundy, Joyce. "An Unpublished Conversation Piece by Thomas Hudson." *Apollo* 108 (October 1978): 248–50.

Bowron 1987
Bowron, Edgar Peters. "A Little-Known Settecento Collector in Rome: Count Cesare Merenda." In London 1987: pp. 18–20.

Bowron 1993
Bowron, Edgar Peters. "Academic Life Drawing in Rome, 1750–1790." In Los Angeles 1993: pp. 75–85.

Bowron 2000
Bowron, Edgar Peters. "Pompeo Batoni's 'Allegory of Peace and War' and Other Subject Pictures." In *Studi di storia dell'arte in onore di Denis Mahon.* Edited by Maria Grazia Bernardini, Silvia Danesi Squarzina, and Claudio Strinati. Milan, 2000: pp. 356–60.

Bowron and Morton 2000
Bowron, Edgar Peters, and Mary G. Morton. *Masterworks of European Painting in the Museum of Fine Arts, Houston.* Princeton, 2000.

Boyer 1768
Boyer, Jean-Baptiste de, Marquis d'Argens. *Examen critique des différentes écoles de peinture.* Berlin, 1768.

Briganti 1996
Briganti, Giuliano. *Gaspar van Wittel.* Edited by Laura Laureati and Ludovica Trezzani. Milan, 1996.

Brigstocke 1993
Brigstocke, Hugh. *Italian and Spanish Paintings in the National Gallery of Scotland.* 2nd ed. Edinburgh, 1993.

Brosses 1991
Brosses, Charles de. *Lettres familières.* Edited by Giuseppina Cafasso. 3 vols. Naples, 1991.

Bryan 1816
Bryan, Michael. *A Biographical and Critical Dictionary of Painters and Engravers, from the Revival of the Art Under Cimabue . . . to the Present Time.* 2 vols. London, 1816.

Bryant 2003
Bryant, Julius. *Kenwood: Paintings in the Iveagh Bequest.* New Haven and London, 2003.

Burkhardt 1985
Burkhardt, Johannes. *Abschied vom Religionskrieg: Der Siebenjährige Krieg und die päpstliche Diplomatie.* Tübingen, 1985.

Burney 1773
Burney, Charles. *Dr. Burney's Musical Tours in Europe.* Vol. 1: *An Eighteenth-Century Musical Tour in France and Italy Based on the Present State of Music in France and Italy.* 2nd ed. London, 1773. Repr. Edited by Percy Scholes. Oxford, 1959.

Bushmina 2001
Bushmina, Tatiana. "Eighteenth-Century Italian Painting of the

Roman School in the Hermitage Collection." In *Roma: "Il Tempio del Vero Gusto." La pittura del Settecento romano e la sua diffusione a Venezia e a Napoli.* Atti del Convegno internazionale di studi, Salerno-Ravello, 1997. Edited by Enzo Borsellino and Vittorio Casale. Florence, 2001: pp. 13–29.

Büttner 1996
Büttner, Frank. "Der autonome Künstler. Asmus Jakob Carstens' Ausstellung in Rom 1795." In Berlin 1996: pp. 195–97.

Casley, Harrison, and Whiteley 2004.
Casley, Catherine, Colin Harrison, and Jon Whiteley, eds. *The Ashmolean Museum: Complete Illustrated Catalogue of Paintings.* Oxford, 2004.

Cassirer 1922
Cassirer, Kurt. "Die Handzeichnungensammlung Pacetti." *Jahrbuch der Preußischen Kunstsammlungen* 43 (1922): 63–96.

Caw 1903
Caw, J. L. *Scottish Portraits.* With an historical and critical introduction and notes by James L. Caw. 2 vols. Edinburgh, 1903.

Chappell 1998
Chappell, Miles L. "Pompeo Batoni as Drawing Master: Some Observations on a New Document." *Antichità viva* 37, nos. 2–3 (1998): 79–85.

Chicago 1986
Bretell, Richard R., and Steve Starling, with an essay by José Ortega y Gassett. *The Art of the Edge: European Frames, 1300–1900.* Exh. cat. The Art Institute of Chicago. Chicago, 1986.

Chracas 1716–1836
Chracas, Luca Antonio, et al. *Diario ordinario.* Rome, 1716–1836.

Chracas 1997–99
Chracas Diario ordinario (di Roma). Sunto di notizie e indici. 3 vols. Rome, 1997–99.

Cincinnati 2000
European Masterpieces: Six Centuries of Paintings from the National Gallery of Victoria, Australia. Exh. cat. Cincinnati Art Museum; Kimbell Art Museum, Fort Worth, Tex.; Denver Art Museum; and Portland Art Museum, Oregon. Melbourne, 2000.

Claretta 1893
Claretta, Gaudenzio. *I reali di Savoia. Munifici fautori delle arti. Contributo alla storia artistica del Piemonte del secolo XVIII.* Excerpt from *Miscellanea di storia italiana,* serie 2, vol. 15 (30), no. 1. Turin, 1893.

Clark 1963
Clark, Anthony M. "Batoni's Triumph of Venice." *North Carolina Museum of Art Bulletin* 4, no. 1 (1963): 5–11.

Clark 1972
Clark, Anthony M. "Pompeo Batoni's Portrait of John Wodehouse." *Allen Memorial Art Museum Bulletin* 30 (Fall 1972): 2–11.

Clark 1981
Clark, Anthony M. "Batoni's Professional Career and Style." In *Studies in Roman Eighteenth-Century Painting.* Selected and edited by Edgar Peters Bowron. Washington, D.C., 1981: pp. 103–18. (First published as "La carriera professionale e lo stile del Batoni." In Lucca 1967: pp. 23–50.)

Clark and Bowron 1985
Clark, Anthony M. *Pompeo Batoni: A Complete Catalogue of His Works with an Introductory Text.* Edited and prepared for publication by Edgar Peters Bowron. London, 1985.

Cochrane 1965
Cochrane, Eric. "Giovanni Lami e la storia ecclesiastica ai tempi di Benedetto XIV." *Archivio storico italiano* 123 (1965): 48–73.

Cochrane 1973
Cochrane, Eric. *Florence in the Forgotten Centuries, 1527–1800: A History of Florence and the Florentines in the Age of the Grand Dukes.* Chicago, 1973.

Coen 2002
Coen, Paolo. "L'attività di mercante d'arte e il profilo culturale di James Byres of Tonley (1737–1817)." *Roma moderna e contemporanea* 10, nos. 1–2 (2002): 153–78.

Cole 1973
Cole, Bruce. "Art Historians and Art Critics—X: Giovanni Lami's Dissertazione." *Burlington Magazine* 115 (1973): 452–57.

Collins 2004
Collins, Jeffrey. *Papacy and Politics in Eighteenth-Century Rome: Pius VI and the Arts.* Cambridge, 2004.

Connor 1993
Connor, Louisa M. "The Topham Collection of Drawings in Eton College Library." *Eutopia* 2, no. 1 (1993): 25–39.

Connor 1998
Connor, Louisa. "Richard Topham et les artistes du cercle d'Imperiali." In Lyon 1998: pp. 52–54.

Connor Bulman 2002
Connor Bulman, Louisa. "The Market for Commissioned Drawings After the Antique." *Georgian Group Journal* 12 (2002): 59–73.

Connor Bulman 2006
Connor Bulman, Louisa M. "The Topham Collection of Drawings in Eton College Library and the Industry of Copy Drawings in Early Eighteenth-Century Italy." In Wrede and Kunze 2006: pp. 325–37.

Contarini 1578
Contarini, Gasparo. *De magistratibus et republica Venetorum.* In *Gasparis Contareni Cardinalis Opera.* Edited by Alvise Contarini. Venice, 1578: pp. 259–326.

Copertini 1949–50
Copertini, Giovanni. "I rapporti di Pompeo Batoni con Parma." *Archivio storico per le provincie Parmensi* 4, no. 2 (1949–50): 133–45.

Corp 2001
Corp, Edward. *The King over the Water: Portraits of the Stuarts in Exile after 1689.* Edinburgh, 2001.

Costamagna 1990

Costamagna, Alba. "L'abbazia di S. Paolo ad Albano e la quadreria del cardinale Marcantonio Colonna. Un episodio di mecenatismo settecentesco." In Rome 1990: vol. 2, pp. 299–321.

Cullen 2004

Cullen, Fintan. *The Irish Face: Redefining the Irish Portrait.* London, 2004.

Dallas 2002

Khang, Eik, and Marianne Roland Michel. *Anne Vallayer-Coster: Painter to the Court of Marie-Antoinette.* Exh. cat. National Gallery of Art, Washington, D.C.; Dallas Museum of Art; The Frick Collection, New York. Dallas, 2002.

Dallaway 1800

Dallaway, James. *Anecdotes of the Arts in England; or, Comparative Observations on Architecture, Sculpture, and Painting, Chiefly Illustrated by Specimens at Oxford.* London, 1800.

De Angelis 1951

De Angelis, Alberto. *Il teatro Alibert o delle Dame nella Roma Papale (1717–1863).* Tivoli, 1951.

Debrie and Salmon 2000

Debrie, Christine, and Xavier Salmon. *Maurice-Quentin de La Tour: Prince des pastellistes.* Paris, 2000.

De Juliis 1981

De Juliis, Giuseppe. "Appunti su una quadreria fiorentina. La collezione dei marchesi Riccardi." *Paragone* 32, no. 375 (1981): 57–92.

Delaforce 2002

Delaforce, Angela. *Art and Patronage in Eighteenth-Century Portugal.* Cambridge and New York, 2002.

Dempsey 1966

Dempsey, Charles. "Two 'Galateas' by Agostino Carracci Re-Identified." *Zeitschrift für Kunstgeschichte* 29 (1966): 67–70.

De Rossi 1810

De Rossi, Giovanni Gherardo. *Vita di Angelica Kauffmann, pittrice.* Florence, 1810.

DiFederico 1977

DiFederico, Frank R. *Francesco Trevisani.* Washington, D.C., 1977.

Dijon 2000

L'art des collections. Bicentenaire du Musée des Beaux-Arts de Dijon: Du siècle des Lumières à l'aube d'un nouveau millénaire. Exh. cat. Musée des Beaux-Arts, Dijon. Paris, 2000.

Duncan 1973

Duncan, Carol. "Happy Mothers and Other New Ideas in French Art." *Art Bulletin* 55 (December 1973): 570–83.

Ebersold 1999

Ebersold, Günther. "Die Italiensehnsucht des Kurfürsten." In *Lebenslust und Frömmigkeit. Kurfürst Carl Theodor (1724–1799) zwischen Barock und Aufklärung.* Edited by Alfried Wieczorek et al. 2 vols. Regensburg, 1999: vol. 1, pp. 231–35.

Eckardt 1974

Eckardt, Götz. "Die Bildergalerie in Sanssouci. Zur Geschichte des Bauwerks und seiner Sammlungen bis zur Mitte des 19. Jahrhunderts." PhD. diss. 2 vols. Universität Halle-Wittenberg, 1974.

Edinburgh 1985

Holloway, James. *Treasures of Fyvie.* Exh. cat. Scottish National Portrait Gallery, Edinburgh. Edinburgh, 1985.

Edinburgh 2000

A Companion Guide to the National Gallery of Scotland. Edinburgh, 2000.

Emmerling 1932

Emmerling, Ernst. *Pompeo Batoni: Sein Leben und Werk.* Darmstadt, 1932.

Evans and Fairclough 1993

Evans, Mark, and Oliver Fairclough. *The National Museum of Wales: A Companion Guide to the National Gallery.* Cardiff, 1993.

Fedele da San Biagio 1788

Fedele da San Biagio, Padre. *Dialoghi familiari sopra la pittura.* Palermo, 1788.

Fernow 1795

Fernow, Karl Ludwig. "Über einige neue Kunstwerke des Hrn. Prof. Carstens." *Der neue Teutsche Merkur,* no. 2 (1795): 158–89.

Ferrari 1984

Ferrari, Stefano. "Arte e architettura in un carteggio inedito conservato negli archivi di Palazzo Rosmini a Rovereto." *Studi trentini di scienze storiche,* sezione 2, vol. 63, no. 2 (1984): 187–210.

Ferrari 1987

Ferrari, Stefano. "Pompeo Batoni e Ambrogio Rosmini." *Studi trentini di scienze storiche,* sezione 2, vol. 66, no. 1 (1987): 161–75.

Ferrari 2000

Ferrari, Stefano. *Giuseppe Dionigio Crivelli (1693–1782). La carriera di un agente trentino nella Roma del Settecento.* Trento, 2000.

Finaldi and Kitson 1997

Finaldi, Gabriele, and Michael Kitson. *Discovering the Italian Baroque: The Denis Mahon Collection.* London, 1997.

Fiorillo 1798–1808

Fiorillo, Johann Dominik. *Geschichte der zeichnenden Künste von ihrer Wiederauflebung bis zu den neuesten Zeiten.* 5 vols. Göttingen, 1798–1808.

Fleming 1958

Fleming, John. "Lord Brudenell and His Bear Leader." *English Miscellany* 9 (1958): 127–41.

Fleming 1962

Fleming, John. *Robert Adam and His Circle in Edinburgh and Rome.* Cambridge, Mass., 1962.

Flick 2003a

Flick, Gert-Rudolf. "Missing Masterpieces: *Hector's Farewell to Andromache* by Batoni and *Andromache Bewailing the Death of Hector* by Hamilton." *British Art Journal* 4, no. 1 (Spring 2003): 83–87.

Flick 2003b

Flick, Gert-Rudolf. *Missing Masterpieces: Lost Works of Art, 1450–1900.* London, 2003.

Ford 1955

Ford, Brinsley. "A Portrait Group by Gavin Hamilton: With Some

Notes on Portraits of Englishmen in Rome." *Burlington Magazine* 97 (1955): 372–78.

Ford 1974a
Ford, Brinsley. "James Byres: Principal Antiquarian for the English Visitors to Rome." *Apollo* 99 (June 1974): 446–61.

Ford 1974b
Ford, Brinsley. "Sir Watkin Williams-Wynn: A Welsh Maecenas." *Apollo* 99 (June 1974): 435–39.

Ford and Ingamells 1997
Ford, Brinsley, and John Ingamells. *A Dictionary of British and Irish Travellers in Italy, 1701–1800, Compiled from the Brinsley Ford Archive.* New Haven and London, 1997.

Fornari Schianchi 2000
Fornari Schianchi, Lucia, ed. *Galleria Nazionale di Parma. Catalogo delle opere: Il Settecento.* Parma, 2000.

Foscarini 1721
Foscarini, Marco. *Della perfezione della Repubblica veneziana.* 1721. In Marco Foscarini, *Necessità della storia e Della perfezione della Repubblica veneziana.* Edited by Luisa Ricaldone. Milan, 1983: pp. 109–208.

Fothergill 1974
Fothergill, Brian. *The Mitred Earl: An Eighteenth-Century Eccentric.* London, 1974.

Frankfurt 1988
Ebert-Schifferer, Sybille, Andrea Emiliani, and Erich Schleier, eds. *Guido Reni und Europa. Ruhm und Nachruhm.* Exh. cat. Schirn Kunsthalle, Frankfurt. Frankfurt, 1988.

Frankfurt 1999
Beck, Herbert, Peter C. Bol, and Maraike Bückling, eds. *Mehr Licht. Europa um 1770. Die bildende Kunst der Aufklärung.* Exh. cat. Städelsches Kunstinstitut and Liebieghaus-Museum alter Plastik, Frankfurt. Munich, 1999.

Frederick II 1846–57
Frederick II of Prussia. *Œuvres de Frédéric le Grand.* Edited by Johann Preuss. 31 vols. Berlin, 1846–57.

Frederick II 1879–1939
Frederick II of Prussia. *Politische Correspondenz Friedrich's des Großen.* Edited by Gustav Berthold Volz et al. 46 vols. Berlin, 1879–1939.

Friedman 1993
Friedman, Joseph. *Spencer House: Chronicle of a Great London Mansion.* London, 1993.

Friedrich Christian 1751–57
Friedrich Christian of Saxony. *Das geheime politische Tagebuch des Kurprinzen Friedrich Christian, 1751 bis 1757.* Edited and introduced by Horst Schlechte. Weimar, 1992.

Füssli 1779
Füssli, Johann Rudolf. *Allgemeines Künstlerlexicon, oder: Kurze Nachricht von dem Leben und den Werken der Mahler, Bildhauer, Baumeister, Kupferstecher, Kunstgiesser, Stahlschneider. . . .* Zurich, 1779.

Gandino 1894
Gandino, Francesco. "Ambasceria di Marco Foscarini a Roma (1737–40)." *Miscellanea di storia Veneta,* serie 2, no. 2 (1894): 1–79.

Garms-Cornides 2003
Garms-Cornides, Elisabeth. "*E se venisse Cesare.* Riflessioni intorno ad un progetto di viaggio." In *Religione, cultura e politica nell'Europa dell'età moderna. Studi offerti a Mario Rosa dagli amici.* Edited by Carlo Ossola et al. Florence, 2003: pp. 309–33.

Gedo 2002
Gedo, John E. "Pompeo Batoni's Allegory of Peace and War." *Burlington Magazine* 144 (October 2002): 601–5.

Geneva 2004
Ritschard, Claude, and Allison Morehead. *Cléopâtre dans le miroir de l'art occidental.* Exh. cat. Musée Rath, Geneva. Milan, 2004.

Gibelli 1888
Gibelli, Alberto. *Memorie storiche ed artistiche dell'antichissima chiesa abbaziale dei SS. Andrea e Gregorio al clivo di Scavro sul monte Celio.* Rome, 1888.

Gleichen 1847
Gleichen, Carl Heinrich von. *Denkwürdigkeiten des Barons Carl Heinrich von Gleichen.* Leipzig, 1847.

Gleichen-Rußwurm 1907
Gleichen-Rußwurm, Alexander von. *Aus den Wanderjahren eines fränkischen Edelmannes.* Würzburg, 1907.

Gore 1986
Gore, St. John. "The Bankes Collection at Kingston Lacy." *Apollo* 123 (May 1986): 302–12.

Gould 1976
Gould, Cecil. *The Paintings of Correggio.* London, 1976.

Greifenhagen 1963
Greifenhagen, Adolf. "Nachklänge griechischer Vasenfunde im Klassizismus (1790–1840)." *Jahrbuch der Berliner Museen* 5 (1963): 84–105.

Guarino and Masini 2006
Guarino, Sergio, and Patrizia Masini, eds. *Pinacoteca Capitolina: Catalogo generale.* Milan, 2006.

Hagedorn 1797
Hagedorn, Christian Ludwig von. *Briefe über die Kunst von und an Christian Ludwig von Hagedorn.* Edited by Torkel Baden. Leipzig, 1797.

Harris 1977
Harris, Ann Sutherland. *Andrea Sacchi: Complete Edition of the Paintings with a Critical Catalogue.* Oxford, 1977.

Haskell 1967
Haskell, Francis. "Pompeo Batoni e gli Inglesi." In Lucca 1967: pp. 70–79.

Haskell and Penny 1981
Haskell, Francis, and Nicholas Penny. *Taste and the Antique: The Lure of Classical Sculpture, 1500–1900.* London and New Haven, 1981.

Heartz 2003
Heartz, Daniel. *Music in European Capitals: The Galant Style, 1720–1780.* New York, 2003.

Heinecken 1778–90
Heinecken, Karl Heinrich von. *Dictionnaire des artistes, dont nous avons des estampes, avec une notice détaillée de leurs ouvrages graves.* 4 vols. Leipzig, 1778–90.

Helbig 1963–72
Helbig, Wolfgang. *Führer durch die öffentlichen Sammlungen klassischer Altertümer in Rom.* 4th ed. Edited by Hermine Speier. 4 vols. Tübingen, 1963–72.

Heller 1998
Heller, Wendy. "Reforming Achilles: Gender, Opera Seria and the Rhetoric of the Enlightened Hero." *Early Music* 26 (1998): 562–81.

Hiesinger 1980
Hiesinger, Ulrich W. "Drawings in Eighteenth-Century Rome." In Philadelphia 1980: pp. 2–9.

Hoff 1995
Hoff, Ursula. *European Paintings Before 1800 in the National Gallery of Victoria.* With contributions by Emma Devapriam. 4th ed. Melbourne, 1995.

Hoffmann 1817
Hoffmann, E. T. A. "Der Sandmann." 1817. In E. T. A. Hoffmann, *Sämtliche Werke.* Edited by Wulf Segebrecht and Hartmut Steinecke. 6 vols. Frankfurt, 1985–2004.

Hohoff 1988
Hohoff, Ulrich. *E.T.A. Hoffmann: "Der Sandmann." Textkritik, Edition, Kommentar.* Berlin, 1988.

Holloway 1989
Holloway, James. "John Urquhart of Cromarty: An Unknown Collector of Italian Paintings." In *Scotland and Italy: Papers Presented at the Fourth Annual Conference of the Scottish Society for Art History.* Edinburgh, 1989: pp. 1–13.

Home Journal
Home, Patrick. Grand Tour journal. MS. quoted by permission of Lt. Col. and Mrs. Home-Robertson. Alastair Rowan brought these notebooks to the attention of Brinsley Ford, who supplied Anthony M. Clark with the extracts relating to Batoni.

Hübner 1856
Hübner, Julius. *Verzeichnis der Königlichen Gemälde-Gallerie zu Dresden.* Dresden, 1856.

Ingamells 2004
Ingamells, John. *National Portrait Gallery: Mid-Georgian Portraits, 1760–1790.* London, 2004.

Jackson-Stops 1989
Jackson-Stops, Gervase. "A British Parnassus: Mythology and the Country House." In Washington 1989b: pp. 217–38.

Jacob 1975
Jacob, John. "Ranger's House, Blackheath: A New Gallery of English Portraits." *Apollo* 101 (January 1975): 14–18.

Jacob and König-Lein 2004
Jacob, Sabine, and Susanne König-Lein. *Die italienischen Gemälde des 16. bis 18. Jahrhunderts. Herzog Anton Ulrich-Museum Braunschweig, Kunstmuseum des Landes Niedersachsen.* Munich and Braunschweig, 2004.

Jagemann 1789
Jagemann, Christian Joseph. "Nachrichten von dem Leben und den Werken des berühmten Malers Pompeo Batoni." *Der Teutsche Merkur,* no. 2 (1789): 177–205.

Jenkins 1996
Jenkins, John. "Mozart's Good Friend Dr Laugier." *Music and Letters* 77 (1996): 97–100.

Jenkins and Sloan 1996
Jenkins, Ian, and Kim Sloan. *Vases and Volcanoes: Sir William Hamilton and His Collection.* London, 1996.

Johns 1998
Johns, Christopher M. S. "'That Amiable Object of Adoration': Pompeo Batoni and the Sacred Heart." *Gazette des beaux-arts* 132 (July–August 1998): 19–28.

Johns 2000
Johns, Christopher M. S. "The Entrepôt of Europe: Rome in the Eighteenth Century." In Philadelphia 2000: pp. 17–45.

Johns 2004
Johns, Christopher M. S. "Portraiture and the Making of Cultural Identity: Pompeo Batoni's *The Honourable Colonel William Gordon* (1765–66) in Italy and North Britain." *Art History* 27, no. 3 (June 2004): 383–411.

Jones 1912
Jones, H. Stuart, ed. *A Catalogue of the Ancient Sculptures Preserved in the Municipal Collections of Rome: The Sculptures of the Museo Capitolino, by Members of the British School at Rome.* 2 vols. Oxford, 1912.

Jones 1926
Jones, H. Stuart, ed. *A Catalogue of the Ancient Sculptures Preserved in the Municipal Collections of Rome: The Sculptures of the Palazzo dei Conservatori, by Members of the British School at Rome.* 2 vols. Oxford, 1926.

Jones 1946–48
Jones, Thomas. "Memoirs of Thomas Jones, Penkerrig, Radnorshire, 1803." Edited by Paul Oppé. *Walpole Society* 32 (1946–48).

Justi 1923
Justi, Carl. *Winckelmann und seine Zeitgenossen.* 3rd ed. 3 vols. Leipzig, 1923.

Kagan and Nemerov 1984
Kagan, Julia, and Oleg Nemerov. "Lorenz Natter's *Museum Britannicum*: Gem-Collecting in Mid-Eighteenth Century England. I." *Apollo* 120 (August 1984): 114–21.

Koch 1975
Koch, Guntram. *Die mythologischen Sarkophage. Meleager. Die antiken Sarkophagreliefs,* vol. 12, no. 6. Berlin, 1975.

Krieger 1914
Krieger, Bodgan. *Friedrich der Große und seine Bücher.* Berlin, 1914.

Krückmann 2004
Krückmann, Peter. "Mengs und Batoni in Bayreuth. Die Gemälde-
aufträge der Markgräfin Wilhelmine in Rom 1755." In *Italien-
sehnsucht. Kunsthistorische Aspekte eines Topos.* Ed. Hildegard Wiegel.
Munich, 2004: pp. 23–32.

Kunisch 2004
Kunisch, Johannes. *Friedrich der Große. Der König und seine Zeit.*
Munich, 2004.

Laing 1995
Laing, Alastair. *In Trust for the Nation: Paintings from National Trust
Houses.* Published to accompany the exhibition held at the
National Gallery, London. London, 1995.

Lalande 1769
Lalande, Joseph Jérôme Le Français de. *Voyage d'un François en Italie,
fait dans les années 1765 et 1766.* 8 vols. Venice, 1769.

Landi 1781–1817
Landi, Gaspare. *La vita a Roma nelle lettere di Gaspare Landi (1781–1817).*
Edited by Ferdinando Arisi. Piacenza, 2004.

Lanzi 1809
Lanzi, Luigi. *Storia pittorica della Italia dal risorgimento delle belle arti fino
presso al fine del XVIII secolo.* 1809. Edited by Martino Capucci. 3
vols. Florence, 1968–74.

Legrand 1990
Legrand, Catherine. "A propos de l'exposition du Louvre. La Rome
baroque de Maratti à Piranèse: Pompeo Batoni (1708–1787) ou la
recherché de la perfection." *Revue du Louvre et des musées de France*
40, no. 6 (1990): 502–3.

Lehninger 1782
Lehninger, Johann August. *Abrégé de la vie des peintres, dont les tableaux
composent la Galerie Electorale de Dresde.* Dresden, 1782.

Levey 1964
Levey, Michael. *The Later Italian Pictures in the Collection of Her Majesty
the Queen.* London, 1964.

Levey 1966
Levey, Michael. *Rococo to Revolution: Major Trends in Eighteenth-Century
Painting.* London, 1966.

Lewis 1961
Lewis, Lesley. *Connoisseurs and Secret Agents in Eighteenth-Century Rome.*
London, 1961.

Libby 1973
Libby, Lester. "Venetian History and Political Thought After
1509." *Studies in the Renaissance* 20 (1973): 7–45.

London 1960a
The Age of Charles II. Exh. cat. Royal Academy of Arts, London.
London, 1960.

London 1960b
Italian Art and Britain. Exh. cat. Royal Academy of Arts, London.
London, 1960.

London 1973
Whitfield, Clovis. *England and the Seicento: A Loan Exhibition of Bolognese
Paintings from British Collections.* Exh. cat. Thos. Agnew and Sons
Ltd., London. London, 1973.

London 1977
Goodreau, David. *Nathaniel Dance, 1735–1811.* Exh. cat. The Iveagh
Bequest, Kenwood, London. London, 1977.

London 1979
Miles, Ellen G. *Thomas Hudson, 1701–1779, Portrait Painter and
Collector: A Bicentenary Exhibition.* Exh. cat. The Iveagh Bequest,
Kenwood, London. London, 1979.

London 1982
Pompeo Batoni and His British Patrons. Exh. cat. The Iveagh Bequest,
Kenwood, London. London, 1982.

London 1987
The Settecento: Italian Rococo and Early Neo-Classical Paintings, 1700–1800
Exh. cat. Matthiesen Fine Art Ltd., London. London, 1987.

London 1988
Treasures for the Nation: Conserving Our Heritage. Exh. cat. British
Museum, London. London, 1988.

London 1992
Wilton, Andrew. *The Swagger Portrait: Grand Manner Portraiture in
Britain from Van Dyck to Augustus John, 1630–1930.* Exh. cat. Tate
Gallery, London. London, 1992.

London 1996
Wilton, Andrew, and Ilaria Bignamini, eds. *Grand Tour: The Lure of
Italy in the Eighteenth Century.* Exh. cat. Tate Gallery, London, and
Palazzo delle Esposizioni, Rome. London, 1996.

London 2001a
Hall and Knight Ltd.: MMI. London and New York, 2001.

London 2001b
Laing, Alastair, ed. *Clerics and Connoisseurs: The Rev. Matthew Pilk-
ington, the Cobbe Family, and the Fortunes of an Irish Collection Through
Three Centuries.* Exh. cat. The Iveagh Bequest, Kenwood, London.
London, 2001.

London 2007
Allard, Sebastien, Robert Rosenblum, Guilhem Scherf, and Mary
Anne Stevens. *Citizens and Kings: Portraits in the Age of Enlightenment.*
Exh. cat. Royal Academy of Arts, London. New York, 2007.

Lord 2000
Lord, Peter. *The Visual Culture of Wales: Imaging the Nation.* Cardiff, 2000.

Los Angeles 1993
Campbell, Richard J., and Victor Carlson, eds. *Visions of Antiquity:
Neoclassical Figure Drawings.* Exh. cat. Los Angeles County Museum
of Art; Philadelphia Museum of Art; and Minneapolis Institute
of Arts. Los Angeles, 1993.

Lucca 1967

Belli Barsali, Isa, ed. *Mostra di Pompeo Batoni.* Exh. cat. Palazzo Ducale, Lucca. Lucca, 1967.

Lucchesini 1780–82

Lucchesini, Girolamo. *Das Tagebuch des Marchese Lucchesini (1780–1782). Gespräche mit Friedrich dem Großen.* Edited by Friedrich von Oppeln-Bronikowski and Gustav Berthold Volz. Munich, 1926.

Lucy 1862

Lucy, Mary Elizabeth. *Biography of the Lucy Family, of Charlecote Park, in the County of Warwick.* London, 1862.

Luitjen 1999

Luitjen, Ger. "The Iconography: Van Dyck's Portraits in Print." In Antwerp 1999: pp. 73–91.

Luzón Nogué 2000

Luzón Nogué, José María. *El Westmorland.* Madrid, 2000.

Lyon 1998

La fascination de l'antique 1700–1770: Rome découverte, Rome inventée. Exh. cat. Musée de la Civilisation Gallo-Romaine, Lyon. Paris and Lyon, 1998.

Lyon 2000

Brejon de Lavergnée, Arnauld, and Philippe Durey, eds. *Settecento, le siècle de Tiepolo: Peintures italiennes de XVIIIe siècle exposées dans les Collections publiques françaises.* Exh. cat. Musée des Beaux-Arts, Lyon, and Palais des Beaux-Arts, Lille. Paris, 2000.

Maastricht 2006

Moschetta, Marzia, ed. *Galleria Cesare Lampronti: Rassegna di dipinti dei secoli XVII e XVIII.* Exh. cat. The European Fine Art Fair, Maastricht. Rome, 2006.

Macandrew 1978

Macandrew, Hugh. "A Group of Batoni Drawings at Eton College, and Some Eighteenth-Century Italian Copyists of Classical Sculpture." *Master Drawings* 16 (1978): 131–50.

Macdonald and Pinto 1995

Macdonald, William L., and John A. Pinto. *Hadrian's Villa and Its Legacy.* New Haven and London, 1995.

Madocks 1984

Madocks, Susan. "'Trop de beautez découvertes'—New Light on Guido Reni's Late 'Bacchus and Ariadne.'" *Burlington Magazine* 126 (1984): 542–47.

Maguire 1965

Maguire, Joseph. "Beauty and the Fine Arts in Plato: Some Aporiai." *Harvard Studies in Classical Philology* 70 (1965): 171–93.

Mainz 2003

Paas, Sigrun, and Sabine Mertens, eds. *Beutekunst unter Napoleon. Die "französische Schenkung" an Mainz 1803.* Exh. cat. Landesmuseum, Mainz. Mainz, 2003.

Malvasia 1678

Malvasia, Carlo Cesare. *The Life of Guido Reni.* 1678. Translated by Catherine Enggass and Robert Enggass. University Park, Pa., and London, 1980.

Mann 1997

Mann, Judith Walker. "Baroque into Rococo: Seventeenth- and Eighteenth-Century Italian Paintings." *Saint Louis Art Museum Bulletin* (Winter 1997): 2–63.

Mannings 2000

Mannings, David. *Sir Joshua Reynolds: A Complete Catalogue of His Paintings.* Subject pictures catalogued by Martin Postle. 2 vols. New Haven and London, 2000.

Mariette 1851–62

Mariette, Pierre-Jean. *Abécédario de P.-J. Mariette et autres notes inédites de cet amateur sur les arts et les artistes.* Edited and annotated by Philippe de Chennevières and Anatole de Montaiglon. 6 vols. Paris, 1851–62.

Marzik 1986

Marzik, Iris. *Das Bildprogramm der Galleria Farnese in Rom.* Berlin, 1986.

Mengs 1786

Mengs, Anton Raphael. *Des Ritters Anton Raphael Mengs, ersten Mahlers Karl III. Königs in Spanien hinterlaßne Werke.* Edited by Christian Friedrich Prange. 3 vols. Halle, 1786.

Menozzi 2003

Menozzi, Daniele. "La pietà e l'immagine. La lunga durata del dibattito settecentesco sull'iconografia del S. Cuore." In *Religione, cultura e politica nell'Europa dell'età moderna. Studi offerti a Mario Rosa dagli amici.* Edited by Carlo Ossola et al. Florence, 2003: pp. 391–404.

Menze 1997

Menze, Marianne. "Das künstlerische Schaffen Johann Dominicus Fiorillos vor dem Hintergrund seiner Ausbildung zum Zeichner und Maler in Rom und Bologna." In *Johann Dominicus Fiorillo. Kunstgeschichte und die romantische Bewegung um 1800.* Edited by Antje Middeldorf Kosegarten. Göttingen, 1997: pp. 114–44.

Metastasio 1953

Metastasio, Pietro. "Achille in Sciro." In *Tutte le opere di Pietro Metastasio.* Edited by Bruno Brunelli. Milan, 1953: vol. 1, pp. 751–803.

Meusel 1787

Meusel, Johann Georg. "Todesfälle." *Miscellaneen artistischen Inhalts* 30 (1787): 372–73.

Meyer 1792

Meyer, Friedrich Johann Lorenz. *Darstellungen aus Italien.* Berlin, 1792.

Meyer 1809–15

Meyer, Johann Heinrich. *Geschichte der Kunst.* [1809–15]. Edited by Helmut Holtzhauer and Reiner Schlichting. Weimar, 1974.

Meyer and Rolfi 2002

Meyer, Susanne Adina, and Serenella Rolfi. "L'Elenco dei più noti artisti viventi a Roma' di Alois Hirt." *Roma moderna e contemporanea* 10 (2002): 241–61.

Milan 2002

Il neoclassicismo in Italia: Da Tiepolo a Canova. Exh. cat. Palazzo Reale, Milan. Milan, 2002.

Millar 1969

Millar, Oliver. *The Later Georgian Pictures in the Collections of Her Majesty the Queen.* London, 1969.

Miller 1777

Miller, Lady Anna Riggs. *Letters from Italy Describing the Manners, Customs, Antiquities, Paintings, &c. of That Country in the Year MDCCLXX and MDCCLXXI to a Friend Residing in France.* 2nd ed. 2 vols. London, 1777.

Missirini 1823

Missirini, Melchiorre. *Memorie per servire alla storia della Romana Accademia di S. Luca fino alla morte di Antonio Canova.* Rome, 1823.

Mitchell and Roberts 1996a

Mitchell, Paul, and Lynn Roberts. *Frameworks: Form, Function and Ornament in European Portrait Frames.* London, 1996.

Mitchell and Roberts 1996b

Mitchell, Paul, and Lynn Roberts. *A History of European Picture Frames.* London, 1986.

Montagu 1965–67

Montagu, Lady Mary Wortley. *The Complete Letters of Lady Mary Wortley Montagu.* Edited by Robert Halsband. 3 vols. Oxford, 1965–67.

Moore 1780

Moore, John. *A View of Society and Manners in Italy with Anecdotes Relating to Some Eminent Characters.* London, 1780.

Moore 1985

Moore, Andrew W. *Norfolk and the Grand Tour: Eighteenth-Century Travellers Abroad and Their Souvenirs.* Norfolk, 1985.

Morpurgo 1880

Morpurgo, Emilio. *Marco Foscarini e Venezia nel secolo XVIII.* Florence, 1880.

Moscow 2001

Educated Fancy: The Collection of Nikolai Borisovich Yusupov [text in Russian]. Exh. cat. State Pushkin Museum, Moscow, and State Hermitage Museum, Saint Petersburg. 2 vols. Moscow, 2001.

Munich 1992

Hohenzollern, Johann Georg Prinz von, ed. *Friedrich der Große, Sammler und Mäzen.* Exh. cat. Kunsthalle der Hypo-Kulturstiftung, Munich. Munich, 1992.

Münter 1937

Münter, Friedrich. *Aus den Tagebüchern Friedrich Münters. Wander- und Lehrjahre eines dänischen Gelehrten.* Edited by Øjvind Andreasen. 3 vols. Copenhagen, 1937.

Murcia 2002

El Westmorland. Recuerdos del Grand Tour. Exh. cat. Centro Cultural Las Claras, Murcia; Centro Cultural El Monte, Seville; Real Academia de Bellas Artes de San Fernando, Madrid. Seville, 2002.

Nevinson 1964

Nevinson, J. L. "Vandyke Dress." *Connoisseur* 157 (November 1964): 166–71.

Newbery 2002

Newbery, Timothy. *Frames and Framings in the Ashmolean Museum.* Oxford, 2002.

New York 1982

Pompeo Batoni (1708–1787): A Loan Exhibition of Paintings. Introduction and catalogue by Edgar Peters Bowron. Exh. cat. Colnaghi, New York. New York, 1982.

New York 1985

Liechtenstein: The Princely Collections. Exh. cat. The Metropolitan Museum of Art, New York. New York, 1985.

New York 1986

Stair Sainty Matthiesen. *An Aspect of Collecting Taste.* New York, 1986.

Nicholson 2002

Nicholson, Robin. *Bonnie Prince Charlie and the Making of a Myth: A Study in Portraiture, 1720–1892.* Lewisburg, Pa., and London, 2002.

Northcote 1901

Northcote, James. *Conversations of James Northcote R. A. with James Ward on Art and Artists.* Edited and arranged from the manuscripts and notebooks of James Ward by Ernest Fletcher. London, 1901.

Nugent 1756

Nugent, Thomas. *The Grand Tour; or, A Journey Through the Netherlands, Germany, Italy, and France.* 2nd ed. London, 1756. Repr. London and Tokyo, 2004.

Oesterreich 1770

Oesterreich, Matthias. *Beschreibung der Koeniglichen Bildergallerie und des Kabinets im Sans-Souci.* 2nd ed. Potsdam, 1770.

Oesterreich 1773

Oesterreich, Matthias. *Beschreibung aller Gemählde, Antiquitäten, und anderer kostbarer und merkwürdiger Sachen, so in denen beyden Schlößern von Sans-Souci, wie auch in dem Schloße zu Potsdam und Charlottenburg enthalten sind.* Berlin, 1773.

Olszewski 2004

Olszewski, Edward. *The Inventory of Paintings of Cardinal Pietro Ottoboni (1667–1740).* New York, 2004.

Pantanella 1993

Pantanella, Rossella. "Il Caffeaus." In *Il patrimonio artistico del Quirinale.* Vol. 2: *Pittura antica. La decorazione murale.* Edited by Laura Laureati and Ludovica Trezzani. Rome, 1993: pp. 291–308; 314–25.

Paris 1922

Musée National du Louvre. Catalogue sommaire des marbres antiques. Paris, 1922.

Paris 1987

Subleyras 1699–1749. Exh. cat. Musée du Luxembourg, Paris, and Académie de France, Villa Médicis, Rome. Paris, 1987.

Paris 1990

Legrand, Catherine, and Domitilla d'Ormesson-Peugeot. *La Rome baroque de Maratti à Piranèse: Dessins du Louvre et des collections publiques françaises*. Exh. cat. Musée du Louvre, Paris. Paris, 1990.

Paris 1998

Loire, Stéphane, ed. *La collection Lemme: Tableaux romains des XVIIe et XVIIIe siècles*. Exh. cat. Musée du Louvre, Paris; Palazzo Reale, Milan; and Palazzo Barberini, Rome. Paris, 1998.

Paris 2000

Mochi Onori, Lorenza. *Settecento: L'Europe à Rome. Chefs-d'œuvre de la peinture du XVIIIe siècle des collections de la Galerie Nationale d'Art Ancien du Palais Barberini*. Exh. cat. Mairie du Ve Arrondissement, Paris. Rome, 2000.

Pascoli 1737

Pascoli, Lione. "Pompeo Batoni." [1737]. In Pascoli, Lione: *Vite de' pittori, scultori ed architetti viventi*. Edited by Isa Belli Barsali. Treviso, 1981: pp. 178–89.

Pastor 1925–33

Pastor, Ludwig von. *Geschichte der Päpste seit dem Ausgang des Mittelalters*. 5th–7th eds. 16 vols. Freiburg im Breisgau, 1925–33.

Pavanello 1998

Pavanello, Giuseppe. "I Rezzonico. Committenza e collezionismo fra Venezia e Roma." *Arte Veneta* 52 (1998): 87–111.

Pavanello 2000

Pavanello, Giuseppe. "Un inventario degli arredi di Villa Rezzonico a Bassano." *Notiziario degli Amici dei Musei e dei Monumenti di Bassano* 22–23 (2000): 51–84.

Pepper 1984

Pepper, D. Stephen. *Guido Reni: A Complete Catalogue of His Works with an Introductory Text*. Oxford, 1984.

Percy 2000

Percy, Ann. "Drawings and Artistic Production in Eighteenth-Century Rome." In Philadelphia 2000: pp. 461–67.

Percy and Cazort 2004

Percy, Ann, and Mimi Cazort. *Italian Master Drawings at the Philadelphia Museum of Art*. Philadelphia, 2004.

Petrucci 2005

Petrucci, Francesco. *Ferdinand Voet (1639–1689) detto Ferdinando de' Ritratti*. Rome, 2005.

Philadelphia 1980

Hiesinger, Ulrich, and Ann Percy, eds. *A Scholar Collects: Selections from the Anthony Morris Clark Bequest*. Exh. cat. Philadelphia Museum of Art. Philadelphia, 1980.

Philadelphia 2000

Bowron, Edgar Peters, and Joseph J. Rishel, eds. *Art in Rome in the Eighteenth Century*. Exh. cat. Philadelphia Museum of Art and Museum of Fine Arts, Houston. London, 2000.

Pilkington 1805

Pilkington, Matthew. *A Dictionary of Painters, from the Revival of the Art to the Present Period*. Edited by Henry Fuseli. London, 1805.

Poensgen 1930

Poensgen, Georg. "Die Bildergalerie Friedrichs des Grossen in Sanssouci und Andriaen van der Werff." *Jahrbuch für Kunstwissenschaft* 7 (1930): 176–88.

Posner 1971

Posner, Donald. *Annibale Carracci*. 2 vols. London, 1971.

Potsdam 1986

Giersberg, Hans-Joachim, and Claudia Meckel, eds. *Friedrich II. und die Kunst*. Exh. cat. Neues Palais, Potsdam. 2 vols. Potsdam, 1986.

Prinz 1971

Prinz, Wolfram. *Die Sammlung der Selbstbildnisse in den Uffizien*. Vol. 1: *Geschichte der Sammlung*. Berlin, 1971.

Puhlmann 1774–87

Puhlmann, Johann Gottlieb. *Ein Potsdamer Maler in Rom. Briefe des Batoni-Schülers Johann Gottlieb Puhlmann aus den Jahren 1774 bis 1787*. Edited by Götz Eckardt. Berlin, 1979.

Raggio 1958

Raggio, Olga. "The Myth of Prometheus: Its Survival and Metamorphoses up to the Eighteenth Century." *Journal of the Warburg and Courtauld Institutes* 21 (1958): 44–62.

Raleigh 1994

Ishikawa, Chiyo, Lynn Federle Orr, George Shackelford, and David Steel, eds. *A Gift to America: Masterpieces of European Painting from the Samuel H. Kress Collection*. Exh. cat. North Carolina Museum of Art, Raleigh; Museum of Fine Arts, Houston; Seattle Art Museum; and Fine Arts Museums of San Francisco. New York, 1994.

Ramdohr 1787

Ramdohr, Friedrich Wilhelm Basilius von. *Ueber Mahlerei und Bildhauerarbeit in Rom für Liebhaber des Schönen in der Kunst*. 2 vols. Leipzig, 1787.

Rankin 1972

Rankin, Peter. *Irish Building Ventures of the Earl Bishop of Derry, 1730–1803*. Belfast, 1972.

Razumovsky 1998

Razumovsky, Maria. *Die Razumovskys. Eine Familie am Zarenhof*. Cologne, 1998.

Recueil 1724–91

Recueil des instructions données aux ambassadeurs et ministres de France depuis les traités de Westphalie jusqu'à la Révolution française. Vol. 20, pt. 3: *Rome (1724–1791)*. Edited by Gabriel Hanoteau. Paris, 1913.

Redford 1996

Redford, Bruce. *Venice and the Grand Tour*. New Haven and London, 1996.

Reynolds 1975

Reynolds, Joshua. *Discourses on Art*. Text of the 1797 edition. Edited by Robert R. Wark. New Haven and London, 1975.

Ribeiro 1979
Ribeiro, Aileen. "Furs in Fashion: The Eighteenth and Nineteenth Centuries." *Connoisseur* 202 (December 1979): 226–31.

Ribeiro 1984
Ribeiro, Aileen. *The Dress Worn at Masquerades in England, 1730 to 1790, and Its Relation to Fancy Dress in Portraiture.* New York and London, 1984.

Ribeiro 1995
Ribeiro, Aileen. *The Art of Dress: Fashion in England and France, 1750 to 1820.* New Haven and London, 1995.

Ribeiro 2000
Ribeiro, Aileen. *The Gallery of Fashion.* London, 2000.

Ribeiro 2002
Ribeiro, Aileen. *Dress in Eighteenth-Century Europe, 1715–1789.* Rev. edition. New Haven and London, 2002.

Rice 1997
Rice, Louise. *The Altars and Altarpieces of New St. Peter's: Outfitting the Basilica, 1621–1666.* Cambridge, 1997.

Richardson 1722
Richardson, Jonathan [Senior and Junior]. *An Account of Some of the Statues, Bas-reliefs, Drawings and Pictures in Italy, &c., with Remarks.* London, 1722.

Roettgen 1981
Roettgen, Steffi. "Zum Antikenbesitz des Anton Raphael Mengs und zur Geschichte und Wirkung seiner Abguß-und Formensammlung." In *Antikensammlungen im 18. Jahrhundert.* Edited by Herbert Beck et al. Berlin, 1981: pp. 129–48.

Roettgen 1982
Roettgen, Steffi. "Alessandro Albani." In *Forschungen zur Villa Albani.* Edited by Herbert Beck and Peter Bol. Berlin, 1982: pp. 123–52.

Roettgen 1988
Roettgen, Steffi. "Guido Reni und die römische Malerei im 17. und 18. Jahrhundert." In Frankfurt 1988: pp. 548–75.

Roettgen 1999
Roettgen, Steffi. *Anton Raphael Mengs, 1728–1779.* Vol. 1: *Das malerische und zeichnerische Werk.* Munich, 1999.

Roettgen 2003
Roettgen, Steffi. *Anton Raphael Mengs, 1728–1779.* Vol. 2: *Leben und Wirken.* Munich, 2003.

Rogers 1992
Rogers, Malcom. "British Portraits: Philosophy, Politics, and War." *National Art-Collections Fund Review* (1992): 38–42.

Rogister 1997
Rogister, John. "A Quest for Peace in the Church: The Abbé A. J. C. Clément's Journey to Rome of 1758." In *Religious Change in Europe, 1650–1914: Essays for John McManners.* Edited by Nigel Aston. Oxford, 1997: pp. 103–33.

Rome 1990
L'arte per i papi e per i principi nella campagna romana. Grande pittura del '600 e del '700. Exh. cat. Palazzo Venezia, Rome. 2 vols. Rome, 1990.

Rome 1995a
La regola e la fama. San Filippo Neri e l'arte. Exh. cat. Palazzo Venezia, Rome. Milan, 1995.

Rome 1995b
Vodret, Rossella, ed. *Caravaggio e la collezione Mattei.* Exh. cat. Palazzo Barberini, Rome. Milan, 1995.

Rome 1999
Altieri, Giancarlo, and Anna Coliva. *Una collezione da scoprire. Capolavori dal '500 al '700 dell'Ente Cassa di Risparmio di Roma.* Exh. cat. Museo del Corso, Rome. Rome, 1999.

Rome 2000a
Borea, Evelina, and Carlo Gasparri, eds. *L'idea del bello. Viaggio per Roma nel Seicento con Giovan Pietro Bellori.* Exh. cat. Palazzo delle Esposizioni, Rome. 2 vols. Rome, 2000.

Rome 2000b
The Capitoline Museums. 2000. Rome, 2005.

Rome 2001
Danesi Squarzina, Silvia, ed. *Caravaggio e i Giustiniani. Toccar con mano una collezione del Seicento.* Exh. cat. Palazzo Giustiniani, Rome, and Altes Museum, Berlin. Milan, 2001.

Rome 2003
Androsov, Sergej, and Vittorio Strada, eds. *Pietroburgo e l'Italia. Il genio italiano in Russia, 1750–1850.* Exh. cat. Complesso del Vittoriano, Rome. Geneva, 2003.

Rome 2004
Da Giotto a Malevic: La reciproca meraviglia. Exh. cat. Scuderie del Quirinale, Rome. Milan, 2004.

Rome 2005
Lo Bianco, Anna, and Angela Negro, eds. *Il Settecento a Roma.* Exh. cat. Palazzo Venezia, Rome. Milan, 2005.

Rouen 1999
Meslay, Olivier, and Diederik Bakhuÿs. *Aquarelles et dessins anglais et œuvres d'artistes lies a l'Angleterre, XVIIIe et XIXe siècles.* Exh. cat. Musée des Beaux-Arts, Rouen. Rouen, 1999.

Rouen 2003
Bakhuÿs, Diederik, ed. *I grandi disegni italiani delle collezioni pubbliche di Rouen.* Exh. cat. Musée des Beaux-Arts, Rouen. Milan, 2003.

Rowell 2004
Rowell, Christopher. *Uppark: West Sussex. The National Trust.* Rev. edition. London, 2004.

Rudolph 1983
Rudolph, Stella. *La pittura del '700 a Roma.* Milan, 1983.

Russell 1973
Russell, Francis. "Portraits on the Grand Tour: Batoni's British Sitters." *Country Life* 153 (1973): 1608–10, 1754–56.

Russell 1975–76

Russell, Francis. "The Stourhead Batoni and Other Copies After Reni." *The National Trust Year Book*, 1975–76: 109–11.

Russell 1981

Russell, Francis. "Batoni at Basildon." *National Trust Studies*, 1981: 35–42.

Russell 1985

Russell, Francis. "Dr. Clephane, John Blackwood and Batoni's 'Sacrifice of Iphigenia.'" *Burlington Magazine* 127 (December 1985): 890–93.

Russell 1988

Russell, Francis. "Notes on Luti, Batoni, and Nathaniel Dance." *Burlington Magazine* 130 (November 1988): 853–55.

Russell 1989

Russell, Francis. "The Hanging and Display of Pictures, 1700–1850." In Washington 1989a: pp. 133–53.

Russell 1994

Russell, Francis. "Notes on Grand Tour Portraiture." *Burlington Magazine* 136 (July 1994): 438–43.

Russell 1996

Russell, Francis. "Guardi and the English Tourist." *Burlington Magazine* 138 (January 1996): 4–11.

Russell 1998

Russell, Francis. "A Batoni Patron Identified." *Burlington Magazine* 140 (October 1998): 682–83.

Sánchez-Jáuregui 2001

Sánchez-Jáuregui, María Dolores. "Two Portraits of Francis Basset by Pompeo Batoni in Madrid." *Burlington Magazine* 143 (2001): 420–25.

Sánchez-Jáuregui Alpañés 2002

Sánchez-Jáuregui Alpañés, María Dolores. "El Grand Tour de Francis Basset." In Murcia 2002: pp. 119–43.

Schmitt-Vorster 2006

Schmitt-Vorster, Angelika. "*Pro Deo et Populo:* Die Porträts Josephs II. (1765–1790). Untersuchungen zu Bestand, Ikonographie und Verbreitung des Kaiserbildnisses im Zeitalter der Aufklärung." Ph.D. diss. University of Munich, 2006.

Schwartz 2005

Schwartz, Selma. *The Razumovsky Service: A Porcelain Cabinet of Curiosities.* Published in conjunction with an exhibition at the Musée National de Céramique, Sèvres, 2005–6. Paris, 2005.

Scott 1995

Scott, Jonathan. *Salvator Rosa: His Life and Times.* New Haven and London, 1995.

Scott 2003

Scott, Jonathan. *The Pleasures of Antiquity: British Collectors of Greece and Rome.* London, 2003.

Seifert 2004

Seifert, Hans-Ulrich. "Chronologische Übersicht zur Biographie des Marquis d'Argens." In *Der Marquis d'Argens.* Edited by Hans-Ulrich Seifert and Jean-Loup Seban. Wiesbaden, 2004: pp. 259–76.

Sestieri 1994

Sestieri, Giancarlo. *Repertorio della pittura romana della fine del Seicento e del Settecento.* 3 vols. Turin, 1994.

Seydl 2003

Seydl, Jon. "The Sacred Heart of Jesus: Art and Religion in Eighteenth-Century Italy." Ph.D. diss. University of Pennsylvania, 2003.

Simon 1987

Simon, Robin. *The Portrait in Britain and America with a Biographical Dictionary of Portrait Painters, 1680–1914.* Boston, 1987.

Simon 1996

Simon, Jacob. *The Art of the Picture Frame: Artists, Patrons and the Framing of Portraits in Britain.* Published for an exhibition held at the National Portrait Gallery, London. London, 1996.

Skinner 1958

Skinner, Basil C. "Some Scottish Portraits by Domenico Dupra." *Scottish Art Review* 4, no. 4 (1958): 25–26.

Skinner 1959

Skinner, Basil C. "Some Aspects of the Work of Nathaniel Dance in Rome." *Burlington Magazine* 101 (September 1959): 346–49.

Smart 1964

Smart, Alastair. *Paintings and Drawings by Allan Ramsay, 1713–1784.* London, 1964.

Smart 1992

Smart, Alastair. *Allan Ramsay: Painter, Essayist and Man of the Enlightenment.* New Haven and London, 1992.

Smart 1999

Smart, Alastair. *Allan Ramsay: A Complete Catalogue of His Paintings.* Edited by John Ingamells. New Haven and London, 1999.

Southey 1799

Southey, Robert. *Letters Written During a Short Residence in Spain and Portugal.* Bristol, 1799.

Spinosa 1993

Spinosa, Nicola. *Pittura napoletana del Settecento dal Rococò al Classicismo.* Naples, 1993.

Starcky 2002

Starcky, Emmanuel, et al. *Musée des Beaux-Arts de Dijon.* Paris, 2002.

Steegman 1946

Steegman, John. "Some English Portraits by Pompeo Batoni." *Burlington Magazine* 88 (1946): 54–63.

Stoschek 1999

Stoschek, Jeannette Susanne. *Das "Caffeaus" Papst Benedikts XIV. in den Gärten des Quirinal.* Munich, 1999.

Suárez Huerta 2006

Suárez Huerta, Ana María. "A Portrait of George Legge by Batoni." *Burlington Magazine* 148 (April 2006): 252–56.

Susinno 1998

Susinno, Stefano. "'Accademie' romane nella collezione braidense:

Primate di Domenico Corvi nel disegno dal nudo." In Viterbo 1998: pp. 173–89.

Susinno 2001
Susinno, Stefano: "Alle origini della pittura neoclassica. La competizione per il primato tra Batoni e Mengs." *Bollettino dei musei comunali di Roma* n.s., 15 (2001): 5–24.

Sydney 1998
Warner, Malcolm, Julia Marciari Alexander, and Patrick McCaughey. *This Other Eden: Paintings from the Yale Center for British Art.* Exh. cat. The Art Gallery of New South Wales, Sydney; Queensland Art Gallery, Brisbane; and Art Gallery of South Australia, Adelaide. New Haven and London, 1998.

Talbot 1985
Talbot, Michael. "Ore italiane: The Reckoning of the Time of Day in Pre-Napoleonic Italy." *Italian Studies* 40 (1985): 51–62.

Thorpe Letters
Thorpe, Father John. MS. letters from Father John Thorpe to Henry, 8th Lord Arundell of Wardour. Wiltshire and Swindon Record Office, Trowbridge, Arundell MSS. 2667, and private collection (quoted by permission of Lord Clifford of Chudleigh from citations supplied to Anthony M. Clark by Brinsley Ford).

Thurber 2003
Thurber, Barton T. "Face to Face: Pompeo Batoni's Portraits of Lord Dartmouth and Robert Clements." *Hood Museum of Art Quarterly* no. 5 (Autumn 2003): 12–14.

Tischbein 1956
Tischbein, Johann Heinrich Wilhelm. *Aus meinem Leben.* Edited by Kuno Mittelstädt. Berlin, 1956.

Toulouse 2006
Loisel, Catherine, et. al. *Rome à l'apogée de sa gloire. Dessins des XVIIe et XVIIIe siècles.* Exh. cat. Musée Paul-Dupuy, Toulouse. Montreuil, 2006.

Trumble 1998
Trumble, Angus. "A Roman Holiday—Pompeo Batoni and *Sir Sampson Gideon.*" *Art and Australia* 36, no. 1 (1998): 84–87.

Turin 2003
Maggio Serra, Rosanna, et al. *Vittorio Alfieri: Aristocratico ribelle (1749–1803).* Exh. cat. Archivio di Stato, Turin. Milan, 2003.

Turin 2005
Guarino, Sergio, Maria Elisa Tittoni, and Simonetta Tozzi, eds. *"Il fin la maraviglia": Splendori di Corte e scena urbana tra Sei e Settecento dalle collezioni del Museo di Roma.* Exh. cat. Museo Accorsi, Turin. Turin, 2005.

Urchueguía 2006
Arcangelo Corelli. Sonate a Violino e Violone o Cimbalo, Opus V. Edited by Cristina Urchueguía. *Historisch-kritische Gesamtausgabe der musikalischen Werke.* Vol. 3. Laaber, 2006.

Vaduz 1994
Wieczorik, Uwe, ed. *Fünf Jahrhunderte italienische Kunst aus der Sammlungen des Fürsten von Liechtenstein.* Exh. cat. Liechtensteinische Staatliche Kunstsammlung, Vaduz. Berne, 1994.

Vaduz 1998
Wieczorik, Uwe. *Götter wandelten einst . . . : Antiker Mythos im Spiegel alter Meister aus den Sammlungen des Fürsten von Liechtenstein.* Exh. cat. Liechtensteinische Staatliche Kunstsammlung, Vaduz. Berne, 1998.

Valentine 1970
Valentine, Alan. *The British Establishment, 1760–1784: An Eighteenth-Century Biographical Dictionary.* 2 vols. Norman, Okla., 1970.

Valesio 1977–79
Valesio, Francesco. *Diario di Roma.* Edited by Gaetana Scano. 6 vols. Milan, 1977–79.

Varnhagen von Ense 1844
Varnhagen von Ense, Karl August. *Leben des Feldmarschalls Jakob Keith.* Berlin, 1844.

Vaughan 2000
Vaughan, Gerard. "Thomas Jenkins and His International Clientele." In *Antikensammlungen des europäischen Adels im 18. Jahrhundert als Ausdruck einer europäischen Identität.* Edited by Dietrich Boschung and Henner von Hesberg. Mainz, 2000: pp. 20–30.

Viterbo 1998
Curzi, Valter, and Anna Lo Bianco, eds. *Domenico Corvi.* Exh. cat. Museo della Rocca Albornoz, Viterbo. Rome, 1998.

Viviani della Robbia 1940
Viviani della Robbia, Enrica. "Un quadro famoso con l'effigie del Granduca Pietro Leopoldo." *Illustrazione Toscana* 18, no. 9 (1940): 16–18.

Vivian-Neal 1939
Vivian-Neal, A. W. and C. M. *Poundisford Park, Somerset: A Catalogue of Pictures and Furniture.* Taunton, 1939.

Vogtherr 2003
Vogtherr, Christoph Martin. "Friedrich II. von Preußen als Sammler von Gemälden und der Marquis d'Argens." In *Preußen. Die Kunst und das Individuum.* Edited by Hans Dickel and Christoph Martin Vogtherr. Berlin, 2003: pp. 41–55.

Waagen 1857
Waagen, Gustave Friedrich. *Galleries and Cabinets of Art in Great Britain.* London, 1857.

Walpole 1894
Walpole, Horace. *Memoirs of the Reign of King George III.* 4 vols. London, 1894.

Walpole 1937–83
Walpole, Horace. *The Yale Edition of Horace Walpole's Correspondence.* Edited by W. S. Lewis. 48 vols. New Haven, 1937–83.

Washington 1985
Jackson-Stops, Gervase, ed. *The Treasure Houses of Britain: Five Hundred Years of Private Patronage and Art Collecting.* Exh. cat. National Gallery of Art, Washington, D.C. Washington, D.C., New Haven, and London, 1985.

Washington 1989a
The Fashioning and Functioning of the British Country House. Edited by Gervase Jackson-Stops et al. In *Studies in the History of Art 25* (Symposium Series 10). Center for Advanced Studies in the Visual Arts, National Gallery of Art, Washington, D.C., Hanover, and London, 1989.

Washington 1989b
Treasures from the Fitzwilliam: "The Increase of Learning" and Other Great Objects of That Noble Foundation. Exh. cat. National Gallery of Art, Washington, D.C. Cambridge, 1989.

Watelet and Lévesque 1792
Watelet, Claude-Henri, and Pierre-Charles Lévesque. *Dictionnaire des arts de peinture, sculpture et gravure.* 5 vols. Paris, 1792.

Waterhouse 1958
Waterhouse, Ellis. *Gainsborough.* London, 1958.

Waterhouse 1965
Waterhouse, Ellis Kirkham. *Three Decades of British Art, 1740–1770.* Philadelphia, 1965.

Waterhouse 1978–80
Waterhouse, Ellis. "Pompeo Batoni's *Portrait of John Woodyeare.*" *Minneapolis Institute of Arts Bulletin* 64 (1978–80): 54–61.

Waterhouse 1982
Waterhouse, Ellis. "Batoni at Kenwood [exhibition review]." *Burlington Magazine* 124 (August 1982): 517–18.

Waterhouse 1994
Waterhouse, Ellis. *Painting in Britain, 1530–1790.* 5th ed. Introduction by Michael Kitson. New Haven and London, 1994.

Wethey 1971
Wethey, Harold E. *The Paintings of Titian.* Vol. 2: *The Portraits.* London, 1971.

Whistler 1997
Whistler, Catherine. "An Exchange of Gifts Between David Garrick and Richard Kaye." *Burlington Magazine* 139 (May 1997): 329–30.

Wildenstein 1957
Wildenstein, Georges. *Les graveurs de Poussin au XVIIe siècle.* Paris, 1957.

Wilson 1786
Wilson, William. *The Post-Chaise Companion, or, Travellers' Directory Through Ireland.* Dublin, 1786.

Wilton-Ely 1994
Wilton-Ely, John. *Giovanni Battista Piranesi: The Complete Etchings.* 2 vols. San Francisco, 1994.

Winckelmann 1760
Winckelmann, Johann Joachim. *Description des pierres gravées du feu baron de Stosch.* Florence, 1760.

Winckelmann 1767
Winckelmann, Johann Joachim. *Monumenti antichi inediti.* 2 vols. Rome, 1767.

Winckelmann 1776
Winckelmann, Johann Joachim. *Geschichte der Kunst des Alterthums.*

Text: Erste Auflage Dresden 1764, Zweite Auflage Wien 1776. In *Schriften und Nachlaß,* vol. 4, no. 1. Edited by Adolf Borbein et al. Mainz, 2002.

Winckelmann 1796
Winckelmann, Ludwig von. *Neues Mahlerlexikon zur nähern Kenntniß alter und neuer guter Gemählde.* Augsburg, 1796.

Winckelmann 1952–57
Winckelmann, Johann Joachim. *Briefe.* Edited by Walther Rehm and Hans Diepolder. 4 vols. Berlin, 1952–57.

Wood 1982
Wood, Jeremy. "Pompeo Batoni (1708–87) and His British Patrons [exhibition review]." *Pantheon* 40, no. 3 (1982): 250–51.

Wood 1999
Wood, Jeremy. "Raphael Copies and Exemplary Picture Galleries in Mid Eighteenth-Century London." *Zeitschrift für Kunstgeschichte* 62, no. 3 (1999): 394–417.

Wrede and Kunze 2006
Wrede, Henning, and Max Kunze, eds. *300 Jahre "Thesaurus Brandenburgicus." Archäologie, Antikensammlungen und antikisierende Residenzausstattungen im Barock: Akten des Internationalen Kolloquiums Schloss Blankensee, 30.9.–2.1. 2000.* Munich, 2006.

Wright 1730
Wright, Edward. *Some Observations Made in Travelling Through France, Italy, etc., in the Years 1720, 1721, and 1722.* 2 vols. London, 1730.

Wronikowska 2002
Wronikowska, Dominika. "Gli artisti romani e la corte polacca al tempo di Stanislao Augusto Poniatowski (1764–1795)." *Roma moderna e contemporanea* 10 (2002): 113–29.

Wyndham 1790
Wyndham, Neville. *Travels Through Europe: Containing a Geographical, Historical and Topographical Description of All the Empires, Kingdoms, States . . .* London, [1790?].

Wynne 1986
Wynne, Michael. *Later Italian Paintings in the National Gallery of Ireland: The Seventeenth, Eighteenth and Nineteenth Centuries.* Dublin, 1986.

Yonan 2001
Yonan, Michael E. "Embodying the Empress-Widow: Maria Theresia and the Arts at Schönbrunn, 1765–1780." PhD diss. University of North Carolina at Chapel Hill, 2001.

Yonan 2004
Yonan, Michael E. "Veneers of Authority: Chinese Lacquers in Maria Theresa's Vienna." *Eighteenth-Century Studies* 37, no. 4 (2004): 652–72.

Yonan 2007
Yonan, Michael E. "Pompeo Batoni Between Rome and Vienna." *Source: Notes in the History of Art* 26 (Winter 2007): 32–37.

York 1994
Masterpieces from Yorkshire House: Yorkshire Families at Home and Abroad, 1700–1850. Exh. cat. York City Art Gallery. York, 1994.

INDEX

Orsini d'Aragona, Cardinal Domenico Amedeo, 118, 176

Orsini-Rosenberg, Count Franz Xaver, 100, 102

Ottoboni, Cardinal Pietro, 4

Ovid: *Fasti*, 27; *Metamorphoses*, 27, 28

Pacetti, Vincenzo, 205n63

Pallavicini, Prince Nicolò, 5, 7, 153

Panini, Giovanni Paolo, 98

Papirius group, 83

Pater, Jean-Baptiste, 135

Paul, Grand Duke of Russia, 111, 176

Pécheux, Laurent, 149; *Death of Cleopatra*, 124

Peirse, Henry, 83, 172

Percy, Sir Hugh, 48

Perugino, Pietro, 26

Pery, Edmund Henry, 175

Pesne, Antoine, 90, 91, 92

Petrucci, Francesco, 208n146

Philip Neri, Saint, 5, 7, 7

Philostratus the Younger, *Imagines*, 27

Pierre, Jean-Baptiste-Marie, 92

Pilkington, Matthew, *Dictionary of Painters*, 140

Piranesi, Giovanni Battista, 71

Pius VI, Pope, 90, 115, 116, 118, 127, 130, 173, 176

Plato, 5; *Laws*, 31–33; *Republic*, 21n20, 31

Polykleitos, 147

Pomarancio (Antonio Circignani), *Christ Delivering the Keys to Saint Peter*, 183–84n91

Pompadour, Madame de, 102

Pope, Alexander, 145

Poussin, Nicolas, 16; *Benjamin and the Cup*, 134; *The Death of Germanicus*, 16; *Sacrament of Ordination*, 26

Pozzi, Stefano, 104, 144, 145

Procaccini, Andrea, *William Johnstone, 1st Marquis of Annandale*, 51–52

Puhlmann, Johann Gottlieb, 94, 95; on Batoni's drawing academy, 151; on Batoni's estate, 132; on Batoni's work, 49, 97, 104, 138, 166; replicas painted by, 175; on studio practices, 162, 171, 176

Querini, Cardinal Angelo Maria, 1, 3, 5

Quin, Valentine Richard, 74–75, 75, 84, 87

Quintus Curtius Rufus, *History of Alexander the Great*, 95

Raimondi, Marcantonio, *Judgement of Paris*, 30

Ramdohr, Friedrich Wilhelm Basilius von, 7–8

Ramsay, Allan, 57, 70, 176; *John Bulkeley Coventry*, 57

Ramsay, John, 151

Raphael, 7, 48, 92, 120, 134, 140, 144, 173, 174; *Disputà*, 5; *Justice*, 71; *Philosophy*, 32; *The Sacrifice at Lystra*, 66; *School of Athens*, 45, 144; *Transfiguration*, 143

Razumovsky, Count Kirill Grigoriewitsch, 84, 106, 107, 109, 172, 176

Reni, Guido, 7–8, 12, 53, 92; *Allegory of Fortune*, 7; *Ascension of Christ*, 174; *Aurora*, 7; *Christ on the Cross*, 174; *Saint Joseph and the Christ Child*, 8; *Trinity*, 11; *Wedding of Bacchus and Ariadne*, 30–31

Restout, Jean, 92

Reynolds, Sir Joshua, 42, 43, 45, 132, 134, 170, 176; *Portrait Groups of Members of the Society of Dilettanti*, 186n40

Rezzonico, Prince Abbondio, 115–16, 117

Rezzonico, Cardinal Carlo, 115

Riccardi, Marchese Vincenzo Maria, 17, 18

Richardson, Jonathan, Senior and Junior, *Account of Some of the Statues, Bas-reliefs, Drawings, and Pictures in Italy*, 79

Richmond, George Henry, 3rd Duke of, 38, 40, 62

Richmond and Lennox, Charles, 3rd Duke of, 42, 43, 45

Riedel, Johann Anton, 135

Ripa, Cesare, 32; *Iconologia*, 16

Robinson, Thomas, 115, 169

Rochechouart de Faudoas, Cardinal Jean-François-Joseph de, 120, 121–22, 121

Roda y Arrieta, Marqués Manuel de, 97, 122, 122

Romano, Giulio, *Battle of the Milvian Bridge*, 12

Roma Triumphans, 79

Romney, George, 43

Rosa, Salvator, *Martyrdom of Saints Cosmas and Damian*, 33

Rowley, Arthur, 52

Roxburghe, John Ker, 3rd Duke of, 38, 43, 44

Rubens, Peter Paul, 90, 135

Russel, James, 48

Sacchi, Andrea, 7, 26; *Saint Peter*, 8; *Virgin and Child with Saint Basil of Cappadocia*, 7

Saint Odile, Mathieu-Dominique Charles Poirot de la Blandinier, Baron de, 102, 103, 109

Salimbeni, Ventura, 143

Sandilands, Isabella (Mrs. Robert), 49, 76, 78

Santi Bartoli, Francesco, 145

Sardini, Lodovico, 18, 24, 25, 26, 27, 28, 175

Segni, Gaetano II Sforza Cesarini, Duke of, 122, 124, 124

Shuvalov, Count Ivan Ivanovich, 109, 176

Siena, Guido da, 134

Society of Dilettanti, 45

Society of Jesus, 122

Soldi, Andrea, *Henry Somerset, 3rd Duke of Beaufort*, 52

Sophia Matilda, Princess, 113, 141

Southey, Robert, 130

Spencer, Georgiana Poyntz, Countess, 70–71, 70, 79, 113

Stanislas II, King of Poland, 24, 114, 176

Statius, *Achilleid*, 27, 28, 138

Stern, Ludovico, 51

Stormont, David Murray, 7th Viscount, 42

Stuart, Prince Charles Edward, 174

Stuart, Prince Henry Benedict, 174

Stuart, James Francis Edward, 93, 97, 111

Stubbs, George, 43

Subleyras, Pierre, 51, 118, 181n10; *Mass of Saint Basil*, 35

Swinburne, Henry, 42, 49

Talenti, Bartolomeo, 29, 30

Temple of the Sybil, 79, 81

Terence, *Comedies*, 84

Thanet, Sackville Tufton, 8th Earl of, 54–55, 55, 57, 75, 84, 87, 172

Thorpe, Father John: on Batoni in Rome, 95; on Batoni's clients and patrons, 98, 103, 104, 109, 114, 173, 174, 175; on Batoni's death, 132; on Batoni's income, 109, 176; on Batoni's reputation, 37, 175; Batoni's work described by, 75, 114, 130, 138, 140, 141, 172

Tischbein, Johann Heinrich Wilhelm, 97, 130

Titian, 54, 98, 144; *Charles V with Drawn Sword*, 90; *Clarissa Strozzi*, 71

PHOTOGRAPH CREDITS